Ceramic Sculpture

COLOR PLATE 1

Top row, left to right

Glaze #1 over red clay body White crackle glaze #27 Volcanic ash glaze #14

Transparent lead glaze #3 with yellow base

Second row

Volcanic ash glaze #16 with yellow underglaze color added.

Used over a black clay body.

Volcanic ash glaze #15 over red clay body.

Glaze over glaze, leadless Majolica glaze #10 with copper added, applied over a layer of the same glaze with cobalt added.

Iron red glaze #40

Third row

Gun metal glaze #32

Rutile glaze #25 with cobalt

Spatter. Brown underglaze color spattered on top of glaze #8 with yellow underglaze color added
Lead glaze with ilmenite, glaze #30

Fourth row

Rutile glaze #26 with cobalt

Rutile glaze #26 with nickel oxide and manganese carbonate

Rutile glaze #25 with copper

Transparent lead glaze #3 with brown underglaze color

Bottom row

Borosilicate glaze #13 with copper

Majolica. Underglaze colors painted over white majolica glaze #10

Rutile glaze #25 with copper and cobalt Majolica glaze #8 with cobalt.

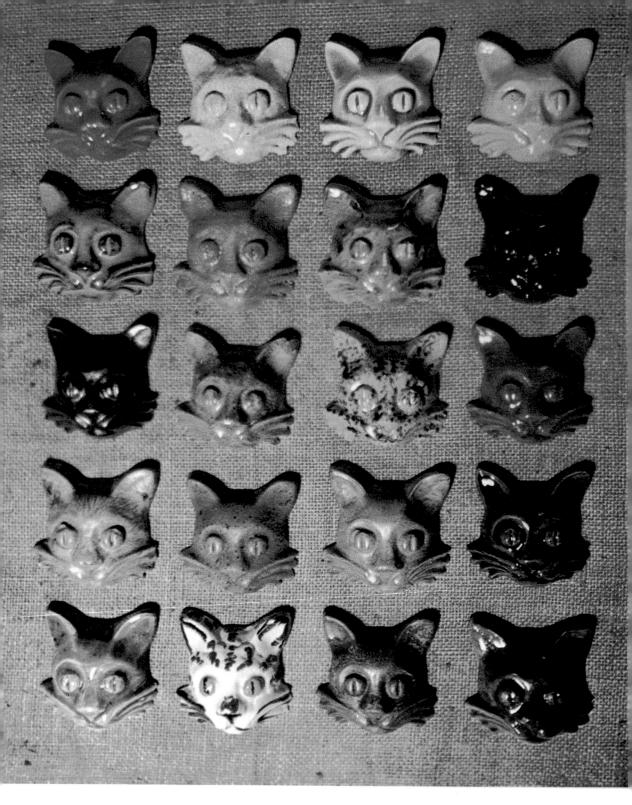

COLOR PLATE 1

Ceramic Sculpture

by

JOHN B. KENNY

with illustrations by the author

CHILTON BOOK COMPANY

Radnor, Pennsylvania

Copyright © 1953 by John B. Kenny All Rights Reserved Published in Radnor, Pennsylvania, by Chilton Book Company and simultaneously in Don Mills, Ontario, Canada, by Nelson Canada Limited Library of Congress Catalog Card Number 53-5530 ISBN 0-8019-0162-6 hardcover ISBN 0-8019-6052-5 paperback Manufactured in the United States of America

13 14 15 16 17 18 19 20 8 7 6 5 4 3 2 1

Acknowledgments

It is with deep appreciation that I acknowledge the help that was given to me in the preparation of this book by people who know the joy of working with clay and who love to share that joy with others. Among these are

the sculptors who posed for the pictures illustrating methods of shaping clay,

the artists who were generous in showing examples of their work,

the ceramists and teachers who allowed me to photograph the work of their students; Lyle Perkins and Dorothy Perkins of the Rhode Island School of Design; Vance Kirkland and John Billmyer of the University of Denver; Lynn R. Wolfe of the University of Colorado; Glen Lukens of the University of Southern California; Laura Andreson of the University of California at Los Angeles; Richard Petterson of Scripps College; Dean Boris Blai of the Tyler School of Fine Arts; Paul Bogaty and Edgar Littlefield of Ohio State University (Edgar Littlefield also told me about the use of wax emulsion); and Sheldon Carey of the University of Kansas who also made available the results of research on the use of volcanic ash in ceramic glazes.

Robert Brightman of *Mechanix Illustrated* who permitted use of portions of an article on building a ceramic kiln which I wrote originally for that magazine,

students of the School of Industrial Art of New York City who posed for many of the pictures,

and my son, Michael, who posed and made suggestions.

To these, and to all my other friends who were generous with their encouragement, my sincerest thanks.

The author

Contents

	$F_{\rm oreword} \ \ldots \ \ldots \ \ldots \ \ldots \ \ldots \ \ldots$	xiii
chapter 1	$ m W_{e}$ Work with Clay $ m$	1
	Modeling with Balls and Cylinders. A Candlestick. Obtaining Clay. Moist Clay. Dry Clay. Liquid Clay. Wedging. Shrinkage. Drying. Joining Clay. Porosity. Grog. Organic Materials in Clay. Hollowing Out. Coil Building. Slab Building. A Newspaper Coil. Keeping Work Damp. Self-hardening Clay. Ovenhardening Clay. Plasteline. Reclaiming Clay. Form.	
chapter 2		
	T_{ools} and Equipment	20
	The Sculptor's Fingers. Modeling Tools. Making a Sculpture Tool. The Wedging Board. Woodworking Tools. The Whirler and Handrest. Modeling Boards. A Damp Closet. A Modeling Stand. Sprayers. Calipers. Proportional Calipers. A Frog. Kitchen Tools. Light. Using a Mirror. Caring for Tools.	
chapter 3		
	$T_{ m he\ Figure}$	32
	Sketching in Clay. Anatomy. Modeling an Anatomical Figure. Modeling a Dancer. Armatures. Working from a Model.	
chapter 4		
	$A_{ ext{nimals}}$	48
	A Cat. A Running Deer. Making Animals by Slab Building. Dogs. A Monkey Tree. An Equestrian Figure. Butterflies. Animal Anatomy. Turtles. Animal Portraiture.	
[vii]		

Preparing an Armature. Making a Portrait of a Boy. Making a Portrait of a Young Woman. Anatomy of the Head. Basic Head Shape and Major Planes. Portraiture. **Molds** **Plaster** of Paris. Gypsum. Types of Molds, Press Molds, Squeeze Molds, Drain Molds, Solid Casting Molds, Waste Molds, Case Molds. Buying Plaster. Hydrocal and Hydrostone. Pottery Plaster. Making a One-piece Press Mold for a Tile. Mixing Plaster. Estimating Quantities. Setting, Pressing a Tile. Making a Drain Mold. Making a Sprig Mold. Plaster Drying Bowls. Sizing. Shellac. Retaining Walls. Making a Two-piece Press Mold. Notches. A Template. A Gate. Determining Number of Pieces. Mold Making without Retaining Walls. Making a Mold of a Candleholder. Making a Press Mold for a Large Ceramic Group. Shims. Making a Waste Mold. Thread Separation. Casings. Modeling in Plaster. Carving. Running Plaster. A Turning Box. Speed of Setting. Plaster Tools. Disposing of Waste. Repairing Molds. Craftsmanship. **Chapter 7** **Materials** **Clay, Residual, Sedimentary, Ball. Fire Clay. Buff Clay. Red Clay. Bentonite. Fluxes. Feldspar. Nepheline Syenite. Body Frit. Glass Cullet. Talc. Whiting. Fillers. Casting Slip. Defloculation. Using Local Materials. Digging Your Own Clay. Preparing Clay for Use. Testing the Properties of a Clay. Altering a Clay. Color. Plasticity. Aging Clay. Opening Up Clay. Firing Range. Casting Properties. Clay Bodies. Recipes, Sculpture Body, Porcelain, Stoneware, White Bodies, Casting Slips, Terra-cotta Bodies. Mixing Clay Bodies, Blunging. The Filter Press. Pugging and De-airing. Preparing Clay Bodies. Making Your Own.	cnapter 5		
a Portrait of a Young Woman. Anatomy of the Head. Basic Head Shape and Major Planes. Portraiture. **Chapter 6** **Molds** **Plaster of Paris. Gypsum. Types of Molds, Press Molds, Squeeze Molds, Drain Molds, Solid Casting Molds, Waste Molds, Case Molds. Buying Plaster. Hydrocal and Hydrostone. Pottery Plaster. Making a One-piece Press Mold for a Tile. Mixing Plaster. Estimating Quantities. Setting. Pressing a Tile. Making a Drain Mold. Making a Sprig Mold. Plaster Drying Bowls. Sizing. Shellac. Retaining Walls. Making a Two-piece Press Mold. Notches. A Template. A Gate. Determining Number of Pieces. Mold Making Without Retaining Walls. Making a Mold of a Candleholder. Making a Press Mold for a Large Ceramic Group. Shims. Making a Waste Mold. Thread Separation. Casings. Modeling in Plaster. Carving. Running Plaster. A Turning Box. Speed of Setting. Plaster Tools. Disposing of Waste. Repairing Molds. Craftsmanship. **Chapter 7** **Materials** **Clay, Residual, Sedimentary, Ball. Fire Clay. Buff Clay. Red Clay. Bentonite. Fluxes. Feldspar. Nepheline Syenite. Body Frit. Glass Cullet. Talc. Whiting. Fillers. Casting Slip. Deflocculation. Using Local Materials. Digging Your Own Clay. Preparing Clay for Use. Testing the Properties of a Clay. Altering a Clay. Color. Plasticity. Aging Clay. Opening Up Clay. Firing Range. Casting Properties. Clay Bodies. Recipes, Sculpture Body, Porcelain, Stoneware, White Bodies, Casting Slips, Terra-cotta Bodies. Mixing Clay Bodies, Blunging. The Filter Press. Pugging and De-airing. Preparing Clay Bodies. Making Your Own.		$P_{ ext{ortraiture}}$	71
Plaster of Paris. Gypsum. Types of Molds, Press Molds, Squeeze Molds, Drain Molds, Solid Casting Molds, Waste Molds, Case Molds. Buying Plaster. Hydrocal and Hydrostone. Pottery Plaster. Making a One-piece Press Mold for a Tile. Mixing Plaster. Estimating Quantities. Setting. Pressing a Tile. Making a Drain Mold. Making a Sprig Mold. Plaster Drying Bowls. Sizing. Shellac. Retaining Walls. Making a Two-piece Press Mold. Notches. A Template. A Gate. Determining Number of Pieces. Mold Making Without Retaining Walls. Making a Mold of a Candleholder. Making a Press Mold for a Large Ceramic Group. Shims. Making a Waste Mold. Thread Separation. Casings. Modeling in Plaster. Carving. Running Plaster. A Turning Box. Speed of Setting. Plaster Tools. Disposing of Waste. Repairing Molds. Craftsmanship. Chapter 7 Materials Clay, Residual, Sedimentary, Ball. Fire Clay. Buff Clay. Red Clay. Bentonite. Fluxes. Feldspar. Nepheline Syenite. Body Frit. Glass Cullet. Talc. Whiting. Fillers. Casting Slip. Defloculation. Using Local Materials. Digging Your Own Clay. Preparing Clay for Use. Testing the Properties of a Clay. Altering a Clay. Color. Plasticity. Aging Clay. Opening Up Clay. Firing Range. Casting Properties. Clay Bodies. Recipes, Sculpture Body, Porcelain, Stoneware, White Bodies, Casting Slips, Terra-cotta Bodies. Mixing Clay Bodies, Blunging. The Filter Press. Pugging and De-airing. Preparing Clay Bodies. Making Your Own.		a Portrait of a Young Woman. Anatomy of the Head. Basic	
Plaster of Paris. Gypsum. Types of Molds, Press Molds, Squeeze Molds, Drain Molds, Solid Casting Molds, Waste Molds, Case Molds. Buying Plaster. Hydrocal and Hydrostone. Pottery Plaster. Making a One-piece Press Mold for a Tile. Mixing Plaster. Estimating Quantities. Setting. Pressing a Tile. Making a Drain Mold. Making a Sprig Mold. Plaster Drying Bowls. Sizing. Shellac. Retaining Walls. Making a Two-piece Press Mold. Notches. A Template. A Gate. Determining Number of Pieces. Mold Making Without Retaining Walls. Making a Mold of a Candleholder. Making a Press Mold for a Large Ceramic Group. Shims. Making a Waste Mold. Thread Separation. Casings. Modeling in Plaster. Carving. Running Plaster. A Turning Box. Speed of Setting. Plaster Tools. Disposing of Waste. Repairing Molds. Craftsmanship. Chapter 7 Materials Clay, Residual, Sedimentary, Ball. Fire Clay. Buff Clay. Red Clay. Bentonite. Fluxes. Feldspar. Nepheline Syenite. Body Frit. Glass Cullet. Talc. Whiting. Fillers. Casting Slip. Defloculation. Using Local Materials. Digging Your Own Clay. Preparing Clay for Use. Testing the Properties of a Clay. Altering a Clay. Color. Plasticity. Aging Clay. Opening Up Clay. Firing Range. Casting Properties. Clay Bodies. Recipes, Sculpture Body, Porcelain, Stoneware, White Bodies, Casting Slips, Terra-cotta Bodies. Mixing Clay Bodies, Blunging. The Filter Press. Pugging and De-airing. Preparing Clay Bodies. Making Your Own.	chapter 6		
Squeeze Molds, Drain Molds, Solid Casting Molds, Waste Molds, Case Molds. Buying Plaster. Hydrocal and Hydrostone. Pottery Plaster. Making a One-piece Press Mold for a Tile. Mixing Plaster. Estimating Quantities. Setting. Pressing a Tile. Making a Drain Mold. Making a Sprig Mold. Plaster Drying Bowls. Sizing. Shellac. Retaining Walls. Making a Two-piece Press Mold. Notches. A Template. A Gate. Determining Number of Pieces. Mold Making Without Retaining Walls. Making a Mold of a Candleholder. Making a Press Mold for a Large Ceramic Group. Shims. Making a Waste Mold. Thread Separation. Casings. Modeling in Plaster. Carving. Running Plaster. A Turning Box. Speed of Setting. Plaster Tools. Disposing of Waste. Repairing Molds. Craftsmanship. Chapter 7 Materials Clay. Residual, Sedimentary, Ball. Fire Clay. Buff Clay. Red Clay. Bentonite. Fluxes. Feldspar. Nepheline Syenite. Body Frit. Glass Cullet. Talc. Whiting. Fillers. Casting Slip. Deflocculation. Using Local Materials. Digging Your Own Clay. Preparing Clay for Use. Testing the Properties of a Clay. Altering a Clay. Color. Plasticity. Aging Clay. Opening Up Clay. Firing Range. Casting Properties. Clay Bodies. Recipes, Sculpture Body, Porcelain, Stoneware, White Bodies, Casting Slips, Terra-cotta Bodies. Mixing Clay Bodies, Blunging. The Filter Press. Pugging and De-airing. Preparing Clay Bodies. Making Your Own.		$M_{ m olds}$	81
Materials		Squeeze Molds, Drain Molds, Solid Casting Molds, Waste Molds, Case Molds. Buying Plaster. Hydrocal and Hydrostone. Pottery Plaster. Making a One-piece Press Mold for a Tile. Mixing Plaster. Estimating Quantities. Setting. Pressing a Tile. Making a Drain Mold. Making a Sprig Mold. Plaster Drying Bowls. Sizing. Shellac. Retaining Walls. Making a Two-piece Press Mold. Notches. A Template. A Gate. Determining Number of Pieces. Mold Making Without Retaining Walls. Making a Mold of a Candleholder. Making a Press Mold for a Large Ceramic Group. Shims. Making a Waste Mold. Thread Separation. Casings. Modeling in Plaster. Carving. Running Plaster. A Turning Box. Speed of Setting. Plaster Tools. Disposing of	
Clay, Residual, Sedimentary, Ball. Fire Clay. Buff Clay. Red Clay. Bentonite. Fluxes. Feldspar. Nepheline Syenite. Body Frit. Glass Cullet. Talc. Whiting. Fillers. Casting Slip. Deflocculation. Using Local Materials. Digging Your Own Clay. Preparing Clay for Use. Testing the Properties of a Clay. Altering a Clay. Color. Plasticity. Aging Clay. Opening Up Clay. Firing Range. Casting Properties. Clay Bodies. Recipes, Sculpture Body, Porcelain, Stoneware, White Bodies, Casting Slips, Terra-cotta Bodies. Mixing Clay Bodies, Blunging. The Filter Press. Pugging and De-airing. Preparing Clay Bodies. Making Your Own.	chapter 7		
Clay. Bentonite. Fluxes. Feldspar. Nepheline Syenite. Body Frit. Glass Cullet. Talc. Whiting. Fillers. Casting Slip. Deflocculation. Using Local Materials. Digging Your Own Clay. Preparing Clay for Use. Testing the Properties of a Clay. Altering a Clay. Color. Plasticity. Aging Clay. Opening Up Clay. Firing Range. Casting Properties. Clay Bodies. Recipes, Sculpture Body, Porcelain, Stoneware, White Bodies, Casting Slips, Terra-cotta Bodies. Mixing Clay Bodies, Blunging. The Filter Press. Pugging and De-airing. Preparing Clay Bodies. Making Your Own.		$M_{aterials}$	118
		Clay. Bentonite. Fluxes. Feldspar. Nepheline Syenite. Body Frit. Glass Cullet. Talc. Whiting. Fillers. Casting Slip. Defloculation. Using Local Materials. Digging Your Own Clay. Preparing Clay for Use. Testing the Properties of a Clay. Altering a Clay. Color. Plasticity. Aging Clay. Opening Up Clay. Firing Range. Casting Properties. Clay Bodies. Recipes, Sculpture Body, Porcelain, Stoneware, White Bodies, Casting Slips, Terra-cotta Bodies. Mixing Clay Bodies, Blunging. The Filter Press. Pugging and De-airing. Preparing Clay Bodies.	
\mathbf{C} .	chapter 8		
Color		C_{olor}	133
Color in Sculpture. Natural Color in Clay. Effect of the Fire. Effect of Reduction. Blending. Agate Ware. Using Clays of Different Color. Adding Color to Clay. Body Stains. Painters' Pigments. Colored Grog. Engobe. Engobe Recipes. Applying Engobe. Stencils. Slip Trailing. A Slip Trailing Tube. Painting Engobe in Molds. Sgraffito. Wax Resist. Glass Forming Engobe.		Effect of Reduction. Blending. Agate Ware. Using Clays of Different Color. Adding Color to Clay. Body Stains. Painters' Pigments. Colored Grog. Engobe. Engobe Recipes. Applying Engobe. Stencils. Slip Trailing. A Slip Trailing Tube. Painting	

gobes, Recipes. Terra Sigillata. Defects in Engobe. Glaze. Preparing Glazes. Principles of Glazing. Use of Feldspar, Clay, Calcined Clay, Flint, Fluxes. Glaze Recipes. Lead Glazes. Gum. Tin Enamel or Majolica Glazes. Translucent Glazes. Alkaline Glazes. Frit. Powdered Glass. Leadless Glazes. Volcanic Ash. Bristol Glazes. Mat Glazes. Rutile. Crackle. Spatter. Speckled Glazes. Metallic Effects. Gun Metal. Glaze Over Glaze. Bubbling. Reticulation. Salt Glaze. Feldspathic Glazes. Cornwall Stone. Red Glazes. Lustre. Color in Glazes. Soluble Salts. Prepared Ceramic Colors, Stains, Underglaze Colors, Overglaze Colors. Mixing Glazes. A Glaze Shaker. Grinding. Mixing Alkaline Glazes. Storing Glazes. Testing. Marking Tests. Applying Glaze, Brushing, Dipping, Pouring, Spraying, Glazing Raw Ware. Glaze Defects, Crazing, Crawling, Blistering, Running. Using Glaze Defects. Surface Treatments. Texture. Vermiculite. Wax. Soapstone. Milk. Oil. Rubbing. Paint, Cement Base Paint, Patina, Form and Color,

chapter 9		
	$T_{\rm he\ Kiln} $	189
	Measuring Temperature. Pyrometric Cones. Refractory Bricks. Insulating Bricks. Fuels. Electric Kilns, Nichrome, Kanthal, Globar. Gas Kilns. Muffle Kilns. Downdraft Kilns. Saggers. Oil Fired Kilns. Periodic and Continuous Kilns. Buying a Kiln. The Firing Cycle, Water Smoking, Dehydration, Organic Matter, Maturing Temperatures, Vitrification, High Fire, Cooling. Grinding. Oxidation and Reduction. Stacking. Kiln Supports. Dry Footing. Kiln Wash. Building a Kiln. Understanding Your Kiln.	
chapter 10		
	$D_{ m ecorative\ Ceramics}$	208
	Ceramic Flowers. Figurines. Making a Mold for a Figurine. Ceramic Lace. Decorating. Underglaze Painting. Polychrome. Majolica. Overglaze or China Painting. Gold. Sgraffito in Glaze. Painting with a Sponge. An Extruding Tool. Using Decalcomanias. Marbelizing. Ceramic Crayons. Defects in Decoration. Principles of Decoration.	
chapter 11		
	$C_{eramics}$ for Use \ldots	225
	Candlesticks. Coil, Clay Strips, Slab. Lamps. Making a Lamp by the Slab Method. Building a Lamp with a Whirler. A Rec- tangular Lamp. Wiring a Lamp. A Felt Base. Drilling. Dec- orating Lamps, Engobe, Modeling in Relief, Pierced Decora- tion, Spiral Decoration, Sprig Molds. Other Lamp Forms.	
[i]		

	Flowerholders. A Tile Top Table. A Tile Tray. Ceramic Stoves. An Electric Stove. A Plate Warmer. Useful Objects. Craftsmanship.	
chapter 12		
	C_{eramic} Sculpture for the Garden	253
	Ceramic Sculpture Out-of-Doors. Firing in Sections. Building a Figure by the Coil Method. Using Proportional Calipers. Joining Sections. A Ceramic Flower Box. Building a Fountain. A Bird Bath. Cooperation with Industry. Sewerpipe Sculpture. Protection from the Weather. Weep Holes.	
chapter 18	3	
	Let's Have Fun	275
chapter 1	4	
	$M_{ m ore\ Ways\ Than\ One}$	293
	There are No Rules. Horses. Representation. Distortion. Stylization. Abstraction. Non-objective Sculpture. Mobiles. Materials in Combination. A Functional Approach. Making a Free Form Bowl. Space. Light. Design Skill. A Final Word.	

List of Illustrations

Photo Series

1 -	- A horse made from coils .]
2 -	- An angel candleholder .										3
3 -	- Making a sculpture tool .										22
4 -	Sketching in clay										33
5 –	An anatomy lesson										37
6 -	- A Balinese dancer										43
7 -	- Modeling a cat—using a pa	per	core								49
8 -	- A deer										52
9 -	Slab building—dogs										55
10 -	A monkey tree										58
11 -	Lady Godiva										5 9
	A turtle										64
13 -	A portrait of a boy										71
14 -	A portrait of a girl										75
	A press mold for a tile .										83
	Making a one-piece drain n										91
	A sprig mold										93
18 –	A two-piece press mold .										96
19 –	A mold for a candleholder										101
	A mold for a large group, T										103
	A waste mold for a portrait						,				105
	Thread separation—a mold f										108
	A turning box										113
	Slip trailing										141
	Firing a large group										193
	Ceramic flowers										208
	Making a figurine										210
	Decorating a figurine, ceram										214
	Using an extruding tool .										220
	Decalcomania										221
31 —	4 11 1										227
32 —	A cylindrical lamp-made by										230
	A lamp, coil built, using a							,			233
	A rectangular lamp-made l										237
	Sgraffito decoration										242
	Making a ceramic stove .										249
	A ceramic plate warmer .										251
	Garden sculpture—coil built										255
	A ceramic flower box .										261
		-	-	-	-	ň	*	1	4	1	

10 - A	ceramic fountain	n.												268
1 - A	ceramic bottle.													275
	eramic fantasy .													279
43 — C	thess men													281
	eramic sculpture							eel						286
15 – F	ree form													297
				p_l	ate	is.								
т	Commis and later													VVI
I	Ceramic sculptu	re .		•		•					•			XVI
II	Figures		•	•	•	•	•	•		•	•	•		18
III	Animals			•					•		•	•		47
IV	Fish		•	•			•	•	•					66
V	Dogs		•					٠	•		•			67
VI	More animals .								٠		•	•		68
VII						;		•	•		•			69
VIII	Plaster casts sho	wing p						•	٠		•			70
IX	Portraits	. •						٠	•		•			78
X	Waxing and col	_			•	•	•	•	•	٠	•			79 70
XI	Shell form lamp			•				•	•	•	•			79
XII	•				•						•			79
XIII	Ceramic Stove .			•	•		•	•	•	•	٠			79
XIV	Sculpture out-of				•		•	٠	• ,		•			80
XV	Toys			•			•	٠			٠	•		134
XVI	More toys			•	•			•	•		٠			188
XVII					•		•				•			254
XVIII								•			•			274
XIX	More ways than					•					•			292
XX	More figures .			•		•	•				•			296
XXI	How modern is	mode	ern		•			•		•	•	•		300
			0	4/44	. 1	1/~4								
			Cl	uoi	t	<i>late</i>	es							
1 - 0	Glaze samples .											facin	g title	page
	lab built dogs .											"	page	_
3 - 1	Majolica deer											"	"	64
4 - 0	Coil built lamp .											"	"	64
5 - 1	Neptune and men	maid										"	"	64
	Ceramic chess set											"	"	64
7 - 5	Slab built lamp .											"	"	64
	The Holy Family											"	"	144
9 - 0	Glaze tests for the	Holy	Fan	nily	grou	up						"	"	144
	Ceramic altar pied						obb	oia				"	"	144
11 - 0	Ceramic fountain											"	"	240
12 - 0	Color samples .											"	"	240
	Ceramic landscap	e .										"	"	240
14 - 1	Majolica fish											"	"	240
													I	xii]

Foreword

Why dogs adopt little boys. The urge is born in us; it makes us want to change the shape of things as they are, to leave our mark upon this world so that it will be different in some degree because we have lived here. We express our joy at being alive by ornamenting the things we use; we study the forms of nature and try to reproduce them. We create new forms, never seen before, products of our imagination. We express our religious spirit by modeling objects of veneration. Our play spirit makes us fashion replicas of people and animals to serve as toys.

The Oriental who cannot afford a palace with a garden builds himself a palace and a garden within a dish, and his little garden is complete with quiet pools, rustic bridges and shady groves, a beautiful private world in miniature.

Through art man speaks to man across the ages. Our earliest ancestor became a sculptor when he carved the decoration on the handle of his first stone ax. From that he went on to more elaborate forms, to representations of the wild beasts that he hunted, to figures that stood for the mysterious forces of the sky and the forest. What he fashioned from clay awed him so that he endowed his figures with the properties of magic, and made amulets and charms to guard him from evil. He even tried to cheat death by making portraits of loved ones that would remain immortal after the subjects themselves had passed away, and, in order that his own entry into the other world would not be lonely, he made figures of people out of clay to share his tomb. When he evolved a medium of exchange and started to make coins, he stamped sculptured designs in relief on discs of metal to identify them as money.

Art is not for the few — it is for all of us. Whoever understands his medium and works with it sincerely is an artist, no matter if the medium be paint and canvas or the cloth which makes a suit of clothes. As ceramic sculptors we work with clay, that wonderful plastic material. Unlike the stonecutters and the woodcarvers we do not cut off and throw away, we do not subtract — we add, we build. We work with fire, too, fire that performs its magic on the forms we create and endows them with hardness and strength and rich warm color. The things we make may be small or large, serious or gay, planned for decoration or for use. When we shape our clay and create order and form where none existed before, we add to the beauty and the happiness of our world.

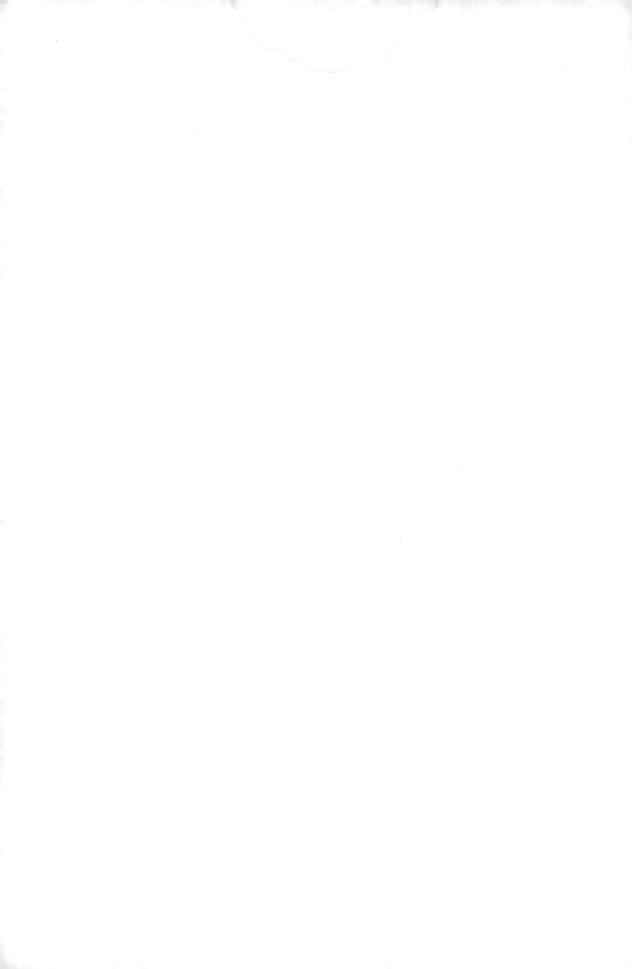

TABLE OF CONE TEMPERATURES

	Centi-	Fahren-	Color	What Happens	Type of Ware
Cone	grade	heit	of Fire	to Clay	and Glazes
15	1435	2615\			
14	1400	2552			
13	1350	2462		porcelain	porcelain
12	1335	2435		matures	
11	1325	$2417 \langle$	white		
10	1305	2381/	WIIIC	, ,	china bodies
9	1285	2345		stoneware clays	stoneware
8	1260	2300		mature	salt glazes
7	1250	2282			
6	1230	2246			
5	1205	2201			
4	1190	2174		red clays melt	china glazes
3	1170	2138			
2	1165	2129			semi-vitreous ware
1	1160	2120			
01	1145	2093	yellow		
02	1125	2057		buff clays	earthenware
03	1115	2039		mature	
04	1060	1940			
05	1040	1904		6 m m	
06	1015	1859		red clays mature	
07	990	1814			low fire earthenware
08	950	1742	orange		
09	930	1706	8		low fire lead glazes
010	905	1661)			
011	895	1643)	cherry		
012	875	1607	red		lustre glazes
013	860	1580)			
014	830	1526			
015	805	1481		organic matter in	chrome red glazes
016	795	1463		clay burns out	
017	770	1418	dull		, ,
018	720	1328	red		overglaze colors
019	660	1220	reu		enamels
020	650	1202			
021	615	1139		11 1 1	
022	605	1121/		dehydration begins	

Pyrometers

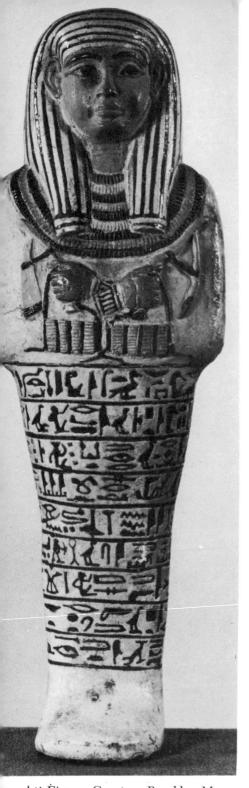

awabti Figure. Courtesy Brooklyn Musen. Shawabtis, four to six inches tall, were ried with the dead in ancient Egypt. Ley were supposed to accompany the derted to the other world and act as servts, doing any work that was needed. Ley had tools, ropes and baskets.

Chinese Tomb Guardian. T'ang Dynasty. Courtesy Brooklyn Museum.

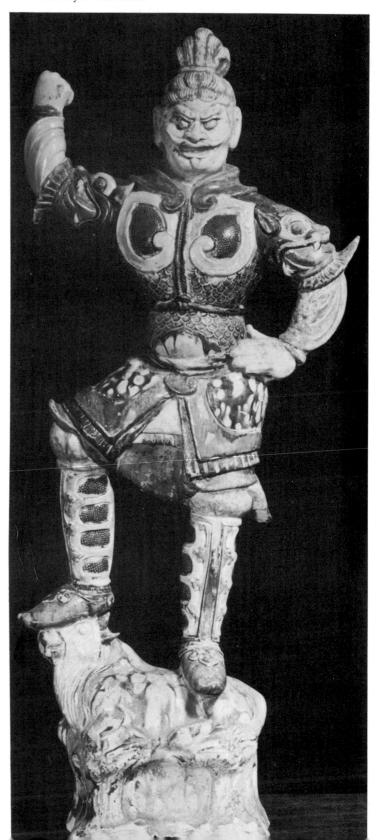

1 We Work With Clay

C ERAMIC SCULPTURE is made of clay and other earthy materials, modeled into shape and heated to a high temperature. Sometimes it is glazed; sometimes it is colored or decorated. The ceramic sculptor, therefore, must know many things: how to create form, how to fire a kiln, how to prepare and apply glazes, how to use ceramic pigments. In the course of our study we shall learn about all of these and others as well. Let's begin by finding out how clay is shaped.

There is no one way of making clay sculpture; there are many. As we explore different methods of shaping clay, trying them out together, you will find some that appeal to you more than others. You may even find a brand new method of working with clay, something all your own.

A good way to start is to model a figure out of clay rolled into cylinder and ball shapes.

Modeling with balls and cylinders

Working on a wooden drawing board or a table top, take a lump of clay the size of an orange and squeeze it until it is roughly cylindrical in shape. Put the cylinder on the board and roll it back and forth with the fingers until it becomes a long clay rope about three-quarters of an inch in diameter. Try to make it even in thickness throughout its entire length. Roll lightly so that it does not become flat.

Cut the clay rope into six pieces, and join them together like this. To make sure the joints hold, roughen the surfaces first by making scratches with a wooden modeling tool, then moisten them. Press the pieces firmly together and seal the edges of the joint with the modeling tool.

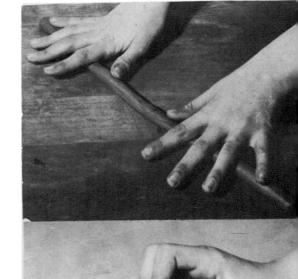

PHOTO SERIES 1

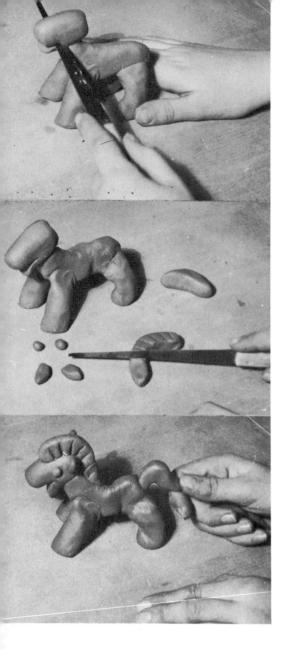

Cut a mouth.

Roll a ball of clay, then press it flat. Out of this cut a pair of ears and a mane; roll a smaller cylinder for a tail, and put them all in place.

Now there's a horse!

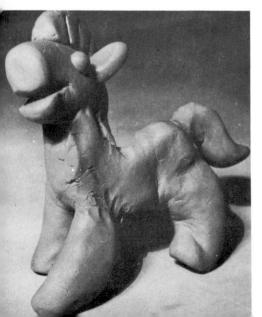

Make him smile.

What we have just done was extremely simple, yet it's an excellent way to start.

A candlestick

Here is another application of this method. A little figure holding a candle is an amusing object, and at the same time it can be a practical candlestick. Let's make such a figure in the form of an angel.

This time we begin by making a sketch of the idea on paper.

A cone of clay will serve for a body, a ball for a head, and cylinders will form arms and wings.

Press a cylinder into a flat shape to make an arm with a flowing sleeve.

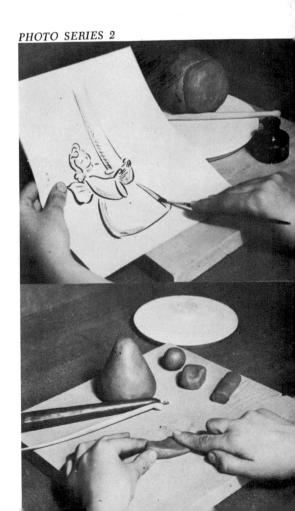

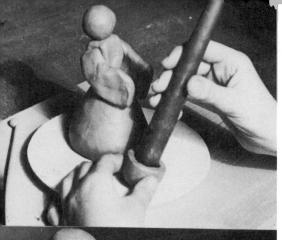

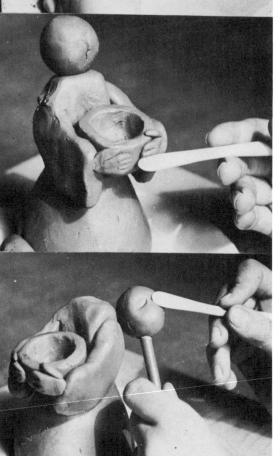

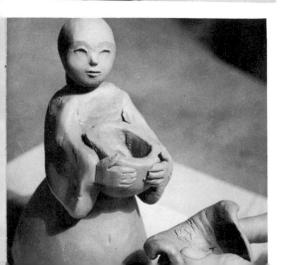

Make a small basket of clay to hold the end of the candle.

The basket in place in the arms. Lumps of clay are added for hands and roughly shaped.

Adding features. The head is removed and held on the end of a pencil while indentations are made for the eye sockets.

Eyes, nose and mouth have been worked into shape. The angel is bald at the moment so let's start work on a wig, page boy style.

She certainly looks better with hair.

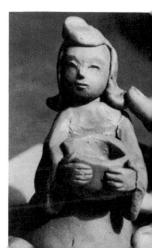

Add a pair of wings and the angel is finished. We could let this figure dry, then fire it and glaze it. Instead, let's hold it until we reach Chapter 6 and then we'll make a mold of it, following the steps shown in Photo Series 19 on page 101.

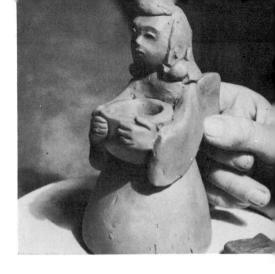

Make some simple figures like those shown in Fig. 1 but using ideas of your own. Avoid complicated subjects, especially ones with unsupported parts. No prancing horse, no dancer balanced on a toe; those will come later on. At the beginning choose subjects that can be modeled compactly in simple masses. Remember some thing you have seen that might lend itself to this treatment — a workman having his lunch, a child hugging a dog, a sleeping cat. Model the figure or the group in clay, trying to capture the essentials and to suggest the action. Your clay will force you to simplify your thinking and eliminate what is not important. Let it help you.

Obtaining clay

At the beginning it is best to buy your clay from a dealer in ceramic supplies. A glance at the catalogues will show a bewildering assortment of clays and clay bodies listed. (A clay is a natural substance dug from the earth; a clay body is a manufactured material made by mixing two or more clays and sometimes adding other ingredients to secure special working or firing properties.) Some of the clays are moist and plastic, others are dry lumps or finely pulverized; still others are liquids. What type should one buy? The answer to this question will depend upon the type of work you plan to do and on the kiln in which you will fire it.

Ceramic supply dealers sell a number of red clays and buff clays. Among the former, you will find such names as Dalton, Campbell, Alberhill red; among the buff clays are Monmouth, Gorden, Jordan, Alberhill blue and others. When we speak of the color of a clay, we mean the color after it is fired. Before firing, clay may be almost any color, gray, green, yellow, red, brown, or even black, but the color of raw clay is of little interest to the ceramic sculptor. What counts is the color of the piece that comes out of the kiln.

In addition to red and buff clays, dealers sell clays that fire black such as Barnard or "Black Bird" clay, but these are rarely used for sculpture work. Their main use is for decoration on other colored clays.

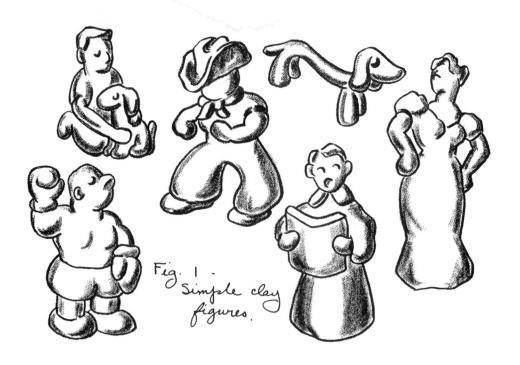

For small pieces of ceramic sculpture on which brilliant colors are desired, it is necessary to use a material that fires white, because any color in the body affects the color of transparent glazes put over it. Natural white clays are difficult to work with and in most cases must be fired to extremely high temperatures, temperatures well beyond the range of ordinary kilns. However, dealers sell specially prepared white clay bodies that can be fired in any studio kiln. These are good for making figurines and ceramic jewelry. Some of the prepared white bodies are almost translucent after they are fired.

Consult your dealer when you select your clay or clay body and be guided by his advice. Remember one thing: some clays require higher temperatures than others to harden properly. If your kiln is limited to a low temperature range, get a clay that matures at a low temperature.

Moist clay

Clay sold in moist plastic form is ready for immediate use. It can be purchased in wooden tubs holding 100 to 125 pounds. If you buy your clay this way, you can use the tub as a storage bin. Keep the tub covered with wet burlap and your clay will always be in good working condition.

Dealers now sell moist clay in plastic bags which are almost completely air tight. Clay kept in such a bag will remain in good working condition for several months without any additional wetting as long as the bag is kept closed.

Dry clay

There are certain advantages to buying clay in dry powder form. Such clay is called *clay flour*. It is usually cheaper, since you are not paying for water, and also it is easier to store until you are ready to use it. Clay flour can be prepared for use by spreading a layer about a half inch thick on the bottom of a pail or a large crock, then sprinkling the layer with water until it is thoroughly moist but not soaking wet. Spread another layer of clay flour on top of the first, sprinkling it as before, and continue the process until the crock is full. After two or three hours the clay will be ready to be taken out of the crock and wedged (Fig. 2).

Some dealers supply plastic bags with the clay they sell in flour form. The clay flour is put into the bag and water is added at the rate of one pint of water for every four pounds of clay. The neck of the bag is then tied shut and the clay and water are kneaded thoroughly and, behold, plastic clay is prepared without even wetting the hands.

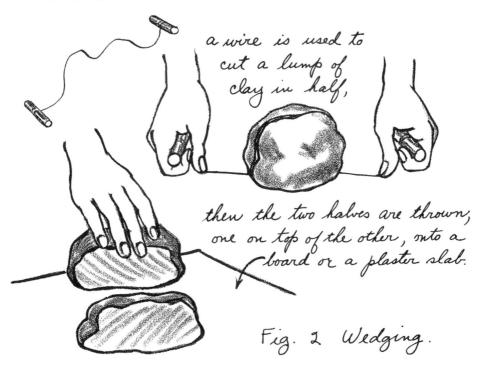

Liquid clay

Clay can also be purchased in liquid form called *slip*. This is used for making castings from plaster molds. Casting clay is also sold as a dry powder to which water can be added to form slip. The methods of using casting slip and molds are described in Chapter 6.

Wedging

Before clay is used it must be wedged. If this is not done, some portions will be harder than others; there may even be lumps that interfere with

[7]

the work. Wedging is a method of mixing a mass of clay thoroughly by cutting it in half and then throwing both halves, one on top of the other onto a plaster slab or a wooden table top. A wire fastened to two pieces of wood that serve as handles can be used to cut the clay as shown in Fig. 2. After the clay is cut, one half is thrown onto the slab and the other half is thrown on top of it. The halves must be thrown with force so that the two portions are wedged into one. This piece is then cut into two halves which are again thrown onto the slab, one on top of the other. To make sure that you get maximum mixing action always throw the halves onto the slab with the cut portion pointing away from you. The process must be continued until the clay has been cut and wedged together at least twenty times. Before you stop wedging, look at the portion of the clay cut by the wire. If the wedging is sufficient, this portion will be smooth and even in texture without air pockets, lumps or stripes.

If your clay is too wet, so soft that you cannot work with it, wedging will remove the excess moisture. If, on the other hand the clay is too dry and hard, you can moisten it during the wedging process by dipping your hand in water and wetting the surface of the mass each time you are ready to cut it. This will soon bring the clay to the right consistency.

If you plan to do a considerable amount of work with clay your studio should have a wedging board. The construction of this piece of equipment is shown in Fig. 16 on page 25.

Shrinkage

Plastic clay contains water, called *water of plasticity*, which makes it pliable and workable. Usually the water is 25% to 35% of the dry weight of the clay. The more plastic the clay, the higher its percentage of water of plasticity.

There is another kind of water in clay called the *chemically combined* water. This is water we never see, for if a piece of clay were allowed to stand in the sun until it became bone dry and then crushed to a powder fine enough to blow away, the chemically combined water would still be present in that dry powder.

Clay shrinks when it dries and it shrinks some more when the chemically combined water is driven out during the firing. As a result of both of these shrinkages a piece comes out of the kiln about one sixth smaller than its original plastic shape. You must anticipate this shrinkage in your planning.

Drying

As clay starts to dry it goes through the *leather hard* state. Leather hard clay is still damp but no longer plastic; if you try to squeeze it into a different shape, it will break. As the drying process continues, all of the water of plasticity leaves, and the clay becomes *bone dry*.

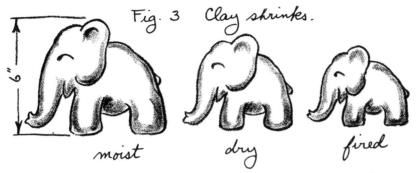

While clay is drying and shrinking, things may happen to cause trouble. If the drying is uneven so that one portion shrinks more rapidly than another, the piece will crack or warp. If one portion is thick and another thin, the latter part may become bone dry while the rest of the piece is still damp and, as a result, break off. To avoid this trouble, clay sculpture must be allowed to dry slowly and as evenly as possible. Clay dries out at the top first, so keep a moistened cloth over the top of a piece while allowing the lower portion to remain uncovered. In order that air may reach the bottom as well as the top and sides, support the work on two strips of wood as shown in Fig. 4.

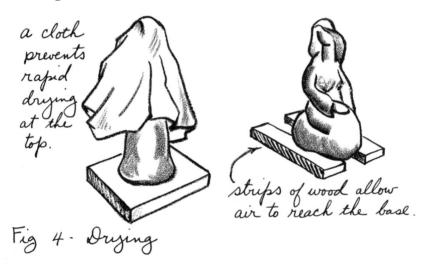

Joining clay

Two or more pieces of clay may be fastened together provided they have the same moisture content. If one piece is drier than the other, there will be unequal shrinkage and the joint won't hold. When joining two pieces, roughen the areas that go together, moisten them with water or slip, then press the pieces firmly together and weld the joint with a wooden modeling tool.

It is a simple matter to join two pieces of clay when they are plastic or when they are leather hard. Joining bone dry pieces is more difficult but it can be done; the only time it should be tried is when some finished

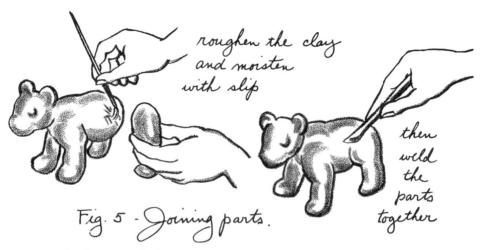

piece is broken just before going into the kiln. Don't use slip or water in this case. Moisten the parts with a few drops of vinegar and hold them firmly together. The acetic acid increases the plasticity of the clay and helps the joint to hold.

Porosity

One of the sculptor's problems is allowing the chemically combined water to escape from clay during the firing. If a piece of sculpture is heavy and the clay is dense, the water will not escape quickly enough, but will be turned into steam which blows up the piece. In small figurines this can be guarded against by using grog to make the clay porous.

Grog

Grog is clay which has been fired and ground up, then screened to workable size. When we mix this ground-up fired clay with our plastic clay, we provide porosity so that the chemically combined water has channels of escape. A good size of grog to use for ordinary work is 40-60 mesh. That means the ground-up pieces are small enough to go through a screen with 40 meshes to the inch but too large to go through a screen with 60 meshes to the inch. Use about one part of grog to two parts of clay. For large sculpture, a coarser size of grog, 20-40 mesh, should be used.

Organic substances

Clay can be made porous by adding organic substances that burn out during the firing. I have used coarse sawdust, mixing it with clay in about equal parts by volume, that is one handful of sawdust to one handful of dry clay. When the piece is fired, the sawdust disappears leaving the resulting piece porous, light in weight, and somewhat soft in texture. Other organic substances, such as oatmeal, coffee grounds and straw can be used to make clay porous, but I have never tried them. You might be interested in experimenting with some of these.

Hollowing out

To be safe, any piece of ceramic sculpture more than a few inches tall should be hollow. This is no problem when we use molds because ceramic sculpture made in molds is hollow. If you are not using molds, a piece of ceramic sculpture can be hollowed out by allowing the clay to become leather hard, then slicing it in two and scooping out each half. A wire loop tool or a knife with a curved blade is handy for this purpose. Try to leave a shell of even thickness all around. This shell should be about one-half inch thick in small pieces; for larger work it may be three-quarters of an inch.

When the halves are hollowed out, moisten the cut edges with water or clay slip, then press the two parts firmly together. Seal the joint by using a wooden modeling tool to weld the edges firmly together. Don't let any sign of a crack remain. If necessary use some of the clay scooped out of the center to wedge into the joint.

A small piece of sculpture can be made hollow without cutting it in two, by scooping it out from the bottom.

Coil building

Instead of making a piece of sculpture solid and then scooping out the insides, we can, if we wish, build it hollow by using coils in a manner similar to the method of coil building pottery. In this process it is advisable to make a small sketch in clay first. Then roll clay into long ropes and proceed to build a wall following the outlines of the sketch by coiling the clay ropes one on top of another. Be sure that all of the coils are pressed firmly together, otherwise cracks will develop in the piece. After a coil is laid in position, the upper edge must be roughened with a modeling tool and moistened with water or slip. Then another coil is laid on top and the two are welded together with the thumbs. Photo Series 38 on page 255 illustrates this method.

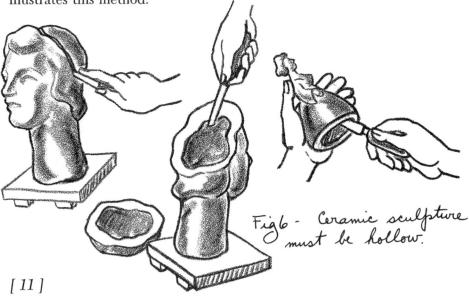

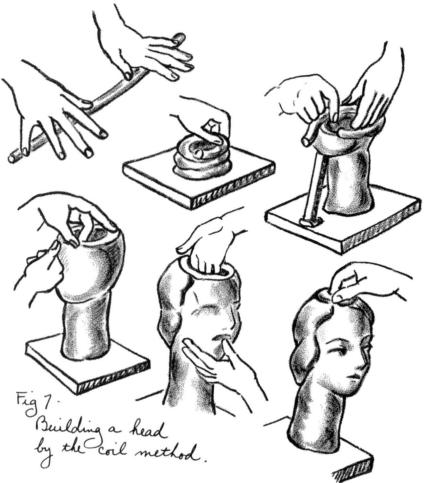

Slab building

Another way of building sculpture hollow is the slab method. In this process the clay is rolled into a layer about one-half inch thick with a rolling pin. A pattern is then cut out of this layer and fitted together. The steps are shown in Fig. 8. It is particularly important to squeeze the joints together tightly when working this way, otherwise they will open during the firing.

Slab building is especially suited to making such things as flower holders, candlesticks, and so forth. A number of articles made this way are described in Chapter 11. Photo Series 9 on page 55 shows the steps in making an animal by this method.

A paper core

Another method of making clay sculpture hollow is to use a core of wet newspaper as shown in Fig. 9. Wet newspaper, if you have never used it, will surprise you with its good working properties; it is almost possible to model with it. Make the core about an inch smaller all the way around than the sculpture is to be, put it on a wooden base, then put a layer of clay

one inch thick all over the core while it is still wet. This layer of clay can then be shaped into the piece of finished sculpture. When the clay is firm enough to stand by itself the paper core can be removed from the bottom. This process is shown in the modeling of the cat illustrated in Photo Series 7 on page 49.

Portrait heads can be made hollow by constructing an armature of a tapered wooden upright fastened to a base as illustrated in Fig. 10. Wet newspaper is wadded around the end of the wood as shown until a core slightly smaller than the head is formed, then the head is modeled in clay on top of the core. When the head is finished it is lifted off the post and the newspaper is scooped out through the hole in the neck. If all of the newspaper is not removed it doesn't matter — small bits of paper left inside the head will burn out during the firing without doing any damage.

Variations of this device are shown in Fig. 10. A ball of heavy twine wrapped around the end of an upright post forms a core for a portrait head. One end of the twine is tied to the base of the post. When the head is finished and lifted off the post, the twine is pulled out through the opening in the neck.

Another method is used by a sculptor who does a lot of portrait work in clay. He has a cloth bag about the size of a five-pound flour sack. He fills this bag with sand and ties it to a post to form a core. When the modeling of the head is completed, the neck of the bag is untied and the sand is allowed to run out. The bag is then removed from inside the head. As an added precaution a piece of oiled paper is put over the bag before the clay is put on. This keeps the bag from sticking to the clay.

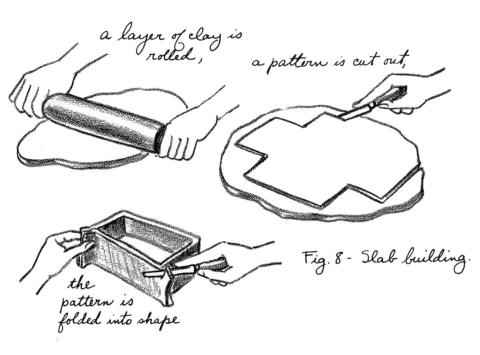

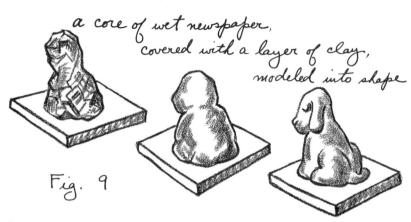

Work in progress

Clay must be kept plastic while you work with it. For this purpose it is good to have a damp closet, that is, a container with a humid atmosphere which will keep clay moist. The construction of a damp closet is shown in Fig. 18 on page 27.

If you haven't a damp closet, a good way to keep small sculpture moist is to place a large can entirely over the work. Put a damp cloth at the base to seal in the moisture.

If your sculpture is so large it cannot be covered with a metal can, keep the clay moist by wrapping it with damp cloths. The object is not to get the piece wet, merely to keep it from drying out, so don't put soaking wet clothes on the piece. Use damp cloths, and to keep them from drying cover them with an impervious material such as oilcloth. An old plastic shower curtain is good. The plastic bags that are used for storing food in deep freezers are excellent for keeping clay sculpture in condition. There are also a number of new materials, similar to waxed paper but made of plastic, which can be wrapped around an object and which seal themselves when the edges are pressed together. As an experiment I wrapped a small piece of plastic clay sculpture in such a material and left it on a

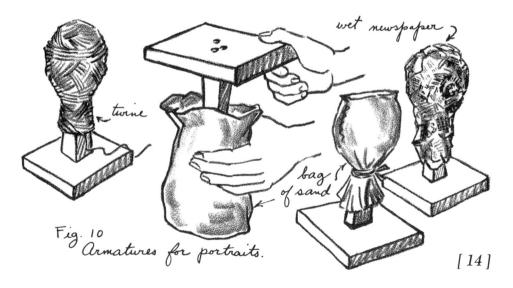

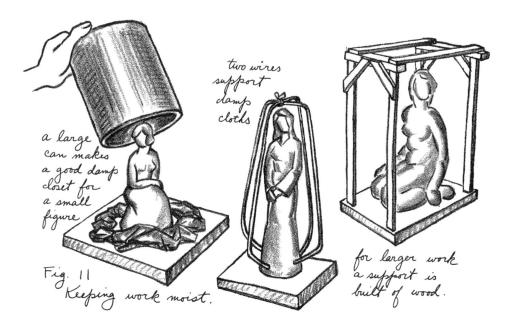

shelf for several months. When it was unwrapped, the clay was just as soft and workable as on the day it was wrapped up.

Delicate modeling may be marred by the weight of damp cloths laid on it, so, when your work is nearing completion, use two heavy wires tied together and bent to form a support as shown in Fig. 11. The ends of these wires can be thrust firmly into the base of the piece. For larger pieces, supports can be made out of pieces of wood. (Some sculptors believe that damp burlap laid directly on their work does not harm it in any way, but that the softening effect of the cloth and the slight texture imparted are actually an improvement.)

If you work on a piece of sculpture for a number of days it will be good to spray it with water each time you start. A spray gun serves well for this purpose, or you may use a stiff brush dipped in water. Drawing a tool across the bristles will release a fine spatter to moisten the piece. Let the clay absorb all the water before you start to model, otherwise the surface will be slippery and difficult to work on.

Clay left in a damp closet for a week or longer will not stay plastic but will become leather hard. To preserve plasticity, cover the piece with damp cloths and spray it occasionally.

If you make a mistake and allow clay that you are modeling to become leather hard, don't try to make it plastic by soaking it in water. That will make it crumble. Clay which has become leather hard can be made plastic once more by long and careful spraying. Make the entire surface moist, wait a minute or two until the moisture is absorbed and the shine disappears, then spray again. Keep repeating the process until the proper state of plasticity is reached.

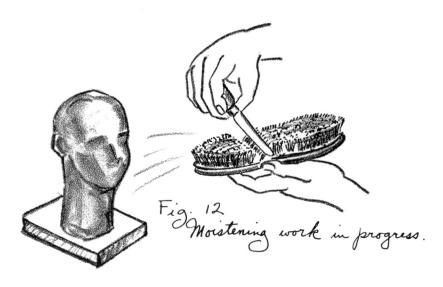

Never let a piece of sculpture become bone dry until you are through working on it. A piece which has dried out can be made plastic once more but it is a difficult process, not to be recommended.

Self-hardening clay

The question is often asked "What about self-hardening clays or those that can be hardened in an oven?"

The term "self-hardening clay" is a misnomer because no clay can be made really hard without firing. Some stoneware clays apparently become quite hard when they are bone dry. I have seen a potter stand on a heavy unfired clay crock without crushing it. Sculpture made of such clay, if not exposed to the weather, could last a long time, but it would not have the satisfying quality of fired clay and it would not be waterproof.

Manufacturers of sculptors' materials sell a variety of so-called self-hardening clays, most of which are clay mixed with a gum to give it extra toughness in the dry state. Sculpture made of such clay can be shellacked and painted. For this reason self-hardening clay has its place in craft work or in sculpture classes for children. Articles made of this material cannot be called ceramic, however, for the term *ceramic* refers to clay hardened by fire. All of the self-hardening clays I have examined will go back into the slip state if immersed in water.

Oven hardening clays

There have recently appeared on the market a number of clays which will harden in an ordinary oven at a temperature no higher than that required to bake a cake (300° F.). These are clays mixed with a plastic product that goes through a setting action at that temperature. Such clays, when oven baked, become quite hard and in some cases are impervious to water. Special hard-surface paints, which look almost like glaze, have been developed for them.

Again, we must not consider these ceramic products. Pieces made of these materials are more like hard rubber than fired clay. They are hard and tough, but they can be broken in the fingers. When tapped they give a dull wood-like tone.

Non-hardening clay

If instead of mixing clay flour with water, we were to mix it with some oil that doesn't evaporate, the result would be a plastic clay which never dries and, consequently, never gets hard. Plasteline is a clay of this type.

Sculptors often use plasteline for preliminary sketches or for models which they intend to cast in plaster of Paris. Plasteline cannot be fired, but it has certain advantages, the main one being that its consistency is always the same and the sculptor doesn't have to think about keeping it damp. Plasteline has excellent working properties and allows for the modeling of finer details than is possible with regular clay.

Reclaiming clay

One good thing about clay is that, until you fire it, you can use it over and over again. Mistakes are not disastrous. Anything that turns out badly can be allowed to dry, broken up into small pieces, thrown into a pail of water and allowed to slake or soak for a while. (Let the clay get thoroughly dry before you break it up — the job is easier that way. Large pieces can be broken with a hammer and small pieces can be crushed into a powder with a rolling pin.) When the clay has slaked for an hour or two, all of the clear water remaining at the top of the pail can be carefully poured off and what is left in the bottom stirred with a stick. This is clay in liquid form, or slip. If this slip is poured into some plaster container like the drying bowl shown on page 89 and allowed to dry partially, it will turn back into plastic clay that can be lifted out and wedged. Take advantage of this property and be completely free when you work with clay. There is no danger of spoiling the material.

Form

When you reach into your clay bin and scoop out a lump of clay, what you hold in your hand is a shapeless mass, without order, without design. The moment you begin to change this mass even by so simple an act as flattening its sides or rolling it into a ball, you begin to create form. What you hold in your hand then is no longer a haphazard product of chance, it is the result of your thinking and your planning. It has design.

Some artists say that all shapes in nature can be reduced to the sphere, the cone, the cylinder, or the cube. It is interesting to do some exploring with these basic shapes, forming them and then combining them in groups. This provides practice in working with clay and at the same time gives experience with sculptural composition. Make a sphere by rolling a lump of clay between your hands. Get it as round and as smooth as you can,

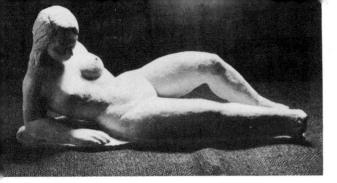

Student Work, School of Industrial Art, New York City.

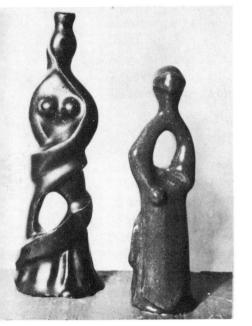

Student Work, Tyler School of Fine Arts, Temple University.

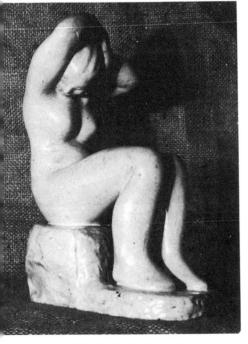

Student Work, Ohio State University.

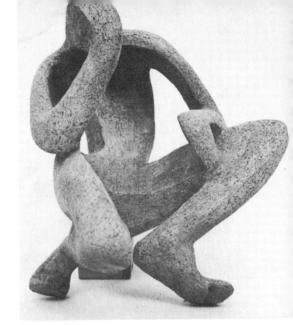

Student Work, University of Kansas.

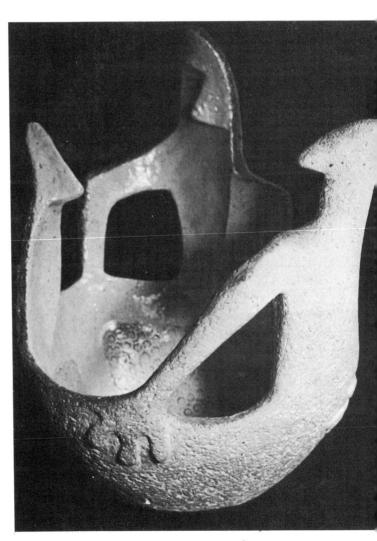

Conference, Lyle Perkins

PLATE II - FIGURES

free from folds or blemishes. Make a cylinder about three inches in diameter and five inches tall by rolling the clay on a table top and tapping the ends to make them flat. Construct a cube by rolling a ball, then tapping it on the table to flatten the six faces. A flat stick used as a paddle will help you get the sides square. Make a cone by rolling a cylinder, then continuing to roll with pressure at one end so that it is narrowed into a point.

When you have done these exercises, try modeling some simple fruit forms. Make an apple or a pear or a banana. You can work from a model if you wish, or better, you can work from memory, putting into your sculpture those remembered features which make up your mental image of the fruit. If you can capture these you will have the essence of the form, something truer than a copy of the real thing.

Now we are going to speak of something hard to put into words, yet of great importance to the sculptor. For want of a better term, let's call it *fullness of form*. Shapes in nature are rarely hollow; they are convex rather than concave, suggesting content swelling from within. As you model, build *up* to form. Let your work suggest solidity; model forms that are rich and full of life. Fruits are good objects to model as practice exercises and they make attractive decorations as well.

We have seen some of the methods of working with clay and we have learned some of its simple rules, but there is another rule which we should list, and that is, that there really aren't any rules about the ways of working with clay. You can do practically anything with clay — squeeze it, pound it, press it, carve it. You can even make it into a liquid and pour it into molds. We will explore more of these methods of working a little later on, but remember, methods are not so important. What counts is your ability to use this wonderful material, clay, to express your thoughts and to create form. Good sculpture is not the result of learning rules, nor does it come about through practice alone. You must have an idea to convey, as well as knowledge and understanding and appreciation and, above all, love of the material with which you work.

2

Tools and Equipment

CERAMIC SUPPLY DEALERS sell a great variety of tools and equipment for making sculpture. There are modeling tools of all sizes and shapes, some of wood, some of metal, some with wire loop ends, some plain; there are turntables, modeling stands, calipers, armatures. How many of these things must the beginning sculptor acquire before he starts to model in clay?

The answer is — very few. One or two modeling tools and a knife are all you need to start with. Build up your collection of equipment slowly, adding items as you need them. Some tools you will have to buy; others you will make for yourself. Still others you will find already at hand in the kitchen or somewhere else about the house.

The sculptor's best tools are his fingers. Yet there are times when he needs other tools to supplement the ones nature gave him. Just as the caveman discovered that the limb of a tree, used as a club, would increase the length of his reach and the force of his blow, so the sculptor finds that certain implements of wood and metal add strength to his hands and increase their scope. Think of tools, then, as helpers. They will assist your fingers but they won't accomplish anything that your fingers can't do.

Let's see how tools enter into the work of shaping a lump of clay. At the beginning, as we rough out the form, we push the clay with the heel of the hand or with the fist. And if the fist becomes weary, why not use a mallet or a block of wood instead? Pieces of wood like those shown in Fig. 13 are good to start with. Use them freely; push and pound the clay without fear. Working this way with a crude block of wood, you will not be able to model small details; you will be forced to look for larger forms and movements — and that is the way it should be.

Tools of this type cannot be bought but they're easy enough to fashion out of odds and ends of wood. You may find handy tools in pieces sawed from broken up furniture. Note the portion of chair leg used by the sculptor modeling the figure of a girl shown in Photo Series 38 on page 255. A tool like this has an extra advantage since part of it is round and another part is square. The square part is used for pushing and pounding; the round portion rolls the clay into shape.

After the roughing out has been completed and the large masses are shaped, more detailed modeling begins. Here the work falls to the fingers, particularly the thumb. Pieces of clay are added and worked into position

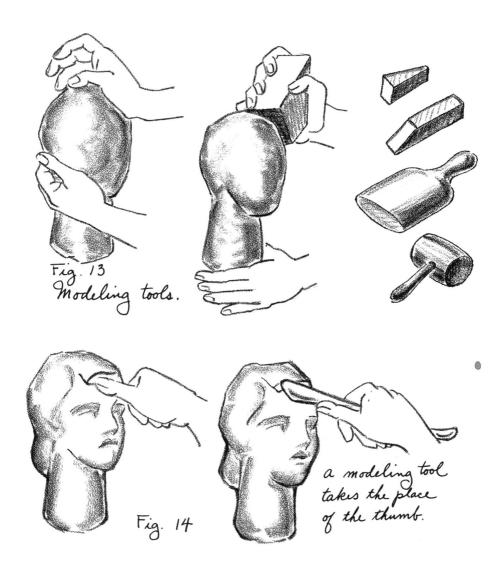

with a pressing motion. Surfaces are pulled together as the fingers move across them. Excess bits of clay are squeezed off with the edge of the thumb. If the thumb becomes weary, the sculptor turns to the tool he probably uses most of all, one of the type shown in Fig. 14. This modeling tool with its broad, slightly curved surface is good for pressing on lumps of clay and building up form. One edge is sharp — not as sharp as a knife, but sharp enough to cut off excess clay when necessary.

For the next stage of modeling, the final details and the finishing of surfaces, the sculptor needs a tool which can gouge out bits of clay. If nothing else were available he would be forced to use his fingernails, but a wire loop serves better. For convenience the wire loop is often placed on the other end of the wooden modeling tool to make an implement like the one shown in Fig. 15. To start with, it is good to have one loop tool about eight inches long with a loop shaped like the one in Fig. 15.

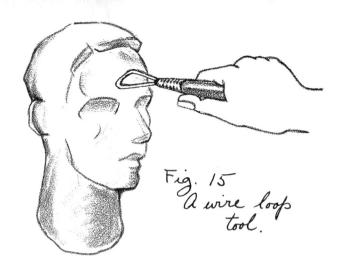

Wire loops are made in various sizes and shapes. Some are smooth, others have teeth cut with a file. Sometimes the teeth are made by winding a thinner wire around the heavier wire of the loop itself. Such tools are good for making textures as well as for modeling forms. The roughness made by the teeth can be partially smoothed with the fingers. A wide variety of surface treatments is possible this way.

Tools like this are sold by dealers, but you can make your own if you wish. It is not nearly as difficult as it seems. Here is how the sculptor, David Micalizzi, goes about making such a tool.

PHOTO SERIES 3

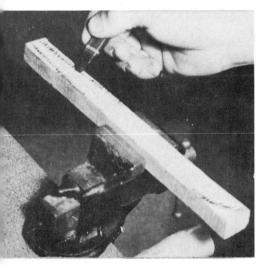

He takes a piece of boxwood cut to the proper length and fastens it in a vise, then draws the profile of the tool he has in mind on the surface.

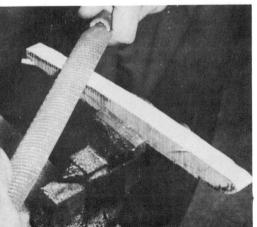

Turning the wood in the vise, he cuts down to the profile he has drawn, using a rasp. After this step is completed, the other profile is drawn and the wood is cut to that outline. The piece of wood is back in the vise once more, this time clamped on opposite corners. The sculptor uses the rasp again to make the shape round.

Now the wood is out of the vise, and a file with finer teeth is used to complete the rounding. After this, sandpaper is used to smooth the surface.

A gouge is used to cut slots on both sides of one end of the tool. A wire loop will fit into these.

Beginning to shape the wire loop. The end of the wire is tapped with a hammer to flatten it.

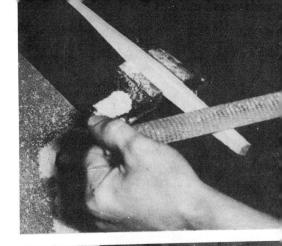

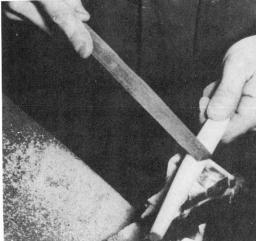

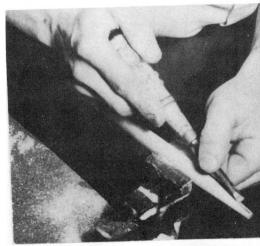

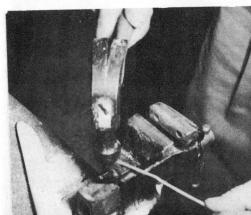

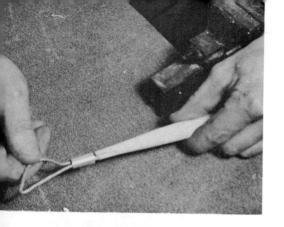

Attaching the wire loop with a ferrule made from a piece of brass tubing. Note the shape of the wire. It has been bent to form a loop narrower on one side than the other with a straight portion between. Thus the tool will actually have loops of two different sizes.

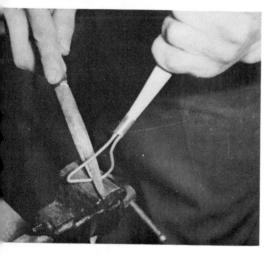

Filing teeth in the loop. The teeth will be cut on one side and on the inner portion.

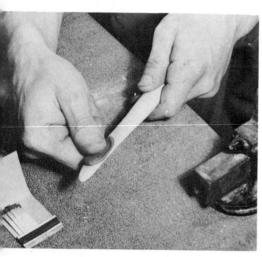

The tool will be more useful if the end is bent slightly. To make the wood bend, it will be necessary to heat it by holding it in the flame of a match. To keep the wood from scorching or catching fire, a lump of plasteline is pressed against it.

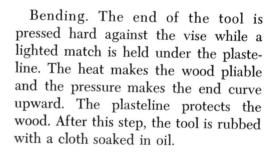

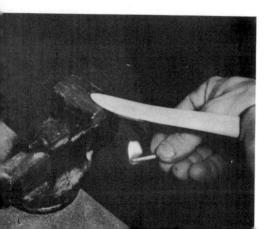

The completed tool. This whole process took less than forty-five minutes.

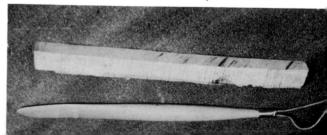

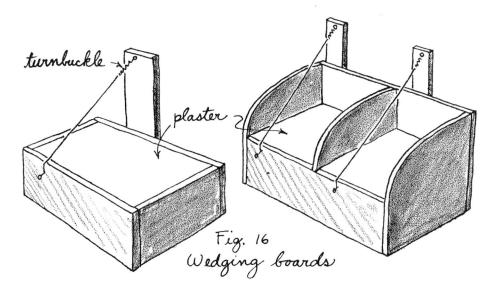

You will need some other things besides modeling tools — calipers for measuring, a modeling stand to hold your work at the proper height and turn it easily, something to put the clay on while you are working, and various other pieces of studio equipment. Let's consider some of these.

Wedging board

The importance of wedging clay was mentioned in Chapter 1. A wedging board is an essential piece of equipment if you plan to do much clay work. You can make a simple one by constructing a box about $15'' \times 26'' \times 6''$ deep, and fastening an upright post about $1'' \times 2'' \times 18''$ at the back. The box and the post must both be solidly constructed for they will have to stand a lot of rough treatment.

Mix enough plaster to fill the box to the brim, using a "heavy mix," and pour it in. (Chapter 6 explains what is meant by a "heavy mix" and also tells how to compute the amount of plaster needed.) Fasten screw eyes to the box and to the post as shown in Fig. 16 and stretch a piece of No. 20 gauge piano wire between them. You will need some means of tightening the wire, so use a turnbuckle or a wing nut as shown. A wire fastened this way makes it easy to cut the lump of clay when you wedge it. Start underneath the wire and draw the clay toward you. This way any bit of clay flicked out by the wire will be thrown away from you instead of hitting you in the face.

Your studio will be neater if your wedging board has a back and sides. These prevent bits of clay from getting on to the floor. If you plan to use clay of different colors, you should have a double wedging board so that one side can be reserved for red clay, the other for buff or white.

The plaster slab of your wedging board must be allowed to dry before you can use it and this will take several days. Once it has dried, avoid getting it wet again. Each time you use it, clean it with a damp sponge.

As you use your wedging board the surface of the plaster will become pitted and scratched. When it gets too bad, resurface it by putting a layer of fresh plaster on top. To make the new plaster hold, cut some deep gouges in the old plaster slab and soak it thoroughly with water. If you try to add new plaster to old without wetting the old first, the new won't stick. After resurfacing, your slab will need another few days to dry out.

Woodworking tools

A hammer and a saw are useful in a sculpture studio, and so are a few other woodworking tools — a plane, some files and rasps, and a try square. If you can manage it, have a workbench with a vise. Along with these you will need a plentiful supply of nails and screws of various sizes. With these tools you will be able to make a number of pieces of special equipment for yourself out of scrap lumber or grocer's wooden boxes.

Whirler

A whirler or banding wheel is used for decorating plates, but it is also good for modeling small figures. The top turns freely and so makes it possible for you to rotate your work constantly. A whirler mounted on some piece of furniture which raises it to the proper height makes a good substitute for a modeling stand.

A hand rest

An adjustable hand rest like that shown in Fig. 17 can be used with a whirler. The bar is raised or lowered to different levels and the right hand is braced on it while the left hand turns the whirler. Thus cylindrical shapes can be built out of coils or slabs and made true. The method of using this hand rest is shown in Photo Series 33 beginning on page 233.

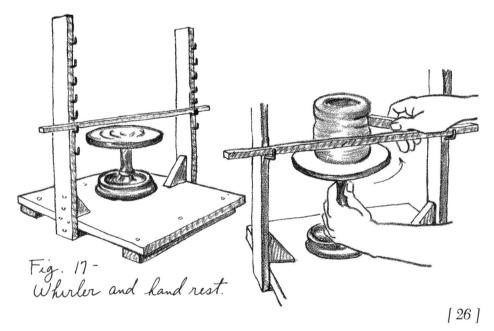

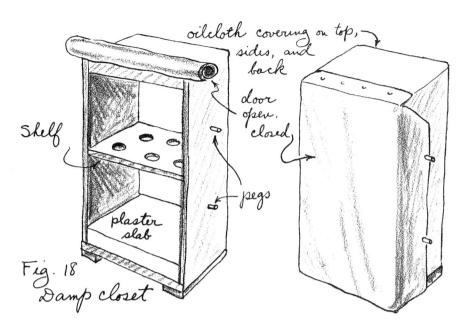

Modeling boards

A modeling board is used to hold clay while it is being shaped. It is a piece of wood with two cleats on the under side. The cleats keep the wood from warping and also act as feet, holding the board slightly off the table so that it can be easily lifted. When you make modeling boards, space the cleats so that they will fit over the head of your whirler. This way you can put any modeling board on top of your whirler and automatically convert it into a rotating stand.

A damp closet

You will need a damp closet in your studio in which to put unfinished work so that it does not dry out. An old style ice-box makes an excellent damp closet, or you can make one out of an ordinary wooden box as shown in Fig. 18. The box is covered with oilcloth, and an oilcloth flap serves as a door. Removable shelves can be rigged up inside the box at various heights. At the bottom of the box put a plaster slab about two inches thick. If this plaster slab is kept moist, pieces of sculpture stored in the damp box will not dry.

Modeling stand

A modeling stand is essential if you are planning large scale work from a model. You can make your own if you wish but my advice would be to buy one. Get one that is good and sturdy, with a top that turns easily and that can be adjusted to different heights.

Sprayers

A spray gun is a handy thing for keeping work wet while you are working on it. If you work on clay for a long time, spray it occasionally. If it has

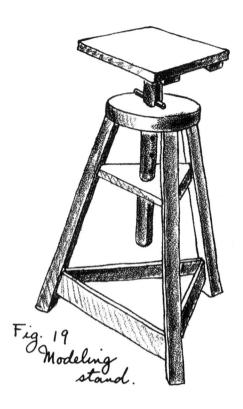

been put aside over night, spray it before you start to work. When you do this, wait a minute until all the shine has disappeared from the surface before you work on it, otherwise you will have a slippery mess on your hands.

Calipers

A pair of calipers is shown in Fig. 20. These are used for measuring the distance between points on the surface of an object where a ruler would not serve. They are especially useful in portrait work for measuring the distance from ear to tip of nose, from back of head to chin, and so on.

Proportional calipers

A pair of proportional calipers is used whenever a small sketch is enlarged. This is a valuable tool because making a small sketch in clay is a helpful step in the making of any sculptural composition. Proportional calipers can be bought from ceramic dealers but you can make a pair for yourself if you wish. Those shown in Fig. 20 are made from two wooden yardsticks with the ends tapered and with holes bored at various points so that a set screw with a wing nut can be used to join them. If the set screw is placed at the 12-inch point, then the calipers are set for a two-to-one enlargement. Any distance measured at the small end will be laid off exactly twice its size at the large end. With the set screw at the 9-inch point, the calipers are set for a three-to-one enlargement and with the set screw at the 6-inch point, they are set for a five-to-one enlargement.

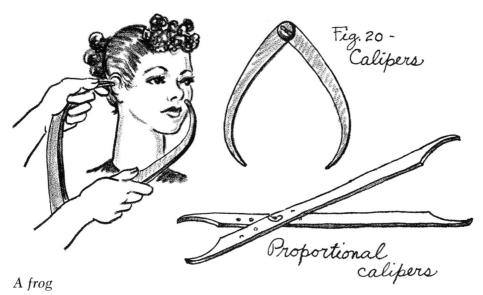

A frog is a tool that has two prongs with a wire stretched between them. It is used to cut clay in the same way as the wire with wooden handles shown on page 7. It won't cut a large mass of clay but it is good for small-or medium-sized lumps and it has the advantage that it doesn't require two hands. You can buy a frog or you can make one by fastening a wire to the ends of a forked stick as shown in Fig. 21.

A tool for hollowing out

A special cutting tool can be made by bending a coping saw blade into a loop and fastening it with fine wire to the end of a piece of wooden dowel as shown in Fig. 22. This tool is good for hollowing out small pieces of sculpture and making the walls even in thickness. The toothed side of the blade can be used for the first cutting and the back will smooth the surface.

Kitchen ware

A number of articles from the kitchen cupboard are useful in clay work. These include bowls, paring knives, flour scoops, strainers, spoons, even cookie-cutters. The rolling pin too will be needed for slab building.

Light

A good light to work by is most important to the sculptor. The ideal studio has a skylight facing north but not all of us are fortunate enough to have this. In the course of taking photographs for this book, I used a portable photographic floodlight and discovered that besides its use in photography it made an excellent working light as well. Such a light can be adjusted to different heights, tilted to different angles, and moved about the work so that it can illuminate any portion from above or below. This not only helps in modeling but it helps, too, to discover faults which might pass unnoticed when the work is lighted only from one direction.

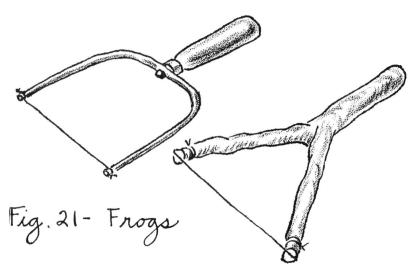

Fig. 22 - a tool for scooping out.

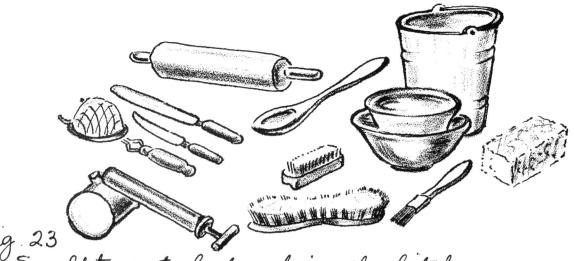

Fig. 23 Sculpture tools found in the kitchen?

A mirror

The sculptor's studio should have a mirror on the wall so that work in progress can be looked at, from time to time, in reflection. It is surprising how a glance at a piece of sculpture reflected in a mirror will make errors stand out clearly. In addition to pointing out mistakes, a mirror gives the sculptor a different view of his composition and helps him to strengthen design.

Other tools and equipment

Your studio should have a crock or two for holding moist clay, some varnish brushes for applying size, sponges, sieves, scrapers, and two or three bowls. Don't buy these all at once but acquire them as you need them.

Care of tools

Take good care of your tools right from the start. Have a place to keep them and keep them there. Clean them each time you are through working. Don't leave tools soaking in water but dry them carefully, and if they have any metal portions, wipe them with a cloth dipped in oil to prevent rusting.

As you use tools to model clay you will become fond of some special ones that seem to work better than others. All of the sculptors that I know have favorite tools that they treat with loving care. But all tools deserve good treatment, and any sculptor worthy of the name has as much respect for his tools as he has for the clay.

3 The Figure

The most interesting thing in the world to man is man himself, and so it is only natural that the human form should be a favorite subject for sculpture. There are many ways of modeling the figure. Some sculptors aim for realism while others work for design and stylization. Some seek to develop an ideal through close study of nature. Others use the figure for experimental studies of problems of form. There has been conflict between those who strive for realism and those who prefer abstract forms, but this is not necessary; there is room for both. Even within the ranks of the realists, great variations exist. Some sculptors work compactly, making figures which proclaim their origin in the clay of the earth like the ancient Chinese ceramists, while others prefer to create pieces that are light and open like those of the eighteenth century European porcelain makers. Between these two extremes there are endless other ways of modeling the figure.

Sketching in clay

Sometimes making a drawing before starting a piece of sculpture is helpful but have you thought about sketching in clay? You can, and if you try it, you will find clay a much better material for sketching than pencil

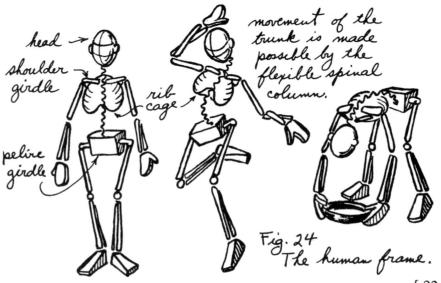

and paper. A drawing is two-dimensional at best, but a sketch in clay gives us a chance to see form in the round, to experience the plastic quality in design. With the clay in our hands we can feel weight and volume and the flow of lines — feel them as well as see them. And we can appreciate how beautifully, how subtly, slight changes in the relationships of masses affect appearance and mood.

Let's watch the scuptor, Frank Eliscu, as he sketches a figure in clay.

PHOTO SERIES 4

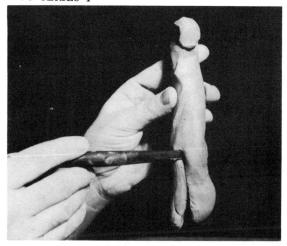

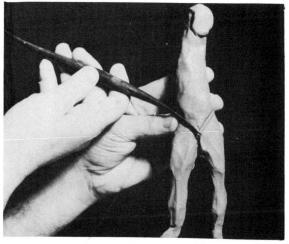

The clay is squeezed into a long, thin shape, and the end is bent to suggest a head. This is better than rolling the head as a separate ball and attaching it, for it is difficult to make such a head stay in place. A wooden modeling tool cuts the lower portion to form two legs.

The end of a leg is bent up to suggest a foot. The modeling tool makes indentations to mark the crotch, the important joint between legs and trunk.

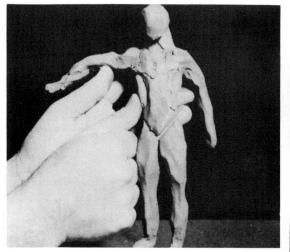

The thigh is pressed into shape. Arms and legs are pliable but the sculptor bends them only at the joints, elbows and knees. An arm or a leg must not look like a rubber loop.

Arms are added.

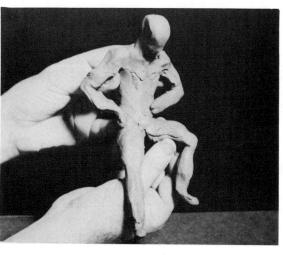

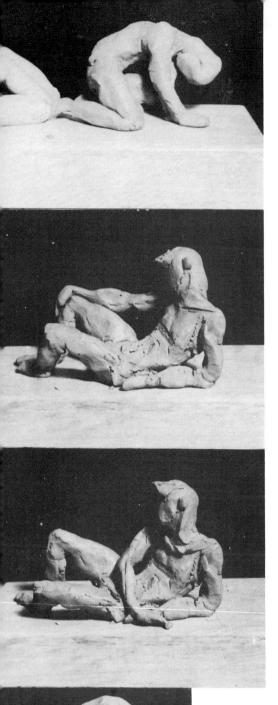

The little figure crouches, and turns over to relax.

A different pose. Note the addition of a few details. A lock of hair and a pair of ears have been added. Some more anatomy, too. A stroke with the modeling tool has indicated the collar bone.

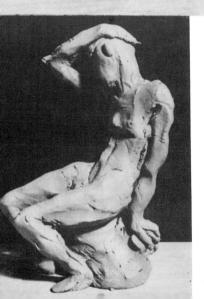

Another pose. The addition of a thumb makes the hand more realistic.

> Another slight change in position to achieve an entirely different effect.

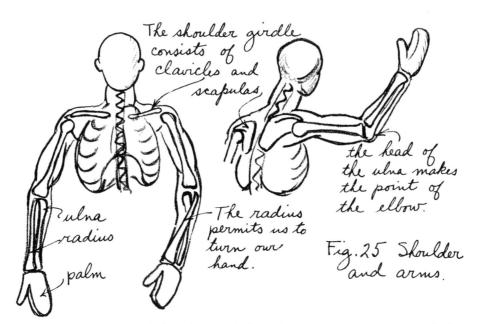

This whole series of sketches took less than twenty minutes, and that was time enough. The sculptor stopped after the last picture was taken and said "No more! The clay is tired." By this he meant that it was beginning to lose its good working quality and would soon become dry and crumbly. If more modeling were to be done with this clay, now would be the time to spray it with water.

A short time spent in exploring ideas by sketching in clay may save hours of work in modeling pieces intended for firing. Incidentally, sketching in clay is an excellent way of learning how to draw. Many people who think they "can't draw a straight line" find when they model with clay that they really have more ability than they thought they had, and this is not surprising when we remember that men were sculptors long before they learned to draw on a flat surface. Anyone who works with clay and then returns to drawing on paper or canvas will have a greater appreciation of the third dimension and a keener understanding of how to achieve it in his work. Many of the outstanding draftsmen among the great painters of history modeled with clay in order to improve their skill in depicting the figure in action.

Anatomy

The sculptor who made the figure above has a sound knowledge of anatomy. Even in the quick clay sketch the accuracy of the construction is evident. Note how the little touches — the stroke marking the collar bone, a suggestion of abdominal muscles — made the figure more life-like. If you are going to make ceramic figures, you should know something about anatomy, but how much anatomical knowledge is essential and how that knowledge should be acquired are not questions which can be answered the same way for everyone.

For thoroughly realistic work, the sculptor's anatomical knowledge must be complete, but not all sculpture is equally realistic. There are some who maintain that even to produce abstract sculpture, the artist must first have a grounding in anatomy, but I don't think that is so. My own exerience and my work with students leads me to believe that anatomy should be studied when the need for it develops. To start modeling the figure by studying charts of muscles and bones is to begin backwards. Let your first exercises with clay be simple. Make your figures without detail, like the little horse on page 1, but try to put into them some essential form which you have observed. Underline that word *essential*; seek what is important and eliminate what is relatively unimportant; try to tell your story directly.

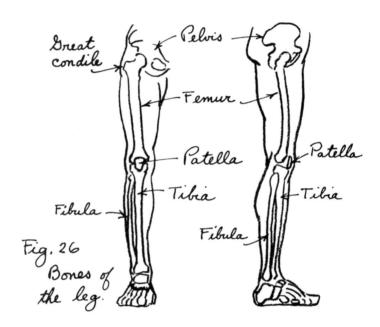

But anatomy is not to be neglected. When you have progressed to the point where you employ a model and your observation must be helped out by more knowledge of what lies under the skin, then is the time to learn about the bony structure of the body and the muscles which move it.

Anatomy is a study of structure, of balance, of movement. Essentially the human frame consists of a head, a rib cage, and a pelvic girdle, each of which is attached to a flexible spinal column. All of the movement of the trunk is due to the flexibility of this column, which by turning, twisting, bending, permits endless variations in the positions of the other three portions.

Fastened to the rib cage is a shoulder girdle made up of two collar bones in front, *clavicles*, and two shoulder blades, *scapulas*, in back. To this girdle, the arms are attached. The legs are attached to the pelvic girdle.

The bony structure is moved by muscles which contract and exert a pull. No muscle can push, and so to control movement, muscles must work in pairs; if one muscle or group of muscles pulls a bone in one direction, another group must pull it back again. The ends of a muscle are attached to bones by means of tendons. The ends of a muscle must be attached to two different bones-otherwise no movement would be possible.

The arms have joints at shoulder, elbow, and wrist; the legs are jointed at hip, knee and ankle. Both arms and legs have one big bone in the upper portion and two in the lower. The bone of the upper arm is called the *humerus* and those of the lower are the *radius* and the *ulna*. The radius gets its name because it has a radial movement, as shown in Fig. 25, which makes it possible for us to turn our hands palm up or palm down.

The bone of the thigh is the *femur*, those of the lower leg the *tibia* and the *fibula*. There is no radial movement here similar to that of the arm. At the knee cap is a small bone held in place by tendons. This is the *patella*.

The human figure is rhythmic in its movements, and no single part of the body moves without affecting in some degree the movement of all other parts. Keep this in mind when you model; as you work an arm into position, think of the other arm in relation to it and think of both arms in relation to the head, the trunk, and the legs. If you look closely, you will see how rhythmic lines in one limb are repeated in others.

An anatomy lesson

As sculptors, our knowledge of anatomy must be expressed in clay, so let's continue our anatomy lesson by modeling a figure, noting as we go along how muscles and bones affect the surface form.

For our study, we'll choose a male figure, seated, because the position of many muscles is shown more clearly in such a pose. A block of clay is used to represent a stool. A lump of clay, roughly elongated to represent the torso has been put in position on the stool and a cylinder for one of the legs has been attached.

PHOTO SERIES 5

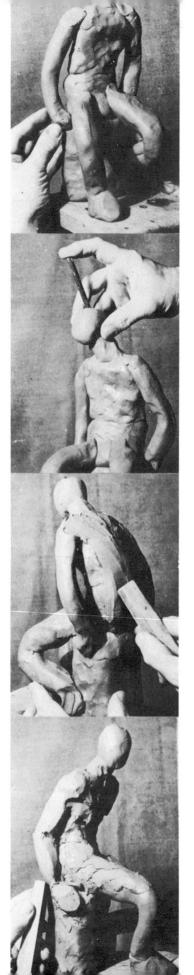

The other leg is added and so are cylinders for the arms. A foot is roughly shaped.

A cylinder is added for the neck and a ball for the head. Now we have a figure which looks a bit like a man and somewhat like a string of sausages. To keep the head from falling off, a pencil is pushed through the head and neck into the torso.

We begin to change the figure from a string of sausages into something closer to human form. Using a piece of wood as a tool, we roughly shape the large masses, following lines of movement. The back of a figure can become a confusing mass of bumps if one is not careful. Better to treat it first as one form, but be sure to get the rhythm of the pose. Drawing the piece of wood over the clay in the direction of the rhythmic lines of the body will help to accomplish this.

The beginning of structural detail. Masses of the chest and hips have been blocked in and the *deltoid* or shoulder muscle has been roughly shaped. So have the muscles of the upper and lower arm. The hand has been formed as a mitten. Fig. 28 shows the muscles that are beginning to take shape.

The modeling carried further. Collar bones have been indicated and the important neck muscles, the *sterno-cleido mastoids*, have been put in These two muscles, sometimes called the "bonnet strings," are attached at the lower end to the breastbone, the *sternum*, and to the clavicles. At the upper end they are fastened to the *mastoid processes*, two small projections of the skull in back of the ears as shown in Fig. 28. These muscles act like a pair of reins, turning the head from side to side. In the V-shaped hollow between these muscles is the cylinder of the throat.

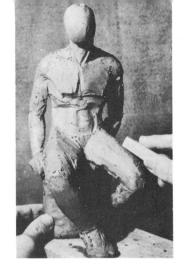

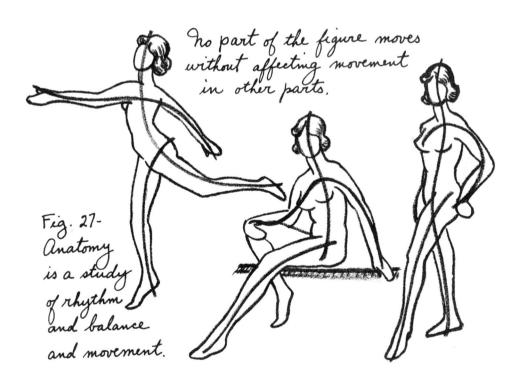

The two collar bones, or clavicles, lie across the shoulders somewhat in the manner of a yoke; below them the two large chest muscles, the *pectorals*, form a comparatively flat area. The rib cage is underneath these muscles and the lower edge shows as a ridge slightly further down.

Continuing further downward, we see the abdominal muscle, the *rectus abdominus*, blocked in, flanked on each side by a muscle, *the external oblique*, which comes from the back. The shape of this muscle is affected by the crest of the pelvic bone underneath it.

The legs begin to take shape. The large bone of the thigh, the femur, joins the pelvis in a ball and socket joint, and the head of this bone, the great condile, makes a projection below that of the pelvic crest. The muscles of the leg have been blocked in roughly. Note that the inner portion of the upper thigh is quite flat, the knee is square. Fig. 29 shows the muscles considered so far.

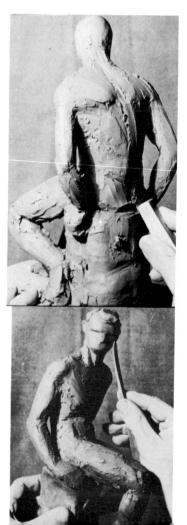

More detail on the back. The two shoulder blades are indicated and the line of the spine is marked. Work is begun on the large muscles of the back, the *trapezius*, the *latissimus dorsi*, the external oblique, but care is taken to preserve the simplicity of the larger form. The buttocks, or *gluteal muscles*, are shaped; since the model is sitting these forms are flattened at the lower edge as shown in Fig. 30.

The clay is firm enough to stand without support now, so we have taken the pencil out of the head and carried the modeling further at that point. Hair and ears have been added and the main planes of the head have been blocked out. Modeling of the legs has been carried a step further and we have started to shape the large muscle of the calf, the *gastrocnemius*, which is attached to the bone of the heel, the *os calcis*, by the tendon of Achilles. The *soleus* muscle lying underneath the calf is also indicated. Fig. 31 shows the structural elements considered up to this point.

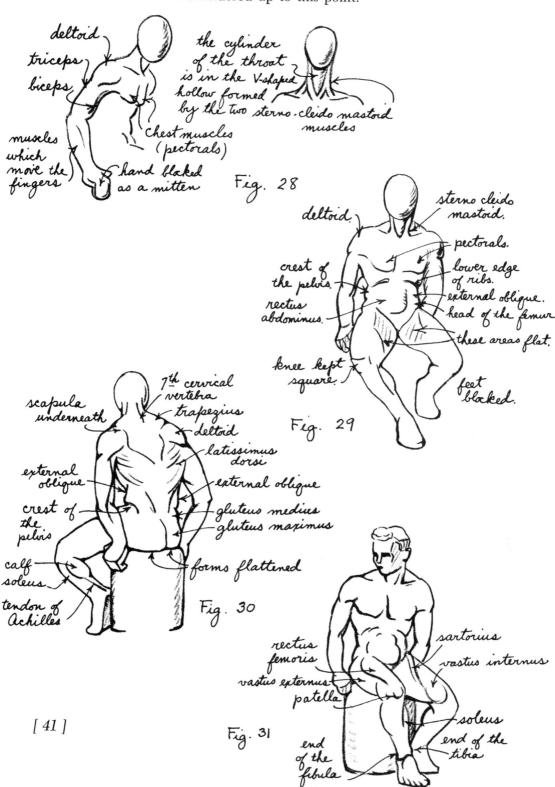

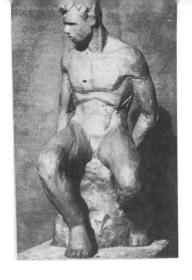

More work is done on the body, with all of the parts being shaped more carefully. Hands and feet are carried further, and the muscles and bones of the legs are shaped.

The two bones of the lower leg, the tibia and the fibula, end in projections which show as the bones of the ankle.

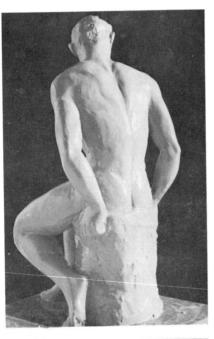

Our sketch is finished; modeling has been carried as far as seems necessary for a figure of this size and surfaces have been smoothed with a sponge. (Look out for too much sponging—you can easily destroy modeling that way).

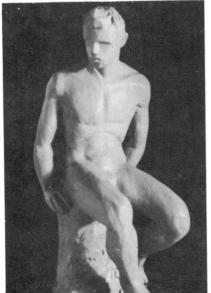

The finished sketch, front view.

We have made a little figure and we have learned a bit of human anatomy by considering some of the big bony and muscular forms which affect surface shape. There are many others, however. If you wish to be really thorough, you must consult some of the books on anatomy that have been prepared especially for artists.

An anatomy figure

If you plan to do much figure work, you will find a cast of the anatomical figure made by Houdon helpful. This shows a standing man with the outer skin removed, with all the muscles and tendons in place. Since all forms are shown three-dimensionally, this makes an excellent reference for the sculptor.

Modeling a dancer

Now let's watch Scuptor Eliscu again as he creates a Balinese dancer in clay — not a sketch this time but a figure intended for firing and glazing. Note — we said not a sketch, but watch and see how all of the freedom of the sketch is retained in this more finished piece.

This time, just to be different, the sculptor starts by making a drawing.

The sculptor starts with an elongated lump of clay and pushes a wooden dowel through it to serve as a support. One end of the lump of clay has been divided to form two legs.

PHOTO SERIES 6

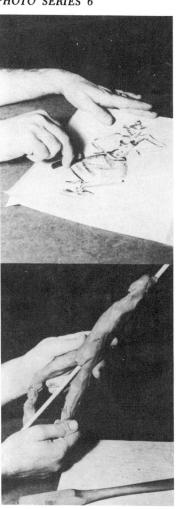

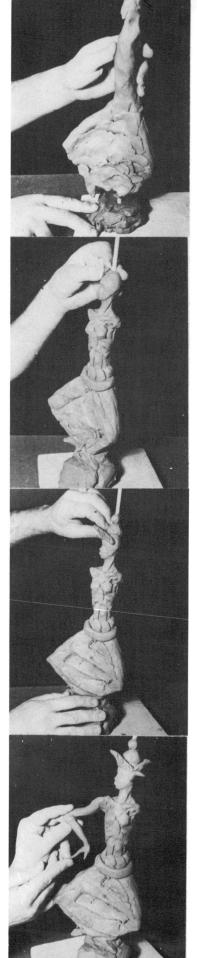

Strips of clay have been put across the two legs to form a skirt. The dowel is stuck into a lump of clay so that the figure will be held upright.

Some anatomical detail. Neck and shoulders have started to take shape and lumps of clay are added to form the breasts. The rib cage is indicated and the large abdominal muscles are placed.

Features are indicated; the plane of the cheek is marked and the line of the jaw is made more definite. Nose and lips begin to take shape. A block of wood is used to model the skirt.

This is to be a Balinese dancer and so she needs an elaborate headdress. The beginning of the headdress.

An arm is added and a hand is formed.

Two arms are in place and more detail has been added to the face. A close-up view.

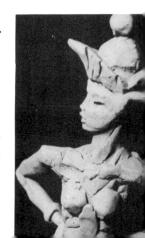

Small strips of clay are rolled to form the hair.

Using a wire to cut the figure away from the base. This is done to enable the sculptor to pull out the dowel rod.

The wooden rod has been pulled out and the sculptor is bending the figure slightly to secure more action.

The modeling is finished. A piece of wood is placed against the figure to support it until the clay becomes firm enough to stand alone. The sculptor compares the figure with his original sketch.

The dancer completed. The clay figure was fired, then the sculptor painted glazes of various colors on different portions to produce a polychrome figurine. This method of glazing is illustrated on page 176.

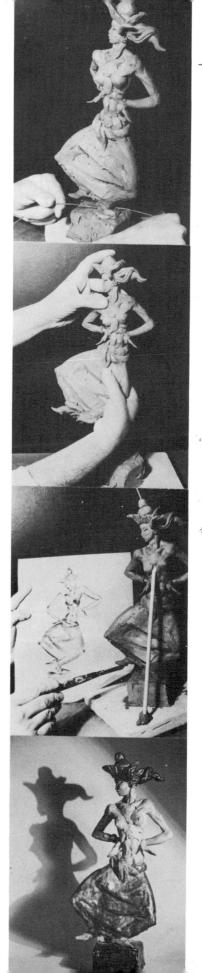

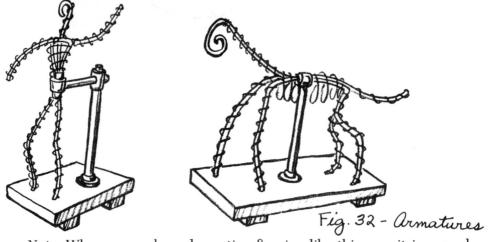

Note: When you make a decorative figurine like this one, it is a good idea to glue a piece of felt to the base so that it will not scratch polished surfaces. Detailed instructions for attaching felt are given in the section on ceramic lamps, page 241.

Armatures

An armature is a support for clay. It may be a simple upright of wood nailed to a modeling board or it may be a more complicated arrangement of gas pipe and wire like the ones shown in Fig. 32. Armatures of this type are flexible and are often helpful to the sculptor who is doing figures in action poses. Later on in Chapter 4, we shall see an armature in use.

A word of warning. It is obvious that if you use an armature, the figure you model over the wire cannot be fired. It will be necessary to cast a plaster mold from it and to use this mold for pressing clay or for pouring clay slip in the manner described in Chapter 6.

My suggestion would be to avoid using armatures of this type because an armature will tempt you to try poses not suited to ceramic work. A wire support will permit clay to take a position in which it could never support itself. This is not so bad if the clay model is merely a preliminary step in the production of a statuette in metal, but for ceramic sculpture, better quality will be obtained if you work directly in clay and fire the piece that you have modeled. When you do this, the limitations of the material will force you to develop structural soundness in your design.

Working from a life model

If you have the opportunity to join a life class and work in clay from the model, by all means do so. It is a wonderful experience. Time spent that way will increase your powers of observation and your understanding of form. Study from nature as much as you can.

Remember, however, that mere imitation of nature is not enough. Accurate copying of shapes that happen to be in front of you will not, by itself, produce a work of art. More than this is needed. The artist through his work must tell us what he thinks and what he feels; he must put something of himself in everything he makes.

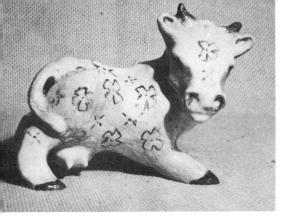

Cow. Student work, University of Denver.

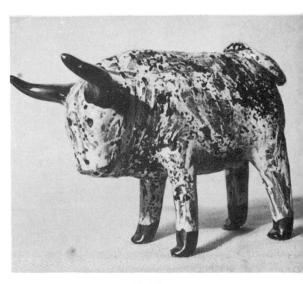

Bull. Mexican.

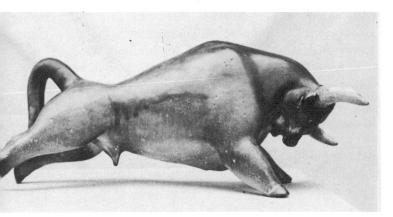

Bull. Paul Bogaty

PLATE III - ANIMALS

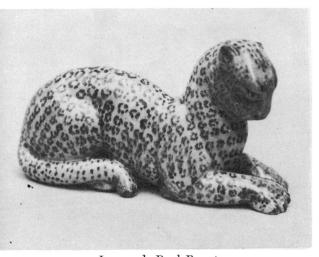

Leopard. Paul Bogaty.

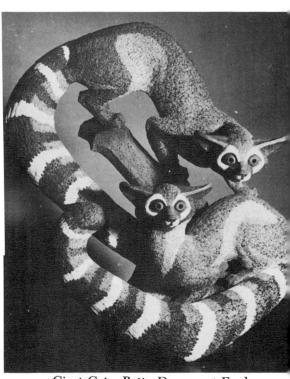

Civet Cats. Betty Davenport Ford.

Animals

A NIMALS ARE FASCINATING subjects for ceramic sculpture. The earliest works of art we know are outlines of animals scratched on the walls of caves in prehistoric times, and if we trace the development of civilization from the beginning until today, we find that in the art of every period, sculpture of animals has an important place.

One reason for the great popularity of animals is their almost infinite variety of character and movement. They come in all sizes and shapes. Like the human figure, too, animals can be modeled in different ways. The sculptor's approach may be realistic, in which case his work will require an accurate knowledge of anatomy, with careful study of detail and action, or he may use his animal model to produce a work in which realism is less important than design. Here the form of the animal will be simplified and much of the detail eliminated. The horse shown on page 1 is an example of this type of work. Animals may be modeled in imaginative fashion; they can be made playful and amusing, or stylized and decorative, or exaggerated like those shown in Fig. 33.

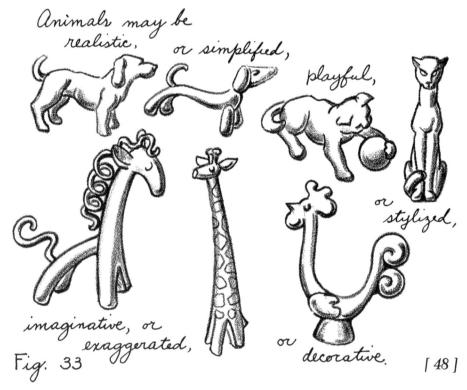

A good way to begin modeling animals is to make a number of small quick sketches in clay of some household pet — a cat or a dog. Make several such sketches when the animal is in repose, sitting or lying down. Study the animal in order to get good proportions and a characteristic pose. Select the sketch which you consider the best one and use it as a model for still another clay sketch. This time pay less attention to realism and think more of sculptural composition. Eliminate whatever detail is not needed. Emphasize the large forms of the animal, work for a good relationship between masses and for flowing, rhythmic line. Turn your sketch as you work on it and study its form from all sides.

When you have created something that pleases you, that has good sculptural quality, enlarge it to the size you want. A figure intended for firing must be hollow. You can build the form solid and then hollow it out, or you may build it hollow by shaping it out of a layer of clay placed over a core of wet newspaper. This is an interesting process. Here are the steps demonstrated by the sculptor, Eleanor Gale.

A portrait of a cat

A tiny sketch of a cat has been made in clay. The finished figure will be eight times this size. The sketch has been placed on a board, a rectangle has been drawn around it, and another rectangle eight times as large has been drawn on another board. In making the enlargement, the artist will use a pair of calipers to measure the position of each part of the sketch within the small frame and will then lay out the position of the enlarged part in a corresponding position in the larger frame.

PHOTO SERIES 7

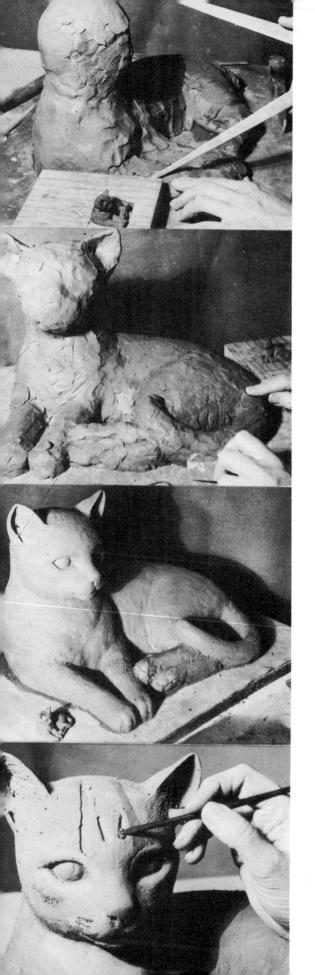

Modeling the form. This figure is built over a newspaper core as shown in Fig.9. Proportions are checked with the sketch.

Inlaying clay

This artist obtains most of her color effects by a method of inlaying clays of different colors in the body of the piece. In some cases she adds pigments to clay to get the tone she wants while in others she makes use of the natural clay colors. Here she has mixed brown underglaze color with some of the clay and is inlaying it.

The coloring is completed. White engobe has been used around the eyes and the mouth and under the chin. Yellow and black engobe have been used on the eyes. The rest of the pattern has been made by inlaying colored clay. (Engobe is described on page 138.)

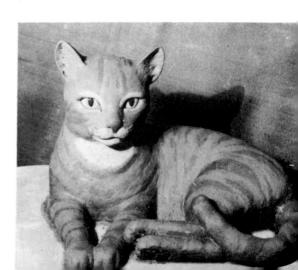

The cat has been lifted off the pest and now the paper core is being removed. The clay is leather hard. The cat is tilted back on a pillow and the paper is pulled out. When this operation come thoroughly dry, then it will be sprayed with a transparent glaze and fired.

is completed the figure is allowed to be-The finished cat.

Clay is an ideal material for making compact solid compositions like the one we have just watched, but this is not the only way to use it. Clay is a plastic medium and a fluid one, well suited to capturing the rhythms of motion. It can portray an animal leaping in the air as well as one asleep. Let's watch the sculptor Frank Eliscu as he makes a figure of a running deer.

PHOTO SERIES 8

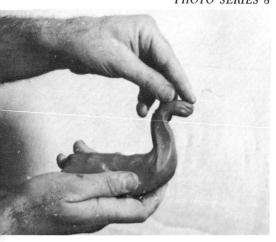

He starts with an elongated lump of clay. It is important that this clay be quite plastic and thoroughly wedged. One end of the lump is bent to form a neck and a head.

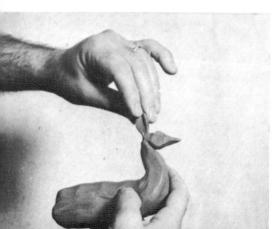

One end of the head is pinched to form a nose. Ears are added.

The back end is squeezed to make it longer and is then divided into two legs. A pencil is thrust into the chest to serve as a support and a handle. Starting to shape the hind legs.

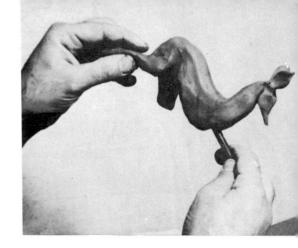

Adding pieces of clay for the front legs and working them into shape.

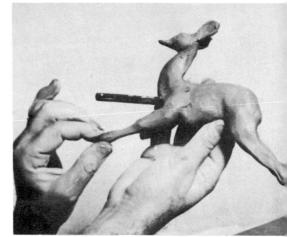

Lumps of clay are added to form the muscles of the chest.

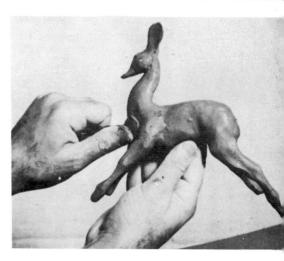

The round end of a wooden modeling tool is used to form the eye sockets.

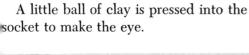

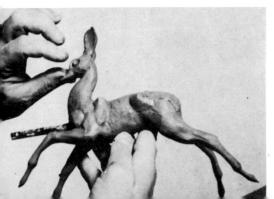

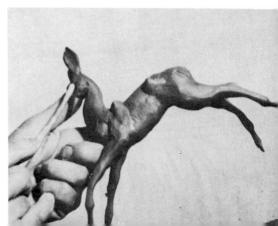

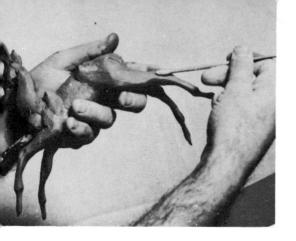

More anatomy on the legs. The modeling tool forms the depression at the back of the joint on the hind leg. This is the hock, which corresponds to the ankle in a human.

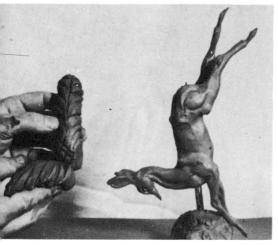

The figure is too delicate to stand on its legs so the sculptor braces the pencil support in a lump of clay while he starts to model some decorative foliage. Direct strokes are made with the modeling tool in elongated lumps of clay to form leaves.

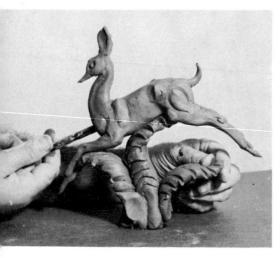

A tail is added to the deer. The animal is put in place on three leaves.

A pair of horns and the modeling is finished.

Later. The animal has been bisque fired and glazes of different colors are being painted on. After this it will be fired again. The finished glazed piece is shown on Color Plate 3.

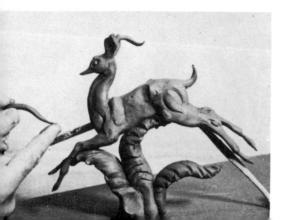

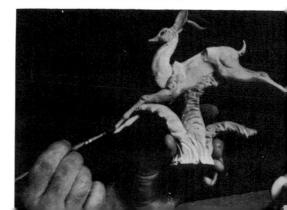

Making an animal by slab building

If a pattern like the one shown in Fig. 34 is drawn on a sheet of paper, cut out and folded on the dotted lines, it will produce an animal — a paper one. Do the same thing with a layer of clay and the result is a clay animal, and this can be made into something good if you remember that a layer of clay is not a sheet of paper. Clay has a plastic quality so that when you cut a pattern you can do more than merely fold it together; you can model it and achieve interesting form. Here are the steps in making a slab-built dog.

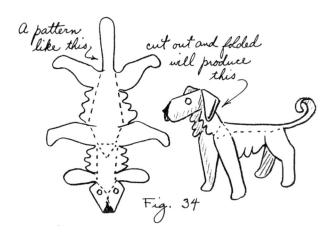

PHOTO SERIES 9

A layer of clay was rolled with a rolling pin. This layer should be about $\frac{1}{2}$ " thick.

Cutting out a pattern that looks somewhat like a bearskin rug. The pattern was drawn on the layer of clay with a pencil and then the pencil itself did the cutting.

Starting to fold the pattern. A piece of cardboard fastened to a block of wood with thumbtacks will serve as a temporary support.

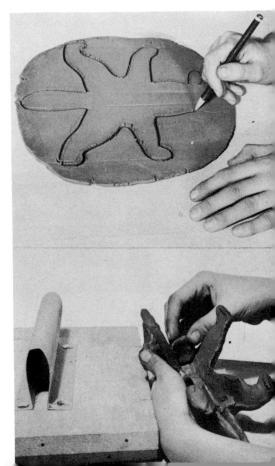

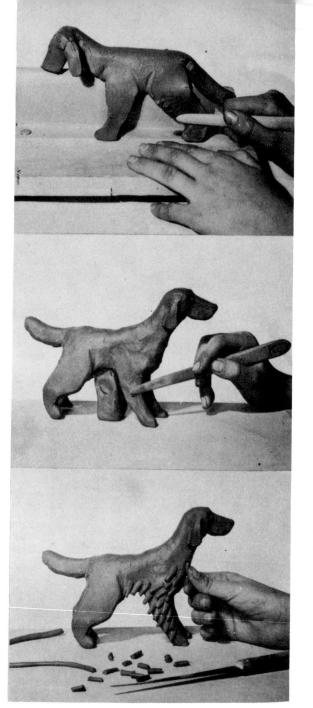

The pattern on the carboard support. Starting to model additional form.

Completing the modeling. The clay is firm enough now so that the card-board support can be removed. A temporary prop of clay is still needed to support the dog in the middle.

Let's make him a shaggy dog. A long thin coil of clay cut into half inch pieces will do as hair.

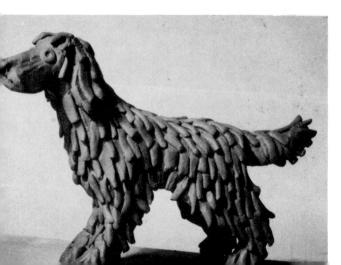

Our shaggy dog completed.

Suppose we don't care for shaggy dogs but prefer stylishly trimmed poodles. The poodle is made the same way by cutting and folding a pattern but he has longer legs and a more pointed nose. To make the hair, take a ball of clay and press it through a sieve. This produces a kind of curly wool. Cut it off the sieve with a knife and attach it to the poodle in the proper places.

The two dogs fired and glazed are shown on Color Plate 2.

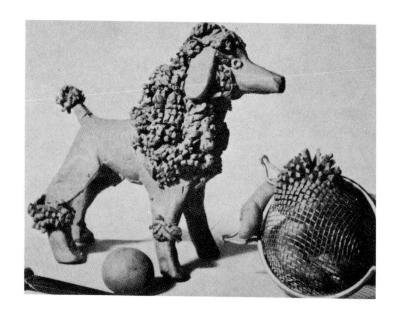

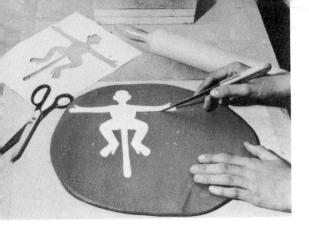

A pattern of a monkey is cut from a layer of clay.

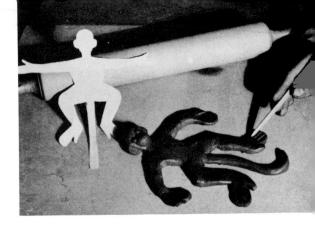

Eyes and nose are added; toes and fingers are indicated. After this the figure is bent into an action position and allowed to dry. Clay props can be used as supports during the drying process.

A monkey tree

Here is another way to use the slab building method to produce an amusing type of sculpture.

A number of monkeys hanging in a tree. The tree is a branch, trimmed, painted white and fastened into a block of wood.

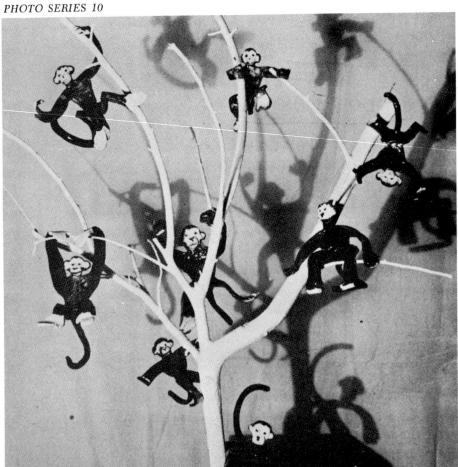

An equestrian figure

Now let's watch the creation of a composition involving both an animal and a human figure. When the sculptor, Albino Cavallito, returned from a visit to Mexico, he was inspired with the idea of portraying Lady Godiva as a Mexican woman riding on a burro. His plan was to make a large ceramic piece, about thirty inches high. Here is the way he went about it.

An armature

Since the piece will be large with a number of open portions and since the original will not be fired but cast in a mold, the sculptor starts by building an armature. A piece of gas pipe is screwed into a flange which in turn is fastened to a board. At the other end of the pipe is a T through which heavy lead wire has been passed. By ingenious use of the pliers, the sculptor has fashioned a wire outline that suggests a donkey and a rider. The sculptor begins to press clay around the armature.

Butterflies

Another type of secondary support for the clay is shown here. These are the little crossed blocks of wood hung by wires to the upper portion of the armature. These are called *butterflies*. Their purpose is to keep large masses of clay from sagging away from the armature.

PHOTO SERIES 11

The armature is completely covered with clay and the blocking out of form begins. The sculptor works with a large wooden block at this stage.

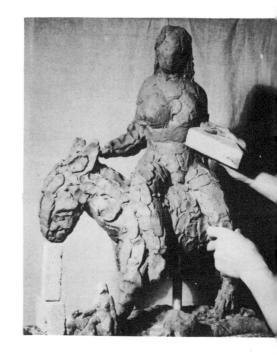

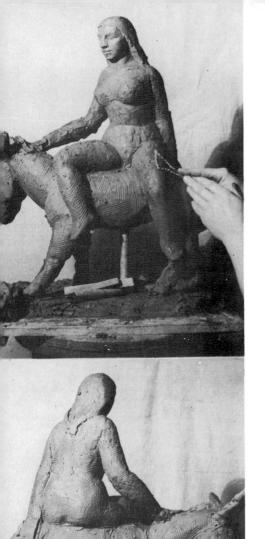

More careful modeling is done with a wire loop tool.

A view of the back.

The modeling completed.

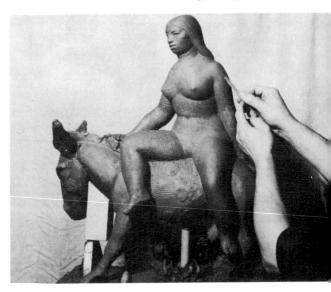

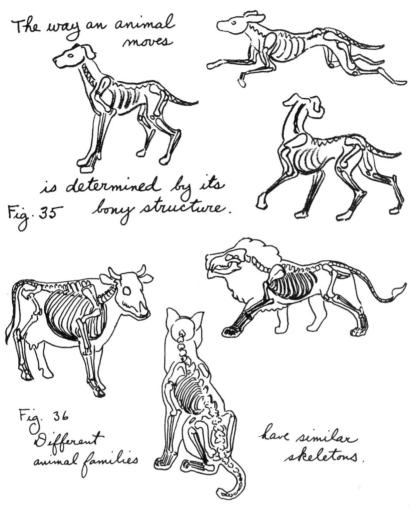

Animal anatomy

If you choose to model animals in a non-realistic manner, an accurate knowledge of animal anatomy is not important. But if your aim is to capture in clay the appearance and the spirit of real animals, then you must spend a lot of time observing them and you should learn something about their physical structure.

The way that an animal moves is determined by its bony structure. Different animal families have different characteristics yet there are certain similarities in the skeletons of all of them and they all correspond in many ways with the skeleton of a human. In fact most animal bones and muscles have the same names as corresponding parts of the human frame.

A quick comparison can be made by glancing at the diagram in Fig. 37 which shows the simplified skeletons of a dog and a man. The dog's skeleton, like the man's, is made up of a flexible spinal column to which are attached a skull, a rib cage, and a pelvic girdle. The dog's shoulder blades

lie along the rib cage held in place by muscles. The forelegs are attached to the shoulder blades and the hind legs to the pelvic girdle. The dog has no collar bone.

The dog's spinal column may be divided into three parts, the neck, the trunk and the tail. The dog has much more flexibility in his neck than we have in ours, yet he has the same number of vertebrae, namely seven. Incidentally this is true of practically all animals; even the giraffe has no more bones in his neck than you have in yours.

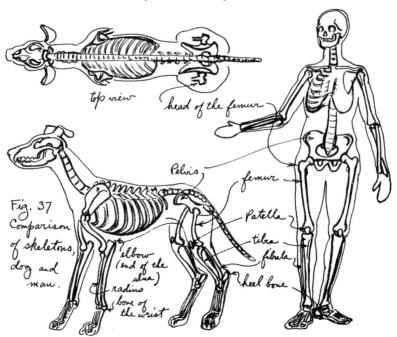

The dog's skull, like the man's, is fastened to the end of his spinal column; but while the man's skull is attached vertically, the dog's is horizontal. The dog's legs have portions which correspond to the arms and legs of a man but the proportions are different. The bones of the upper arm and the thigh (the humerus and the femur) are shorter in the dog and are encased in the flesh of the trunk. Note how high the knee cap is placed on the dog and note too that the bone corresponding to the heel of a man is far off the ground. Actually the dog, like most quadrupeds, walks on his toes. (An exception to this is the bear. He walks flat footed with his heels on the ground. His toes turn in, too.)

The dog cannot turn his paw as we can turn our hands because his radius bone cannot rotate across the ulna as ours can. When a dog shakes hands he must do it palm down.

Important points

When you model an animal, think of the spinal column and the shoulder blades and the hip girdle, for these determine the shape of the body. The proportions of the neck and the head are important. The bones of the

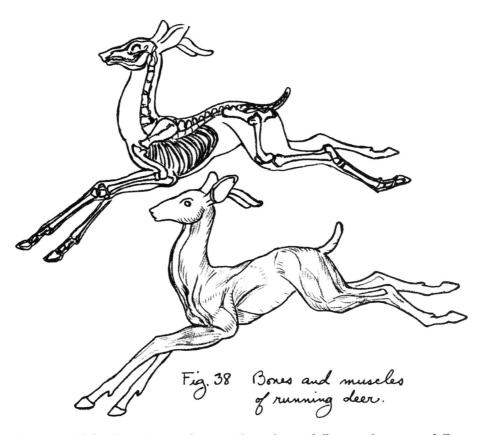

legs should be kept in mind, too. These have different shapes in different species; you must get them right in order to show an animal's true characteristics.

To see how bones and muscles affect surface form in animals, let's turn back to the deer shown on page 52 and study its main anatomical features. Fig. 38 shows diagrams of the deer with the outlines of major bone and muscle forms drawn in. A comparison of these diagrams with the photograph of the finished deer will show that even though the work was only a sketch, and the artist was not consciously trying to make it anatomically perfect, his knowledge of anatomy helped him to get proportion and movement.

How much anatomy must one study in order to model animals? Again, as in the case of human anatomy the answer depends upon your interest in the subject. Satisfactory animal sculpture can be made from observation with no anatomical knowledge at all. However, once you have learned something about the anatomy of an animal, modeling that animal becomes an easier and a more satisfying activity.

If you wish to go into the subject more thoroughly, there are books on animal anatomy filled with diagrams showing the bones and muscles of different species. There is also an anatomical figure of a horse similar to the anatomical man mentioned in Chapter 3 which shows bones and muscles. You can purchase a cast of this in an art supply store. In museums

of natural history you can see the mounted skeletons of animals. A sketching trip to such a museum will prove profitable.

Your study of anatomy must be supplemented by observation of animals themselves. Watch them as they move about. Learn how they run and jump and climb, how they walk, how they stretch, how they relax. You can learn a great deal by studying a cat or a dog that lives with you. Draw your pet in a variety of poses and make a number of sketches in clay as well. Try in each case to depict some characteristic action. Supplement this with further study of animals wherever you have the opportunity to see them. Make sketching trips to a farm and to a zoo, and when you have made a number of animal drawings, try outlining the skeletons on them.

When you have learned a great deal of anatomy, it is good to forget some of it. By that time you will be getting better proportion in the figures you model without thinking too much about it. Large rhythms, line and mass, count for more than a multitude of details. Sculpture of animals is often better when detail is omitted.

The modeling of animals is fun, and sometimes gay and amusing results can be achieved with very little effort. I once knew a very young sculptor (age six) who learned how to make turtles by this simple method.

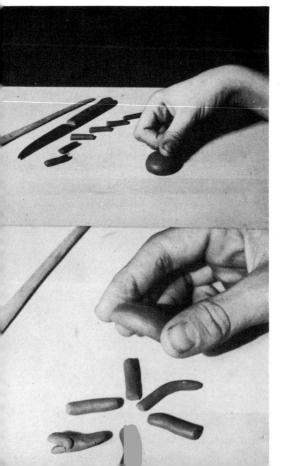

PHOTO SERIES 12

A thin coil of clay is cut into six pieces, each about an inch long. These will form head, legs and tail. A ball of clay is flattened to form the body.

Head, legs and tail are placed in position so that the body can be pressed on top of them. Eyes and a mouth have been added to the head.

Color Plate 2 Slab built dogs. The poodle glazed with brown lustre glaze #44, the setter glazed with white crackle glaze #27.

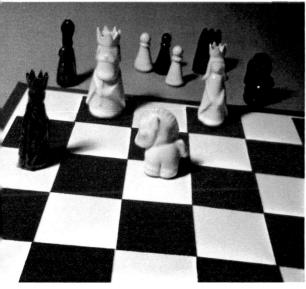

COLOR PLATE 6 Ceramic chess set. The white pieces glazed with majolica glaze #10; the black pieces glazed with mirror black glaze #33.

COLOR PLATE 4 Coil built lamp. Glazed with ilmenite glaze #30.

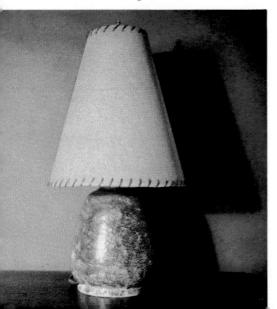

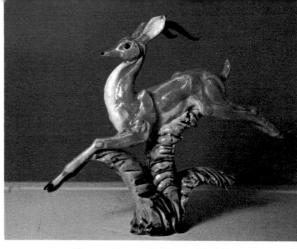

Color Plate 3 Deer. Majolica.

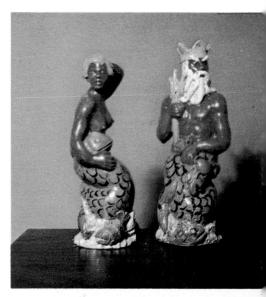

COLOR PLATE 5 Neptune and mermaid.

Made of red clay. Transparent glaze
#7 used on the bodies; majolica glaze
#8 with colorants used on other portions.

Color Plate 7 Slab built lamp. Glazed with majolica glaze #8 with copper; decoration painted over with white majolica.

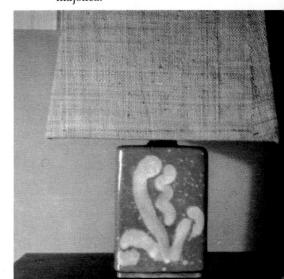

The body in place. Lines are made on the back to indicate the markings of a shell.

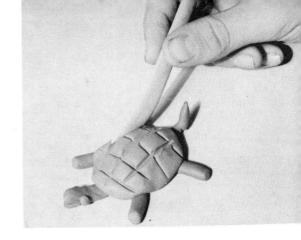

Simple figures such as this one are good for making glaze tests. The young sculptor became so proficient at making turtles that he went into business and took orders for turtles from his grown-up friends. He was always careful to ask his clients whether they wanted boy turtles or girl turtles. When a customer was incautious enough to ask what the difference was, the young sculptor replied, "Well, the only difference is that girl turtles cost five cents and boy turtles cost a dime." (This extra valuation can probably be accounted for by the fact that the sculptor was himself a boy).

Animal portraiture

Animals are more than constructions of bone and muscle covered with fur; they are living beings. They have feelings. Their movements are caused by such things as joy or fear, anger or affection. In order to capture the true character of animals in your work, you must know how they feel and how they express their emotions. You must understand their language.

Yet, it is not necessary to be realistic at all times when making animal sculpture. The animal on page 1 is all wrong anatomically, still there is no doubt in our minds as to what he is. That little figure is a horse! The essentials are there. Capture the essentials and your sculpture will be good.

Fish.
Edgar Littlefield.
Courtesy Columbus
Gallery of Fine Arts,
Columbus, Ohio.

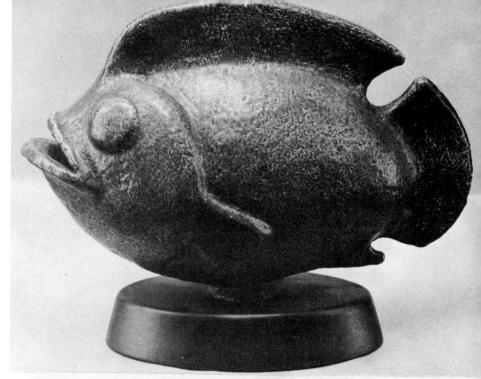

Fish.
Painted Pottery.
Ancient Egypt.
Courtesy Brooklyn
Museum.

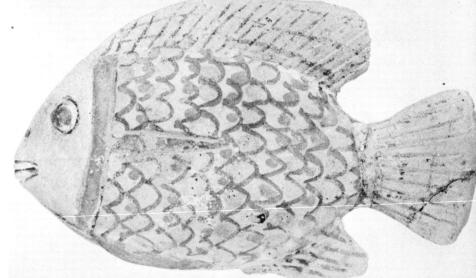

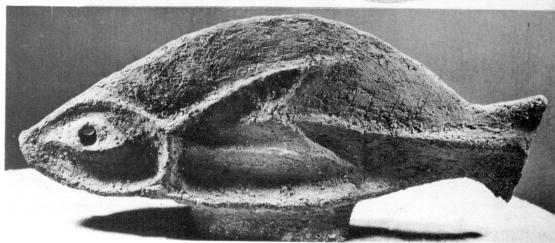

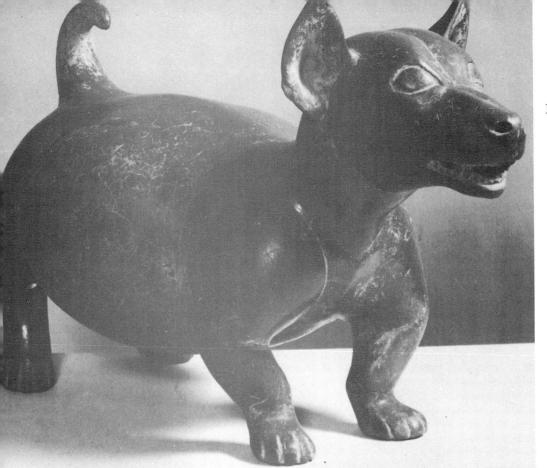

PLATE V DOGS

Red Pottery Dog. Tarascan Culture, ca. 500 A.D. Colima, Mexico. Courtesy Brooklyn Museum.

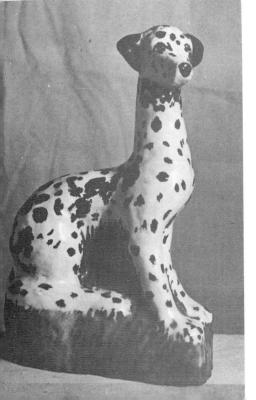

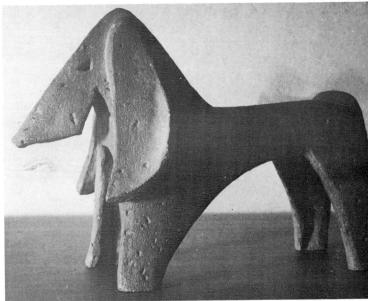

Slab Built Dog. Student work, University of California at Los Angeles.

Spot, a Dog in Staffordshire style.

Jane Courtney.

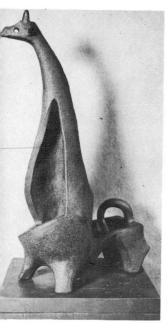

Abstract animal. Student work, Tyler School of Fine Arts, Temple University.

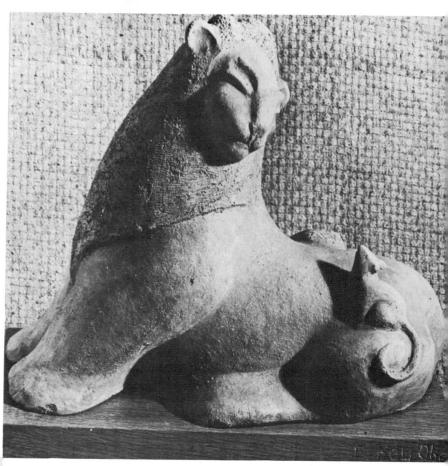

Lion and Mouse Ellen Key-Oberg

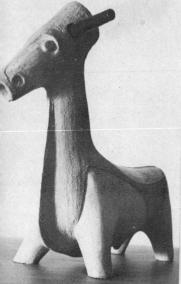

Animal. Student work, University of California at Los Angeles.

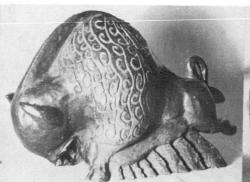

Buffalo. Student work, University of Denver.

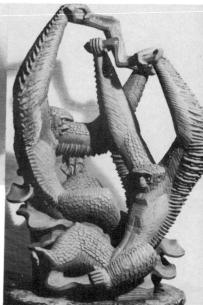

Gibbons. Betty Davenport Ford.

PLATE VI - MORE ANIMALS

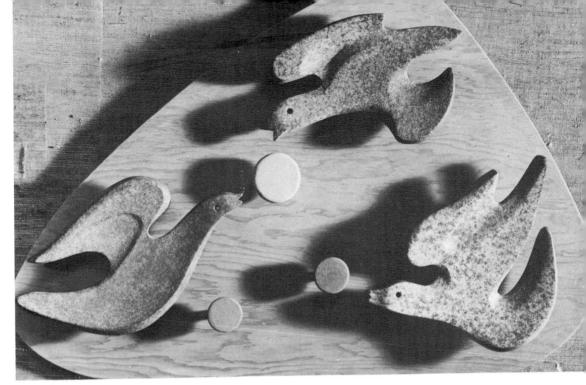

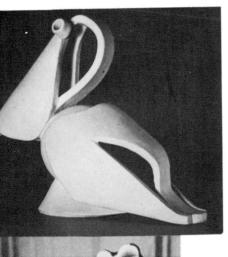

Pigeons – Ellen Key-Oberg

Slab built pelican. Student work, University of California at Los Angeles

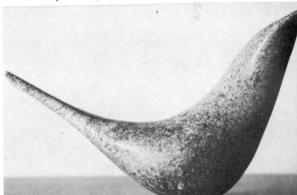

Bird. Student work, University of California at Los Angeles.

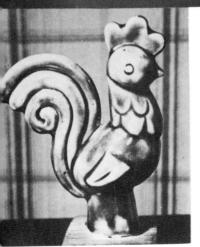

Rooster. Student work, School of Industrial Art, New York City.

Bird bowl. Lyle Perkins

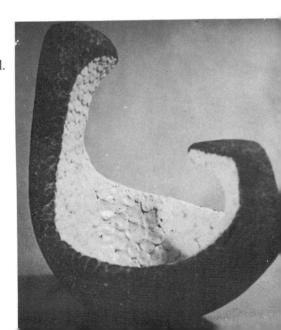

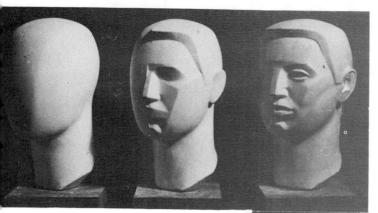

PLATE VIII

Plaster casts showing steps in constructing the planes of the head.

Designed by Albino Cavallito

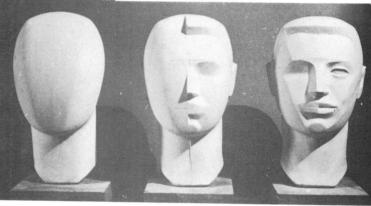

9 Portraiture

 $\Gamma_{
m cause}^{
m ERRA}$ cotta is an excellent material for portrait work not only because of its plastic quality but also because of its warm tone. When a head is modeled in clay the problem of firing must be considered. A head made of solid clay would be much too heavy to put into the kiln. The safest way to do the job would be to make a two-piece plaster mold from the original model and then press layers of clay into the mold. This makes it possible to use specially prepared clay with grog or colorants added. Sometimes such clay is excellent for pressing but not plastic enough for satisfactory modeling. With a press mold it is possible to make the final head a hollow shell of uniform thickness and the likelihood of accidents in the kiln is thus reduced to a minimum. The method of making a two-piece squeeze mold of a portrait head is described in Chapter 6.

It is not necessary, however, to rely upon a plaster mold when making a portrait head. There are advantages in working directly and firing the original model. If a fairly porous type of clay is used and if the head is hollowed out before it is put into the kiln, it can be fired successfully. Let's watch the sculptor Albino Cavallito as he goes through the steps of making a terra-cotta portrait.

Preparing an armature

When a mold is made from the clay model, any type of armature can be used. In this case the original clay model is to be fired, and so a special type of armature like the one shown in Fig. 10 on page 14 is needed. This will permit the head to be lifted off the support after the modeling is finished.

Wet newspaper has been wrapped around a wooden post to form a ball shape somewhat like a coconut. Note that the paper extends far down on the post. Every portion of the post must be covered with paper so that the head will lift off easily. When the paper core is finished, the sculptor covers it completely with clay.

PHOTO SERIES 13

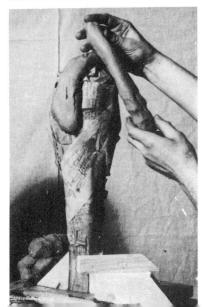

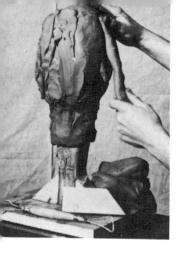

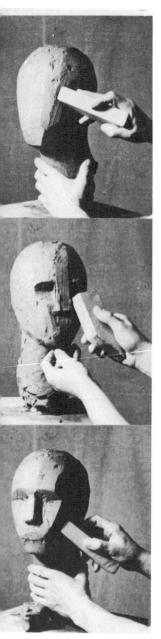

The core completely covered. An elongated ball-shaped head and a neck are roughly outlined. This is the basic form for beginning a portrait. The work is high up on the post; the neck ends several inches above the base and the paper core projects below it.

A portrait of a boy

The sculptor makes a basic head shape.

The sculptor begins to define major planes. Depressions have been made for the eye sockets, the plane of the nose begins to take shape.

More indications of planes. Front and sides of the larger masses of the head are shaped. The lines of separation between front and side planes on forehead, cheek, and chin, are indicated.

Up to this point the sculptor has been constructing a basic head. Now he studies his model and adds pieces of clay to the basic form to build up a shape with the character and the proportions of the subject.

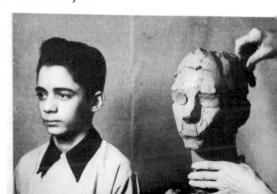

The sculptor moves his modeling stand around the model as he works so that he can view his subject from all positions. Balls of clay have been added to form the eyes, and lips are roughly blocked out. The nose begins to assume more definite shape. Clay has been added to form ears and to indicate the masses of the hair.

As he works, the sculptor shifts his light so that planes are lighted from different angles. This helps him to see forms more clearly.

The thickness of the eyelids has been increased in order to deepen the shadows beneath them. This gives the illusion of color to the eye.

Note the surface texture of the skin. This has been obtained by building up the form, adding pieces of clay and pressing them into place with the end of a wooden tool. There has been no smoothing of the surface. The finish is the result of direct pressure. Note too how a few lines serve to give an indication of hair.

The clay has become leather hard; now the head is lifted off the armature.

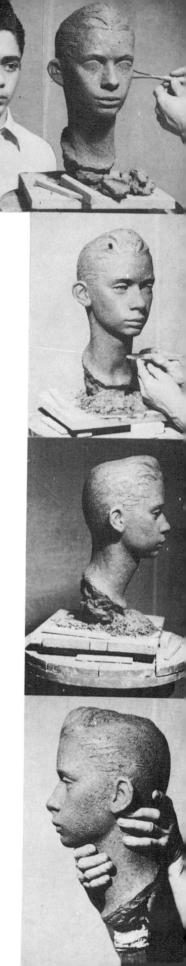

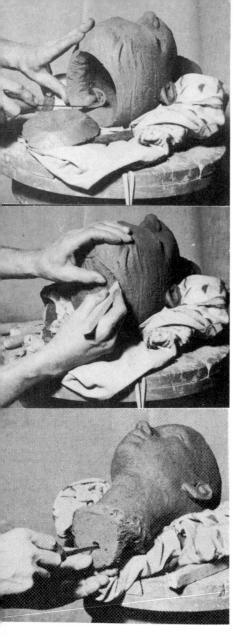

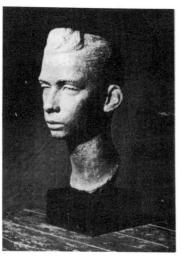

An operation has been performed. A section at the top of the head has been cut and lifted out. The newspaper that was used to form the core has been removed. During this step the head rests upon a cushion made of soft dry cloths. Using a long knife with its end bent into a hook shape, the sculptor scoops out the inside in those places where the wall is too thick.

Sealing the opening. The piece that was removed is put back in place and a wooden tool is used to weld it firmly into position. The edges to be joined were roughened and moistened with water. After the seam has been thoroughly welded, a bit of modeling is needed to remove the traces.

Preparing the base for mounting on the wooden block. The base is made flat, with a hole passing through it so that it can be bolted to the wooden block as shown in Fig. 39.

The finished head mounted on a wooden base.

This piece of sculpture required several days for completion. The sculptor constantly studied the model and his work from all angles, sometimes crouching near the floor to look at them from below, at other times standing on a chair to view them from above. He made use of a mirror to see his work reversed, for this will often make faulty proportions more apparent. He used a movable light so that he could light his model and the work from all sides, throwing planes into sharp relief as he worked on them, and to check on his proportions he made frequent use of a pair of calipers.

PHOTO SERIES 14

Portrait of a young woman

Starting with the basic head shape, the sculptor begins to define the important planes of the head, keeping front, sides and back in mind. The forehead and the nose have been blocked in with the angles between the front and the side clearly marked. The cheek too has front and side indicated. The depression that forms the eye socket has been kept as a flat plane, sloping inward and intersecting the planes of the forehead in the line which will be the brow.

The sculptor studies the model and searches for characteristic proportions. Before he works in detail on any feature he looks for the relationships of large masses. Clay has been added to form the volume of the hair.

The planes of the cheek, the line of the jaw and the chin, the nose and the lips are in their proper places. The hair is treated in large simple masses in order to secure pleasing design.

At this point the work shows the marks of the wooden blocks, and it shows too how small pieces of clay have been added in the building-up process. The neck is no longer a straight cylinder but has assumed a natural slope. A ball of clay has been added to form the eye, and the line of the upper lid has been indicated.

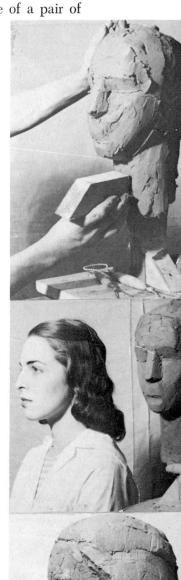

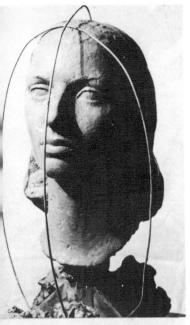

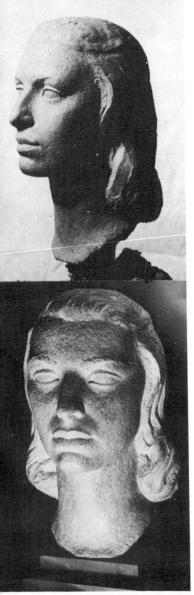

A portrait like this must be worked on during a period of several days. To keep the clay in good condition, it must be sprayed with water each day and it must be covered between working periods with damp cloths and a layer of some impervious material such as oilcloth or plastic. To keep the weight of this cover from marring the modeling, the sculptor sets two curved pieces of wire in place bracing them in clay at the base of the support, as shown. These form a sort of cage over the head on which wet cloths can rest.

The portrait is completed. Study the careful modeling of the eye and the portion above it. Note how the sculptor has secured accuracy of detail in the nose and the lips without getting a feeling of hardness, and note too how each part of the form has been built up. The surface still shows traces of the pieces of clay that have been added; the sculptor will leave these, for making the work smoother would destroy much of its beauty. The hair is treated as a simple mass with the suggestion of a few lines.

After the head became leather hard, it was lifted off the post and the newspaper core was removed by the same method as that used for the portrait of the boy illustrated on page 72. The base of the neck was finished as shown in Fig. 39 so that the head could be mounted on a wooden base.

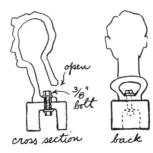

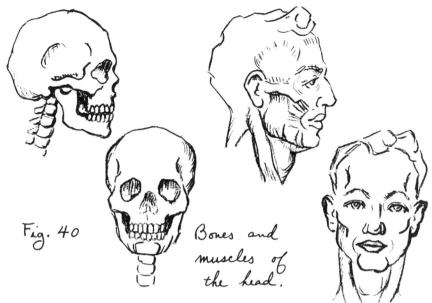

Anatomy of the head

Once more we come to the question of anatomy. How much must one know about the structure underneath the skin in order to model a portrait in clay? The answer depends upon your interest in the subject. Anatomical knowledge is good to have, yet it is possible to work from observation alone. But, as in the case of the figure and the modeling of animals, your work will be more successful if you know something about the structure underneath.

The character of a head is largely affected by the shape of the skull. Fig. 40 shows in simplified form the bones of the skull and the major muscles of the head and the face. Look for these in your subject when you work on a portrait. If you wish to make a thorough study of the anatomy of the head, obtain a skull or a cast of one from an art supply store and examine it. To help you further in your study there are plaster casts of parts of the head and the face, eyes, ears, nose, lips and so forth.

The sculptor Albino Cavallito has prepared the series of plaster casts shown in Plate VIII. These illustrate the basic head shape and the steps in the development of the major planes.

A portrait is a work of art

Don't let your study of anatomy get in the way. A portrait is not merely something that is anatomically correct nor is it just a perfect replica of the model. It must contain something of the subject's personality, must show the kind of person he is. To capture this you must look at your sitter not only as a shape to be copied, but as a human being. You must know him and have a bond of sympathy with him, understand his emotions, his aspirations, his hopes, so that you will be able to recognize the marks that these have left upon his features.

Capture the spirit of your sitter in clay and your portrait will be more than a likeness. It will be a work of art.

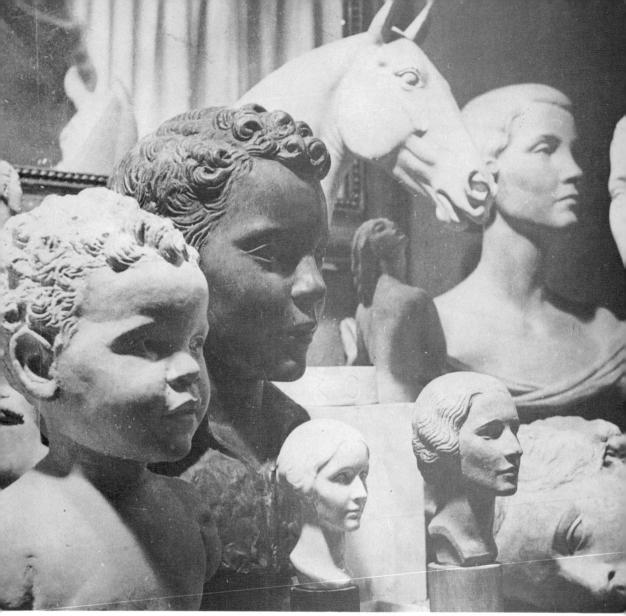

 $Ceramic\ portraits-Wheeler\ Williams$

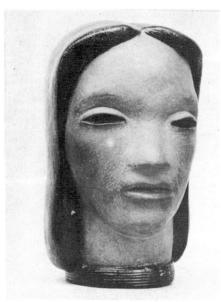

Native Girl Paul Bogaty

Head of Christ. Student work, School of Industrial Art, N.Y.C.

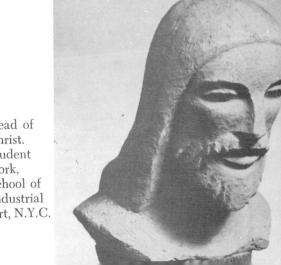

PLATE IX

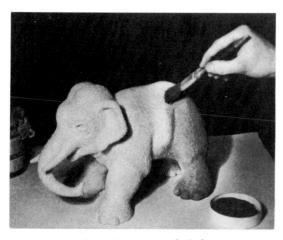

 $PLATE\ X$ — Waxing and Coloring.

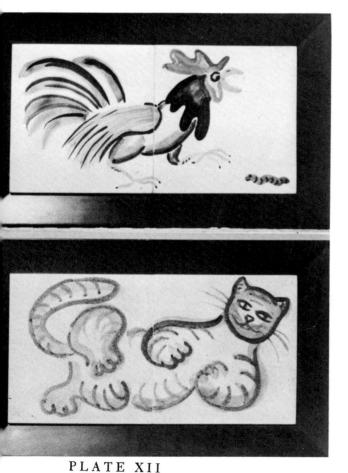

Pair of Ceramic Trays, Pat Lopez.

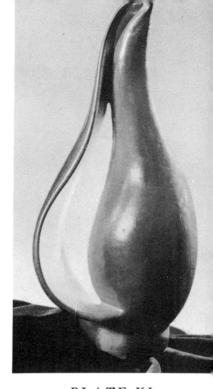

PLATE XI
Shell Form Lamp.
Student work, School of
Industrial Art, New York City.

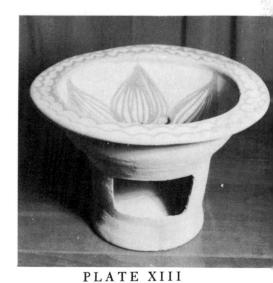

Ceramic Stove, Mexico.

Polar Bear Cub. Eleanor Gale.

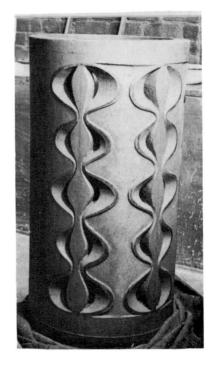

Sewer pipe sculpture. Student work, Scripps College. This will be used as a garden ornament, lighted from within.

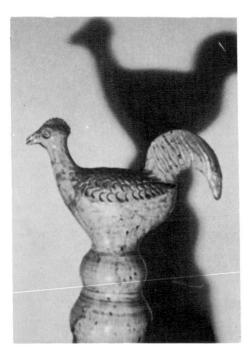

Roof ornament — French 17th century. Courtesy Musée des Arts et Traditions Populaires, Paris.

PLATE XIV - SCULPTURE OUT-OF-DOORS

6 Molds

PLASTER OF PARIS is a valuable aid to the ceramic sculptor. It allows him to make molds of the forms he creates in clay, and from these molds to make reproductions of his work. Since replicas made in molds are hollow, plaster solves the problem of firing pieces that otherwise would be too large and solid to put into the kiln. Plaster of Paris can be given a smoother finish than is possible with clay. So where a high degree of surface perfection is required, the scuptor makes a plaster model of his work in order to carry the modeling further. There are other ways in which plaster helps. Plaster bats are excellent things on which to model small pieces and plaster drying bowls are necessary whenever liquid clay slip is to be converted into plastic clay.

Plaster of Paris is made from gypsum rock. When this material is heated, chemically combined water is driven off and the result is a soft material easily crushed into a fine white powder. When water is added to this powder in the correct proportion, the gypsum crystallizes once more into its hard, rock-like state. Fortunately for the sculptor, this crystallization, or setting action, is not immediate. The mixture of plaster and water is quite liquid at first; after a few minutes it starts to thicken into a heavy cream, then it becomes still thicker until it enters its period of plasticity when it has the consistency of cream cheese; after this it becomes hard. Plaster poured at the moment it starts to thicken will flow over any surface, filling every crevice and faithfully reproducing each detail. Thus plaster can be used to make a mold, or negative shape, of practically anything at all, and from this negative, positive reproductions of the original form can be made in plaster or in clay.

After it has set and been allowed to dry, plaster has an amazing capacity for absorbing water; in fact it acts almost like blotting paper. Plastic clay resting on a plaster slab soon becomes dryer and harder at the point where it touches, and a drop of liquid clay slip falling onto a piece of plaster turns into plastic clay in a few minutes. It is this property that makes plaster of Paris such an excellent material for molds.

Types of molds

Most of the molds used by the ceramic sculptor fall into two groups — those using plastic clay and those using clay slip. In the former group are

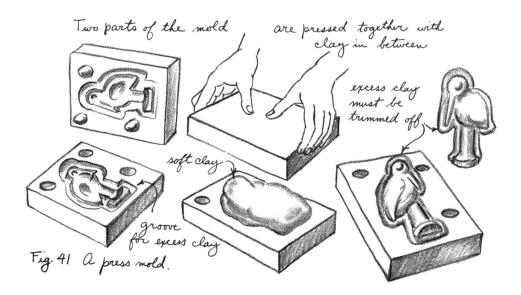

the various kinds of *press molds* and *squeeze molds*, in the latter the *drain* and the *solid casting* molds. In addition to these two groups, the ceramic sculptor sometimes uses *waste molds* to make plaster models from which press or drain molds can be made. If he is engaged in mass production, the sculptor may also use *case molds*. These are molds used for making duplicates of drain molds so that quantities of replicas may be produced at one time, a process suited to the factory rather than the studio.

What plaster to buy

The manufacturers of plaster of Paris have made big improvements in their product within recent years and have developed a number of different kinds of plaster with special properties. *Hydrocal* and *hydrostone* are casting plasters that set extremely hard, excellent for executing large figures in plaster and for making case molds. They are not good for regular mold making, however, as they are too hard and dense.

The best type of plaster of Paris for the ceramic sculptor is *pottery* plaster. This can be bought from ceramic dealers in five-pound cartons or in hundred-pound bags. If there is any trouble in obtaining this type, buy "Red Top" or "Sunflower" from a dealer in building supplies.

Unless you put it in an air-tight container plaster won't keep. Better buy just enough for each job and use it all up immediately.

Press molds

Plastic clay may be pressed into the inside of a plaster mold and allowed to remain until it starts to dry, a matter of ten minutes or so. As it dries, the clay becomes firm enough to hold its shape and, at the same time, it shrinks slightly so that it can be taken out of the mold without difficulty provided there are no undercuts.

Of all the molds used by the ceramic sculptor, the simplest to make is a one-piece press mold for a low relief plaque or an incised tile. In order to gain experience in the handling of plaster, let's make a mold for a tile.

A one-piece press mold

Draw a design for the tile full size on a sheet of thin paper. Remember to allow for shrinkage. If you want to end up with a tile $6'' \times 6''$, make your drawing about $6\frac{3}{4}'' \times 6\frac{3}{4}''$. You may find that you get best results by making a series of rough drawings, altering them until the design pleases you, then tracing the final form. Many commercial designers work this way.

Roll a layer of clay about $\frac{1}{8}$ " thicker than you want your finished tile to be. Use two strips of wood as guides to get the thickness right.

Cut a square of the right size out of the layer and round the corners slightly. Lay the drawing on the clay and go over the outline of the design with a sharp pencil. This will reproduce the design on the clay.

PHOTO SERIES 15

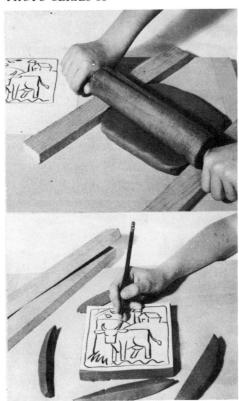

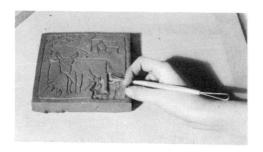

Cut out the background with a wire loop tool leaving the design in relief.

Try to cut the background to an even depth and avoid making undercuts. The portion of the design not cut away must be slightly wider where it joins the background to provide *draft* so that pressings will come out of the mold easily. The sides of the tile itself need not taper, for the shrinkage of the clay will make pressings come out of the mold even though the sides are perfectly vertical.

When the background is cut out, do some more modeling on the design itself. Skillful treatment of the edges of such a relief can give the appearance of great depth to a design which is actually all on one plane, but don't make the design complicated. Do only enough modeling to give a suggestion of three-dimensional quality, destroying the "cut-out" look. You are working with clay, so avoid sharp corners.

When the modeling of the tile is finished, lay a flat board lightly on top of it in order to make sure that the tops of the various parts of the design are all in the same plane.

Put the clay tile on a sheet of glass or on a smooth board and construct a retaining wall for the plaster around the model about an inch and a half away from it. This retaining wall can be made of clay. Roll a fat coil of clay about two inches in diameter and flatten it into a strip three inches wide. The wall must be securely anchored to the glass so that there is no danger of its lifting up when the plaster is poured. Work on a sheet of glass, if possible, for you get a beautiful surface on the mold that way and there is no need to worry about sizing. If you work on a wooden surface, coat the wood with oil or size (see page 94) before you pour plaster against it.

Mixing plaster

In mixing plaster of Paris, the plaster must always be added to the water. Never add water to plaster. For mold-making the ratio should be 23/4 lbs. of plaster to each quart of water. A smaller proportion of plaster will set into a soft crumbly substance, too weak for a satisfactory mold, while an excess of plaster will make a heavy mix which sets into a hard dense mass, not absorbent enough for mold work. It is advisable, therefore, to measure the water and weigh the plaster each time you mix a batch.

How much plaster?

It is important to mix enough plaster for each job, yet you don't want a large amount left over. When you have acquired some experience in plaster casting, you will be able to estimate the amount of plaster needed for a mold, but until then you may have to do some computing. One quart of water plus $2\frac{3}{4}$ pounds of plaster will fill a volume of 81 cubic inches. Keep this figure in mind and when you are ready to pour a mold compute the volume within the retaining walls in cubic inches, divide by 81 and the answer will be the number of quarts of water to start with. For example, if the retaining walls enclose a space $10'' \times 10''$ and the mold is going to be about $1\frac{1}{2}''$ thick on the average, then the volume of plaster will be $10'' \times 10'' \times 1\frac{1}{2}''$ or 150 cubic inches. Therefore, two quarts of water plus $5\frac{1}{2}$ pounds of plaster will be ample.

Put the water into a clean container and sprinkle the plaster into the water. It is important to sprinkle it so that no lumps form.

If you do not have a scale and must estimate the amount, continue to sprinkle plaster into the water until enough has been added to form a cone shaped mound above the surface. Allow the plaster to stand for about two minutes so that it can soak into the water. This action is called *slaking*. This slaking period is important for if you start to stir too soon, the plaster will form a lumpy mass difficult to make smooth.

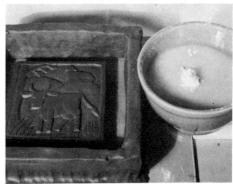

After the plaster has all settled, if any water remains on top, it means that you did not use enough plaster. Don't try to add any more plaster but pour off the excess water carefully before you start to stir.

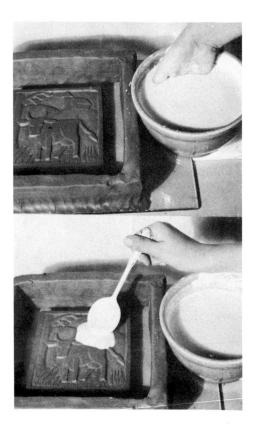

Stirring

After the plaster has slaked, stir. You may use your hand for this or a large spoon but in either case stir from the bottom and try to get all the bubbles out of the mixture if possible. Don't whip the plaster (that will put more bubbles in), but stir gently and agitate the entire mass. As you stir you will feel the mixture start to thicken. When it reaches the consistency of heavy cream, thick enough so that your finger leaves a slight mark as you draw it over the surface, then is the time to pour.

Pouring

Plaster must be poured quickly and smoothly, without splashing. Take care to cover the entire surface of the model; don't leave any vacant spaces. If the model has a lot of delicate detail, you may use a spoon to put a small quantity of plaster on it first, and then gently flow it over the surface.

If you do this, pour the first bit of plaster a little sooner, while it is still fairly thin. You may use a brush to paint the first layer of plaster over the model if you wish, but have a container of clean water handy so that the brush may be rinsed immediately. A brush with hardened plaster in its hair is ruined.

When plaster has been poured, the working table should be jarred violently several times in order to loosen any bubbles which might adhere to the model. As these bubbles rise to the surface, blow on them to break them.

a drain mold for a shape that tapers, such as a bell, can be made in one piece. 3. a layer of slip remains on the inside surface, when 1 slip is the layer powred of slip dries into the the mold can mold and be lifted off. then is poured out. allowed to stand, This shape has draft. a drain mold for a more complicated shape must be Fig. 42 Drain molds in two or more parts.

Setting

After the plaster has been poured and you have gotten rid of most of the air bubbles (you'll never get rid of all of them so don't be discouraged if you find a few in your first molds), the plaster must be allowed to set. The setting action is interesting to watch. When you pour it, the plaster is a liquid, but it soon thickens into a paste-like consistency and enters its period of plasticity. If you dipped a spoonful of plaster out of the mass now, the hole you took it from would not fill up but would remain, and the plaster in the spoon would be firm enough to stand by itself. Soon the plaster becomes so stiff that you cannot dip out a spoonful and shortly after that it becomes hard. If you touch it now you will find it warm. It is crystallizing, going through a physical change in which heat is given off. As soon as it passes its maximum heat and starts to cool, the setting action is finished; it is safe now to remove the mold from the model.

Drying a mold

A plaster mold is not ready for use until it has dried out thoroughly, a process which may take several days. The drying can be hastened if the mold is put near a warm radiator, but don't let it get hot. A mold that gets too hot to touch will become soft and start to crumble. You can tell when a mold is dry enough to use by holding it against your cheek. If it feels cool it is still damp, if it doesn't it is ready to use.

Pressing a tile

A tile is less apt to warp if the clay from which it is made has a liberal portion of grog added. Before using the tile mold, prepare a tile body by wedging together two handfuls of clay and one of grog. Wet the grog first to make the wedging easier.

Form the clay into a shape almost like that of the finished tile but slightly smaller so that it will go into the mold easily. Make the top as flat and as smooth as possible.

Clay that contains grog can have a number of different surface textures. The edge of a knife blade drawn across it will drag out pieces of grog giving the clay a rough, pockmarked appearance. Wiping the clay with a wet sponge will make the grog stand out in relief, while drawing the side of a knife blade or spatula over the clay with a kind of "buttering" action will make all of the grog sink out of sight and will produce a smooth flawless surface.

Smooth the clay before you put it into the mold.

When the surface is smooth, put the clay into the mold, smooth side down, and press it firmly with the thumbs. Press from the center outward and exert enough pressure so that every crevice of the mold is filled. The center of the back of your tile should be lower than the edges, and there should be a rim about half an inch thick at the sides. Press the clay so that such a rim is formed.

Cut off the excess clay with a knife leaving an even footing for the tile.

Cut a series of grooves in the back of the tile with a wire loop tool. These will help the tile to dry without warping.

Allow the clay to stand in the mold for about ten minutes, then remove it by turning the mold over and tapping it gently on the table.

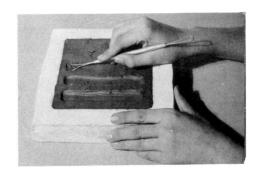

Sometimes the first pressing in a mold sticks and has to be dug out. If this happens, check the mold to make sure there are no undercuts. If you find any, remove them with a knife. Dust the inside of the mold with flint or talcum powder and try again. This time it should work.

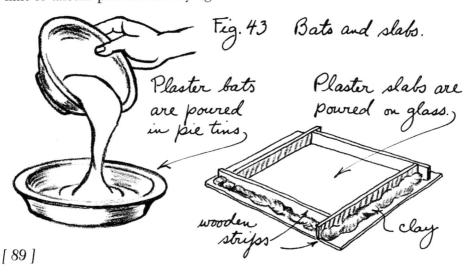

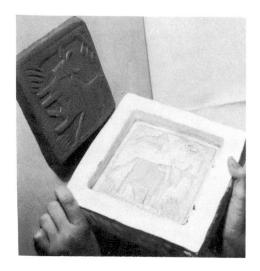

Drain molds

When liquid clay slip is poured into a mold, the plaster absorbs water from the slip where it touches the inner surface of the mold. If the mold is inverted and all of the slip allowed to drain out, a layer of clay will remain lining the inside of the mold. The longer the slip is allowed to stand in the mold before being poured out, the thicker this layer will become. After the slip has been poured out, the layer remaining in the mold will start to dry. After an hour or two it will become firm and will shrink away from the mold. When it is lifted out it will be a hollow shell, faithfully reproducing the form of the inside of the mold.

A one-piece drain mold

To make a one-piece mold that can be used for pouring slip (and for pressing clay too for that matter), we'll start by modeling a cat face in clay. A shape like this is good for trying out glazes, as we shall see later on.

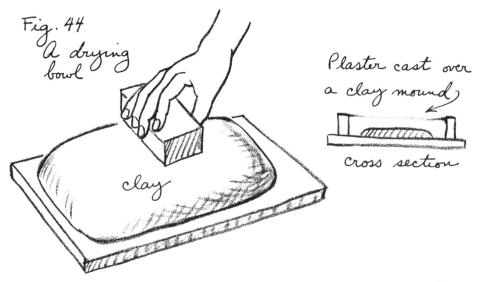

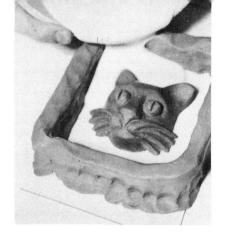

PHOTO SERIES 16

The cat face is placed on a piece of glass and a retaining wall is set in position and firmly pressed against the glass so that no plaster will leak out. The retaining walls enclose a volume roughly 5" x 5" x 13/4" deep, or about 44 cubic inches. Using the formula of 81 cubic inches to one quart of water given on page 85 we find that a pint of water plus 13/8 pounds of plaster is just enough. The plaster has been mixed and is being poured.

Thirty minutes later. The plaster has set, the retaining wall has been removed and the clay cat face has been taken out of the mold. Now the mold must be allowed to dry.

It is difficult to make a clay model free from imperfections. Any scratch in the surface of the clay produces a projecting ridge on the inside of the mold. Such ridges can be removed with a knife. The rough edge of the mold can be trimmed with a knife also.

Next day. The mold has dried overnight. Clay slip is poured in.

The slip was allowed to stand in the mold ten minutes. Now all of the slip which is still liquid is poured out.

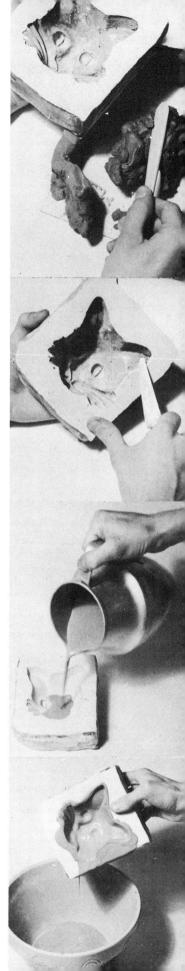

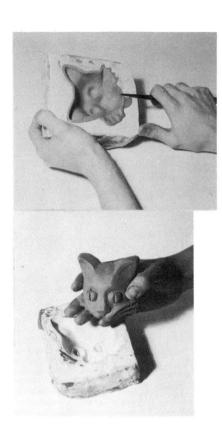

Removing the slip from the face of the mold.

Removing the cast head.

A mold of the type we have just made is intended for use with clay slip. However, if we prefer, we can press plastic clay into the mold and reproduce the cat face that way. Incidentally, if we were to do this and compare a pressed head with one made by pouring slip, we would find the pressed head larger. This is because clay slip has a greater water content than plastic clay and so shrinks more when it dries.

A sprig mold

A mold made for pressing small ornaments is called a *sprig mold*. This type of mold can be used for making buttons or for making decorations to apply to the surfaces of vases or other pottery forms. Here are the steps in making and using a sprig mold.

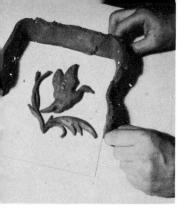

PHOTO SERIES 17

A flying bird has been modeled in clay and placed on a sheet of glass. A retaining wall of clay is built around the glass. When casting plaster over small forms like this, wet the back of the ornament and press it firmly on the glass. Otherwise it will float away when the plaster is poured.

The plaster has been poured, the mold has been completed and allowed to dry Now it is ready for use. Rolls of clay are pressed into the design.

Excess clay is trimmed off, and the ornament is removed from the mold.

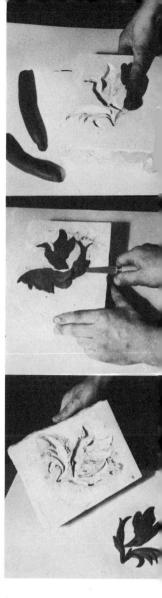

Plaster bats and slabs

Plaster bats and slabs are useful in the studio. A bat is made by pouring plaster into a metal pie pan. Rub the pan with a little oil first so that the plaster won't stick. Place the pan on a level table and pour plaster in until it is filled, then jar the pan slightly so that the plaster flows into a smooth layer with a flat surface. This will produce a bat of even thickness.

Whenever you are making plaster molds, it is a good plan to have some oiled pie pans in readiness in case you overestimate the quantity of plaster. Extra bats always come in handy.

A plaster slab is made by pouring plaster on glass using four strips of wood as retaining walls as shown in Fig. 43. The wooden strips must be firmly anchored to the glass with clay or else held down by weights; otherwise they will be lifted up when the plaster is poured. The wooden strips must be given a coating of oil or size to keep the plaster from sticking to them.

A plaster drying bowl

You will need a few plaster drying bowls in your studio for reclaiming clay and drying clay slip. The method of making such a bowl is the same as that used in making the mold of the tile except that the model is larger. Make a shape in clay like the inside of a shallow platter upside down. The form can be round or rectangular, it doesn't really matter, but it should be at least ten inches across and two inches high. Work it into shape roughly with a block of wood and smooth it with a flat steel scraper, then set retaining walls around it two inches away from the form, and pour enough plaster to cover the clay to a depth of two inches. These steps are illustrated in Fig. 44.

Size

When we made the mold of the cat face we did not have to bother putting oil or anything else on the model. That was because plaster can be poured over moist clay or onto a clean sheet of glass and will come off without adhering when it sets. For that reason we set our models on glass whenever possible. But plaster poured against wood or metal or plaster will stick fast unless some parting material is used.

The best parting material for all-around use is soap size. Most ceramic supply dealers sell this in prepared liquid form, but if you want to make your own you can do so by cutting up a cake of brown laundry soap into small pieces and boiling them in a quart of water until the soap has entirely dissolved. This will produce a thick brown liquid which must be thinned by adding another quart of water after it has cooled. When it is ready to use, size should be a clear honey-colored liquid slightly thicker than water. Add more water if it is too thick.

Applying size

Wood and metal surfaces can be sized merely by brushing on one coat, but the process of sizing plaster is more complicated. Size must be put on plaster with a soft brush, then wiped off with a sponge, then brushed on once more and wiped off again until five coats have been applied. The sponge should be dipped in size and squeezed as dry as possible but not rinsed in water. The hands should not be rinsed either but should be wiped on a clean cloth. The purpose of sizing is to build up a glass-like surface on the plaster, completely non-absorbent. Any water on the hands would spoil the job. When the last application is wiped off make sure that no trace of size remains on the plaster for this would spoil the surface of the mold poured against it.

Sizing must be done just before plaster is poured. If a model is sized and allowed to stand for half an hour or more, the size will lose its effectiveness.

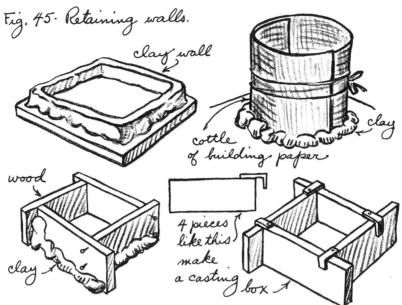

Removing size

If by accident size gets on the inside surface of a mold, it will prevent the plaster from absorbing moisture and so will make the mold ineffective. Such size can be removed with a cloth soaked in vinegar.

Shellac

If plaster is to be cast against a porous material such as cardboard, the surface must be shellacked and then sized. Apply three or four coats of shellac allowing each one to dry for twenty minutes, then put on one coat of size and the surface is ready for casting.

Molds can be made from clay models which have become bone dry if the clay is shellacked and then sized.

Retaining walls

When plaster is poured over a model, some kind of retaining wall must be set up to confine the plaster and to keep it from flowing all over the table. Such walls may be made of a variety of materials — clay, wood, metal, building paper, even sheets of plastic. For work in which the depth is not great like the tile and the cat face, a clay retaining wall is satisfactory, but as height becomes greater, the pressure on the wall increases, so that more strength is needed. Use wood or building paper when you pour plaster to a depth of three inches or more and reinforce the wall with nails or twine as shown in Fig. 45. Weld a coil of clay around the base of the retaining wall to keep plaster from seeping out.

If you plan to do a lot of mold work, it will be a good idea to make a casting box like the one illustrated in Fig. 45. Such a box is simple to construct and very convenient, for with it you can enclose rectangular areas of different sizes and shapes quickly and accurately.

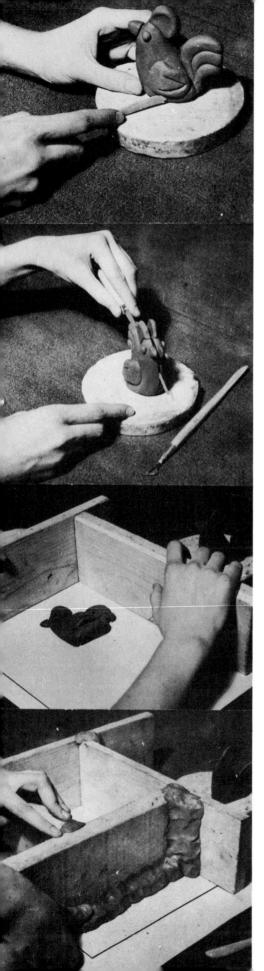

PHOTO SERIES 18

A two-piece press mold

A simple way to make a two-piece mold of an orange would be to cut it in half and cast each part separately. This method can be used with a small piece of clay sculpture also. Here is the way it is done.

A bird is modeled in clay,

and is cut in half along the center line.

One half of the bird is placed on a piece of glass and a retaining wall made of four pieces of wood is set in place.

Completing the retaining wall. Clay is pressed into the joints to prevent plaster from leaking through. After this, plaster is poured over the model to form one half of the mold.

The first piece of the mold has set and the retaining walls have been removed. The half of the bird remains embedded in the plaster.

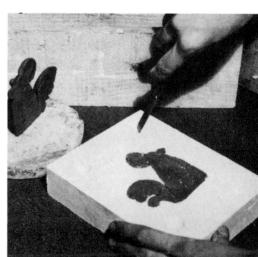

Notches

Before the retaining walls are set for the second half of the mold, notches must be cut in the first half so that the two portions, when completed, will fit together properly. A good tool for this purpose is a potter's knife with the end bent into a hook shape or one of the regular notch-cutting knives sold by ceramic dealers. For that matter, an ordinary table knife with a round-ended blade can be used. Rotate the knife against the surface of the plaster until it cuts a circular depression about an inch in diameter and half an inch deep.

When you cut notches in a mold, space them irregularly. It is a good idea to have two notches fairly close together at one end and one notch at the opposite end, because this way, when you are putting the two halves of the mold together you can see at a glance how they fit.

After the notches are cut, the portion of the first half of the mold which will touch the second half must be thoroughly sized. Be careful to size the inside of the notches but don't allow any free size to remain there.

The notches are cut and the top surface of the first part of the mold has been sized. The other half of the bird has been placed on top of the portion that still remains in the plaster so that the edges match perfectly. Retaining walls are set in place again, making ready to pour the second half of the mold.

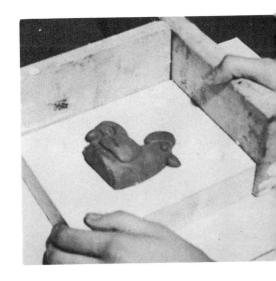

When a two-piece press mold of this type is used, plastic clay is placed in the opening of one half of the mold and then the two halves are pressed together. This forces the clay into all parts of the mold but there must be a space where excess clay can go when the two halves of the mold come together. To provide this space, a groove must be cut in each half of the mold outside of the outline of the figure.

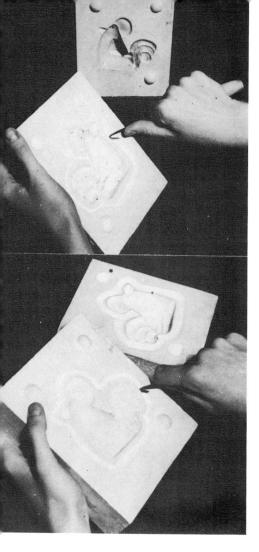

The two halves of the mold have set, the retaining walls and the model have been removed. Using a hooked knife we begin to cut the groove in one half of the mold.

Cutting the groove in the second half.

The mold in use. Excess clay has been forced into the grooves and made a ridge that will be trimmed off with a knife.

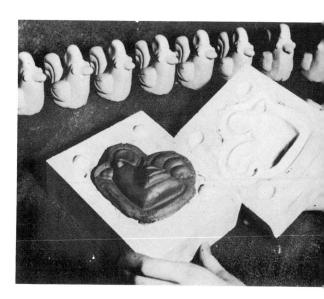

Undercuts

Molds of simple forms like the cat face and the tile can be made in one piece, but usually two or more pieces are needed. The number depends upon the shape of the model. It is easy, for example, to make a mold of half an orange. Merely put it on a piece of glass, cut side down, set retaining walls around it and pour plaster over it. Suppose, however, that we want a mold of a whole orange? If we followed the same procedure, we could reproduce the shape of the orange but the portion beyond the center diminishes in size, and so forms an *undercut*. The plaster reaching around there would lock the orange firmly in the mold and we could not get it out. It is obvious, therefore, that a mold of a spherical shape must be in two parts separated at the widest portion.

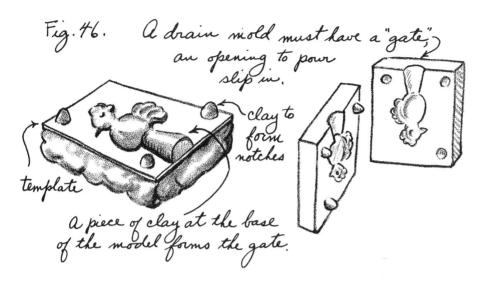

Using a template

Suppose that in making the mold of the bird, we were not permitted to cut the model in two? In that case we would have to cover up one half of the bird while we poured plaster over the other half. We could do this by embedding the model in clay up to the center line or we could cut an opening shaped like the profile of the bird in a piece of cardboard and then place the bird half way through the cardboard, backing them both up with clay or some other supporting material. A piece of cardboard cut and used this way is called a *template*. Templates may also be cut out of thin sheets of plaster that have been cast on pieces of glass. More accurate cutting is possible with plaster but such thin sheets break easily. Cardboard is tougher.

A cardboard template will have to be given three or four coats of shellac and then sized before the plaster is poured against it. For a plaster template sizing alone will suffice.

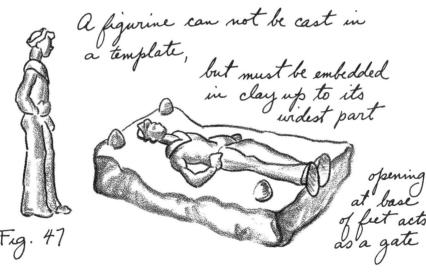

A gate

Fig. 46 shows the steps in using a template to make a drain mold of the bird. In a drain mold there must be an opening called a *gate* into which slip can be poured. To form the gate, pieces of clay are placed against the bottom of the model as shown.

Bedding a model in clay

When a model is not symmetrical and its widest portion is not in a flat plane, a template cannot be used. In this case it is necessary to embed the model in clay up to its widest point while one half of the mold is poured as shown in Fig. 47. The series of pictures beginning on page 161, showing the making of a mold for a figurine, illustrates this.

How many pieces?

Many of the forms from which a sculptor makes molds are more complicated than those we have studied so far, and the molds often require more than two pieces. The problem of deciding how many pieces a mold should have and where the division between the pieces should be is an intricate one. To solve it we must consider the problem of *draft*, and decide the direction in which each section of the mold is to move as it comes away from the model. Each piece of the mold should cover as large a portion of the model as possible without reaching around any projecting portion so that it holds fast. You should be able to remove all pieces of the mold from the model without marring it in any way (note — this does not apply to waste molds; they are a special case). Molds of complicated shapes must often have many parts, with special pieces cast to fill undercut portions. Sometimes too, the sculptor finds it easier to remove some projecting portions, like hands, and make molds of them separately.

The angel candle holder made in Chapter 1 requires a mold in five pieces. Because of the wings, one piece is needed for the back, two more pieces are needed for the sides and a fourth is required for the front. The basket in her arms which provides a socket for a candle makes an additional piece necessary, to take care of the hollow portion.

Mold making without retaining walls

During its period of plasticity (sometimes called the "cheese state"), plaster can be handled and shaped with the hands or with tools. You can actually model with it if you are quick enough. We can take advantage of this period of plasticity to make molds without using retaining walls. It is a good thing that this is so for otherwise the problems involved in making a mold for a figure three or four feet high would be serious indeed. The weight of plaster to be poured would be so great that a derrick would be neded to hoist it, and constructing retaining walls able to withstand the pressure would be quite an engineering feat.

When he makes large molds, the sculptor doesn't bother with retaining walls but applies plaster directly to the model. We can illustrate the process on a small scale by making a mold of the angel candle holder.

A mold for the candle holder

The inside of the basket complicates matters. A separate piece of the mold will have to be made for that portion and the piece will have to be notched so that it is held in place by the surrounding pieces. A spoonful of plaster is poured into the basket.

The first piece has set. Now it is being sized. A notch has been cut in this piece so that the other pieces of the mold will hold it in place.

Preparing to make the front portion of the mold. The figure stands on a sheet of glass while a wall of clay is built along the line of separation.

PHOTO SERIES 19

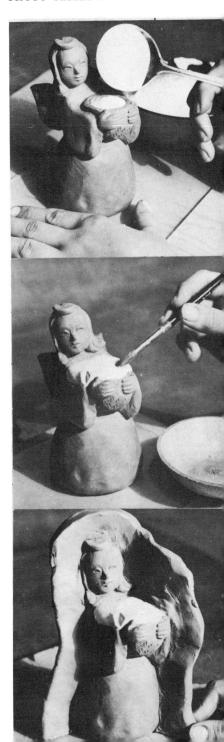

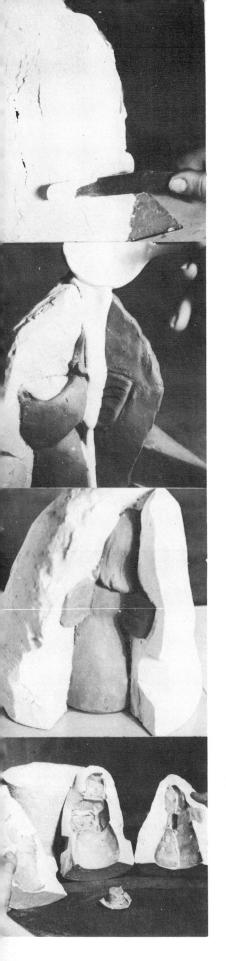

The front portion completed. Thin plaster was poured over the figure first, then the plaster was allowed to thicken sufficiently so that a layer one-inch thick could be built up with a spatula.

Making one of the side portions. The front piece has been notched and sized. A clay wall has been built at the back along the line of separation through the center of the wing. Spoonfuls of plaster are poured over the model for the first layer.

Ready to make the last piece. Note the notches.

The completed fivepiece mold.

A pair of fired and glazed holders in use.

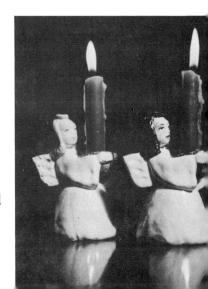

PHOTO SERIES 20

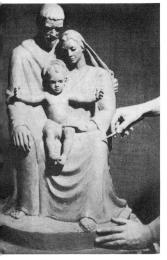

The group.

A press mold for a large group

Here is a series of pictures which shows the same type of mold used to make a large piece of ceramic sculpture intended for a church. This group of the Holy Family was a commission executed by the sculptor, Eleanor Gale.

The mold has been made according to the method described for the candle holder. The artist is preparing to remove the separate pieces of the mold and is using a piece of black charcoal to mark the joints. Note that a metal rod has been embedded in the piece of the mold shown on the right, to serve the double purpose of reinforcement and handle. In the left piece two loops of heavy twine have been inserted as hand grips.

Beginning to separate the pieces of the mold. The artist uses a rubber hammer. A few forcible blows with this will make the parts of the mold separate more readily.

Lifting off one piece of the mold. The artist holds it by two metal grips.

Removing the front piece. The head of Joseph has been removed and so has the foot of the Infant. Separate molds have been made of these parts.

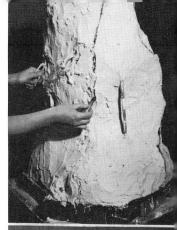

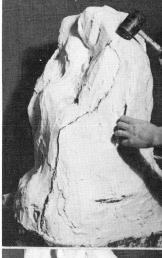

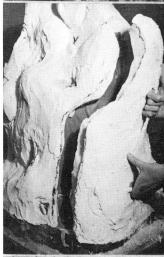

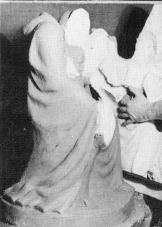

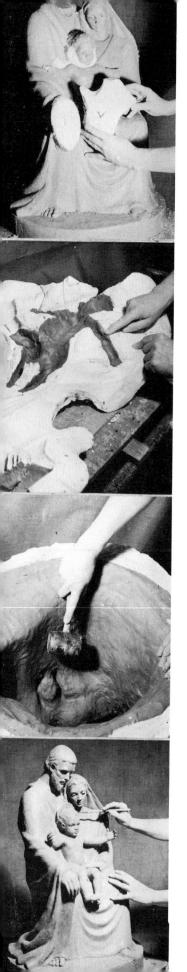

Removing another portion of the mold. A heavy black V has been drawn on this piece to indicate the direction in which the piece must be removed. Note the small portions of the mold which fill in the space underneath the chin of the Infant and the portion over the shoulders. No mold has been made of the halo. That will be modeled separately and, since it will be of gold, it will be fired at a lower temperature and attached after the composition is finished.

Using a press mold

The artist has pressed clay into the portion which forms the figure of the Infant. This sculptor obtains much of the color in her finished work by using natural clays of different colors. In this case a buff firing clay will be used for all of the portions of the composition which are to be flesh colored. White clay will be used for the remaining portions.

All parts of the mold have been filled and the mold has been put together. Now it stands upside down while the artist works from the inside welding all the joints. The rubber hammer is used again. Putting the pieces of the mold together and turning it upside down was a job which required two assistants. When the mold was assembled, it was tied together with rope and stood upside down in a bushel basket so that the artist could reach all portions of the interior. Clay must stand in the mold for several days until it becomes leather hard.

The pressing is completed, the clay has become leather hard, and the mold has been removed. The artist puts some final touches on the work before allowing it to become bone dry. In Chapter 9, Photo Series 25 will show how this group was fired.

Shims

In the molds for the little angel candle holder and the Holy Family group, clay walls were used to separate the parts of the mold. With this method, only one piece of the mold can be cast at a time. There is a quicker way than this, using *shims*.

Shims are cut from thin sheets of brass with a pair of scissors. The pieces are usually made three or four inches long and about an inch and a half wide. They are cut to shape to fit roughly the contour of the model, but accuracy in cutting is not essential. The shims are pressed into the clay so that a wall about 3/4" high is built up along each line of separation. At intervals along the line of separation, the shims are bent to form **V** shapes. These serve the same purpose as notches in making the parts of the mold fit together accurately. Shim brass is sold by ceramic supply dealers.

When the shims are in place, the sculptor mixes his plaster and, while it is still liquid, covers the model completely by brushing a thin layer of plaster over the clay. After every portion of the model is completely covered, the sculptor allows the plaster to thicken, and then, as soon as the plaster is thick enough to stand by itself, builds up a layer of plaster all over the model. When the plaster has set, the sculptor uses a mallet and a chisel to separate the parts of the mold along the lines of the shims.

The method of using shims is illustrated in the series of photos which follows.

A waste mold for a portrait

Shims are placed in the clay model dividing it into two parts. Note the \boldsymbol{V} shapes that will serves as notches.

The line of shims in place. A piece of cardboard is fastened at the base of the neck so that the mold will have an even edge.

PHOTO SERIES 21

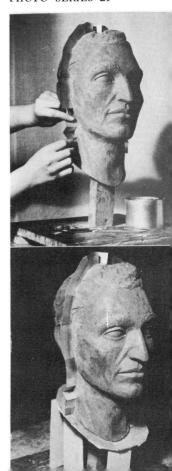

[105]

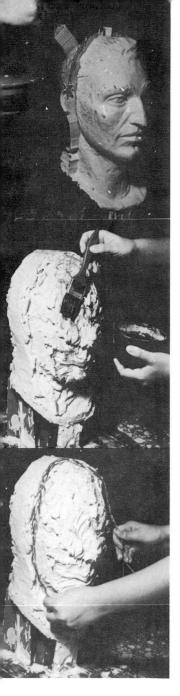

Applying the first layer of plaster. This is the blue coat. Bluing was added to the water when this plaster was mixed so that the first layer of plaster will be a different color. When the sculptor chips the waste mold away from the final plaster casting he will know when he approaches the surface of the casting.

Brushing clay water on top of the blue coat. This is a very thin slip. It serves to keep the outer layer of plaster from sticking to the blue coat and makes the chipping away easier.

Reinforcing plaster

Reinforcing materials can be embedded in plaster to give it extra strength. A strip of twisted wire is placed in the plaster for this purpose.

The waste mold completed. A mallet and a chisel were used to separate the two halves. Now the front half of the mold is removed.

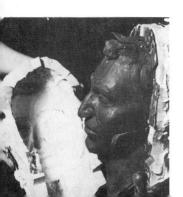

Removing bits of clay from the inside of the mold. After this the inside surface is sized.

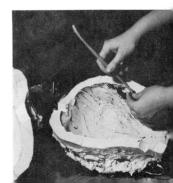

Fastening the two halves of the mold together. Strips of burlap soaked in plaster of Paris are used to seal the joint.

Pouring plaster into the mold. The opening will not be completely filled with plaster for that would make the casting too heavy. Plaster is poured in and then the mold is tipped from side to side so that a layer of plaster covers the entire inner surface, then the excess plaster is poured out. This process is repeated several times until a layer of the right thickness (about ½ inch) is built up.

To provide additional strength, layers of burlap soaked in plaster are pressed onto the inside of the casting.

The casting completed. Chipping away the waste mold.

Removing the final piece of the waste mold.

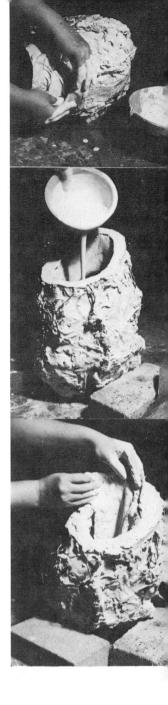

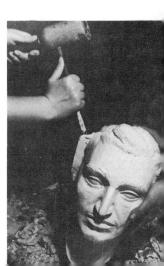

The main use of waste molds is to reproduce sculptural forms in plaster, but, as we said before, ceramic sculptors often make replicas of their models in plaster before making the final molds. Clay has wonderful plastic qualities but there are certain limitations to its use. The fine surfaces possible with plaster cannot be obtained in clay models and so, for highly finished work, it is necessary to model in clay first, then make a waste mold and reproduce the model in plaster. Plaster tools and sandpaper can then be used on the plaster model to get the most perfect finish possible. After this a ceramic mold can be made from the model. These are the steps involved in the commercial manufacture of porcelain figurines.

A waste mold made by thread separation

Still another way of separating the pieces of a mold is to use strong linen thread. The thread is set in place on the clay model along the line of separation, then plaster is mixed and a layer an inch and a half thick is built up all over the model. When the plaster starts to harden, the two ends of the thread are pulled up so that the thread cuts through the plaster. These are the steps.

PHOTO SERIES 22

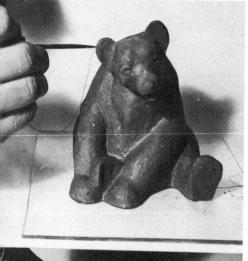

A clay model of a bear rests on a piece of glass while the sculptor places a piece of thread on the line of separation.

The thread is in place; the sculptor covers the model with plaster, using a brush.

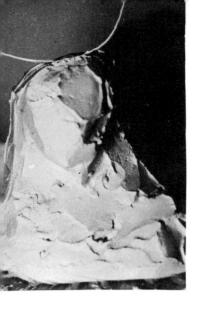

As the plaster begins to set, the thread is pulled up. It is important to pull the thread at the right time — when the plaster has the consistency of cream cheese.

After the plaster has hardened, the two halves of the mold that were separated by the thread are pulled apart. Parts of the clay model will remain in the mold. These must be removed and the inside of the mold must be cleaned.

The two halves of the mold were tied together, the inside was sized and plaster was poured in. Now the sculptor uses a chisel and a mallet to cut away the waste mold.

Preparing to cast a piece mold from the plaster model. This will be in six parts. Lines of separation are drawn on the plaster model and a clay wall is set in readiness for making one piece of the mold.

Putting plaster on for one piece of the mold. The model was thoroughly sized first.

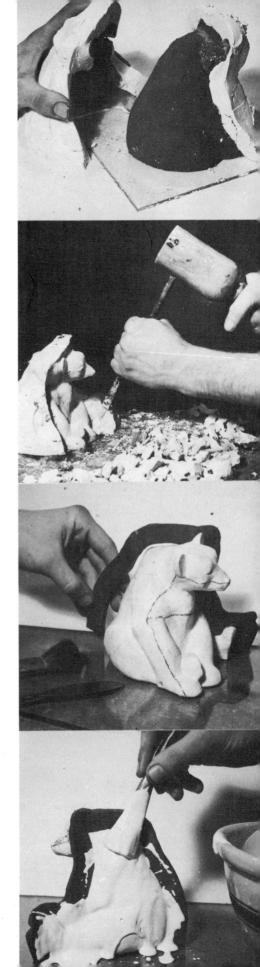

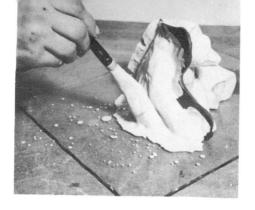

When the first piece of the mold has hardened, the clay wall is removed and another wall is set in place for the second piece. The model and the edge of the first piece are sized, then plaster is put in place.

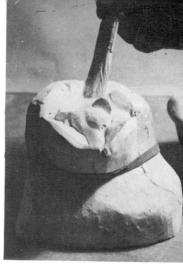

Applying plaster for the last piece.

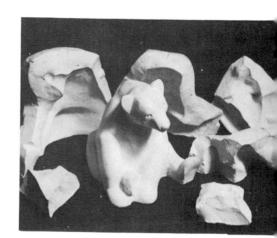

The completed mold in six parts.

Casings

When slip is poured into a drain mold, the parts of the mold must be held firmly together. For two-piece molds, a heavy rubber band cut from a piece of inner tube is an excellent binder. Sometimes, however, if a mold has four or five parts, it is difficult to tie them together.

To meet this difficulty, sculptors often make casings as shown in Fig. 48. The casing is a containing mold which is cast over all of the other pieces of the mold when they are assembled. It serves to hold them in place while the mold is in use.

Modeling directly in plaster

Sculptors sometimes build up figures directly in plaster while it is going through its period of plasticity. For large figures a light supporting frame is made of wood and on this a core of chicken wire is built. The core approximates the shape of the finished figure but is slightly smaller all around. Strips of burlap are then soaked in liquid plaster and wrapped around the wire core in such a way that the whole surface of the wire is covered and the strips overlap slightly. Burlap soaked in plaster and used this way

Fig. 48 a casing. a piece cast over the parts of a mold serves to hold them together.

— casing pieces of mold cross section

hardens in a few minutes and makes a strong light shell. After the shell is finished, more plaster is mixed and stirred until it becomes thick enough to work with. Then final details of form are modeled in plaster directly on the burlap and plaster shell.

Carving

Objects can be formed of clay by carving it when it is leather hard, but clay is not really a carving material. If you wish to carve, it is better to work with some hard substance like wood or plaster of Paris.

Sculptors sometimes create forms by carving plaster that has been cast in the form of blocks or cylinders. Plaster is a good material for carving low relief placques or tiles, and from the carvings plaster molds can be cast and pressings made in clay and fired.

This is a good exercise which you may wish to try. Set retaining walls to cast a rectangular block of some convenient size, then mix plaster with a slightly smaller proportion of plaster to water than you would use for mold work. This will make the resultant plaster block slightly softer, hence easier to carve. The carving can be started as soon as the plaster has set; it is not necessary to wait for the plaster to dry. It is easier to cut the plaster while it is wet so if the carving extends over several days, it is advisable to moisten the plaster each time you work on it.

The artistic problem involved here is to see form within the block and remove the plaster from around the form. Don't cut away too much. Light, airy, delicate forms with fluid movement should be made by modeling. Carved forms should bear a resemblance to the solid mass from which they come.

Shapes carved in plaster are sometimes best retained that way. However there are times when you will wish to make molds of carvings so that you can make clay pressings to fire. Molds are made from plaster models by the same methods used for clay models. The only difference is that plaster must be thoroughly sized first.

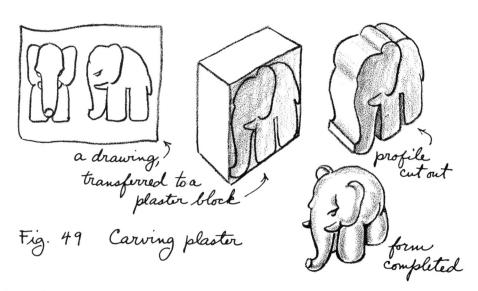

Carved sprig molds

Another way of using carving in ceramic sculpture is to cut a design in a plaster slab and then press clay against the cut-out portion so that the design is transferred to the clay in relief. In other words, make a sprig mold by carving directly in the plaster without any modeling beforehand, as shown in Fig. 50.

This method is effective for simple designs that can be made with direct strokes of the cutting tool — designs like those found in carved wooden butter molds. Use a slab of plaster about $1\frac{1}{2}$ " thick that has been cast on a sheet of glass and cut the design with V or U shaped gouges like those used for making linoleum block prints. Avoid going over any part of the design a second time; cut each portion with one complete stroke. Use gouges of different sizes so that you can make both thick and thin cuts.

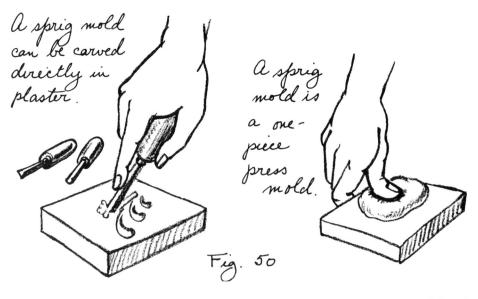

Running plaster

Plaster can be shaped by moving templates over it while it is plastic, or by turning it on a spindle and holding a pattern against it. This method can be used to make any type of cylindrical shape — pedestals, lamp bases and similar forms.

A turning box is shown in Fig. 51. This is a wooden box with a metal rod that has one end bent to form a handle. The rod is held in place by two strips cut from a tin can which serve as bearings. The profile of the shape to be turned is cut from tin and fastened to a piece of wood. This in turn is fastened to the turning box, as shown, so that it is the right distance away from the metal rod to turn a shape of the required size. (The distance from the center of the metal rod to the profile must be exactly half of the diameter of the form to be turned.)

In order to see how a turning box is used, let's go through the steps of making a cylindrical lamp base to which sculptural ornaments may be applied.

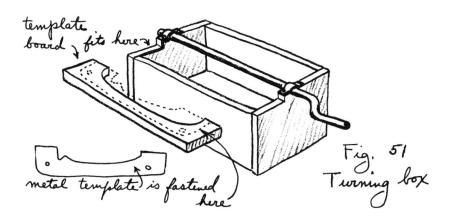

PHOTO SERIES 23

The turning box is set up ready for use. A pattern has been cut from tin and fastened to the template board. Since this is a rather large form, the sculptor has a number of strips of burlap on hand to provide bulk so that less plaster will be needed. The sculptor soaks a burlap strip in plaster.

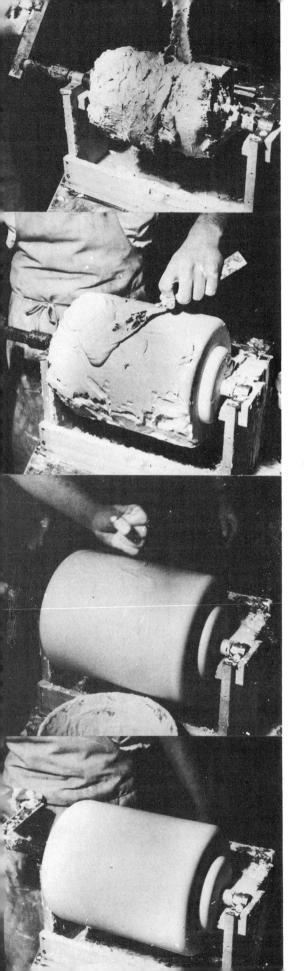

Wrapping plaster-soaked burlap around the spindle to form a core. Since volume is needed here, anything that will provide bulk without much weight can be used. Sculptors sometimes use excelsior or even crumpled newspaper to fill the space in the center of forms like this one.

The plaster has been built up to such size that when the spindle is turned the template scrapes the plaster and begins to cut the desired form. Where the plaster was not high enough, holes are left in the surface. The sculptor fills these holes by adding plaster with a spatula.

The finish coat. As the shape nears completion, the sculptor applies plaster which is more liquid in order to obtain a smooth finished surface. He can mix a fresh batch of plaster for this final layer, but a better method is to dip out a small bowlful of his original batch of plaster before he stirs it. Plaster sets more rapidly when it is stirred. The bowl of plaster, set aside and not disturbed, will remain quite fluid long after the batch which the sculptor has stirred has started to set. When the sculptor is ready to apply the finish coat, this second bowl of plaster will be fluid and just right for use.

The completed turned shape. The sculptor is now ready to remove the form from the spindle, size it, and cast a mold.

Making the mold.

Clay pressed into the three pieces of the mold. (The third piece was cast against the bottom of the form.) The sculptor roughens the edges of the clay with a knife. Slip will be brushed on the edges also before the parts of the mold are assembled.

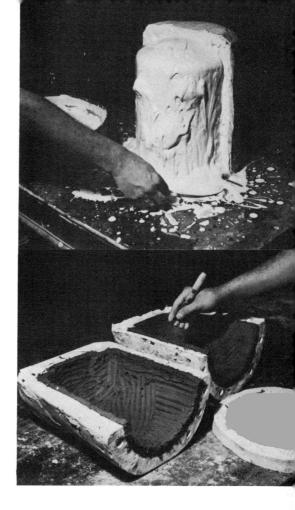

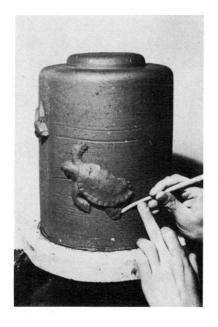

The pressing of the lamp base completed. The sculptor attaches decorations that have been made in sprig molds.

Speed of setting

We have seen that when plaster is not stirred, its setting action is delayed. The speed of setting is affected by the temperature of the water also. If you use warm water, the plaster will set faster. Foreign materials in the plaster or in the water delay the setting action. Sometimes gelatinous substances are added to plaster for this purpose. Salt, on the other hand, speeds up the setting action.

[115]

Plaster Tools

In addition to the tools described in Chapter 2, there are special tools for plaster work. These include *spatulas* for handling plaster during its period of plasticity and for building up molds without retaining walls, *steel scrapers* both toothed and plain, in pallet and block shape, for finishing plaster surfaces, and *steel plaster shaping tools* for detail work on plaster models. The catalogues of ceramic supply dealers illustrate a wide assortment of such tools.

A rubber hammer is convenient for making pressings in large molds, but if you haven't one, a rubber tip placed over an ordinary hammer makes a good substitute.

Disposal of waste

Disposing of waste plaster is a problem. When you are casting plaster, don't rinse your bowls or your tools under the kitchen faucet. Doing that will almost certainly clog up the pipes. Don't let any scraps of plaster go down the drain.

Mixing bowls can be cleaned before the plaster sets by wiping them with old newspapers. If plaster has hardened in a bowl, it can be loosened by soaking in cold water, provided the inner surface of the bowl is smooth.

Your hands and any tools you use can be rinsed in a bucket of water. The waste plaster will settle to the bottom of the bucket and when the water is poured off, the plaster can be disposed of as ordinary refuse.

Brass mixing bowls or bowls made of rubber are good to use for plaster work because when plaster hardens in these, a slight bend of the bowl loosens it.

Repairing molds

If a plaster mold is broken, the pieces can be fastened together with Duco cement.

Plaster as an aid

Plaster is a help to the sculptor in other ways than mold making. When modeling has been carried as far as possible in clay, if the sculptor is still dissatisfied, he can make a mold of the piece and then cast it in plaster. Mistakes can be corrected in the mold before a casting is made. The plaster model gives the sculptor a fresh approach to his work and may help him to overcome his difficulties. The final press or drain mold can be cast from the finished plaster model.

Plaster sometimes helps out in an emergency. A sculptor friend of mine once made a ceramic piece to send to a national exhibition. It was over three feet high and a beautiful job. When it was ready to be packed and shipped, the piece was broken. Undaunted, the sculptor reassembled the work and glued the pieces together, then made a mold. Into this mold he pressed layers of clay to form a replica of the original sculpture, glazed it, fired it and sent it on to the exhibition without further mishap.

To the ceramist, plaster of Paris is merely an aid in the shaping of clay. When you have worked with clay and fire, sculpture made of plaster can never be completely satisfying. It is true that plaster is often painted to look like other substances, but such camouflage can never take the place of the real thing.

Be careful

Plaster, improperly handled, can make an awful mess. Clean up as you go along. Protect yourself and your studio as well as you can. Put newspapers on the floor or a layer of sawdust that can be swept up when you are through casting.

Take care of your tools. Clean them promptly. Don't let plaster set in the hairs of a brush or harden on your metal tools. Treat the latter to an oil

rub occasionally.

Guard your clothing. Wear a smock or coveralls. When plaster gets on your clothes, let it set, then remove it by soaking in cold water without using soap.

Take care of your hands. Vaseline rubbed into the hands before you begin will make it easier to get the plaster off and will prevent soreness.

And, finally, be a craftsman. Perfect your technique in using plaster so that your work will be neat and accurate. Good craftsmanship will reward you with better molds and better pieces of sculpture.

7 Materials

So far we have not said much about clay except to list some of its rules and tell how to buy it. However, sculptors like to know a little more about their materials. There are times when it is necessary to change the characteristics of a clay to make it more workable or to eliminate cracking during the firing or some other defect. In that case some technical information is necessary.

Without going deeply into the chemistry of clay, the ceramic sculptor must recognize the characteristics of various types of clay and know how they can be used. He should know the difference between a clay and a clay body, and what is meant by china clay, ball clay, or common clay. He does not need all of the scientific knowledge the potter must have to produce table ware, but he should be familiar with some of the materials the potter uses — flint, feldspar, and a few others — and be able to combine these with his clay when necessary.

In this chapter we shall describe the ingredients of clay bodies and list some body recipes. The knowledge of materials is more important to the sculptor than recipes, however, for if he knows what each material contributes in a body it will be a simple matter to formulate recipes of his own.

Clay

Clay is a natural material that comes from the earth. It is formed by the decomposition of feldspathic rocks. Feldspar is composed of alumina and silica combined with potash and soda. Through a weathering process that takes many centuries, the potash and the soda are dissolved out of the feldspar, leaving alumina and silica. And that is what clay consists of — alumina and silica plus water and a number of mineral impurities.

After it has been formed, clay is often carried great distances by winds and streams and is deposited in the beds where we find it. Clay which has not been transported but has remained on the spot where it was formed is called *residual clay*. That which has been moved and deposited somewhere else is called *sedimentary clay*.

Residual clay

Residual clay is coarse and not very plastic, and so it is a difficult material to work with. It is extremely refractory, that is, it resists the action of heat. In fact, such high temperatures are needed to make residual clay mature that it would not be possible to fire articles made of it in any ordinary kiln unless some other materials were mixed with the clay to lower its firing temperature.

The big advantage of residual clay is its color, for most clays of this type fire a beautiful white. Because of its poor working qualities and its high maturing temperature, residual clay is practically never used by itself, but it is an important ingredient of porcelain and whiteware bodies. *Kaolin* and *china clay* are residual clays.

There is one type of residual clay which has better working properties than most. It comes from Edgar Lake in Florida and is called *Florida Lake Kaolin* or *Edgar Plastic Kaolin*. It has a finer grain than is usually found in residual clays and, hence, is more plastic.

Sedimentary clay

Sedimentary clay is much more plastic than residual clay, but in the course of its travels it picks up impurities and so it is darker in color. Most sedimentary clays fire buff or red.

There are many varieties of sedimentary clay. Some of them have such good working properties that they can be used just as they come from the ground. Others must be mixed with different materials to form clay bodies. The following are types of sedimentary clay most frequently used in pottery work and ceramic sculpture.

Ball clay

Ball clay is a sedimentary clay that has been transported in a stream and deposited under water. It is finer in grain than most other clays and more plastic. In its natural state it often contains organic matter and may be quite dark in color before firing, but after firing it is almost white. This makes it a valuable ingredient in white bodies, for ball clay added to kaolin will produce a material that is plastic and workable.

If you look through the catalogues of ceramic supply dealers, you will see that they sell not one type of ball clay but several. These have names such as English ball, Tennessee No. 1, Kentucky special, and so on. A ceramic engineer who makes products for industrial use must know what each of these ball clays contains so that he can specify the right one for each job. Frequently he uses two or three or more ball clays in a body. Unless you plan to do a lot of experimenting with clay bodies, one or two ball clays should suffice for your work in ceramic sculpture.

Fire clay

Fire clay is a refractory material that withstands high temperatures. It is used industrially to make such things as furnace brick and kiln linings. Its texture is coarse and it is not easy to work with, but it is a valuable ingredient in stoneware bodies.

Buff firing clays

Those natural clays that fire buff are the best for ceramic sculpture as far as working properties are concerned. They are good for modeling and they have a long firing range, from cone 02 up to cone 11 or 12. (Cones are devices for measuring kiln temperatures. The way they are used is described on page 189 and a table of cone temperatures is given on page XV. Ceramists usually think of temperatures in terms of cones and that is why we use the term here.)

Most buff firing clays will stand high fire and by themselves are satisfactory materials for stoneware. If it is ever necessary to make them mature at temperatures below cone 02, the firing range can be reduced by adding fluxes as we shall explain a little further on.

Red firing clays

The clays that fire red are the common clays, the materials used for making bricks. The red color comes from oxides of iron that have been picked up by the clay in its travels. Common clay is abundant; you can find it in every part of the country. It matures at the lowest temperature of all clays, somewhere in the neighborhood of cone 06. This makes it ideal for the sculptor who works with an electric kiln which is limited to temperatures below cone 04.

Common clays vary considerably, both in working properties and in behavior in the fire. As a rule the color of such clays is warm and pleasing, but the firing range is short. A clay that has a beautiful color at cone 06 may be seriously overfired at cone 02, with much of its beauty gone. If you work with a common clay, you will have to test it to learn its characteristics.

Bentonite

Bentonite is a clay formed by volcanic action. It is extremely plastic, about the most plastic substance known. Small percentages of bentonite added to non-plastic clays will make them plastic and workable. Bentonite has been used in bodies where the bulk of the material was not clay at all but a form of crushed granite called *ceramispar*. Because of the extreme plasticity of the bentonite, the resulting material can be worked in the same manner as clay. Bentonite is sold under the name of *volclay*.

Fluxes

If there were no limit at all to the temperature we could reach in our kilns, most of our problems in ceramics would disappear. We could use any of the residual clays and, if we fired them at high enough temperatures, could produce ware that possessed hardness, strength, and great beauty. But our kilns are limited in their temperature range, and so we must find ways of making our clay mature at temperatures within our reach. We do this by adding *fluxes*.

[120]

A flux is a substance which is added to other materials to bond them together and to make them melt at lower temperatures. Common clays contain their own fluxes; the impurities present, particularly the lime and the iron, act as fluxing agents. That is why such clays mature at temperatures of about 1850° F. or cone 06. Residual clays, however, require added fluxes.

Much of the research that has been done on clay bodies has been concerned with finding satisfactory fluxes. Within the last few years great progress has been made in this direction with the result that ceramists are now able to produce white ware bodies that have many of the qualities of high fired porcelain, yet can be fired at temperatures of cone 04 or lower. The fluxes generally used in clay bodies are feldspar, nepheline syenite, frit, glass cullet, tale, and whiting.

Feldspar

Feldspar is the material from which clay is formed. It is a natural flux. At high temperatures it is the only flux needed. Equal parts of kaolin, ball clay, feldspar, and flint blended together produce porcelain. This is the true porcelain or "hard paste" as distinguished from china or "soft paste" which contains additional fluxes added and which fires at a lower temperature.

There are many feldspars available — Godfrey spar, Eureka spar, Buckingham spar, and others. All feldspar contains alumina (Al_2O_3) and silica (SiO_2) . In addition they contain varying quantities of soda (Na_2O) and potash (K_2O) . Some feldspars contain only soda and others only potash but most contain a combination of the two. Other feldspars contain lime (CaO).

Nepheline Syenite

Nepheline syenite is a mineral mined in Canada. It belongs to the feldspar family but has a higher percentage of potash and soda and contains less silica. As a result its melting point is lower, and so it is a valuable flux for low temperature bodies. This material makes it possible to compound white bodies that mature in the same temperature range as red clays.

Body frit

Frit is a glaze that has been fired and then ground up. Its main use is as an ingredient of glazes but it is an excellent flux for clay bodies also. A special type called *body frit* is sold for this purpose.

If you want to lower the maturing point of a clay or a clay body by adding frit, make a series of tests to determine the right amount. Make a small batch with 1% of frit added, another with 2%, and so on, up to 5%. Make a test tile of each batch, mark it, then place all of the tiles in the kiln resting each one on two supports. Fire the kiln to cone 06. You will

be able to tell by examining the fired test tiles which percentage of frit is the right amount. If a tile has sagged during the firing it means too much flux was added. The highest amount the clay will take without deforming is the right amount to use. When used with white clays, body frits can produce a body that is translucent.

Glass cullet

Glass cullet or ground scrap glass can be used in place of frit as a body flux but it is not as satisfactory. Bodies with ground glass added are apt to have an abrupt end point to their firing range. The least overfiring makes the body slump completely. You will find frit more satisfactory.

Talc

Talc is one of the new things in ceramics. It is a valuable body ingredient that provides a high degree of resistance to thermal shock, and so it is used in oven wares. It is a rapid flux, producing hardness at low temperatures, and at the same time reducing shrinkage so that glazes fit better. The use of talc makes it possible to fire wares in shorter time, for talc bodies have a rapid firing cycle at temperatures between 1800° and 2200° F. Ceramists have used bodies containing up to 70° of talc without other fluxes and by this means have reduced shrinkage almost to zero.

Talc is a natural hydrous magnesium silicate $(H_2Mg_3\ (SiO_3)_4)$ but it is never found pure. Such impurities as lime, iron, alumina and sometimes potash and soda are present. These impurities affect the behavior of talc in a clay body and so the selection of the right talc is important. Good for general ceramic work is a blend of several talcs which is called C.B. 99 (C.B. stands for ceramic body), a product of the Sierra Talc Company of Los Angeles. This is available through ceramic supply dealers.

There is one drawback to talc bodies and that is their shori firing range in high temperature work. At low temperatures, however, talc actually lengthens the firing range of a body.

Whiting

Calcium oxide or lime provides fluxing action and so acts as a binder in clay bodies. It also serves to lighten the color. The ceramist obtains lime from whiting, which is calcium carbonate (CaCO₃). During the firing, the calcium changes from carbonate to oxide form.

Fillers

Another important ingredient of clay bodies is a *filler*. This is a non-plastic substance which is added to provide strength and porosity. A clay which is very plastic is apt to be extremely fine in grain and close textured. Such a clay is likely to warp during the firing and so a filler is added as a corrective.

Flint, which is practically pure silica (SiO_2) is pulverized quartz or sand. It makes the best filler for clay. Many ceramists believe that 5 or 10% of flint added to practically any clay will improve it. Flint makes a clay body less porous, reduces warping and makes glazes fit better. Since clay itself contains silica, the addition of flint serves to increase the proportion of this material and the addition of quantities above 10% will raise the maturing point of a clay.

Natural clays contain sand which serves as a filler. The more sand in a clay the less plastic it will be. This defect can be overcome either by screening out all of the sand or by adding ball clay or bentonite. In terra-cotta bodies, grog acts as a filler.

Casting slip

Dry clay broken into small pieces, thrown into a bucket of water, and allowed to slake will produce *clay slip*. Ordinary clay slip can be used for casting in simple molds but it is not good for molds of sculpture. The water content is too high and shrinkage is too great. For really satisfactory casting, the slip should be *deflocculated*. This is done by adding small quantities of an alkaline substance, *sodium silicate*, *soda ash*, or *sodium tannate* to the water. This alkaline substance, called an *electrolite*, reduces the attraction that the minute particles of clay have for each other and they stop "flocking" together; hence the name deflocculation. When this happens, less water is required to produce a slip which will pour easily, shrinkage is reduced, and there is less trouble with castings breaking in the mold. Prepared casting slips with the proper percentage of deflocculent already added can be bought from ceramic dealers.

Deflocculation

If you want to try deflocculating some of your own clay, this is the way to go about it. Put one pint of water into a large bowl or a pail, then weigh out two and one-quarter pounds of dry clay. Crush the clay so that no lumps remain, then pour all of it into the water and stir the mixture with your hand. You will find you have a thick, sticky mud. Add a few drops of sodium silicate to the mixture, continuing to stir as you do so. When you have added about a dozen drops, the mixture may suddenly change into a smooth liquid, thin enough to pour easily. If that happens you have succeeded in deflocculating the clay and have a good casting slip. Note, however, we said the clay *may* change into a liquid. There is a chance that it may not, for not all clays can be deflocculated. Try again, using a solution of soda ash and sodium silicate in water. If this does not work, use sodium silicate, soda ash, and sodium tannate. Sodium tannate is prepared by adding 10 grams of soda ash and 10 grams of tannic acid to 100 cc of boiling distilled water.

Some common clays cannot be deflocculated. If you don't succeed after a number of trys, your clay may be one that just won't work this way.

Casting slip should be allowed to age for several days before it is used. Keep it in a covered container and stir it at frequent intervals. When you are ready to cast, screen the slip through a 60 mesh sieve. Sometimes slip contains air bubbles which leave small holes in the surfaces of cast pieces. Pouring the slip slowly back and forth between two pitchers will eliminate most of this trouble.

Local materials

In your work with clay, try to find the materials which work best and cost least. Often these are local products. The cost of transporting clay is high so if you find a local clay that serves your purpose, it is better to use that than one which must be shipped across the country. Many clays can be purchased only in regions close to the place where they are mined. East Coast potters, for example, use North American fire clay while West Coast potters use Lincoln fire clay. The same is true of many varieties of buff and red firing clays. Other clays such as the ball clays of Tennessee and Kentucky have such good working properties that they are shipped all over the country and are available to ceramists in any region.

Visit any brickyard or tile plant in your neighborhood and find out what clays they use. Ceramic sculptors are often able to purchase clay economically directly from such plants.

Natural clay

If it is at all possible for you to get clay from the ground, dig some of it and use it. There is great satisfaction as well as economy in working with a material you have obtained directly from the earth itself. Natural clay is widely distributed; it can be found in all parts of our country. No two samples from different beds will be exactly alike, yet if you come upon some clay, you can test its properties and make it work for you.

The first thing you will learn about a natural clay you have dug is what it feels like. By squeezing a lump in your fingers you will be able to judge whether it is coarse or fine in texture and whether or not it contains a lot of sand. The next thing to test is its plasticity. Try rolling a piece. Can you make a cylinder one-half inch in diameter and twelve inches long? If so, your clay is fairly plastic and workable — a *long* clay. If your cylinder crumbles as you try to roll it, your clay is not very plastic. It is *short*.

It is important to find out how the clay behaves in the kiln. Make a number of small test figures and fire them to your regular kiln temperature. When they come out these test figures will tell you a number of things. First they will show the color of your clay. Then they will give you some indication of the firing range, for you will be able to tell by examining the pieces if the clay has matured at the temperature to which you fired it. Tap them. If they ring with a clear tone the clay has matured; if they give off a dull sound they are underfired.

Touch a piece with your tongue. This will tell you the degree to which the clay has become hard and dense. If your tongue sticks to the piece it is quite porous and too absorbent; if not, the piece is dense enough.

Did any change take place in the shape of the pieces? Are they warped and twisted? If they are, your clay is probably too fine in grain and not porous enough. Did a standing figure slump? If so, the clay has probably been overfired. Did some piece suffer a "blow out"? That is, did a bit of stone force a chunk out of the surface leaving a crater behind? If so, your clay needs screening.

Cleaning clay

All of the tests we have described were performed on the clay just as it came from the ground. You may be fortunate in finding clay that can be used that way. Often, however, natural clay contains stones and other impurities that will cause trouble unless the clay is cleaned.

The best way to clean a clay is to make it into slip. After the clay is dug, break it into small pieces, spread it on boards and put it out in the sun to dry thoroughly. When the clay is bone dry, pound the pieces with a mallet or a block of wood until all large lumps are broken up. It is not necessary to pulverize the clay, but see to it that no lumps bigger than a walnut remain. When it is broken up, sift the clay into a pail of water and allow it to slake for an hour or two. Use more water than clay so that the resulting slip will be fairly liquid.

When the clay has slaked, stir the slip, then pour it through a sieve. The texture of your clay will depend upon the size of mesh you use. A 20 mesh sieve (that is one with 20 meshes to the inch) will allow coarse particles to go through; a 100 mesh sieve will produce a finer clay but getting the slip through such a sieve may prove a tough job. In general, for larger work, a coarse screen (about 40 mesh) is desirable; for small pieces use a 60 mesh screen.

When the slip has been screened, allow it to settle for several hours, then carefully pour off the water from the top and empty the remaining slip into drying bowls. Allow the slip to dry until it becomes plastic clay, firm enough to be lifted out in one piece. When the clay reaches that state it is ready to be wedged and used.

Try the clay again after it has been screened. You will find it smoother now since the coarser particles of sand have been removed, and you may find it more plastic. Make another set of test figures and see how they come through the fire.

Sometimes a natural clay is greatly improved by screening, sometimes not. Occasionally potters find that after all of the sand is taken out of a clay, the material is not porous enough and so they put some of the sand back.

The method of cleaning a natural clay we have just described can be used as well for studio scraps. Keep a barrel into which broken pieces and rejects can be tossed (before they are fired, of course) and when

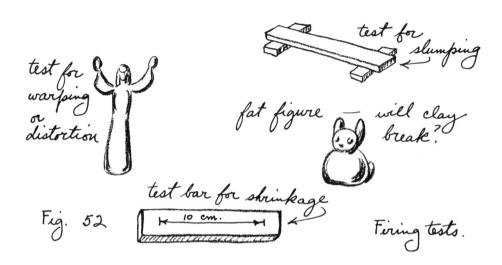

you have collected a considerable amount of scrap, put it through the same process. If you use more than one type of clay in your work, have a barrel for scraps of each kind.

Testing the properties of a clay

To test the firing properties of a clay more accurately, make a test bar 6" long, 1" wide and ½" thick, as shown in Fig. 52. Fire this in your kiln resting on two supports as shown. If the bar sags during the firing, you know that the temperature was too high for the clay. If the bar comes out of the kiln without any deformation, give it the absorption test. Weigh the bar dry, then soak it in a pan of water overnight. Take it out of the water next day, wipe off the excess moisture and weigh it again. The percentage of absorption will then be as follows:

$$\frac{\text{weight wet-weight dry}}{\text{weight dry}} \times 100 = \text{percentage of absorption}$$

If the percentage of absorption turns out to be 10% or less, your clay has matured properly. An absorption greater than 10% probably indicates under-firing.

Shrinkage

It is advisable to know the shrinkage of any clay you use. To measure this, make a test tile as shown in Fig. 52 and while the clay is still moist and plastic, draw a line on the tile exactly 10 centimeters long. Allow the tile to become bone dry and measure the line. This will tell you the amount of dry shrinkage. Next fire the tile and when it comes out of the kiln, measure the line once more. This will tell you the fired shrinkage. Since you started with a line 10 centimeters long, it will be easy to express the shrinkage as a percentage. Multiply the loss in length by ten. Thus

if the line when fired is 8.3 centimeters long, the percentage of shrinkage is $10-8.3 \times 10$ or 17%.

Changing the properties of a clay

We have spoken about testing a clay to find out its defects. Now how about remedying those defects?

Color

The color of a natural clay can be changed by a little judicious blending. If it fires too dark, adding a percentage of buff clay will lighten it. If it fires red but not red enough, a small percentage of iron oxide (1 or 2 percent) can be added. More extensive coloring of clay will be described in Chapter 8.

Plasticity

As a rule, the sculptor does not need as plastic a clay as the potter requires. The man that works on the potter's wheel seeks the most plastic clay he can obtain, but for sculpture pieces extreme plasticity is sometimes a drawback. However, clay must be plastic enough so that it is workable and does not crumble in the fingers.

Aging

Clay which stands for a long time in a wet state will gradually become more plastic. This is because of the formation of bacteria which slightly increases the acidity of the clay. Sometimes adding a small quantity of well-aged clay to a new batch will hasten the aging process. Clay that has been aging for a long time will occasionally have a bad odor, but don't be concerned about that. The odor is due to the decomposition of organic matter in clay, a process which increases plasticity. All of the things that cause the unpleasant odor burn out completely in the kiln and no harm is done.

A small quantity of vinegar added to clay will serve to increase plasticity. I have been told that the potters of France add a small quantity of molasses to make clay more workable. A surer way of increasing plasticity is to add 10% of ball clay or 1 or 2% of bentonite.

Porosity

Clay can be made more porous or "opened up" by adding 5 to 10% of flint. Porosity of a natural clay can be increased also by using a coarser mesh sieve to screen it. For large scuptural pieces, add 40-60 mesh grog.

Firing range

The maturing point of a natural clay can be lowered by adding fluxes as described earlier in this chapter. If it is ever necessary to raise the maturing point, you can do so by adding 5 to 10% of china clay.

Casting properties

It is difficult to alter the casting properties of a natural clay. Some can be deflocculated and work very well, others cannot. If you have a natural clay that you want to use for casting, it will be necessary to run a series of deflocculation experiments as described on page 123 using all three of the electrolites mentioned there.

Clay bodies

As we mentioned before, when two or more clays are blended together or when other mineral substances are added, the resultant product is called a *clay body*. As a rule clay bodies contain some clays selected for their color and others selected for their plasticity and working properties. In addition they contain fluxes and fillers.

It is a simple matter to develop a formula for a clay body if you know the qualities you want and are familiar with the materials that produce those qualities. Here, for example, is an interesting body for ceramic sculpture used by the ceramist, Pat Lopez.

Sculpture body	$cone \ 06$
Fire clay	62
Bentonite	2
Grog (40 mesh)	12
Sand	6
Glass cullet	16
Illmenite, granular	2

This body produces work with a coarse surface texture, grayish in color. Note the quantity of non-plastic ingredients, the fire clay, the grog and the sand, balanced by the bentonite which adds plasticity and makes the body workable. The glass cullet lowers the maturing point and the illmenite provides color.

Note: In all of the recipes given in this chapter, quantities refer to proportions. The gram is a good unit of measure to use in weighing out batches.

Here are some more recipes for clay bodies. *Porcelain*

Porcelain bodies are usually composed of almost equal parts of cnina clay, ball clay, flint and feldspar. Commercial producers of porcelain use more than one type of china clay and ball clay for they find that blending clays gives better results.

Porcelain body	cone 12
China clay	15
EPK (Edgar plastic kaolin)	10
Ball clay	25
Feldspar	22
Flint	28

This body may be made into a casting slip by deflocculating it as follows.

Clay body	1000
Water	400
Sodium silicate	1.5
Soda ash	1.0

Stoneware

Stoneware bodies mature at lower temperatures than porcelain, usually between cone 4 and cone 8. For this reason they must contain other fluxes besides feldspar. Stoneware bodies are rarely white but usually fire some shade of gray or brown. They often contain fire clay or grog which give surfaces a rough texture. Stoneware is a good material to use for work that is to be salt glazed.

Stoneware	cone 4 to cone 6
China clay	20
Ball clay	20
Fire clay	10
Nepheline syenite	38
40 mesh grog	12
Stoneware	cone 2 to cone 4
P.V. clay (plastic vitrox)	82
Ball clay	13
Bentonite	5

These bodies fire gray. They are suitable for large sculpture pieces.

Low-fire white bodies

The use of fluxes such as body frit and talc makes it possible to produce white bodies that mature at low temperatures, between cone 06 and 04. These are sometimes called art-ware bodies.

White body	cone 04
EPK	50
Ball clay	10
Feldspar	10
Flint	26
Cryolite	3
Bentonite	1
White talc body	cone 06
China clay	30
Ball clay	20
Talc C. B. 99	50
White talc casting body	cone 06
China clay	15
Ball clay	30
Feldspar	9
Talc C. B. 99	25
Flint	15
Frit 3195 (Ferro Enamel Co.)	6

This body deflocculated as follows:

Clay body	1000
Water	480
Sodium silicate	1.5
Soda ash	1.5
Sodium tannate	2

Terra-cotta bodies

Terra-cotta bodies are well suited to ceramic sculpture. They mature between cone 06 and 04, and usually fire some shade of red although they may also be made to fire buff or gray.

Red terra-cotta body	cone 06
Buff clay (Monmouth or Jordan)	20
Red clay (Dalton or Alberhill red)	35
40 mesh grog	30
Flint	15
Red terra-cotta talc body	cone 06
Buff clay	20
Red clay	20

Talc C. B. 99 40 mesh grog	30 30
Gray terra-cotta body	cone 06
Buff clay Tale	34 30
40 mesh grog	30
Iron chromate	6

Mixing clay bodies, blunging

When industrial manufacturers of pottery make clay bodies they weigh the ingredients dry, add enough water to form a slip, and then mix them in a machine called a *blunger*. This is a device for stirring the slip thoroughly for several hours. When it is completely mixed, the slip is screened and then, if it is intended for white ware, passed over a series of magnets to remove any particles of iron. (The tiniest speck of iron in a white body produces an ugly blemish).

The filter press

After being screened the slip is pumped through a *filter press* where water is squeezed out and the product emerges as slabs of plastic clay. If the body is to be used for casting, these slabs are allowed to dry, then crushed, made into casting slip, and deflocculated. If the ware is to be formed by pressing or jiggering, however, the slabs of clay that come from the filter press are not allowed to dry. This clay can be used just as it is, but is better to let it age for a while. It is, therefore, stored in a damp atmosphere for a period ranging from three weeks to three months. This increases plasticity and improves working quality.

Pugging and de-airing

After it has aged, the clay is put into a *pug mill* where it is mixed once more (this is equivalent to wedging). Sometimes an additional step is introduced, called *de-airing*. A vacuum pump is attached to the pug mill and as the clay is mixed, air is drawn from it. This improves the working qualities of the clay still further. After this the clay is ready for use.

Prepared clay bodies

Ceramic supply dealers sell prepared clay bodies for all purposes. You can buy bodies that are white or colored, that mature at high temperatures or low. You can even buy bodies that are translucent. Some bodies are prepared especially for modeling, already pugged and de-aired, while others are made for casting. Prepared casting slips can be bought

in liquid form or dry. Terra-cotta bodies with grog added can be purchased also. In fact the dealers have provided so well for all of the ceramic sculptor's needs that it is not necessary to do any body preparation of your own.

Preparing your own

There is a great feeling of satisfaction in using clay that you have prepared yourself. I have never known a ceramic sculptor who did not get a special thrill out of working with a clay body made by himself or a clay that he had dug from the ground. And if the clay had not only been dug, but had been tested and analyzed and made into a better substance because of the sculptor's experimentation, the thrill was that much greater.

When you make a clay body, weigh the ingredients and mix them dry, then sift them into a container of water. The job will be easier if you use warm water and add a little vinegar, about two tablespoons to a gallon. This will help the plasticity of the clay and also will make the work kinder to your hands. (Don't use vinegar when you are preparing casting slip; it upsets the deflocculation.)

Allow the clay to slake, then stir the slip and screen it. After that pour it into drying bowls and allow it to dry until it is ready for wedging.

You don't need a great deal of equipment to experiment with clay bodies. A mechanical blunger is not necessary. All you require is a scale, a sieve of 60 mesh, and a few pails and drying bats. You will need about a dozen of the minerals mentioned earlier in this chapter. Your supplies should include china clay, ball clay, feldspar, flint, whiting, and talc. If you wish to make your own casting slip, you will need small quantities of sodium silicate and soda ash. These minerals are not costly and small quantities will go a long way. If you have these materials at your disposal, you can do a lot of experimentation with clay and you will be able to know the joy of preparing and working with a material which is all your own.

8 Color

S HOULD SCULPTURE BE COLORED? There is little agreement on the answer to this question. We know that the sculptors of ancient Greece put color on their work, sometimes trying for realism and at other times using color merely for its decorative quality. They painted their terracotta figurines and their marble statues, they even put paint on their bronzes, but time and the elements have conspired to remove most of the pigments they used. Except for some small terra cottas, what remains to us of Greek sculpture shows the natural color of the material of which it is made. Modern taste prefers sculpture in the nature color of stone or bronze.

But ceramic sculpture is another matter. Clay itself is rich in color, offering a wide range of tones, and these in turn vary with the nature and the intensity of the fire. Glaze is a natural ally of terra cota for it too is a product of earth and fire; the use of glaze on ceramic sculpture is therefore right. And there are other ways of using color on ceramics. Pigments can be added to clay before it is fired, or applied to the surfaces of pieces after they come out of the kiln; colors can be mixed with slip and brushed or sprayed over unfired clay as engobe. When it is employed with understanding and restraint, color can do a great deal to enhance the beauty of ceramic sculpture.

Color in Clay

The natural color of clay

Make use of the natural color of your clay when you are able to do so. Many pieces of ceramic sculpture, especially figures, are best when they are not glazed at all, and others are good when some parts are glazed and other parts are left bare. Even when an entire piece is glazed, satisfactory results can be obtained by using a transparent glaze on portions of the figure so that the natural color of the clay shows through. Buff firing clay, for example, gives a good approximation of flesh color when it is under a transparent glaze and the fired color of red clay is usually warm and pleasing — just right for some types of terra-cotta work.

Tiny Figures Made in France (Shown Full Size)

Ceramic animals, Whistles and Banks. Mexico.

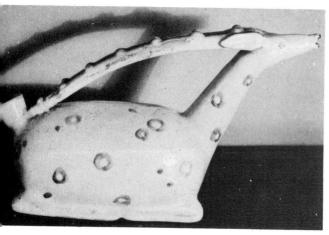

Deer decanter. Maxim Goldsheider. Courtesy Kagan and Dreyfuss.

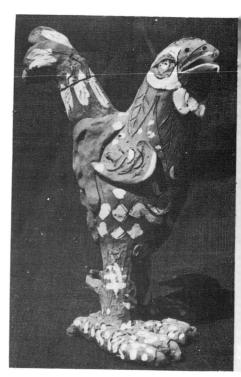

Ceramic bottle, Student work, University of Southern California.

Effect of the fire on color

The color of clay is affected by temperature. This is especially true of red clay; the higher the kiln is fired, the darker it becomes. Clay that is a pale salmon color at cone 08 will be a deep red at cone 04, and at cone 01 will become blackish brown. Even when the kiln temperature is carefully controlled there will be differences in the shades of red produced; no two pieces made of the same red clay come out of the kiln exactly alike. In fact, portions of the same piece may vary slightly in tone because the kiln chamber is hotter in some parts than in others. Such variations in color are not a drawback, however. On the contrary, they give terra cotta a live and natural quality too often lost when pieces are covered with flat uniform color.

Effect of reduction on color

There is another way in which the fire affects the color of clay. If a piece made of red clay is fired in a gas kiln with the dampers closed and a yellow flame so that the kiln chamber is filled with smoke, the piece will come out black. This change is caused by the free carbon in the kiln which brings about *reduction*.

The potters of ancient Egypt produced some interesting effects by reduction. When they fired vessels made of red clay they used to bury the pieces partly in sand and then pile wooden chips around the exposed portions. As a result, the bottoms of the pots would be red while the tops which had been subjected to the reducing action of the carbon from the wooden chips would be black. This "black top" ware was apparently

quite popular with the Egyptians for they made a lot of it.

Many primitive potters fire their ware in reducing fires and manage to achieve good results. They don't use reduction by choice but from necessity. Since their kilns are often mere holes in the ground with bonfires built around and over the ware, a reducing fire is the only kind they can get. Ceramic sculptors, however, usually try to avoid reduction. Red clay loses much of its beauty in a reducing fire and most low temperature glazes, especially those containing lead, are ruined. Buff clay, on the other hand, and some types of stoneware clays are improved by reduction. Clay which is pale and lacking in warmth when fired in a non-reducing or oxidizing fire turns a rich silvery gray when it is reduced. The way of bringing about controlled reduction to produce such effects is described in Chapter 9.

Blending clays

Some sculptors who work in unglazed terra cotta, particularly those who make portraits, prefer a color lighter than that of red clay but darker and richer than the color of buff. They obtain this result by mixing the two. If you have a red clay which fires to a color too dark for your taste or if you are interested in experimenting with the blending of clays for

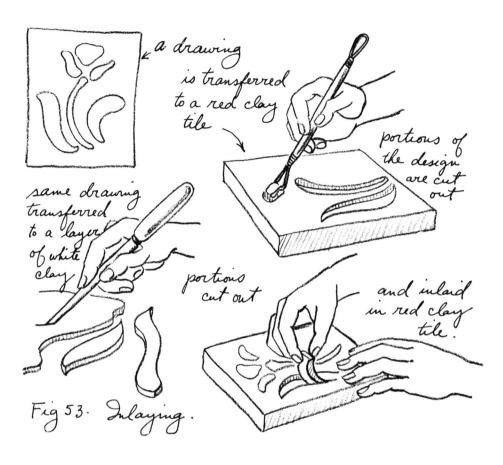

color, make a number of small test pieces composed of varying proportions of red clay and buff. Mark these, then fire them in your kiln and examine the results. You may find a blend which is better suited to the kind of work you plan to do than either red or buff clay by itself.

Agate ware

If clays of two colors are mixed together but not blended thoroughly, the pieces produced will show irregular striations of the two colors. Work made this way is called *agate ware*.

Clays of different colors

Clays of two or more colors can be used together for decorative effects. One method is to inlay one clay in another as shown in Fig. 53. A piece of red clay is rolled into a layer and a square tile is cut from it. A design is traced on the surface of the tile and cut out with a wire loop tool. The portion of clay cut out is then replaced with a white or a buff clay and the surface of the tile is made smooth.

The device of inlaying one clay in another to secure color in sculpture is used in making the portrait of the cat shown in Photo Series 7 on page 49.

Adding color to clay

The natural color of clay can be changed by adding metal oxides before the clay is fired. The process is not recommended for large pieces of sculpture because the cost is high, but for small pieces the method has possibilities.

Three percent of red oxide of iron will turn a buff firing clay into a red firing clay. Magnetite, or black oxide of iron, will make a buff clay

blackish gray when added in quantities up to 5%.

Five percent of copper oxide added to a buff clay produces an interesting grayish green that is especially good under a transparent glaze.

Eight percent of iron chromate makes a buff firing clay a good warm

gray.

Manganese oxide added to buff clay in quantities of 5 to 8% gives a gray brown. Ten percent of manganese oxide plus 5% of black iron oxide will produce a dark brown verging on black.

Cobalt added to clay makes it blue and chromium produces green. Mixed with a white clay body these oxides will produce the colors used by Josiah Wedgwood in his Jaspar ware. Used with buff clay, the oxides are not so effective.

When adding metal oxides to clay, weigh the quantities and mix them dry, then make the clay into slip. Stir the slip thoroughly to insure even distribution of the color, then dry it in a plaster bowl until it is right for wedging.

Body stains

Stains for coloring clay bodies are sold by dealers in a variety of colors. These body stains are less expensive than the metal oxides. They are added to clays in percentages ranging from 3% to 10%.

Painters' pigments

Some of the pigments used by house painters can be added to clay to give it color. Not all these pigments work. The blues and the greens disappear in the fire, but the earth colors — raw sienna, burnt sienna, umber, and ochre — are stable. I have used burnt sienna and have obtained a rich red brown by the addition of 5% to a buff clay. Burnt sienna is better to use than raw sienna because it has greater strength for less volume. (Actually, burnt sienna is about 60% clay anyway.) The big advantage of painters' pigments is the low cost.

Grog

We have spoken about the use of grog to make clay more porous. It can be used for color as well. Red grog added to a buff clay gives an interesting surface that is well suited to certain types of sculpture. Fusible grog that melts during the firing sometimes gives additional interest to the work. This effect is obtained when red grog made of a low firing clay is used in pieces fired to stoneware temperatures.

Engobe

When colored clay slip is used to decorate an object made of clay of a contrasting color, the slip used that way is called *engobe*. Engobe may be a natural clay slip, for example red clay slip used on a piece made of buff clay, or Barnard clay slip, which fires black, used on a piece made of red clay. More often, however, engobes have colors added.

Even though you were to use the lowest priced colorants, adding color to a large mass of clay would be expensive. A more economical way of achieving a similar result is to add the pigments to liquid clay slip, and use this to color the surface of a piece of sculpture.

Colored engobe can be made by adding metal oxides or body stains to any clay, but the color of the clay itself will affect the color of the engobe. Thus it would be impossible to add anything to a red firing clay in order to achieve an engobe that fired bright green. In other words pigments can be added to clay to make it fire some darker shade than it would ordinarily. Terra cotta can often be decorated effectively with engobes made by adding pigments to a slip made from the same clay as that used in modeling the piece.

To obtain bright colors in an engobe, it is necessary to add pigment to an engobe which fires white. Here is a recipe for such an engobe.

Engobe No. 1 for use on wet class	Engobe	No.	1	for	use	on	wet	clar
-----------------------------------	--------	-----	---	-----	-----	----	-----	------

China clay	25
Ball clay	20
Whiting	2
Feldspar	17
Flint	30
Magnesium carbonate	6

Add for color:

Blue – Co	balt	oxide	1
Dark blue	e — (Cobalt oxide	3
Blue green		(Copper oxide	2
_		Colbalt oxide	1
Green		Copper oxide	3
Yellow	_	Antimony oxide	3
Red		Pink oxide	10
Purple	_	(Cobalt oxide	1
rarpic		Pink oxide	5
Brown	_	Iron oxide	8
		(Manganese carbonate	7
Black	_		2
		Copper oxide Cobalt oxide	3
		`	

Caution: This engobe shrinks as it dries. When it is put on a piece of clay, therefore, the clay must be moist so that the engobe and the clay will both shrink the same amount while drying. If the clay is too dry, the engobe will shrink more than the clay. This will cause the engobe to fall off the piece.

An engobe for use on dry clay

Putting engobe on dry clay is a much easier job than putting it on clay that is moist and plastic. To make it stick, however, the formula of the engobe must be corrected so that shrinkage from the moist to the dry state is greatly reduced. This can be done by increasing the silica and adding fluxing agents. The following recipe is for an engobe that can be used on bone dry clay or even on clay which has been fired. It cannot be used on moist clay.

Engobe No. 2 for dry clay or bisque

China clay	20
Ball clay	20
Borax	5
Whiting	5
Nepheline syenite	10
Feldspar	15
Flint	25
Add for $color$ — same as Engobe No. 1	

Applying engobe

Engobes can be applied to clay in a number of ways. The simplest is to use a soft brush and paint it on. When engobe is covered with a transparent glaze, the glaze dissolves some of the clay that forms the engobe and sometimes makes a thin application of engobe disappear completely. If you paint engobe on with a brush, make sure to put it on thick enough. Small pieces may be dipped in engobe. There is danger with both of these methods, however, that the coating of engobe may destroy some of the detail of the modeling. More satisfactory results are obtained when engobe is sprayed. Any of the equipment described in the section on spraying glazes (page 177) can be used for engobe as well.

Stencils

When engobe is sprayed, decorative effects can be obtained by using stencils cut out of cardboard as shown in Fig. 54.

Slip trailing

Engobe can be applied to clay by using some type of tube through which the engobe can flow, and trailing a design with it. This method was popular with the Pennsylvania Dutch potters who used it to decorate

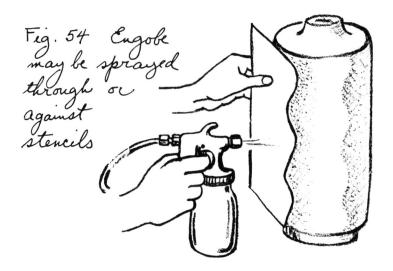

their gay pie plates. It can be used for decorations on sculpture as well. Various tools are used for slip trailing — goose quills attached to pottery cups, rubber syringes, and others. The best, in my opinion, is a glass tube narrowed at one end. The steps in making such a tube are shown in Fig. 55. Buy a piece of glass tubing, ½ inch in diameter, about eighteen inches long. This can be obtained from a chemical supply house or from your local drug store. Grasp the tube at both ends and hold it in the flame of a Bunsen burner or a gas stove so that a portion near one end is heated. Rotate the tube in the flame to heat all sides evenly.

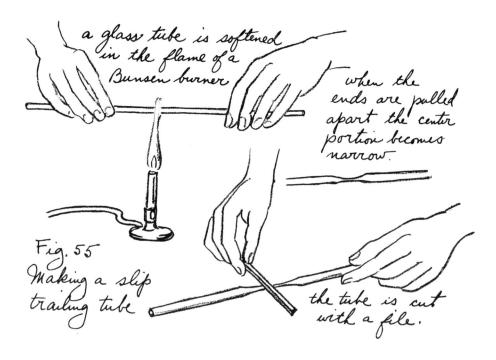

When the glass becomes soft (it will begin to look red at this point) remove the tube from the flame and pull the two ends apart, increasing the length of the tube about two or three inches. This will make the soft portion become narrower. Allow the tube to cool, then break it at the narrow portion; a scratch with a file will help to get a clean break. Put the broken end in the flame for a moment — just long enough to make the rough edge smooth — and the tube is ready for use.

Using the slip tube

The method of using the slip trailing tube is shown in the next series of photos. The tube is filled by suction, and when it is filled, a finger placed over the opening at the large end keeps the slip from running out. When the finger is removed, the slip starts to flow. Regulate the speed of flow by changing the position of the tube. When the tube is horizontal the slip won't move, but as the tube is tipped up the slip will run out. The nearer the tube approaches a vertical position the faster the slip will flow. It takes a little practice to acquire skill with this tool but once you have mastered it you will find it valuable for many types of decorating. You can even use it for building up sculptural reliefs.

Painting engobe in molds

If a design is painted with engobe on the inside surface of a drain mold and slip is then poured into the mold before the engobe has dried, the casting will contain the engobe design embedded in the piece.

This method works with press molds as well and so it is a good way to decorate tiles. The design may be painted in the mold with a brush or a slip trailing tube can be used. Here are the steps.

PHOTO SERIES 24

A mold for a square tile without sculptural ornament is used. A design is made with a slip trailing tube.

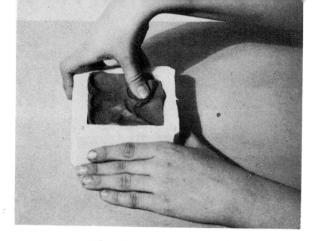

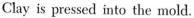

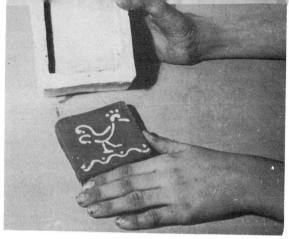

The tile removed from the mold. The design forms an inlay.

A mold for a tile that has sculptural decoration like the cow tile shown on page 85 can have engobes of different colors painted into the various portions of the design. Clay pressed into the mold will pick up all of the engobe and come out of the mold a tile in full color.

A piece can be cast in a solid color if colored engobe is poured into the mold and allowed to stand for a few minutes. After this, the engobe is poured out of the mold and regular casting slip is poured in. The casting when it comes out of the mold will show the color of the engobe.

Sgraffito

When a coating of engobe is put over a piece of clay, a design may be cut or scratched in the engobe so that the color of the clay underneath shows through. This method of decoration, called *sgraffito*, is illustrated in Photo Series 35 on page 242.

Sgraffito designs may be made while the engobe is wet, after it has become leather hard, or when it is bone dry. The quality of line obtained will be different in each case. The tool used to cut or scratch the design will affect the quality of line also.

The choice of tool is important. It may be a pen, a wire loop, a wooden modeling tool or a knife. Try out various tools until you find one that you can use with single clean strokes, and that will produce the type of line you want. It may be that you can make your own tool by cutting the end of a piece of wood to just the right shape.

Effective use can be made of sgraffito on pieces of ceramic sculpture by applying a coat of engobe to the entire piece, either by brushing it on or spraying, then cutting away the engobe from some parts of the work so that the engobe is left in areas planned to produce a dark and light pattern. The sketches in Fig. 56 illustrate this method.

Sgraffito work is usually covered with a transparent glaze and fired. In some cases, however, the sgraffito is fired without being glazed. This is often done with large lamp bases and other pieces of decorative sculpture where a rough surface is desired.

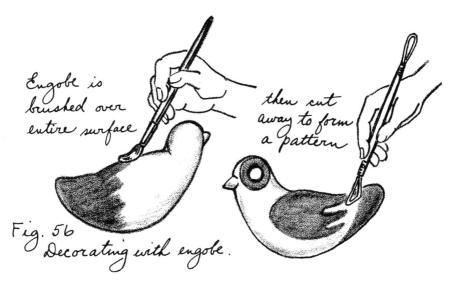

Wax resist

Ceramic sculpture can be decorated by a method called wax resist, shown in Fig. 57. This consists of painting a design on the unfired clay with liquid paraffin, then putting colored engobe on the piece. Wax repels the engobe so that those areas where the paraffin has been painted show the color of the clay underneath. The paraffin burns out and disappears completely during the firing.

This method used to be a troublesome one. The paraffin had to be boiling hot and it was difficult to handle, for it started to cool as soon as it touched the surface of the piece. In addition the brush used to apply the paraffin had a short life for whenever it was dipped a trifle too far into

the hot liquid paraffin, the hairs would loosen and fall out.

A new product developed by the Socony Vacuum Oil Company has

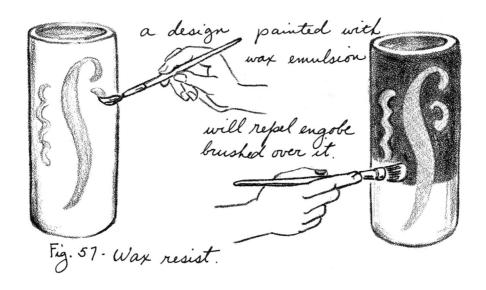

removed these difficulties. The product is *ceremul A*, a liquid emulsion of paraffin which can be applied like tempera paint without heating. Brush it on unfired clay, allow it to dry for a few minutes, then put engobe on the piece. The engobe may be painted on or sprayed, or the piece may be dipped in engobe. In any case, the wax prevents the engobe from adhering to those areas covered with paraffin. If the brush is cleaned immediately after it is used, the paraffin can be removed merely by rinsing in water. Don't let the emulsion harden in the brush, for if that happens it must be cleaned with benzine.

Wax resist permits a bold, free brush technique. Work with single strokes, using brushes of different sizes for thick and thin lines. After the paraffin has dried, sgraffito decorations can be made by cutting designs in the paraffin with a pointed tool. The engobe will stick where the paraffin is scratched away.

Decoration of this type is most effective when the engobes are of natural clay color. Try a red clay slip on buff clay or try a slip made of Barnard clay (also called "blackbird") on a red clay body, or use a slip made of the same clay as the piece itself with some earth colors added — sienna, umber or ochre.

Glass-forming engobes

An engobe is clay and when it is fired, it has the dull surface of a piece of bisqued ware. If we are seeking a glossy surface, an engobe must have a glaze over it. Ceramists sometimes try a short cut by making engobes that are glossy when fired and so need not be covered with glaze. These are called *glass-forming engobes*.

To tell what we mean by the term glass-forming engobe, we shall have to talk briefly about the principles of glazing. If we prepare colored engobe according to the formula given on page 138 and put it on a piece of clay and fire it to cone 04, when it comes out of the kiln the surface will have the color we want but it will be rough and dull. If, however, we overfire the piece, say up to cone 10 or 12, the engobe will melt in the kiln and when we take it out, its surface will be bright and glossy, very much like the surface of a glaze. If we like this effect but don't have a kiln able to fire high enough to achieve it, we can obtain the same result by adding fluxes to the engobe formula. Fluxes lower the melting point of the material and if we add enough flux, we will make our engobe melt and start to flow at cone 04 so that instead of having the dull rough surface, our engobe will come out of the kiln with a gloss. Suppose we were to add too much flux? In that case we would produce something that would actually be a glaze. In other words what we call glass-forming engobes can really be considered a mid-step between engobes and glazes.

Glass-forming engobes, like regular engobes, can be bought already prepared from dealers. If you wish to make your own, however, here are some recipes.

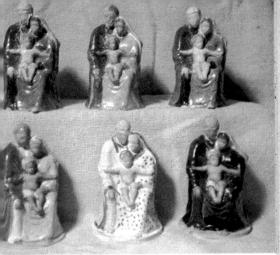

Color Plate 9 Glaze tests for the Holy Family group.

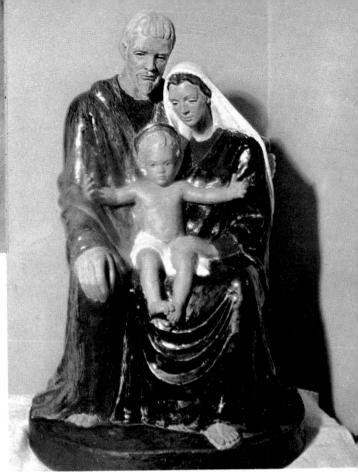

COLOR PLATE 8 The Holy Family by Eleanor Gale. Transparent glaze used on hands and faces; remaining portions majolica.

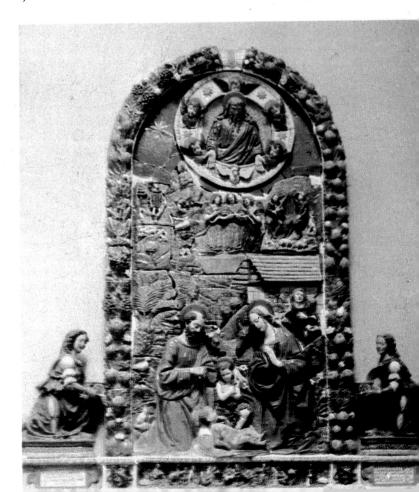

COLOR PLATE 10 Ceramic altar piece by Giovanni della Robbia, Florence.
A ceramic composition made and fired in sections.

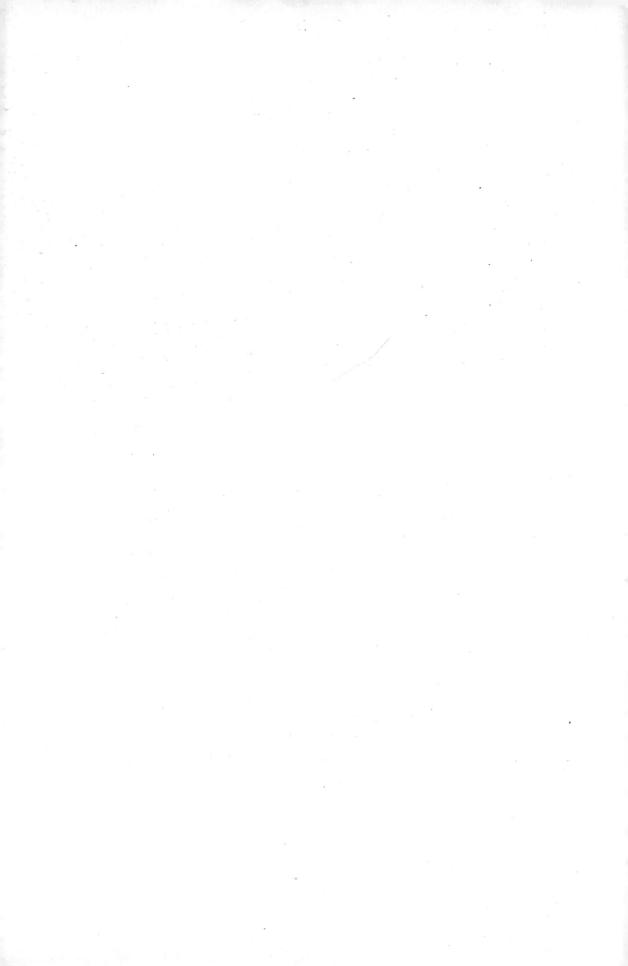

Engobe No. 3 - glass-forming engobe

White lead		45
Whiting		8
Feldspar		10
China clay	w.	8
Flint		19
Tin.oxide		10

Engobe No. 4 - glass-forming engobe

Ferro-Enamel Frit 3304*		4	45
China clay]	12
Ball clay			10
Whiting			3
Feldspar			8
Flint			12
Tin oxide]	10
Add for $color$ — same as Engobe	No.	1	

These two engobes must be used on clay that is bone dry or on bisque. They can be used effectively on work where parts of the piece are to be colored and the rest left unglazed. It is not necessary to use glazes over these engobes.

Terra sigillata

Terra sigillata is a special type of engobe formed by extremely fine colloidal particles of clay. To make terra sigillata, take 1000 grams of common clay, add 1000 grams of water, and grind the mixture in a ball mill for 24 hours. Remove the slip from the ball mill, put it in a tall glass container and add water until the specific gravity of the mixture is exactly 1.2 as measured with a hydrometer. Add 20 grams of sodium hydroxide, stir the slip thoroughly and then let it stand for another 24 hours. At the end of this time you will find that the clay is at the bottom of the container with an almost clear, colorless liquid above it. Siphon off this liquid into another container. This contains the fine colloidal particles of clay. Spray this on raw ware, then allow it to dry. When the piece is fired, it will come out of the kiln with a slightly shiny surface which is quite hard.

Terra sigillata is a good treatment for sculpture. The color varies, ranging from red through buff to brown. It is not possible to tell beforehand what color of terra sigillata a given clay will produce. Often it is something quite different from the color of the clay itself. Some clays don't lend themselves to terra sigillata work. It is necessary to run a series of tests to see if a clay will produce terra sigillata, and if so what its color will be.

This is a product of the Ferro-Enamel Company. Frits are described on page 153.

Defects in engobes

Sometimes engobe will come off the piece after it has been fired, a defect called *shelling* or *peeling*. This is usually caused by improper fit between the engobe and the body, although it sometimes results from firing pieces before they have had a chance to dry. To correct this defect increase the silica content of the engobe by adding flint or decrease the proportion of silica in the body by adding more plastic clay. Firing the work to a slightly lower temperature will sometimes overcome this trouble. Make sure pieces are thoroughly dry before putting them into the kiln.

If engobe peels off before it is fired it probably means that the slip is too plastic. Add flint to the engobe.

Glaze

A glaze is a glossy coating formed on a piece of clay during the firing process. Actually it is a kind of glass. Glazing is an ancient method of making clay articles more durable, more waterproof, and more attractive. The secrets of glazing were apparently discovered independently in many parts of the world. The potters of Ancient Egypt, China, Assyria, and Babylon all produced glazed ware many centuries ago.

A glaze is made by mixing clay and mineral ingredients, all of which have been ground to extremely fine powder form, and applying them to a piece of clay sculpture or pottery. The ingredients are ground together in water to form a suspension, liquid enough so that it may be brushed or sprayed, and some type of gum is added to make the mixture stick on the piece until it is put into the kiln. The piece that is glazed may be raw clay which has not yet been fired or it may be *bisque*, that is, clay which has already been through the fire. In either case, the piece with its coating of glaze must make a trip through the kiln in order that the glaze ingredients can melt and flow over the surface of the piece. If the process has been successful, when the firing is over and the article is removed from the kiln, it will be covered with a beautiful smooth hard coating of glaze.

Prepared glazes

Glazes all mixed and ready for use may be obtained from dealers in pottery supplies. The ceramic sulptor who needs only small quantities may find it convenient to buy his glazes. But there are a number of advantages in mixing your own. There is the joy of creating, the chance for experimentation, and the possibility of developing individual effects.

It would be good to have a knowledge of chemistry before starting to mix your own glazes, but it is not absolutely necessary. A thorough study of glazes involves a great deal of technical information. This subject was covered at some length in my previous book *The Complete Book of Pottery Making*. Readers who wish to know more about the chemistry of

glazes and who would like to calculate molecular formulas are referred to the chapter on glazes in that book.

Here we shall avoid theory as far as possible and shall limit ourselves to practical information about glazes for use on ceramic sculpture, telling how to mix and how to apply them, and giving recipes for glazes of various types for various uses. At the same time enough of the general principals of glazing will be covered so that you may conduct experiments, exploring the effects of different combinations of glaze ingredients and developing recipes which are all your own.

Some principles of glazing

Most glazes are made up of three essential ingredients: silica (SiO_2) , alumina (Al_2O_3) and a flux, with metallic oxides added to provide color.

Glaze is a form of glass, and glass is melted sand or silica. But sand alone would not melt in an ordinary kiln; fluxes must be added to lower its melting temperature. And silica plus a flux, while it produces a satisfactory glass, does not make a good glaze, for the product is too thin and liquid to adhere to clay. A third ingredient must be added to provide viscosity, to keep the glaze from draining off the piece during the firing process. This third ingredient is alumina.

Feldspar

We have already spoken of the mineral feldspar as an ingredient in clay bodies. It forms an important part of most glaze recipes also. It contains all three of the essential glaze ingredients, for in addition to silica and alumina, it provides soda and potash, substances that act as fluxes. There are many varieties of feldspar and it would be impossible to list here the chemical formulas of all of them. As we mentioned in the previous chapter, some feldspars contain potash (K_2O) , others contain soda (Na_2O) or lime (CaO) or various combinations of the three. Ceramic supply dealers sell a feldspar containing soda and potash that is satisfactory for use in most glaze recipes. Since feldspar contains all three of the essential glaze ingredients, it could be used as a glaze all by itself, but only at extremely high temperatures.

Clay

China clay or kaolin $(Al_2O_3 \cdot 2SiO_2)$ provides both silica and alumina in a glaze. Common clay, in addition to alumina and silica, contains impurities such as lime (CaO) and oxides of iron which act as fluxes, and so, like feldspar, it would form a glaze all by itself if fired high enough. Certain types of common clay, Albany slip and others, are actually used as glazes on other clays that have a higher maturing point.

Glaze recipes sometimes call for China clay and sometimes for ball clay. In the low temperature range a glaze will often work equally well with either. For glazes on terra-cotta sculpture fired at low temperatures the clay that forms the piece itself may be used in the glaze as well.

China clay adds whiteness to a glaze and in larger amounts causes opacity. It reduces fusibility, so an increase in this ingredient raises the temperature of a glaze. Ball clay makes a glaze plastic and easier to handle.

Clay serves another important function in a glaze recipe. When all of the ingredients are ground together in water the clay that is present makes the mixture into an engobe that is easier to apply to a piece and that holds better once it is on.

Calcined clay

Some glaze recipes call for calcined clay. This is clay which has been fired as a dry powder. You can calcine some of your china clay by putting it in an unglazed pottery container and placing it in the coolest part of your kiln when you fire.

Flint

Flint (SiO_2) is used in glaze recipes when more silica is required in addition to that furnished by the feldspar and the clay.

Fluxes

A flux is a substance that promotes the fusing of minerals. It is what makes the alumina and the silica melt and flow over the piece while it is in the kiln. The fluxes most commonly used in glazes are oxides of lead, sodium, potassium, calcium, and zinc. Also used, but not so frequently, are oxides of barium, magnesium and strontium.

The part played by fluxes in glazes is so important that glazes are usually classified according to the type of flux they contain. Thus we speak of lead glazes, leadless glazes, alkaline glazes (those that derive their fluxing action from the alkaline substances soda and potash), feld-spathic glazes, boro-silicate glazes, and so on. In the following section we shall say a word about each of these and list some recipes.

Glaze Recipes

Glaze formulas are often jealously guarded secrets. This is true not only among ceramic artists, but in industrial ceramic production as well. Don't be disappointed if glaze recipes that you obtain from various sources fail to produce the results you hope for. A formula that works well in the studio of one ceramist may not do so in another where conditions are slightly different — the kiln doesn't fire the same way, or the clay body does not have the same ingredients. Even variations in the water used to mix the glaze may affect the results.

Your best glaze recipes will not be given to you; you will work them out for yourself. That is not difficult once you have a knowledge of the materials that go into glazes and an understanding of their behavior during the firing. With that knowledge you will be able to compound glazes that are right for the sculpture you create. In the recipes that follow, therefore, we shall consider the glaze ingredients and see why they are used in each case.

Lead glazes

Low temperature glazes usually rely upon lead as a flux. The ceramist obtains lead from lead carbonate or white lead (2PbCO₃ · Pb(OH)₂). Red lead (Pb₃O₄) and litharge (PbO) can also be used but they are much more difficult to handle than white lead. In the temperature range below cone 08, lead can be used by itself.

Glaze No. 1 — low fire, transparent lead cone 012 — 08
White lead
Clay

95
5

The above is an extremely low-temperature glaze. It is soft with a slightly yellow color. It is good over red clay and so is well suited to terracotta work. China clay or ball clay may be used in this recipe or even the clay of which the piece of sculpture is made.

For a transparent colored glaze, add the following:

Blue - Cobalt carbonate 1
Dark blue - Cobalt oxide 2
Blue green - Copper oxide 3
Cobalt oxide 0.5
Green - Copper oxide 4
Gray green - Chromium oxide 1
Tan - Red iron oxide 3

Yellow — Yellow base 10 (see page 172)

Iron red — Red iron oxide 8

Red – Pink oxide 12 (this is an underglaze color)

Purple - \(\begin{aligned} \text{Cobalt carbonate 1} \\ \text{Pink oxide 8} \end{aligned} \)

Violet – Manganese carbonate 4

Gray – Nickel oxide 2

Manganese carbonate 7

Black – {Copper oxide 2 | Cobalt oxide 3

Other colors can be made by adding underglaze colors (see page 172) in quantities ranging from 1 to 10%, depending upon the strength of the

color and the depth of tone desired. The table of colorants given here can be used for many of the glaze recipes which follow.

The quantities in this recipe and in all of the glaze recipes to follow refer to proportions. A good unit of measure for weighing out glazes is the gram; if quantities in this recipe are weighed in grams the result will be a batch of 100 grams. Multiply quantities by three and you will have a 300-gram batch or a trifle more than half a pound. This will make a pint of glaze, enough to cover a piece of sculpture two feet tall or a number of smaller pieces.

Gum

A glaze needs a binder to hold it in place after it has been applied. Without this it would dust off a piece as soon as it dried. Various substances are used this way, among them molasses, gum arabic, dextrine, sodium alginate, and gum tragacanth. Ceramic supply dealers also sell prepared gums under various trade names. A good gum for all-purpose use is gum tragacanth. Buy it in powdered form and prepare it for use by mixing a teaspoonful with an ounce of alcohol. Stir till smooth, then add a cup of water and stir some more. Two or three tablespoons of this preparation will be sufficient for a pint of glaze. Gum tragacanth will spoil in a few days unless a preservative — carbolic acid or oil of cloves — is added. A better way is to mix just enough at a time and use it all up.

Gum tragacanth has a number of commercial uses. It is used in making cigars and is the main ingredient in many preparations made for the hair. I have used wave set in a glaze and have found it just as satisfactory as the gum tragacanth I mixed myself.

Another gum that is popular with ceramists is a cellulose gum called CMC. This works in the same way as gum tragacanth but it has an important advantage — it will not spoil. To prepare CMC add two tablespoons to a cup of water, allow it to soak for an hour, then stir it thoroughly (beating it with an eggbeater is good). As soon as the solution is smooth, it is ready for use.

Between cone 07 and cone 1 or 2 (the area in which most terra cotta is fired) lead is usually combined with other fluxes, especially calcium which the potter obtains from calcium carbonate, or whiting (CaCO₃).

Glaze No. 2	low fire	transparent	lead	cone	07	_	05
White le	ead			78			
Whiting				13			
China cl	ay			9			
Add for color -	– same as	Glaze No. 1					

The above glaze will stand a slightly higher temperature than glaze No. 1 but it is still limited to the low fire range.

Glaze No. 3 transparent lead	cone $05 - 02$
*(CBPM No. 1)	
White lead	45
Whiting	12
Feldspar	20
China clay	7
Flint	16
Add for $color$ — same as Glaze No. 1	

This is a better balanced glaze than Numbers 1 or 2. In addition to lead and calcium it derives fluxing action from soda and potash present in the feldspar.

Glazes 1, 2, and 3 are transparent. They can be used without colorants over a clay body which itself has an interesting color. This strengthens the color of the body and enriches it. When color is added, the result is a transparent colored glaze. Glazes of this type used over sculptural forms will flow into depressions on the surface and show darker color there. This brings the modeling more sharply into relief. Note this effect on the rooster shown on Plate VII.

The color of a transparent glaze is affected by the color of the body; the true color of the glaze is seen only over a clay that fires pure white. If you want bright colors on a body which is dark in tone you must either cover the body with white engobe before applying the glaze or else use a glaze that is opaque.

Tin enamel or majolica glazes

To make a glaze opaque it is necessary to add a substance that is white and that does not dissolve, but remains in suspension in the glaze melt. A number of minerals will do this. The one most commonly used in low temperature glazes is tin oxide (SnO_2) . Ten percent of this added to a recipe produces a glaze that is white, with an opalescent, pearly appearance. Colorants may be added in the same proportions as those used for Glaze No. 1.

^{°(}Note: This glaze recipe was given in the Complete Book of Pottery Making where it was listed as recipe No. 1. Most of the recipes given here are new ones but occasionally it has been found necessary to repeat a recipe that was listed in the former book. In such cases the original number of the recipe is noted.)

Zirconium

During World War II when ceramists were unable to obtain tin, they found a substitute in zirconium. Like tin, zirconium oxide remains suspended in a glaze and makes it opaque and white. The color has less of the opalescent quality of tin glazes but is a more creamy white.

Zirconium may be purchased as zirconium oxide (ZrO_2) or zircopax $(ZrO_2 \cdot SiO_2)$. Zircopax gives best results. Zirconium is not as strong an opacifier as tin so it is necessary to use twice as much. Add 20% to a glaze recipe.

Translucent glazes

Adding opacifiers to a glaze in smaller quantities than those listed above will produce glazes with a milky translucent quality which is good over a red or a buff body.

Alkaline glazes

Low-fire glazes that do not use lead but substitute the alkaline substances soda and potash as fluxes produce better colors than lead glazes. The beautiful turquoise blue developed by the Egyptians comes from copper in an alkaline glaze. This color can be obtained in no other way, for copper in a lead glaze produces a harsh grassy green.

Potash can be obtained by the ceramist from pearl ash (K_2CO_3) or potassium bichromate $(K_2Cr_2O_7)$. Soda is obtained from soda ash $(NaCO_3)$, sodium nitrate $(NaNO_3)$ sodium bicarbonate $(NaHCO_3)$ and borax $(Na_2O \cdot 2B_2O_3 \cdot 10 \; H_2O)$, which in addition to soda contains oxide of boron. Soda ash and borax are the materials most commonly used. All of these substances are soluble and so their use in glazes presents problems. The ingredients must be weighed out and ground with just the right amount of water since no excess of water can be poured off as is the case with lead glazes. It is advisable to mix glazes of this type and apply them to the piece immediately; they cannot be stored any length of time. When an alkaline glaze is applied to clay, some of the liquid is absorbed into the body of the ware, and so results are uncertain. In general, the use of raw alkaline glazes is not recommended, but if you wish to try a glaze of this type, here are some recipes.

Glaze No. 4 Raw alkaline	cone $07 - 04$
Soda ash	28
Whiting	10
Feldspar	50
Flint	12

This recipe contains no clay; the alumina and the silica are supplied by the feldspar and the flint.

Glaze No. 5 Raw alkaline	cone $05 - 03$
Borax	32
Soda ash	16
Whiting	7
Feldspar	20
China clay	5
Flint	20

The above glazes are transparent. Colors may be added in the same proportions as those used with Glaze No. 1. One of the main reasons for using alkaline glazes is to produce various shades of turquoise blue. For these, add the following:

For Egyptian blue	_	Copper oxide	2
For Persian blue	_	(Copper oxide)Cobalt oxide	3 0.5

Turquoise shows its true brilliance only over a white body or a white engobe.

Alkaline majolica

Opacifiers may be added to alkaline glazes so that brilliant colors can be obtained over red or buff bodies. To the above glazes add 10% of tin oxide or 20% of zircopax. Copper used with these glazes will not produce a true turquoise, as the opacifiers change the color to a pale blue.

Lead alkaline glazes

Good results can be obtained with glazes that use both lead and alkaline fluxes. The colors are not as bright as those produced by leadless glazes but they are better than the colors of straight lead glazes.

Glaze No. 6	Lead alkaline	cone $07 - 04$
White le	30	
Whiting	3	
Borax	23	
Feldspar	18	
China cl	ay	8
Flint		18

Frit

The big drawback to raw alkaline glazes is that the fluxing agents are soluble in water. This can be overcome by using *frit*. Frit is a glaze that has been fired and then ground. When this is done, the water soluble ingredients become insoluble. But this is not the only advantage of using a frit. Many of the things that go into glazes contain materials such as

carbon or organic substances which must be burned out during the firing. These things can cause trouble when they leave a glaze. In a frit, they have already been burned out, so one source of trouble is eliminated.

Formerly the ceramic artist had to make his own frits, a long and difficult business involving the use of a special frit kiln. Now, however, commercial frits can be purchased ready prepared and ground. The behavior of a frit depends upon what is in it. Some frits contain lead while others are leadless. Some are made for low temperatures, others for high fire work. Formerly frits supplied only a portion of the ingredients of a glaze, requiring the addition of other materials to produce a satisfactory glaze. Now many commercial frits contain all of the necessary glaze ingredients so they can be used without the addition of anything else except 10% of china clay or ball clay. The clay adds a small quantity of silica and alumina and at the same time makes the glaze into a slip so that it is easier to apply to ware.

I have used frits made by the Ferro-Enamel Company of Cleveland, Ohio, who have been pioneers in the production of commercial frits and have found them highly satisfactory. Frits are made by a number of other companies as well. As far as possible, know the ingredients of the frits you use. In selecting a frit, consult the catalogues of the dealers and choose one that suits your temperature range and that contains the right ingredients for your work.

Glaze	No. 7	Transparent lead frit co	ne 07 to 04	Į.
	Ferro-Ena Ball clay	amel Frit 3304 (high lead co	,	90 10
Glaze	No. 8 Ferro-Ena Ball clay Tin oxide	White majolica lead frit amel Frit 3304	cone 07 to 82 9	04
Glaze	No. 9	Transparent leadless frit	cone 07 to	04
	Ferro-Ena Ball clay	mel Frit 3195 (leadless)	90 10	
Glaze	No. 10	Leadless white majolica	cone 07 to	04
	Ferro-Ena Ball clay Tin oxide	amel Frit 3195	82 9 9	

Colorants may be added to the above in the same proportions as those listed for Glaze No. 1.

Glaze	No.	11	Translucent	lead	frit	cone 07 to 04
	Hon	nmel	Frit 2117			95
	Ball	clay				5

This is a good glaze for sculpture. Its slightly milky quality is particularly effective on modeled surfaces. It can be used with the colorants given for Glaze No. 1 and also is good used with underglaze colors.

A word of caution: Fritted glazes will settle to the bottom of a container forming a tough mass that is difficult to stir. To prevent this, add a teaspoonful of epsom salts to the batch.

Powdered glass

Glass cullet or powdered scrap glass can be used as a glaze ingredient. Actually ground glass is a type of frit. My recommendation would be to avoid using this material, relying instead upon the commercially prepared frits mentioned above. Since glass cullet is made of scrap glass, the ingredients are not absolutely constant and you may find that two batches of the material do not behave in the same way. However, if you wish to try it, here is a recipe.

Glaze No. 12 Tarnsparent	glaze using glass cullet	cone 07 to 04
Glass cullet	58	
Whiting	28	
China clay	14	

Leadless glazes

We have seen that it is possible to make glazes without lead by using the alkaline fluxes, soda, potash and borax, either in raw form or in frits. But there are other ways of avoiding the use of lead. Mother Nature has produced a natural frit in which calcium has been combined with boron to produce a mineral called calcium borate or colemanite (2CaO \cdot 3B₂O₃ \cdot 5H₂O). This produces a good low temperature glaze when combined with zince oxide (ZnO) and barium carbonate (Ba₂CO₃).

Glaze	No. 13	Borosilicate	or	Colemanite		cone	06	to	04
	Colemanit	e			30				
	Feldspar				45				
	Zinc oxide				5				
	Barium ca	rbonate			6				
	China clay	7			4				
	Flint				10				

Colors may be added to this glaze in the same proportions as those listed for Glaze No. 1. Since this is a leadless glaze, it will produce a beautiful turquoise blue with the addition of 1.5% to 3% of copper oxide.

Volcanic ash

The heat of volcanic action in ages long passed fused feldspar and quartz together in much the same way as they are melted today in a frit kiln, so that in *pumicite*, or *volcanic ash*, we find another natural frit. This is mined in the form of minute shards of rock glass.

At the University of Kansas, studies have been made of volcanic ash from all of the known deposits in the state. It was found that the material has properties which make it valuable to the ceramist. The chemical content of ash from different beds varies somewhat but not as much as might be expected. In general, Kansas volcanic ash contains about 70% of silica (SiO₂), 12% of alumina (Al₂O₃), 8% of potash (K₂O), 2% of soda (Na₂O), 1% of iron oxide (Fe₂O₃), with smaller amounts of lime (CaO) and rutile (TiO₂). In other words, it is a lot like feldspar except that the proportion of silica is higher. In ceramic glazes 100 parts by weight of ceramic ash can generally be substituted for 70 parts of feldspar and 30 parts of silica.

Here are some glaze recipes using volcanic ash which were developed in the University of Kansas research laboratories.

Glaze No. 14	Volcanic ash	cone 02 to 8
Volcanic	67	
Colemani	28	
Bentonite)	5

The above glaze is transparent with a light grayish-green color caused by the iron present in the volcanic ash. Adding 5% of whiting improves the transparency. The glaze can be made opaque by the addition of 5% to 10% of zircopax.

Variations can be made in the proportions of volcanic ash and colemanite. Good results have been obtained by using equal parts of each.

Glaze No. 15 Volcanic ash	cone 02 to 8					
Volcanic ash						
Colemanite	47.5					
Bentonite	5					

If borax is substituted for colemanite the result is a glaze that matures at a slightly lower temperature but still has a long firing range.

Glaze No. 16	Raw borax	volcanic	ash	cone 04	to 4
Volcanic a	ash			67	
Raw bora	X			28	
Bentonite				5	

Lead can be used with volcanic ash in glazes.

Glaze No. 17 Raw lead volcanic	ash cone 07 to 04	Ł
White lead	35	
Zinc oxide	1	
Volcanic ash	52	
Whiting	8	
China clay	4	

Volcanic ash glazes are particularly effective on sculpture made of clay that fires to some dark color. Other advantages of the material are its low cost and the fact that it gives glazes a long firing range. It is a newcomer among ceramic materials and is not in general use as yet, but a number of commercial potteries have adopted it and it is used in many schools. It can be obtained through some of the dealers in ceramic supplies.

Bristol glazes

Above cone 2 we enter a temperature range where lead is no longer needed as a flux. At cone 7 lead becomes useless in a glaze for it volitalizes and disappears. Between cone 4 and cone 8 the ceramist gets fluxing action from calcium in the form of whiting $(CaCO_3)$, zinc oxide (ZnO), and magnesium obtained from magnesite $(MgCO_3)$ or from dolomite $(CaCO_3 \cdot MgCO_3)$.

Glazes using these fluxes are called *Bristol glazes*. Because of their higher temperature they cannot be used on red firing common clays. They can be used on buff firing clay as well as on stoneware bodies.

Glaze No. 18 Zinc oxide Whiting Feldspar China clay Flint	cone 4 to cone 7 10 68 8 7	8
Glaze No. 19 Zinc oxide Dolomite Feldspar China clay Flint	using dolomite 6 10 67 8 9	cone 4 to cone 8

Lead borosilicate fritted glaze

Ferro-Enamel Frit #3496 is a lead borosilicate and a good all-purpose frit for studio use.

Glaze	No. 20	Lead	borosilicate	fritted	glaze	cone 07 to 04
	Ferro-Enam	el Frit	#3496		90	
	Ball clay				10	

This glaze can be made into opaque white majolica by the addition of 10% of tin oxide or 20% of zircopax. Colorants may be added in the same proportions as those listed for Glaze No. 1.

Mat glazes

The sculptor's problem in selecting glazes is different from that of the potter. The latter is often interested in bright colors and in the accidental effects that occur when two or more glazes run together, but such things would destroy the beauty of sculpture. The sculptor must find glazes that enrich and beautify his work without destroying form. Glazes must not produce a coating so thick that delicate details of modeling disappear, and colors must not be strong enough to detract from the line and the rhythm of his work. He must beware, too, of high gloss, for on modeled surfaces a profusion of highlights becomes confusing. For that reason glazes with a mat or a semi-mat surface are good to use.

Glazes can be given a mat texture in a number of ways, by underfiring, by increasing the alumina content, by adding barium carbonate or zinc oxide or rutile. An opaque glaze of the majolica type becomes mat when the proportion of opacifier is increased. Here are some recipes for mat glazes.

Glaze	No.	21	Alumina	mat	cone	06 –	04		
	Whit Feld	spar a clay					46 11 20 16 7		
Glaze	No.	22	Alumina	coleman	nite ma	ıt	cone	06 –	- 04
	White Cole: Feld:	manite spar a clay					34 15 10 9 4 17		

The above glaze gives especially good results when used on sculpture.

Glaze No. 23 Ba	rium, zinc mat	cone 06 - 04
White lead		38
Whiting		5
Feldspar		19
Barium carbo	nate	13
Zinc oxide		3
China clay		7
Flint		15
Glaze No. 24 W	hite majolica mat	cone $07 - 05$
Frit 3304		70
Ball clay		7
Tin oxide		23

Be careful not to overfire a mat glaze, for that makes it lose its mat surface and become glossy.

Rutile

The mineral *rutile* which is composed of titanium oxide (TiO₂) plus various impurities, among them iron oxide, has a way of forming crystals in a glaze that produces some interesting results on ceramic sculpture. Quantities of rutile, from 5% to 8%, added to a glaze will give it a partially mat quality with variations in surface texture. Crystal formations will make some parts bright while others are dull, and there will be alternating lines of light and dark. Results are dependent upon chance to a great extent; no two pieces covered with a rutile glaze come out of the kiln exactly alike. If no other pigments are added, the glaze will be a cream-colored tan, but the color of rutile combines well with other colorants, especially copper. Here are some recipes for rutile glazes that are well suited for ceramic sculpture.

Glaze No. 25	Rutile	cone	06 - 04	
(CBPM No. 17)				
White lead				68
Feldspar				10
China clay				2
Flint				14
Rutile				6

The above is a semi-mat, semi-opaque glaze with a light tan or cream color. The crystallization of the rutile produces light and dark stripes.

Glaze No. 26	Alkaline rutile	cone $06 - 04$
White lea	d	27
Whiting		4
Borax		18
Feldspar		18
Flint		18
Rutile		5
Tin oxide		10

Colorants can be added as follows.

For green mat with light and dark stripes, add copper oxide 3 For light blue mat, yellow and brown stripes, add cobalt oxide 0.3 For brown mat, yellow crystals, add iron oxide 5

There is practically no limit to the variety that can be obtained with rutile glazes. Experiment by using the colorants listed for Glaze No. 1.

Crackle glazes

Crackle is a series of fine cracks in a glaze. Actually it is a defect, called *crazing*. Its appearance means that the glaze does not fit the body it covers, that it shrinks more in cooling than the clay underneath. Crazing, or crackle, may show immediately after the piece is removed from the kiln or it may not appear for several weeks. Since crazing is due to a faulty relationship between glaze and body, a glaze which crazes on one type of clay may not do so on another. Often crazing is not caused by the glaze at all but by the body it is on. This happens when the body is too porous as a result of faulty composition or when it is underfired.

In the production of table ware, glazes that craze are avoided, for pottery covered with a crazing glaze is not waterproof; but on ceramic sculpture that is not intended to hold liquids (and which will not be placed out of doors) crackle glazes are satisfactory and often quite beautiful.

It is not difficult to make a crackle glaze. Almost any glaze can be converted into a crackle merely by leaving out some of the silica or some of the alumina called for in the recipe. This alters the fit of the glaze and, nine times out of ten, will make it craze.

Glaze	No. 27	White crackle	cone 06		
	White lead	l		46	
	Whiting			6	
	Feldspar			24	
	China clay			4	
	Flint			10	
	Tin oxide			10	[160]
					1 100 1

Glaze	No. 28	Fritted	white	crackle	cone 06
	Ferro-Enar	nel Frit	3304		85
	Tin oxide				15

The two glazes given above are well suited to decorative ware, figurines, lamps and similar work. The appearance of the crackle may be hastened by plunging the piece into a pail of water as soon as it comes out of the kiln. To make the lines of crackle stand out more prominently, mix black underglaze color with water and rub it into the cracks, then wipe the surface clean. The underglaze color will penetrate the cracks and make them more visible.

Potters who wish to produce crackle ware that is waterproof are able to do so by firing a glazed piece to a temperature too low to make the body mature. When the piece is removed from the kiln, the underfired body makes the glaze craze. Color is then rubbed into the cracks and the piece is fired once more, this time to its proper temperature. This makes the body mature and the glaze fit; the cracks disappear but the pattern of the crackle which has been traced in color remains.

Spatter

Ceramic sculpture often looks better when it is covered with glazes that have a slightly speckled or flecked appearance, somewhat like the surface of granite. Such effects can be secured by spatter. The piece is covered with a flat colored glaze, then some of the glaze is mixed with underglaze color, preferably black, and spattered over the piece so that it makes small colored flecks of irregular size. A spray gun can be used provided it has a nozzle that can be adjusted to make a coarse spray. A regular spray nozzle gives too fine and even a tone. A simpler way to get a spatter effect is to use a stiff bristled brush, dipping it into the darker colored glaze then drawing a knife blade across the bristles.

At terra-cotta plants where spattered glazes are sometimes used on large quantities of tile, a device like the one illustrated in Fig. 58 is used as a spatter box. A circular brush is rotated by means of a crank handle. As the brush turns, the bristles dip into a container of the glaze that is to be spattered, then they pass under a blade that makes them throw the glaze outward to form the desired specks.

Speckled glazes

Another way of securing a speckled effect in glazes is to introduce some granular material that does not melt during the firing but remains in suspension in the glaze and shows as specks of color. I have tried fine sand and finely ground red grog with good results. Granular ilmenite $(\text{TiO}_2 \cdot \text{FeO})$ is good also.

Ilmenite in an alkaline glaze produces black specks, while in a lead glaze the specks are tan. Here are two recipes.

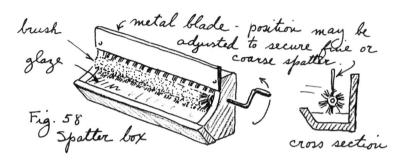

Glaze No. 29	Alkaline with ilmenit	e cone $06 - 04$
Ferro-En	amel Frit 3195	85
Ball clay		7
Granular	ilmenite	8
Glaze No. 30	Lead with ilmenite	cone 06 04
Ferro-En	amel Frit 3304	85
Ball clay		7
Granular	ilmenite	8

Be sure to use the ilmenite in *granular* form. Pulverized ilmenite is so fine that it will produce a flat tone instead of the specks you want.

If the colorants added to a glaze are not thoroughly ground the glaze will have a speckled appearance. This is especially true of cobalt oxide and manganese dioxide.

Still another way of making speckled glazes is to sprinkle dry underglaze color on a glazed surface before the piece is fired. A little underglaze color goes a long way so if you try this, use the color sparingly. To get an even distribution of color, rub the pigment on a piece of cardboard, then hold it over the piece and tap it. Stencils may be used with this method for decorative effects.

Metallic effects

When the quantity of metal oxide used as the coloring agent in a glaze is greatly increased, the result of such overloading is the formation of dull areas on the surface of the glaze where the oxide produces a metallic appearance. Sometimes the effect is good, especially with copper in an alkaline glaze. If you want to try this, use any glaze in which copper oxide is the coloring agent and double the quantity of copper used. Here is a recipe for a turquoise blue copper glaze with black metallic areas.

Glaze No. 31 (CBPM No. 13)	Black and	blue copper	cone $06 - 04$
Soda ash			18
White lead			30
Zinc oxide			2
Feldspar			24
Flint			18
Tin oxide			5
Copper carb	onate		2
Copper oxide	e		1

Gun metal

If the quantity of copper oxide is increased still more, the entire surface of the glaze will be a dull black, like gun metal.

Glaze No. 32 G	un metal black	cone $06 - 04$
Soda ash		17
White lead		27
Zinc oxide		2
Feldspar		22
Flint		17
Tin oxide		5
Copper carbo	onate	10

Mirror black

This glaze will produce a bright surface just like a black mirror.

Glaze No. 33 Mirror black	cone $06 - 04$
(CBPM No. 11)	
White lead	56
Whiting	6
China clay	9
Flint	22
Cobalt oxide	3
Red iron oxide	2
Manganese dioxide	2

Glaze over glaze

Unusual effects can be obtained by putting one glaze over another and firing them together. Results depend on many factors: the colors of the glazes, their degree of opacity, the thickness of application, the way each glaze behaves in the fire, whether it flows much or little, whether it forms bubbles during the melting process, and so on. The ceramic sculptor who seeks original surface treatments has an unlimited field of exploration open to him. Experimentation is necessary; combinations must be tried out and fired on test pieces. If the experiments are carefully controlled, if records are kept of the glazes used and the thickness of application, the sculptor can be reasonably certain of being able to reproduce on larger works the effects obtained on his tests.

When two glazes that have the same behavior in the fire are placed one over another, the result will be a haphazard mingling of the colors of the two glazes. However, if the glaze underneath is quite fluid and the one on top is less so, the bottom glaze will flow more than the one over it and the top glaze will be broken into areas of color almost like a large crackle. On the other hand if the more fluid glaze is on top it will run in lines, producing thin streaks of color. When the second glaze is sprayed on with a very thin application, it will form hair lines of color. In high-fire porcelain decoration, the fur on animal figurines is sometimes indicated by lightly spraying color over a very fluid glaze. The running of the glaze turns the color into hair lines.

When you use two glazes that are not extremely fluid, it is possible to paint a design with one glaze on the surface of the other. During the firing, the top glaze melts into the one beneath and the outline of the design becomes somewhat blurred, but on some types of work this is good. The decoration on the lamp shown on Color Plate 7 was made this way.

It is possible to use the glaze-over-glaze method with two glazes that mature at different temperatures, firing each glaze separately. For example a cone 04 glaze is applied and the piece is fired. Then a decoration is painted on the surface with a glaze that matures at cone 07 and the piece is fired again to the temperature of the second glaze so that it flows over the surface of the first glaze and penetrates slightly. Again there is no limit to the effects that can be obtained. To learn the possibilities of the method you must try it out.

Bubbling

Some pieces of modern ceramics owe much of their strength to rough surface textures achieved by the use of glazes that form bubbles during the firing. As they break these bubbles leave craters in the surface of the glaze. Such glazes are not good on small, delicately modeled figurines, but on massive sculptural forms they are sometimes just right.

Many ingredients cause glazes to bubble during the firing process. Borax acts this way and so does colemanite. Carbonates release their carbon in the form of carbon dioxide, and as this leaves a glaze it forms bubbles. In most cases as the firing continues the bubbles are all driven out, the glaze flows into a smooth surface, and no trace of the bubbling action remains. If you want to preserve the rough pitted surface it is necessary to watch the piece while it is in the kiln (place it so that it

can be seen through the peep hole) and stop the firing when the bubbling action is at its height.

Reticulation

Another way of preserving the pattern of bubbling action is to spray another glaze, preferably an opaque one, over a glaze that bubbles. During the firing the bubbles break through the glaze on top leaving a weblike, reticulated pattern of color. Here is a recipe to try.

Glaze No.	34 cone $06 - 04$		
Ferr	o-Enamel Frit 3304	68	
Cole	12		
Ball	Ball clay		
7iree	onay	12	

This glaze bubbles during the firing. Interesting results can be obtained by spraying a layer of some opaque colored glaze over this one.

Salt glaze

Zircopax

Salt glazing is a method of glazing that differs completely from all others. In this process, pieces to be glazed are placed in the kiln without having any glaze coating applied beforehand. The pieces are usually green (unfired) although sometimes for ease in handling they are bisqued first. The kiln is then fired and when it reaches its maximum temperature, quantities of salt are thrown into the kiln chamber. The salt volatilizes into a vapor which settles evenly on every object in the kiln, forming a thin, extremely hard glaze.

Salt glazing gives surfaces an "orange peel" texture that is excellent for certain types of ceramic sculpture, but there are limitations to its use. First of all, the process must be carried out at comparatively high temperatures cone 8 to cone 10, and so it can be applied only to high-fire bodies - stoneware or porcelain. Secondly, since the salt vapor glazes the insides of the kiln as well as the pieces, it must be done in a special kiln reserved for salt glazing only. The kiln used must be of the downdraft type.

Salt glazing is usually done in a reducing fire. Since the glaze itself contains no coloring pigments, the color of the body is important. The clay bodies listed on page 128 are good for this type of work.

Feldspathic glazes

For high-fire work, from cone 8 to cone 13, feldspar is used as a flux in glazes for stoneware and porcelain.

	No. 35 M No. 20)	Stoneware	glaze	cone 9
	Feldspar Dolomite Whiting China clay Flint			35 16 6 9 34
Glaze	No. 36 Feldspar Whiting China clay Flint	Porcelain	cone	12 to 15 27 20 20 33

The above glazes can be used clear or made opaque by the addition of 10% of tin oxide. Colorants may be added according to the table on page 00. Glaze No. 36 will produce a celadon green if 1% of red iron oxide is added and the piece is fired in a reducing atmosphere.

Cornwall stone

Cornwall stone is a member of the feldspar family. It is used in glazes for tableware and white wares that are fired between cones 2 and 4.

Glaze No. 37 (CBPM No. 19)	Cornwall stone	cone $2-4$
Cornwall s White lead Whiting Zinc oxide	d	65 21 10 4

Red glazes

Red is a difficult color for the ceramist. There is no ready source of red in a glaze comparable to some of the sources of blues, greens and browns. Brilliant reds have been produced by Chinese potters who make the beautiful sang-de-boeuf glazes on their porcelains. This is a glaze which requires high fire and reduction. The coloring agent is copper which ordinarily produces green but in the reducing atmosphere changes to a lower oxide form (Cu_2O) which is red. Some vivid colors ranging from blood red to deep maroon can be produced this way.

Glaze No. 38 Sang-de-boeuf cone 9 (CBPM No. 21)

Feldspar	35.5
Calcined borax	10
Whiting	14
Flint	37
Tin oxide	2
Copper carbonate	0.5
Bentonite	1

When the above glaze is used the kiln must reach its full heat, then be reduced violently for about 20 minutes, after which the burners are turned off and the kiln allowed to cool.

Pink oxide

Red glazes at lower temperatures can be obtained by using red underglaze colors such as *pink oxide*, *maroon base*, *crimson base*, etc. These are made by manufacturers who take advantage of a peculiar reaction which chrome has with tin. When the two are heated together, they produce shades of red.

Glaze No. 39 Red cone 06 - 04

Ferro-Enamel Frit 3304	80
Ball clay	10
Pink oxide	10

It is not good to use an opacifier with the above glaze. Since the colorant is largely tin, adding more tin makes the glaze dull. Best results are secured when this glaze is sprayed over a white body.

Iron red

Iron oxide produces a beautiful red when added to a lead glaze in proportions of 8% to 10%.

Glaze No. 40 Iron red cone 07 - 04

Ferro-Enamle Frit 3304	87
Ball clay	5
Red iron oxide	8

Aventurine glaze

If the proportion of iron in the above glaze is increased the glaze will become a deep maroon with the gold flecks characteristic of aventurine glazes.

Glaze	No. 41	Aventurine	cone 07	-04
Ferro-Enamel Frit 3304			80	
]	Ball clay			5
]	Red iron	oxide		15

Chrome red

Another way of securing red is to use chromium at a low temperature. Chrome makes a glaze green or brown when fired at cone 06 but at cone 012 it produces a bright red.

Glaze No. 42	Chrome red	cone 012	
White le	ead		78
China clay			
Flint			14
Chromiu	m oxide		2

The above glaze must be used over a white body which has previously been fired to its maturing point. Be careful not to overfire, for this glaze will lose its color quickly

Lustre

Lustre is an iridescent effect on the surface of a ceramic piece secured by depositing a thin film of metal on top of a glazed surface. The metals are usually applied in the form of soluble salts. During the firing process the kiln must be reduced. The free carbon produced by the reducing action prevents the metals from forming oxides and so the thin metallic layer is left.

Glaze	No. 43	Lustre	cone 06	to 04
Ferro-Enamel Frit 3195			87	
Ball clay Silver nitrate Bismuth subnitrate			10	
			1	
			2	

The above glaze can be applied to raw ware or to bisque. It must be fired to cone 04. Then the kiln is allowed to cool down to cone 016 or 795° centigrade. At this point, create a reducing atmosphere in the kiln, either by the introduction of organic matter or by closing the dampers and adjusting the burners so that they produce a yellow flame. After about ten minutes of reduction, turn off the kiln and allow it to cool.

This lustre glaze can be applied to a piece which has been fired and

glazed. Mix the recipe with cornstarch and put a thick layer on the piece. Fire to cone 07, then proceed as above, allowing the kiln to cool to cone 016, then reducing.

Prepared lustre glazes can be purchased from ceramic supply dealers. These do not require reduction, but their firing range is limited to extremely low temperatures, hence they must be used as overglaze colors and applied to the surface of a glazed piece after it has been fired.

Brown lustre glaze

Still another way of obtaining the effect of lustre is by using a glaze heavily loaded with manganese and iron. Such a glaze doesn't require reduction.

Glaze No. 44	Brown lustre	e cone	06	to	04
(CBPM No. 12)					
White lead				5	8
Feldspar				1	.3
China clay					4
Flint				1	.6
Manganese	carbonate				6
Iron oxide					3

Color in glazes

The pigments that color glazes are metal oxides. When they are put into the glaze batch the metals may be oxides or some other chemical compound, carbonates or sulphates, but after the firing process they remain in the glaze as oxides. Some metals combine with oxygen in two or more ways, producing oxides of different colors. Thus we have seen that copper, which usually makes a glaze green, will under certain conditions in a reducing fire turn into another oxide form and produce a glaze that is red. Here is a list of the principal metal compounds used as glaze colorants.

Antimony oxide (Sb_2O_3) produces yellow when added in quantities from 3% to 6%. This metal is a trouble-maker, however, as it blisters. Most potters prefer to use it as yellow base (see page 172).

Cadmium Sulphide (CdS) produces yellow in very low temperature glazes (below cone 010). When combined with selenium and sulphur it produces red.

Chromium oxide (Cr_2O_3) has a variety of colors. At cone 05- cone 2 in a leadless glaze or one with very little lead, 2% to 5% of chromium produces green. At low temperatures (cone 012) in a high lead glaze it gives a bright red. In the presence of tin oxide, chromium produces shades of pink, crimson and maroon. This is how pink oxide and crimson base are made. Be

careful when you place a chromium glaze in your kiln for it will change the color of any tin glazes near it.

Cobalt carbonate (CoCO $_3$) produces various shades of blue when used alone. Use 1% to 2%.

Cobalt oxide (Co_3O_4) produces the same blues as cobalt carbonate but it is stronger and more difficult to grind into a smooth even color. Use $\frac{1}{2}\%$ to 1%.

Copper carbonate (CuCO₃) produces a grass green in a transparent lead glaze; when used in quantities from 2% to 6% in an alkaline glaze it is turquoise blue. In a glaze containing tin, copper produces a pale blue. When fired in a reducing atmosphere, $\frac{1}{4}\%$ to $\frac{1}{2}\%$ of copper in an alkaline glaze produces colors ranging from purple to bright red.

Copper oxide is used in the same way as copper carbonate. It comes in two forms, red (Cu_2O) and black (CuO); the second is more usually used. Black oxide of copper is a stronger colorant than copper carbonate. Use 1% to 4%.

Iron chromate (FeCrO $_4$) produces a greenish gray in quantities from 1% to 3%. In the presence of tin, it turns pink.

Iron oxide comes in two forms, red (Fe₂O₃) and black (FeO). Both are used by potters in quantities of 5% to 10% to produce colors ranging from tan through yellowish brown to red. Red iron oxide is a good body colorant. In a reducing atmosphere, 1% of iron produces the green of celadon.

Lead chromate (PbCrO $_4$) produces green in an alkaline glaze, yellow in a lead glaze. In the presence of tin it produces shades of pink. Use 3% to 6%.

Manganese carbonate ($MnCO_3$) produces purple browns in quantities from 5% to 10%. In an alkaline glaze it turns violet. Combined with copper and cobalt it produces black. In the presence of iron it gives a lustre. Glazes containing this ingredient will often blister.

Manganese dioxide ($\mathrm{MnO_2}$) is used in the same way as manganese carbonate.

Nickel carbonate (NiCO $_3$) produces shades of green, brown, and purple when used from 2% to 5% in high temperature glazes.

Nickel oxide comes in two forms, black (Ni_2O_3) and green (NiO). Both are used by potters in the same way as nickel carbonate.

Ochre is an earth material consisting of a mixture of iron oxide, clay, and sand. It will produce shades of yellow brown and red. Potters rarely use it in glazes but frequently use it in its raw form as a body colorant.

 $Rutile~(TiO_2~impure)$ is an oxide of titanium that contains various impurities, among them iron. Its color is pale tan. See page 159 for its special uses.

 $Tin\ oxide\ (SnO_2)$ is an opacifier. Without other colorants, 10% of tin produces white; with colorants it produces opaque colored glazes. In the presence of chromium, tin oxide turns pink.

Titanium oxide (TiO_2) in its pure form is used as an opacifier. Lacking the iron impurities found in rutile, it is white instead of tan. From 5% to 10% in a glaze produces a mat surface and forms crystals.

Umber is a mixture of iron oxide, manganese, and clay that produces a chestnut brown. Potters use it in clay bodies, either in its natural state, called raw umber, or after it has been heated to form burnt umber. The latter produces a reddish brown.

Vanadium pentoxide produces yellow, but ceramists rarely use it in this form, preferring vanadium stain which is made by combining vanadium with tin.

Zinc oxide (ZnO) is not a colorant but it affects other colors. It turns chromium brown and makes iron a mustard yellow. Zinc intensifies the blue of cobalt. It makes a glaze semi-opaque and, in quantities above 10%, in low-fire glazes will produce a mat surface.

Zirconium oxide (ZrO_2) acts very much in the same manner as tin, except that twice as much must be used to achieve similar results.

Zircopax ($ZrSiO_4$) is a form of zirconium oxide that is preferred by ceramists. It can be used in place of tin in opaque glazes but quantities must be doubled.

Soluble salts

The sulphates, the nitrates and the chlorides of bismuth, cobalt, copper, silver, and other metals are all soluble in water. They are rarely used as glaze colorants but sometimes are used in clay bodies. Cobalt sulphate and cobalt nitrate, for example, are used in whiteware bodies to impart a blue-white color. Soluble salts are used as oversprays on art pottery and to produce lustres.

Prepared ceramic colors

Manufacturers of ceramic supplies prepare a number of different colors, many of which would be difficult for the ceramist to make for himself. These prepared colors are sold as stains, underglaze colors, and overglaze colors.

Glaze stains

Glaze stains are pigments for coloring glazes. They are similar to the body stains mentioned on page 137, except that the colors are finer and there is a much greater range to choose from.

Some glaze stains are sold in liquid form. These eliminate the need for weighing quantities; just add 5 teaspoonsful of the liquid stain to a pint of glaze.

Underglaze colors

As the name implies, underglaze colors are intended for use under a glaze, but they may also be used as colorants in a glaze. They can be used, too, to paint decorations over a glaze in a way which will be described in the section on decorating technics on page 217. Underglaze colors are suited to any temperature range and they make satisfactory colorants, although they tend to make a glaze opaque. The choice is wide; it is possible to purchase practically any shade of any color, including some reds and purples that are almost impossible to obtain in any other way. Consult a ceramic dealer's catalogue for a list of the colors available.

Yellow base is an underglaze color which you can prepare for yourself. To make it mix together 15 grams of red lead, 10 grams of antimony oxide, and 4 grams of tin oxide. Put the mixture into an unglazed receptacle and fire it in the coolest part of your kiln. After firing, regrind it and it is ready for use.

Overglaze colors

Overglaze colors are intended for use on top of a glaze which has already been fired. They will not stand high temperatures, but are limited to cone 010 or lower. The best results are obtained with overglaze colors from cone 018 to cone 012. For this reason they cannot be used to color a glaze.

Overglaze colors are brighter than underglaze colors and are frequently used for decorating china and porcelain figurines. Among the overglaze colors are many special pigments, metallic gold and copper, for example, and a number of lustres. The method of using overglaze colors is described on page 163.

Mixing Glazes

The materials that are combined to make a glaze must be thoroughly mixed. Some ceramists grind them together in a ball mill. This is a machine with porcelain jars into which the glaze ingredients are placed along with a charge of pebbles and water. The jar is then rotated for an hour and the pebbles perform a mixing and a grinding action. Many ceramists, however, don't use a ball mill. The glaze materials purchased from ceramic supply dealers have been ground extremely fine, so that thorough mixing plus screening is sufficient.

Mixing by hand

To prepare a glaze from a recipe, weigh out the ingredients, put them into a bowl, and mix them dry. Add water, stirring the mixture as you do so, until it has the consistency of thin cream, then screen the mixture by passing it through a 100-mesh sieve. If you have trouble in getting the glaze through the sieve, force it through with a rubber spatula. The screen-

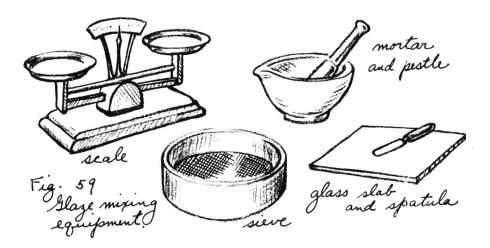

ing action not only removes coarse particles but completes the mixing of the material.

An ingenious device for mixing glazes is shown in Fig. 60. It consists of two wide-mouthed jars with screw-on metal lids. The centers of the lids have been cut out, a circle of 100-mesh screen placed between them, and the lids have been soldered together back to back. When the two jars are screwed into the lids, a sort of hour-glass arrangement is formed, with the screen at the narrow portion. When the device is used, the glaze ingredients are placed in one jar, water is added and the two jars are fastened together and shaken. After about 10 minutes of shaking, the jars are reversed so that the one containing the glaze ingredients is on top and the shaking continues until all of the glaze has passed through the screen into the bottom jar. By this time the glaze is thoroughly mixed, screened, and ready for use.

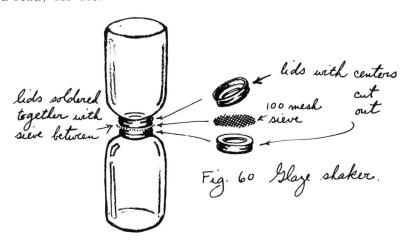

Grinding glazes

Glazes mixed by shaking and screening will not be as even in texture and in tone as those that have been ground. Some of the pigments, especially cobalt, may show flecks of color. As a rule, this is an advantage in sculpture work rather than a drawback. If perfectly even colors are required, however, it is necessary to grind the glaze ingredients together for an hour, either in a ball mill or with a mortar and pestle. When a ball mill is used, the glaze materials are put into a jar of the mill, water is added at the rate of half a cupful for every 300 grams, a double handful of pebbles is thrown in, and the jar is rotated. After grinding for an hour, the glaze and the pebbles are removed from the jar and put into a bowl. In order to save all of the glaze, the inside of the jar is rinsed with clean water and this water is poured into another bowl. The pebbles are then washed in the second bowl, and the contents of the two bowls are poured into one and allowed to stand for an hour or so, after which the excess water is poured off and the glaze is ready for use.

A ball mill is expensive and unless you are making large quantities of glaze, an investment in such a piece of equipment is hardly justified. Small glaze batches can be ground by hand, when necessary, using a mortar and pestle.

Glazes should be ground for an hour — no longer. Over-grinding makes the glaze particles too fine and may cause *crawling* (see page 181).

Mixing alkaline glazes

Raw alkaline glazes present a problem. Because some of the ingredients of these glazes are soluble, no excess of water can be used in the mixing process, for any water poured off carries some of the essential glaze materials with it. For this reason a ball mill will not serve. Raw alkaline glazes cannot be made by simply mixing the ingredients and screening them, because the alkaline materials when combined with water form a paste that is difficult to get through a screen. When making raw alkaline glazes, therefore, the ingredients must be ground by hand, using a mortar and pestle, with just enough water added to make a mixture having the consistency of thick cream. Such glazes cannot be stored for any length of time; they must be used immediately after they are prepared.

The term *raw* used in the preceding paragraph refers to glazes that have not been fritted. When the alkaline ingredients of a glaze have been combined in a frit, the resultant material is not soluble in water and so it can be handled like any other glaze material, that is, ground in a ball mill or simply mixed and screened.

Storing glazes

Mixed glazes, other than raw alkalines, can be kept for any length of time in tightly covered glass jars. Add water when you put a glaze away. As it stands the glaze will settle. When you are ready to use the glaze, pour off the excess water from the top before you start to stir it, then add enough water to bring the glaze to proper working consistency.

Sometimes after a glaze has been standing for a while it will settle and form a rubbery mass at the bottom of the jar so that it is quite difficult to stir the glaze and get it into usable condition. A brush left standing in such a glaze will sink in and be gripped fast so that there is danger of pulling out the hairs when you try to loosen it. We have already spoken about this problem in connection with frits but other glazes occasionally behave this way also, particularly those containing litharge or red lead and, to a lesser extent, white lead. If you have this difficulty, add a teaspoonful of epsom salts to the glaze after it is mixed. This will keep the glaze in suspension and will save time and trouble.

Have a box of labels handy and when you put a glaze into a jar, label it in ink immediately. It may seem unnecessary to mention a detail like this but I have seen too many potters' studios with rows of jars each containing some unknown quantity. The labels have been lost or they were written in pencil and are no longer legible. As an added precaution, I find it good to write the list of glaze ingredients on the label as well.

Testing glazes

When you apply a glaze to a piece of sculpture you should know beforehand just what that glaze is going to look like after it is fired. That means that you must fire a sample of every glaze before you use it. This is true of glazes that are bought ready prepared as well as those you mix yourself.

For ceramic sculpture it is not sufficient to try out glazes on flat tiles. Make a press mold like the cat face shown on page 91 or the bird on page 96. Test pieces pressed in such molds are excellent for trying out glazes intended for sculpture. Press molds are better than drain molds for making test pieces; not only are they easier to use, and quicker, but they make it possible to press test pieces out of the same clay as that used in the sculpture for which the glaze is intended, and that is important. A test on another type of clay will tell you little.

Marking tests

Be sure to keep a record of every glaze that you test. It is good to have a small 3" x 5" card file for this purpose. List the ingredients of each trial glaze on a card and give the card a number, then put the number on the test piece, using marking fluid and a fine brush. Marking fluid can be bought, or you can make your own by mixing a small amount of transparent glaze with black underglaze color, adding enough gum and water to make the mixture flow evenly from the brush. Another simple way of making tests is to use a ceramic pencil made of pigments that remain during the firing process. Ceramic supply dealers sell pencils of this type.

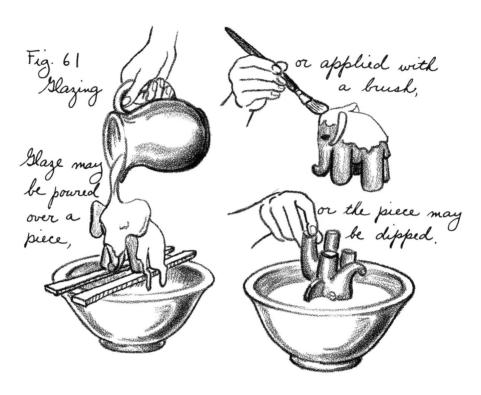

Applying Glaze

Glaze can be applied to ceramic sculpture before it has been fired, while it is still raw, or after it has been fired to the bisqued state. It can be put on with a brush, or pieces may be dipped, or the glaze may be sprayed.

Brushing

When applying glaze with a brush use a large brush with soft hairs. Work quickly, brushing on an even coat 1/32'' to 1/16'' thick. The thickness needed varies with different glazes; raw alkaline glazes must be applied thicker than fritted glazes. Your test pieces will tell you what is the right thickness for each glaze. Don't go over any area of the piece more than once. On large areas glaze can be applied with a sponge.

Dipping

Small figurines can be dipped into a container of glaze. It is important to have the glaze of the right thickness. If the glaze is too liquid, the coat applied in the dipping process will be too thin. If the glaze is too thick, too much glaze will adhere to the piece.

As a rule, dipping is used only for work which has been fired, for raw ware dipped into a container of liquid glaze may absorb too much moisture and crumble. When you dip a bisqued figure into a bowl of glaze, soak the piece in water first. Then with a clean cloth wipe off all the ex-

cess moisture that remains on the surface. Saturating the piece this way cuts down its absorption and makes it possible to take more time and care in the dipping. The glaze used in this case must be fairly thick. Since the piece has been saturated, it will not absorb an excess of glaze. It can therefore be dipped again and again until the coating is just right.

Some ceramists prefer to dip pieces without soaking them first, using a glaze which is thinner. Since bisqued ware that has not been soaked is extremely absorbent, it is necessary to work quickly, putting the pieces in and out with one rapid motion.

The portions of the figures that have been grasped with the fingers must be touched up with the brush before the piece is put into the kiln.

Pouring

A piece may be placed on strips of wood resting on the top of a bowl as shown in Fig. 61, while glaze is poured over it. Any portions of the underside that require glaze must be covered first with a brush.

Spraying

The most satisfactory way of applying glazes is by spraying. A spraying outfit consists of a compressor which can deliver compressed air at a pressure of from 30 to 60 pounds per square inch, a spray gun, and a spray booth. Such an outfit is illustrated in Fig. 62. Work to be sprayed is placed on the whirler as shown, glaze is placed in the container of the spray gun and is sprayed on the piece while the whirler is turned. The exhaust fan of the spray booth prevents glazes from blowing back into the face of the operator.

A satisfactory spray gun and compressor of the type sold by ceramic dealers costs about \$50.00. A slightly less expensive outfit that will work almost as well is a paint spray gun of the type sold in hardware stores.

Spray booths can be purchased from ceramic equipment manufacturers or they may be home-made. I have seen a satisfactory one rigged up using the motor and fan from an old vacuum cleaner.

A hand sprayer of the type shown in Fig. 63 can be used to spray glazes. It requires patience, however; a long time is required to build up a coat of glaze of the proper thickness.

When using any type of spraying equipment, screen the glaze through a 100-mesh sieve. If this is not done, the spraying nozzle will become clogged. Take care to clean the spray gun immediately after use; any glaze that remains in it will harden and become difficult to remove later on. If you use a mechanical compressor, keep it clean and well oiled.

When you spray glazes, be careful not to inhale any of the material. If you have a spray booth with an efficient exhaust fan, this may be enough of a safeguard but if you ever use any spraying equipment without such a booth, cover your nose and mouth with a respirator. For small quantities of spraying done with a hand-type spray gun, a handkerchief tied over the nose and mouth will be satisfactory.

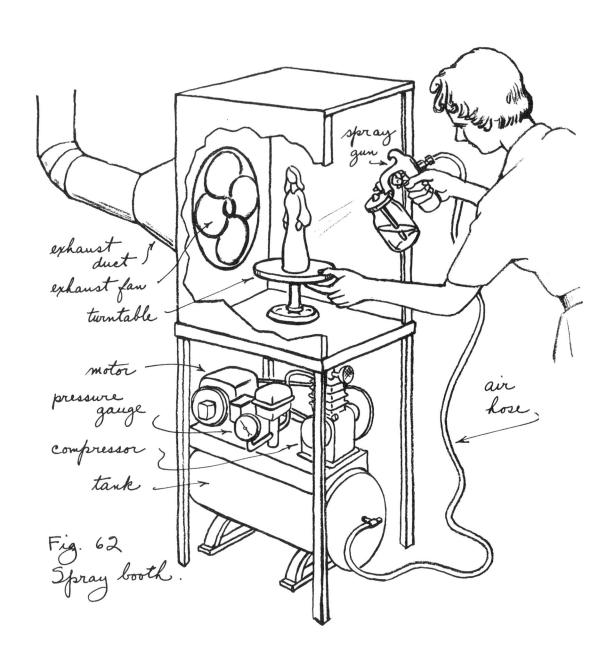

Glazing raw ware

It is possible to apply glaze to raw clay and then put the piece into the kiln, firing both clay and glaze in one operation. Be sure that the piece to be glazed is free of dust. Sponge it off just before glazing. If the glaze is to be put on with a brush, apply a thin coat of gum to the surface first. If the glaze is to be sprayed, this will not be necessary. Use gum arabic instead of gum tragacanth if you plan to apply glazes to raw ware.

Raw clay will absorb a large amount of water when it is glazed, so allow plenty of time for drying before you put the piece into the kiln - at least 24 hours - and when you start the kiln bring the temperature up slowly.

Porcelain and stoneware are usually fired once. Both body and glaze are planned for high temperatures, and best results are secured when they mature together. Ceramic sculptors who work in porcelain, however, often bisque their pieces by firing to a low red heat before they apply the glaze. This does not make the porcelain body mature but it drives off the chemically combined water, hardens the clay, and makes the work easier to handle and to glaze. Wherever possible, fire your clay pieces first before putting on the glaze.

Some safety precautions

When you work with glazes, remember that many of the ingredients you handle are poisonous, especially all forms of lead. Be careful to wash your hands thoroughly after mixing or applying glazes. Don't bring any food into your studio. Sometimes you are tempted to stop work and have a bite to eat but when you feel the need for this, put your glazes away, wash your hands, and go out of the studio before you eat anything.

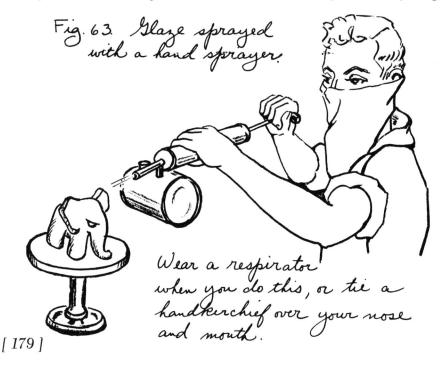

Glaze Defects

Not everything we put into a kiln comes out just the way we hope it will; there are many disappointments when glazes blister or discolor or crawl. Sometimes such mishaps can be corrected by another application of glaze and another trip to the kiln. If we know the cause of the defect, we can prevent its recurrence.

Glaze fit

The most frequent defects in glazes occur when the glaze does not fit the body, when the coefficients of expansion of the glaze and of the body are not the same. Both glaze and body expand during the firing process and then contract as they cool. If the body shrinks more than the glaze, tensions are set up that may cause portions of the glaze to be pushed off the piece, especially on convex areas. This is called *shivering*. When the reverse happens and the glaze shrinks more than the body, tiny cracks develop in the glaze, a defect called *crazing*. Both of these defects can be corrected by altering the coefficient of expansion of either the glaze or the body or both to secure a better fit in the glaze.

To correct shivering, lower the silica and the alumina content of the glaze and increase the amount of flux. To correct crazing, do just the opposite; increase the silica and the alumina content and decrease the amount of flux.

Some glaze materials promote crazing. Among these are the alkalis, potash, and soda. The substitution of lime or zinc for these materials will reduce crazing. Boric oxide in a glaze will also decrease crazing. Firing the body and the glaze to a higher temperature will sometimes eliminate the trouble.

Crazing may be due to faults in the body. A piece of bisque should not have an absorption greater than 10%, otherwise glazes on it will craze. If your fired clay is too absorbent, tighten it up by adding flint or fire it to a higher temperature or, if you cannot go higher in your kiln, lower the maturing temperature of your clay by adding glass cullet or body frit as described on page 153.

Crazing may develop in a glaze immediately after it comes out of the kiln, especially if the piece is cooled too quickly. Sometimes it does not appear until several months have elapsed.

Other defects in glazes may be due to errors in the glaze recipe, or to mistakes in application. They may result from incorrect firing or be caused by faults in the clay itself. The following paragraphs list some of the things that can go wrong in glazes along with suggestions for remedying them.

Crawling

A glaze that crawls leaves bare areas on the surface of the work. This may be caused by dirt on the piece at the time the glaze was applied. Sponge your work carefully just before glazing it. Look out for grease; this will make a glaze crawl. Be careful in handling a piece, for finger marks may often cause this trouble.

When a piece is put into the kiln the coating of glaze must be thoroughly dry. Don't be impatient and try to fire your work too soon after it has been glazed. When the coating of glaze has dried it should be smooth and unbroken. Cracks are apt to develop into crawl areas during the firing. If there are breaks in the coating of glaze, try removing them by brushing your finger lightly over the surface. If you can get rid of the cracks this way, it is safe to fire the piece; if not, it is better to remove all of the glaze and start again. Add a little more gum tragacanth to the glaze before you apply the next coat. Don't use an excess of gum, however, for that too can cause crawling. A tablespoonful of liquid gum to a pint of glaze is enough.

Too high a clay content in a glaze causes crawling; try reducing this. Glazes containing zinc have a tendency to crawl. If your glaze contains a high proportion of zinc, lower the amount.

Crawling sometimes results when a glaze has been ground too fine. If you use a ball mill, don't grind any glaze longer than one hour. If a glaze is applied too thick, it is likely to crawl. Check on your test piece to make sure that you have the thickness right.

Sometimes crawling is due to underfiring. The kiln was turned off before the glaze was given an opportunity to flow into a smooth even coat. Fire higher next time.

Defects in the body sometimes cause crawling. The body must not be too porous. If your clay has an absorption greater than 10% after it is fired, tighten it by the methods described in the paragraph on crazing.

Glazes made from recipes that contain ball clay sometimes crawl because the clay used in the glaze is too plastic. Such a clay shrinks as it dries and again when it is fired; this shrinking makes the glaze contract leaving bare areas on the piece. This trouble can be corrected by substituting china clay for the ball clay or by calcining the clay before it is used. To calcine a material put it in an unglazed container and fire in the kiln.

Pieces on which the glaze has crawled can usually be saved by another firing. Apply additional glaze to the bare spots and put the piece in the kiln again, this time bringing it a cone or two above its previous firing temperature.

Water

Sometimes potters who have had difficulty in making glazes behave properly have found the cause of their trouble in the water they used. Hard water may make a glaze crawl. In some communities, chemicals added to the water as purifiers upset the balance of a glaze recipe. If you have trouble with glazes and are unable to correct it in any other way, try mixing a glaze batch with distilled water. If this works, then you have located the source of your difficulty. Use distilled water or rain water in your glaze work.

Blistering

Another defect is the appearance of ugly blisters on the surface of a glazed piece. Sometimes such blisters are due to sulphur in the clay. If this is the case, put the piece back in the kiln and fire it again; the sulphur will eventually burn out and the blisters will disappear. If your trouble is caused by sulphur, add 2% barium carbonate or magnesium carbonate to the clay you use. It will be necessary to make the clay into a slip in order to add these materials.

Blisters are also caused by the action of a reducing fire on any glaze containing lead. If you suspect that this is the cause, try firing two test pieces, one with a lead glaze, the other with a leadless glaze. If blisters appear on the former and not on the latter, your kiln is not working properly and is giving you a reducing atmosphere. Check the burners to see that they are properly adjusted, check the flue to see that it is open, and seal any cracks in the muffle of your kiln with kiln cement.

Some substances such as manganese carbonate, borax, and colemanite form bubbles during the firing which remain as blisters if the firing is stopped too soon. Such blisters can be removed by refiring.

Running

Sometimes things go wrong with a glaze because the materials in the recipe are not weighed out properly. Or the recipe itself may be at fault. A glaze that runs too much and forms a pool on the floor of the kiln contains too much flux. Either the glaze is intended for a lower temperature than you are using or you made a mistake in quantities. Weigh out another small batch and try it on a test piece; if it still runs, reduce the amount of flux in the recipe or add more clay.

Dryness

A glaze that comes out of the kiln with a dry appearance probably has not enough flux or else needs a higher temperature. Sometimes a rough, sandpaper surface indicates that the glaze was not applied thickly enough.

Glossiness

If a glaze that is supposed to have a mat surface comes out of the kiln with a high gloss, it has probably been overfired.

Pinholes

Tiny air pockets in clay will cause pinholes in the surface of a glaze. Watch out for this, especially in cast pieces. If you have this trouble, ex-

amine your casting slip to make sure it is free from bubbles. Examine your molds also; if they are old and pitted, discard them and make new ones, for old molds cause pinholes in castings. Sponging the surface of the clay before it is put into the kiln for its first firing will often correct this difficulty.

Pinholes may also be caused by too rapid firing or too rapid cooling.

Using defects

Ceramists sometimes deliberately produce glaze defects in order to achieve unique effects. Crazing, for example, properly handled makes a beautiful crackle, and the blisters that come from bubbling glazes are often decorative. Even crawling can be used to advantage. If the bare areas left by a glaze that crawls are filled with a lower temperature glaze and the piece is refired to the temperature of the second glaze, interesting variations in color and texture will result. The secrets of such special effects can be learned only by experimentation.

Surface Treatments

The surface of a smooth piece of clay that has been fired but not glazed or treated in any way is sometimes dull and uninteresting. On the other hand, glazing ceramic sculpture can destroy much of its effectiveness. This is especially true of work of large size. In such cases the sculptor is forced to find other ways of providing his surfaces with color and vitality. One way of doing this is through texture.

Texture

Texture is always present on the surface of his work whether the sculptor seeks it or not. As he builds a form, ever changing patterns develop; each movement of his fingers as he presses clay into place, leaves its mark. These marks of clay and fingers never disappear completely. No sculptor would want them to, for a satisfying work of art should show how it was made.

Texture can be obtained by adding clay in small pellets, pressing them into the form but not obliterating them entirely. Texture is provided also by various toothed modeling tools and scrapers. These, drawn over the clay in different directions, make patterns that can be modified by pressing smooth tools on the surface. Many articles of common use may add interest to a clay surface. A sieve, a piece of coarse cloth, a cork, the threads of a bolt, the end of a stick of wood — there is no limit to the variety of things that may be tried. Note the articles used to provide textures in Photo Series 42 on page 279.

Textures of another kind are secured in ceramic sculpture by adding things to clay that burn out during the firing leaving the surface marked by slight depressions. In Chapter I we mentioned sawdust and other organic materials added to clay to make it porous. These will give surface texture as well.

Vermiculite, or bloated mica, which is valuable as an insulating material has been used in clay bodies by some ceramic sculptors with good results. Mixed with the clay in equal parts by volume, this material produces interesting surface areas. If you use vermiculite be sure to calcine it first, that is put it in your kiln and fire it before adding it to the clay. If this is not done, the vermiculite may expand when you fire your work and blow it up.

Wax

Even with good surface texture, ceramic sculpture usually needs something to enhance the color of the clay, to do for it what a transparent glaze would do without giving the high gloss and the extra thickness that a glaze would add. Wax serves well in this capacity.

Automobile wax is good and so is shoe polish. Saturate a soft cloth with the wax and rub it briskly over the entire surface of the piece, then use another soft cloth and rub off all of the excess. Pigments such as burnt sienna, umber, or red iron oxide can be added during this process. Brush the pigment on top of the wax, then use a cloth to rub the pigment into the wax. After the pigment has been thoroughly rubbed in, polish the work with a clean cloth. Plate X illustrates this process.

Wax can be applied with greater ease if the object is warm, so if you plan to wax a piece of sculpture do it immediately after it comes out of the kiln before it has a chance to cool off.

Soapstone

Powdered soapstone or tale can be used to polish terra cotta. Rub it into the surface of the piece, then polish with a soft cloth.

Milk

Soaking a piece of fired clay in milk will give it a surface very much like that obtained with wax. A small piece may be completely immersed in a container of milk and left for an hour or two, then removed and allowed to dry thoroughly (overnight is best). After it is dry, it should be polished with a soft cloth. If color is desired, powdered pigments such as umber or iron oxide may be added to the milk.

For larger pieces, too big to dip into a bowl, stand the work in a pan and apply the milk with a soft brush. Keep on applying the milk as long as the piece will absorb it, then allow it to dry overnight and finish by polishing with a cloth.

Linseed oil

Another way of obtaining a surface midway between plain bisque and

transparent glaze is by using raw linseed oil. Apply this with a brush, giving the work a smooth even coat, then wait an hour or two and apply a second coat. After the second coat has soaked into the piece, inspect the surface and decide if the finish is satisfactory. If it is still too dull, give it one more coat. Linseed oil dries very slowly; sometimes it takes as much as a week. It may be necessary to give the work a final coat after several days have elapsed.

Rubbing

The pueblo Indian potters do not use glaze, yet they are able to secure a glossy surface on their ware by rubbing it with a smooth stone or a piece of bone or polished wood before the clay is fired. This method is not suited to complicated sculptural forms but for simple shapes that are not too large it is worth trying. The rubbing should be done while the clay is leather hard. Use a smooth modeling tool and rub the surface of the clay until it has a slight shine. Continue this until the entire surface is uniform, then allow the clay to become bone dry and fire it. It will come out of the kiln looking almost as if it were covered with a mat glaze. This method will work over colored engobes as well as undecorated clay.

Paint

Ceramic sculpture can be painted, although this is probably the least satisfactory of all of the methods of surface treatment. If you do use paint, avoid putting on a thick coat that completely hides what is underneath. Mix the colors with linseed oil and turpentine and brush on fairly thin. Use one ounce of oil and one of turpentine to a pint of prepared paint.

Oil colors

Another way of using paint on ceramic sculpture without applying a coat with a brush is to use artist's oil colors. These are thinned with turpentine and then rubbed over the surface of the fired clay with a cloth. Good effects are secured by mixing together contrasting pigments, for example, red and blue or orange and green. The colors are rubbed into the sculpture and allowed to dry for 24 hours, then polished with a clean cloth.

Cement base paint

Large pieces of terra cotta that are to be placed out-of-doors can be painted with a cement base paint. This paint protects the work from the weather and reduces the likelihood of efflorescence. Sculpture that has been treated this way loses the appearance of terra cotta and looks more like concrete or stone; in some cases this is a disadvantage, but there are times when such a finish is appropriate for a particular garden setting.

Cement base paints are sold under a variety of trade names — Rocktite, Medusa, and others. They come in dry powder form in several colors and need only to be mixed with water. These paints must be used on porous surfaces, so they cannot be applied to any terra cotta that has been glazed. The

surface of the sculpture must be wet before the paint is applied. Soak it for an hour or so beforehand, then allow any surface water to dry off. Make sure there is no loose dirt on the piece. For the first coat mix the paint with water in the ratio of a pound of paint to a pint of water. Pour the water slowly into the paint, stir it with a stick (not the hands) to prevent lumps. Then brush it on with a stiff bristled brush, rubbing it well into the surface. Avoid overlapping as far as possible. Don't mix more paint than can be used at one time for after 3 hours it will set and become useless. When the first coat is finished, spray the work lightly with water. The cement must be allowed to cure for 24 hours without drying out, so either spray it at intervals or else cover it with damp cloths just as if it were a piece of clay sculpture which had to be kept moist.

When 24 hours have elapsed, apply the second coat. The paint can be mixed a little thicker for this coat and it can be flowed on with a wide soft brush. The second coat should also be sprayed with water, and the work should be kept from drying out for another 48 hours.

Be sure to clean your brushes immediately after using paint of this type; if the paint stays in your brush it will be ruined. Guard your hands, too; cement base paint is alkaline and can be injurious to the skin of some people. Wash your hands thoroughly after using it.

Patina

Sculptors who work in bronze sometimes apply a patina to their plaster casts which makes them look like weathered bronze. If this is done with the aim of deceiving the public it is not good, but it has a worthwhile purpose when it permits the sculptor to see what a bronze casting of his model would look like. Thus, if changes are needed, they can be made in the plaster model before the expensive process of bronze casting is begun. A patina of this type can be applied to unglazed terra cotta as well.

There are many different ways of applying a patina. Most sculptors have devised their own methods. The process is fairly simple, however, and with some experimentation you would be able to give your terra-cotta sculpture interesting surfaces. The steps are these.

First brush a coat of thin shellac over the surface of the terra cotta. If the terra cotta is made of red clay no additional coloring will be needed, but if it is buff, add a little iron oxide or burnt umber to the shellac. This addition of brown gives a warmth to the terra cotta and provides a good base for the bronze to follow.

After the first coat of shellac has dried, apply a second coat of thin shellac with bronze powder added. Rub this well into the surface. This will give the work an appearance like bright new metal. The next step is to apply a coat of wax and to add pigments. Brush the wax over the bronze with a stiff bristled brush, then apply colors. Don't mix these together beforehand but apply each pigment separately and blend them on the piece itself. The predominant color to use is chrome green but in addition to that

use Venetian red, Naples yellow, and a touch of white. These are dry powdered pigments used by house painters. They can be bought in any painters' supply store. When you have achieved the color you want, polish the piece with a soft cloth or with a dry brush. This will give the surface a slight gloss and a somewhat metallic appearance.

Another method of coloring terra cotta is to rub it with metallic oxides mixed with water so that the color sinks into the surface of the piece. This should be done before the work is fired but the method can be used on bisque as well. In this case the work should be put into the kiln and refired so that the color is bonded to the piece. I have seen good results obtained by using manganese oxide and powdered illmenite.

A final word

Let's emphasize once more that clay itself has color and that the wise ceramic sculptor makes use of it whenever he is able to do so. Sculpture is not pottery. Form must not be subordinated to color. For this reason it is wise to avoid strong, bright colors on any but the smallest pieces. For larger work, use soft, subtle, subdued colors, colors that come from the earth and that harmonize with your clay.

Color is not more important than form but at the same time it is not less so. The two go together. You cannot model a shape and then decide on a glaze later on. The ceramic sculptor plans the glaze while he builds form.

A number of glaze recipes have been given in this chapter. But don't rely entirely upon them. Explore. The field of ceramic materials is a wonderland inviting the artist who has courage and imagination. Learn all you can about the materials you work with so that you may use the full range of their possibilities. Seek constantly for new effects. Don't try just to be different, but be original. Look for a way of expressing yourself in ceramics, a way that is individual, that is your own.

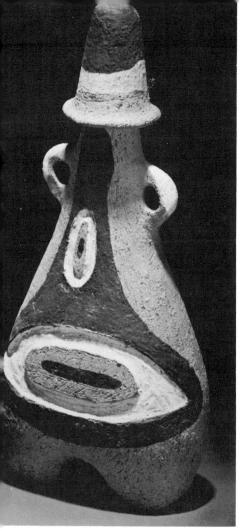

Ceramic bottle — Student work, Rhode Island School of Design.

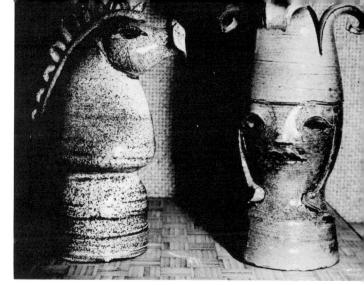

Chessmen, Ceramic Sculpture made on the Wheel. Richard Petterson.

Ceramic Christmas Card. Albino Cavallito.

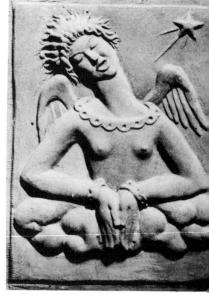

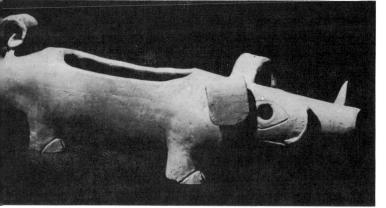

Planter. Student work, University of Southern California.

Cat, Ceramic Sculpture made on the Wheel. Student work, Rhode Island School of Design.

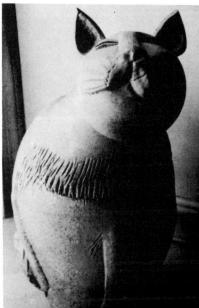

9 The Kiln

CERAMIC SCULPTURE is hardened by fire. This means that the ceramic sculptor must understand the effect of heat upon ceramic materials. He must be able to operate a kiln, and to measure its temperature.

Measuring temperature

A ceramist who is experienced enough can judge the temperature of his kiln by its color, as many of the old-time potters used to do. A Chinese potter once told me, "In China, the old men tell the temperature of a kiln by spitting into it." This may be a good method, but for practical purposes it is best to have a more reliable measure.

Electric kilns can be provided with pyrometers that give a direct reading of the temperature inside the kiln chamber. Such pyrometers do not work on gas kilns however; in these, ceramists use *pyrometric cones*. Even when he works with a kiln that has a pyrometer, the ceramist usually uses cones as well as an additional safeguard.

Pyrometic cones

A cone is a device for measuring kiln temperatures. It is made of clay, shaped like an elongated triangular pyramid and has fluxes added so that it will become soft and start to bend at a particular temperature. A number stamped in the side tells the ceramist what that temperature is. Cones are numbered in a peculiar way, upward and downward from 1. Thus cone 2 measures a higher temperature than cone 1, but cone 01 measures a lower temperature, and so on. The table on page xv gives cone temperatures.

When he uses cones, the ceramist places them in a lump of clay called a *cone pat*. Three cones are placed in a row slanting to the right as shown in Fig. 64. The middle cone is the one which measures the temperature to which the kiln is to be fired; the one to the right is a cone of the next lower temperature and the one at the left is the next higher. Thus if you are planning to fire your kiln to 1904°F. or cone 05 you would make a cone pat using cones 04, 05, and 06, in that order from left to right.

The cone pat is put in the kiln in a position where it can be seen through the peephole. As the kiln begins to approach the required temperature, the cone at the right will start to bend. This is a warning signal to the ceramist; it says "Watch closely, it is almost time". Shortly after this when the tem-

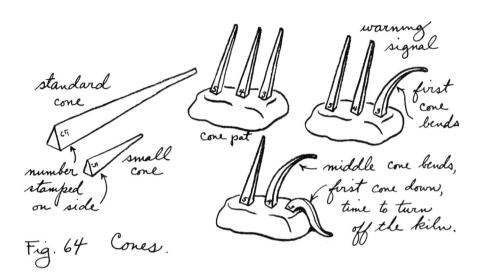

perature goes up a little further, the cone at the right flattens out and the middle cone begins to bend. Watch the middle cone. As soon as the tip is well down, turn off the kiln; the firing is completed. The cone to the left should still be standing, proof that you did not overfire.

Standard cones are about $3\frac{1}{2}$ " long. These take up a lot of room in a small kiln, so for those who operate tiny electric kilns there is a special small size cone, 1" high.

Cones will not tell you the exact temperature of your kiln, but they indicate when the required degree of heat has "soaked" into the ware. Their behavior is affected by the rate of firing. At a slower rate they bend at slightly lower temperatures. The table given on page XV indicates cone temperatures for a temperature rise of about 300°F. per hour. Be careful not to place cones too close to the peephole so that cold air can strike them.

Cones are in such general use among ceramists that temperatures are rarely spoken of in any other way. Thus a ceramic sculptor knows that a common red clay matures at about cone 06, that stoneware clays mature in the neighborhood of 8, and so on. He would probably have to consult the table to translate these cones into degrees.

Kilns

Essentially a kiln is an oven, one planned to reach temperatures far beyond those of ordinary ovens. A kiln must provide a way of generating heat, either by burning fuel or electrically, and it must keep the heat confined within the chamber where the ware is placed. The portions next to the flame and on the inside of the chamber must be built of *refractory* materials, able to stand high temperatures. Around these there must be layers of *insulating* materials to prevent heat from escaping.

Bricks

Bricks that are used on the inside of a kiln must be refractory. Regular refractory bricks are heavy and extremely dense; they can stand high temperatures but they also conduct heat readily. A kiln built of such brick would lose most of its heat through the wall. When refractory bricks are used as a kiln lining, it is necessary to put layers of insulating materials such as bloated mica (vermiculite) or glass fibre or fuller's earth around them and then to build another layer of insulating brick on the outside. Insulating bricks are soft and porous. They will not readily conduct heat but at the same time they cannot stand high temperatures. A brick of this type used on the inside of a kiln chamber will crumble during the firing. This defect has been overcome by the development of a new product, a brick which is both insulating and refractory. These are porous and do not conduct heat readily, yet they will stand high temperatures. I have seen one end of such a brick held in a flame until it became red hot. The other end was still cool enough to hold in the hand. Insulating refractory brick comes in grades numbered 20, 22, 26, etc. The number indicates the temperature the brick will stand; number 20 is good for 2000°F., number 22 will go up to 2200°F., and so on.

Fuels

Kilns may be classified according to the type of fuel they use — oil, gas, electric; according to their construction — muffle, up-draft, down-draft; and according to their operation — periodic or continuous.

Electric kilns

Manufacturers have made tremendous strides within the last few years in developing electric kilns that are easy to operate and comparatively inexpensive. For the sculptor who does not plan to do much work greater than 14 inches in height, an electric kiln is the most suitable. Occasional pieces, taller than 14 inches can still be fired in 14 inch kilns by the method of firing in sections that is shown in Photo Series 38, page 255.

An electric kiln has a chamber that is surrounded by insulating refractory bricks. These in turn are enclosed in an outer casing, usually made of metal. The door, also made of refractory insulating brick with a metal outer casing, may swing on hinges or may have a set of pulleys and counterweights so that it will slide up and down. The door is usually at the front of the kiln, but in some kilns the opening is on top. Some small electric kilns are made so that they may be turned on end and fired either as a front-loading or top-loading type.

The door usually has a peephole through which the ceramist can watch the pyrometric cones during the firing process. In addition many electric kilns have pyrometers.

The heat in electric kilns is provided by elements. These are made of nichrome wire or Kanthal wire or a ceramic product called globar.

Nichrome

Nichrome wire is formed into coils very much like those used in an electric toaster. These coils are set into grooves in the refractory brick which form the lining of the kiln chamber. The best designed electric kilns have the elements set in the sides and the back and in the door as well so that ware is evenly heated from all sides when the kiln is fired. Look for this feature when you purchase a kiln.

Nichrome wire elements are limited to low fire. A kiln with such elements cannot be safely fired above cone 02, but most ceramic sculpture with the exception of stoneware and porcelain can be fired quite satisfactorily in this temperature range. Kilns with nichrome elements are easy and safe to operate and, at the same time, inexpensive. Chamber sizes range from 3" x 3" x 4" for tiny test kilns up to 14" x 14" x 14". The latter is a good size for most studio work.

Kanthal

Kanthal is an iron-chrome-aluminum alloy that is made in the form of wire and also as a ribbon. Kanthal wire is shaped into coils like nichrome wire, while the ribbon is bent into zigzag shape. Both coils and ribbon are placed in grooves on the inside of the kiln.

Kilns with Kanthal elements can be fired to cone 8 and so can be used to produce stoneware and certain low-fire types of porcelain.

Globar

Globar elements are non-metallic. They are made of a ceramic product, silicon carbide, formed into bar shape and set in receptacles in the kiln chamber. Globar elements will stand high temperatures up to cone 13, so kilns with such elements can be used for high-fire porcelain.

Electric kilns, because of their dependability and their ease of operation, are becoming more and more popular. Industrial producers of ceramic wares are making greater use of kilns of this type and so are ceramic sculptors. Not so long ago, studio electric kilns were limited to comparatively small work, but for sculptors who plan large ceramic figures a good type of electric kiln is one made in sections as shown in Photo Series 25. Each portion of this kiln encloses a hexagonal space 23 inches in diameter and 6 inches high. Each section has its own electric element. To fire a piece whose diameter does not exceed 23 inches, sections can be placed one on top of another to provide a kiln chamber of the exact height required, from 6 inches to 6 feet.

Let's see the operation of a kiln of this type by watching the firing of the large group that was shown in Photo Series 20.

An important advantage of this kiln is the ease of loading. It would be a difficult job to maneuver a piece this size through the door of a kiln. Here such maneuvering is not necessary. The floor of the kiln is left in position and the work is placed on it, supported by a number of fire bricks.

Rings of the kiln are passed over the top of the work, one by one,

so that the kiln is actually assembled around the piece. A series of cones in a cone pat is placed on a column of fire brick so that it can be watched through the peep-hole of the next ring. Each ring has a peep-hole so it is possible to place cones at various heights in the kiln.

The roof of the kiln being placed. In order to secure greater height, one ring of insulating refractory brick was used next to the top layer. The roof of the kiln is heavy. In order to make it possible to lift it, a pulley has been fastened in the ceiling directly over the kiln and a wire support has been run through the pulley across to the wall of the studio where a series of counterweights takes up much of the load.

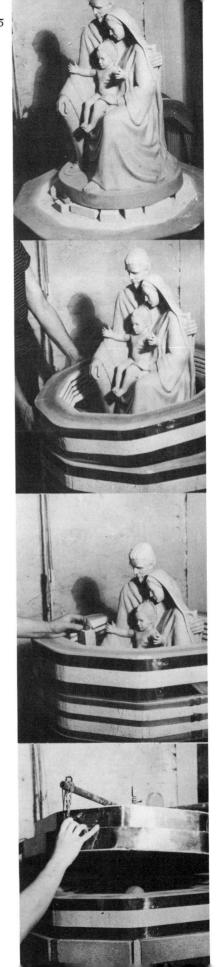

The bisque firing has been completed. The artist begins to apply the glaze. Note that the little sketch has been glazed and fired in a test kiln and note also the difference in the color of the faces and hands. This is due to the different clay pressed in these portions. (see page 104.)

The halo on the Infant was modeled as a separate piece so that it can be given a coating of gold and fired to cone 018, then attached. The finished glazed group is shown on Color Plate 8.

Kilns of this type are made in smaller sizes with rings enclosing a space 11 inches in diameter. As a rule such kilns have nichrome elements.

Electric kilns do not require chimneys and so they can be set up anywhere. A small electric kiln can be plugged into an ordinary 110-volt house circuit but the medium and large kilns require special, heavy duty wiring. This must be installed by an electrician.

Electric elements burn out in time, but proper care can prolong their life for quite a while. They must not be fired beyond their temperature limits, and care must be taken in stacking the kiln to see that no piece is in direct contact with an element and that no glaze gets on it. In spite of all precautions, however, elements will eventually burn out and need to be replaced. It is most important, therefore, before purchasing any type of kiln to make sure that replacement elements can be easily obtained and easily installed and that they don't cost too much.

Gas kilns

Gas kilns may be designed so that the ware being fired is exposed to the flame or protected from it in a sealed chamber called a *muffle*.

Muffle kilns

Muffle kilns are usually of the updraft type like that shown in the diagram in Fig. 65. Here the burners are on the bottom and the flames travel completely around the muffle and continue into a flue at the top. The muffle may be a separate construction within the kiln or the flames may be conducted through the muffle in a series of tubes. A gas kiln with tubes obtains more even heating than other muffle types because tubes are placed in the front of the kiln just inside the door as well as in the sides and the back. These tubes are removed when the kiln is stacked and replaced just before the door is closed and the kiln is fired. Kilns without such a tubular arrangement for the front are cooler in that portion and it is difficult to secure even firing. Muffle kilns are usually of the portable type, that is, they are built in a factory and delivered in one piece. A gas kiln requires a chimney.

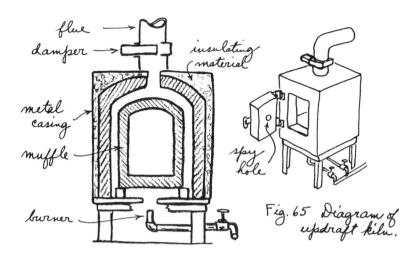

Downdraft kilns

Downdraft kilns are not portable but are built in place. They rarely have muffles. The flames enter such a kiln at the front or sides and go up over a baffle wall (shown in Fig. 66), then are drawn down through the kiln chamber into openings in the floor where they enter a passageway which leads to the chimney. A kiln of this type makes a more efficient use of fuel than an up-draft kiln.

To draw the flames through a downdraft kiln, a strong draft is needed and this requires a chimney at least 20 feet high. To get such a kiln started and the draft working properly, it is sometimes necessary to build a fire in the chimney using the door as shown in Fig. 66.

In a downdraft kiln the flames touch everything in the kiln chamber. This is all right for bisqued ware but most glazes cannot stand actual contact with the flame. Glazed pieces, therefore, must be stacked in fired clay boxes called *saggers*.

Gas kilns should be used only where gas can be supplied cheaply. Natural gas is hotter than manufactured gas. In those sections of the country where natural gas is available a gas kiln is the best type to use. It takes a lot of gas to fire a kiln and sometimes the pressure in gas mains is not sufficient to deliver the gas to the kiln in great enough speed and quantity. In these cases auxiliary blowers must be connected to the burners.

Oil-fired kilns

Where gas is not available, kilns can be constructed to operate with fuel oil. The equipment for such a kiln, in addition to a chimney, includes a tank for fuel, and burners and blowers.

Oil fire kilns can be of the muffle type or downdraft type.

[195]

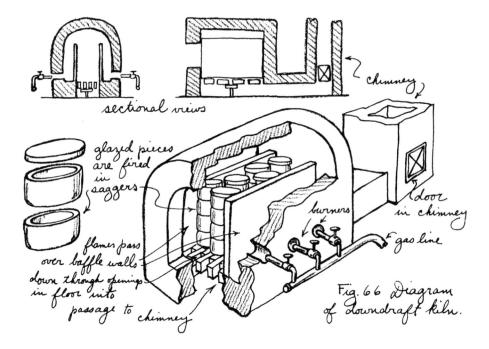

Periodic and continuous kilns

A periodic kiln is one which is fired, turned off, allowed to cool, emptied, then restacked and fired again. A continuous or tunnel kiln is one which is never turned off. The ware moves slowly on cars through the chambers of the kiln encountering increasing temperatures as it moves until, at the center of the kiln, it reaches its maturing temperature. As it continues to move it passes through cooling chambers where its temperature is lowered, until, emerging at the other end of the kiln, the fired ware is cool enough to be lifted off the car. It takes about 36 hours to complete this cycle. Tunnel kilns are used in factory production.

Buying a kiln

Your selection of a kiln will be governed by the kind of work you plan to do, both as to size and firing range, and also by the space at your disposal. Unless you have a fairly large studio, a small electric kiln will be the most suitable type to buy. If natural gas is available in your locality and your studio has a chimney to which you can connect a kiln, a gas-fired muffle kiln of the portable type may serve you best, especially if you plan to do a lot of work and require a large kiln chamber. In a rural location without gas, an oil fired kiln may be best or a gas kiln operated with bottled gas. For stoneware you need a downdraft kiln constructed in your studio. Consult the catalogues of ceramic supply dealers. Kilns of all types are pictured and fully described there.

Before you buy a kiln, acquire as much experience as you can in operating kilns of various kinds. Schools and colleges where ceramic courses are taught have a number of kilns and it is usually possible to enroll for short

courses that permit some kiln operation. The familiarity that you get with kilns this way will help you in making a wise choice.

The firing cycle

Remarkable changes take place in clay when it is heated. In Chapter 7 we learned that clay is formed by the disintegration of feldspathic rock through a weathering process that takes many centuries. When a piece of clay is fired in a kiln, we reverse the weathering process and in a few hours, change the clay back into a substance resembling the original rock from which it was formed.

When we work with clay it is plastic because it contains water, called water of plasticity. When we finish with the modeling and let the clay dry out, the water of plasticity evaporates and our clay becomes rigid and unworkable. There is still some water present, however, in fact water of two kinds. One is atmospheric moisture. Clay is affected by the humidity of the air around it; on a damp day it absorbs a higher moisture content. This is something to keep in mind when you fire large ceramic sculpture, for even though a piece has been drying for weeks, it won't be dry when you put it into the kiln unless it has been kept in a drying room or has been heated.

Besides atmospheric moisture, clay contains chemically combined water. This is present in the molecular structure of the clay particles. You cannot see or feel it, but its presence is what makes clay the workable substance that it is. Once chemically combined water has been driven off, no amount of grinding or soaking in water will make clay plastic again.

Water smoking

The beginning of the firing process is called the *water smoking* period. This is when the atmospheric water leaves the clay. It is an important part of the firing, especially if any large pieces are in the kiln. Go slowly and give all of the moisture a chance to escape without causing damage. In gasor oil-fired kilns, this moisture escapes up the flue. In electric kilns where there is no flue, it is good practice to keep the kiln door open slightly during the first hour so that the moisture can get out.

Dehydration

After the atmospheric water has all disappeared, the next change in the clay comes when the chemically combined water leaves. This occurs before the kiln reaches 1000°F. or just before the clay begins to be red hot. Again this is an important period to watch, especially if the kiln contains large pieces. Raise the temperature slowly. It should take at least two hours to reach the point of complete dehydration, longer in the case of larger kilns.

Just above this temperature, at 1063° F., a physical change takes place in silica making it expand. This is a critical point in the firing cycle, at which large pieces sometimes break.

As the temperature continues to rise, the kiln chamber will start to glow with a dull red heat. Now, if you look through the peephole it will be possible to discern the outlines of objects. At this point, cones become useful (below this temperature you could not see them). At 1121° F. we reach the bending temperature of the lowest cone, 022.

In electric kilns it is not possible, at the beginning of the firing, to judge the kiln temperature by its color because the elements, as they glow, light up the inside of the kiln chamber making it possible to see things in the kiln long before they actually become hot.

Organic matter

From 1000° F. to 1500° F. or from cone 022 to cone 014, the firing process can go more rapidly unless the kiln contains pieces made of natural common clay. During this period organic matter present in common clay burns out, so if much clay of this type is being fired, the temperature must rise more slowly. This is the temperature range of overglaze colors and enamels and also of some extremely low-fire glazes such as chrome reds.

Maturing temperatures

From 1500° F. to 2100° F. or from cone 014 to cone 2, the firing process can be speeded up for unglazed ware. The water has all been driven out of the clay and the critical point of change in silica has been passed, so the temperature can be raised as rapidly as is possible. (This is not true if the kiln contains glazes that require special attention, but most of the glazes used on terra cotta will stand rapid heating.)

Within this range most clays reach their maturing temperatures. Those clays that fire red mature first, in the neighborhood of cone 06 to 04 or about 1900° F. Buff clays must go higher; they rarely mature below cone 1. Look out for red clays as their firing range is short. A red clay that matures at cone 04 will be seriously overfired at cone 1, losing both its color and its shape. Most buff clays, however, have a long range. These can go up to cone 9 or 10 without distortion or other damage.

Vitrification

The higher the temperature to which a clay is heated, the harder it becomes. After it has passed its maturing point, the silica and the fluxes present in it begin to fuse and form a glass. If the clay can be fired up to a high temperature without slumping, the product when it comes out of the kiln will be vitreous, extremely hard and waterproof.

High fire

Beyond cone 2 we get into the temperature range of high-fire work. This is limited to stoneware and porcelain and products made with specially prepared clay bodies. At cone 4 red clays start to melt. This is the point at which a red clay or a brown clay like Albany slip can be used as

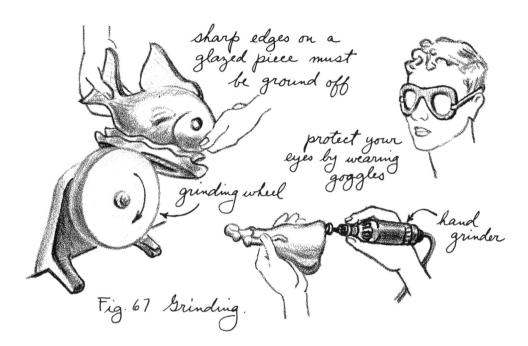

a glaze over a buff clay. At cone 9 the kiln becomes white hot and the maturing point of stoneware clays is reached. This is the temperature at which salt glazing is done. From cone 10 on up to cone 15 is the range of the highest fired of all ceramic work, porcelain.

Cooling

As soon as a kiln reaches the required temperature it may be turned off. There is no need to hold it at the temperature for any length of time. In gas or oil fired kilns the dampers should be left open for a few minutes to allow any gases present in the kiln to escape; after that the dampers should be closed.

The cooling process should be gradual. As a rule most kilns are well enough insulated so that it is merely necessary to turn them off and wait. But wait long enough! Don't hurry the cooling process. A large kiln requires two days to cool and even a small electric kiln should be allowed to cool for twenty-four hours before being opened. Don't ever remove a piece from the kiln until it is cool enough to be lifted in the bare hands.

Grinding

When a piece of ceramic sculpture is taken out of the kiln it may have sharp edges where the glaze has flowed on to the kiln shelf. Look out for these because they can inflict painful cuts. Such edges should be ground off on a grinding wheel or by means of a hand grinder of the type shown in Fig. 67. Protect your eyes by wearing goggles when you do this.

Oxidation and reduction

When the burners of a kiln burn with a colorless flame and the dampers are open, an oxidizing atmosphere is created in the kiln chamber. In most cases this is the atmosphere that the ceramist wants. There are times, however, when he seeks a reducing atmosphere. Such an atmosphere is created when the burners have a yellow flame and the dampers are closed so that the kiln chamber fills with smoke. The free carbon introduced into the kiln that way steals oxygen from other things in the kiln and so reduces the metal oxides to lower oxide forms. Black copper oxide (CuO) which makes glazes green is reduced to red copper oxide (Cu2O) which produces the beautiful red sang-de-boeuf glazes on porcelain, and red iron oxide (Fe2O3) is reduced to black iron oxide (FeO) which produces the pale green color of celadon.

Besides affecting the color of glazes, reduction changes the color of clay bodies, turning buff clay silvery gray and red clay black.

To bring about controlled reduction in a down-draft kiln the ceramist fires the kiln with an oxidizing fire until he has reached the temperature needed to mature the ware, then closes the dampers and shuts off the air from the burners. This fills the kiln with smoke (the room, too) and reduces the ware. After about 20 minutes, the burners are turned off and the kiln is allowed to cool. When it is opened there will be a lot of soot on the inside but this burns out quickly the next time the kiln is fired.

In a muffle kiln it is more difficult to create a reducing atmosphere, for if the muffle is tight smoke won't get inside. It is possible to reduce such a kiln by introducing organic matter such as pieces of fat pine into the kiln chamber.

Electric kilns have no flame and so the atmosphere in these is neutral. An electric kiln can be reduced by putting moth balls into the chamber.

Cones are affected by the kiln atmosphere. In a reducing fire they are not accurate.

Stacking

The process of putting ware into the kiln for firing is called *stacking*. Use care and judgment when you stack your kiln. For the sake of economy, put in as many pieces as you can but don't "choke" the kiln. There must be room for the heat to circulate evenly throughout the entire kiln chamber. When the stacking is completed, if a fly were to go into the kiln just before you close the door, he should be able to fly completely around every piece.

Stacking glazed pieces

Pieces of green ware that are not glazed can touch each other in the kiln. One that is light in weight can be placed onn top of another provided the piece underneath is sturdy and so constructed that it can support the one above it. But pieces that are glazed must not touch anything; if they do they will stick fast. This presents a problem when pieces are glazed all

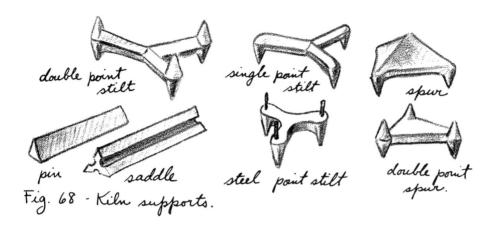

over. Here special supports are needed to hold the work so that no glazed surface touches a kiln shelf.

Kiln supports

To keep glazed pieces from sticking to shelves or to the floor of the kiln, ceramists use supports of a number of different types. Among these are stilts, saddles, spurs and thimbles, shown in Fig. 68. These are made of unglazed porcelain fired to a high temperature. The choice of support to use depends upon the shape, the size, and the weight of the piece it is to hold. The piece must be held in a stable position so that there is no chance of its toppling over, yet the support must touch the piece in as small an area as possible. An assortment of stilts in various sizes serves most of the ceramist's needs.

Home-made kiln supports

There are times when a regular stilt won't serve — the points are not in the right place, or the piece is too small. Bits of ceramic jewelry present this problem and so do forms that don't have a flat base. In such cases, provided you do not intend to fire higher than cone 04, you can make special supports, custom built to fit the objects, using clay and pieces of steel wire, or even nails, as shown in Fig. 69. As an extra precaution mix some fine grog with the clay.

Home-made kiln supports of this type cannot be used for high-fire work because the metal would melt.

Dry footing

Larger pieces of sculpture should be fired standing flat on their bases without any kiln supports. When such pieces are glazed, "dry foot" them, that is remove all of the glaze from the base and from the bottom of the sides leaving a band of bare clay ½ inch wide all around the lower edge of the piece. Such treatment does not mar the appearance of ceramic sculpture; on the contrary, it improves it. With this method, unless you make a mistake and use a glaze that is too fluid, there is no danger of pieces being stuck fast to the kiln shelf.

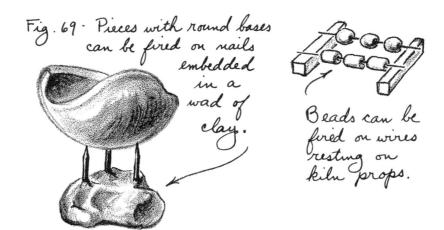

Kiln wash

To protect the shelves and the floor of your kiln against glazes that may run off pieces, paint them with a coating of kiln wash. This is made by mixing equal parts of china clay and flint with enough water to form a smooth creamy liquid. Brush this onto the floor and the shelves with a soft paint brush. Try to get an even coating that is fairly thick. During the firing, kiln wash will harden but will not fuse so that even though glaze drips onto a shelf it can be easily lifted off.

Don't put kiln wash on the walls or on the roof of your kiln chamber because after it hardens it will flake off and will ruin any glazed pieces it lands on. For the same reason apply it to only one side of your kiln shelves.

When you fire small glazed objects that are dry footed, you can stand them on little dabs of kiln wash as shown in Fig. 71. Mix the kiln wash with less water so that it forms a paste. Put a dab of this paste on the shelf, then press the object into position on top of it. The kiln wash then serves the double purpose of holding the object in position and preventing any glaze from reaching its base.

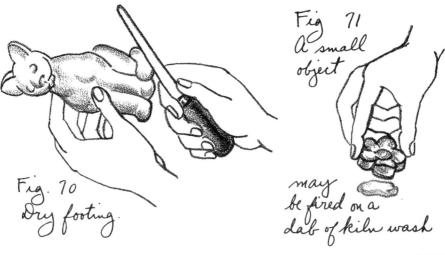

Building a kiln

The electric kilns that are sold by dealers are efficient and comparatively inexpensive. Still many ceramic sculptors prefer to build their own. A simple kiln, hexagonal in shape using iron-chrome-aluminum elements similar to Kanthal can be constructed according to the steps illustrated in Figs. 72-77. The bricks used for this kiln are #26 insulating refractory bricks. Thirty two bricks are required.

Start by drawing a hexagon with sides $8\frac{1}{2}$ inches long, the size of a brick. To do this take a compass and set it for a radius of $8\frac{1}{2}$ inches and draw a circle, then with the compass still at the same setting, divide the circumferences of the circle into 6 equal parts. Connect the dividing points with straight lines and you have a hexagon. It will simplify the work if you cut this hexagon shape out of a piece of cardboard.

The floor of the kiln is made of two layers of refractory insulating brick lying on their sides. The first layer consists of 6 bricks cut to the shape shown in Fig. 72 and then put together to form a hexagon.

The cutting can be planned as shown in Fig. 72. Two bricks are laid on the hexagon pattern so that they form alternate sides, then another brick is placed on top of the other two in such a way that it forms the intervening side. The portion where the top brick overlaps those underneath is marked with a pencil. The brick is then placed in a vise and the marked portion is sawed out with a back saw.

These bricks can be easily cut with a hand saw. When 6 bricks are cut, they are fitted together to make a hexagon. The pieces cut out of the ends are used to fill up the center opening and make a complete layer.

The second layer of the kiln floor is made by cutting 6 bricks as shown in Fig. 73 and putting them together.

The walls of the kiln are made of 2 rows of 6 bricks each. The bricks are stood on edge, with the corners mitred at 60° angles so that when they are placed together they form a perfect hexagon. It is necessary to cut a slot for the element in each brick as shown in Fig. 74. This slot can be made by clamping the brick in a vise and making two straight cuts along the center with a back saw. The cuts should be 3/4 inches apart and 1/2 inch deep. The portion between the cuts is then gouged out with a chisel. The channel cut this way can then be widened at the base with a rasp. If you have access to a milling machine, a better way to cut this slot is with a milling cutter. A simple tool for this purpose is made by grinding the point off a 3/4 inch wood bit and brazing a piece of steel 3/16 inches thick, 1/2 inch wide, and 1/4 inches long to the bottom. This special tool can be placed in a drill, press and rotated while bricks are pushed against it. A block is clamped to the table to guide the bricks under the rotating bit.

The groove in the insulating brick where the heating element comes in contact with the brick should be covered with a thin layer of electric resistor cement. This hardens to a porcelain-like finish and acts as an insulator and a protector of the electric elements. Cement No. 78 manufac-

Fig. 72 · Building a kilm. lay bricks along edge of hexagon and mark with pencil then put brick in a vise and hexagon saw out the marked pattern cut from cardboard first layer second layer 8 bricks cut to form a hexagon third and 60° bevel fourth layers, slot to hold element, with a saw and a rasp, or with this tool [204]

tured by the Sauereisen Cement Company of Pittsburgh, Pennsylvania, is good for this purpose.

The elements for this kiln are made of Jelliff Alloy K, a material similar to Kanthal. This can be obtained from the C. O. Jelliff Manufacturing Corporation of Southport, Connecticut. A ribbon .118" x .0118" is used.

To get good life at high temperatures, it is best to use two elements, each 30 feet long, bent into a zig-zag shape. Each element should fill the slot in one layer of brick around the kiln. To bend the element use a board with brads driven into it as shown in Fig. 75. Insert the 30 foot piece of element in the slot. Bore two holes ½ inches in diameter and allow 4 inches at each end of each element to extend through the brick. Connect the ends of the element outside of the kiln to lead wires using ¾ 6 inch bolts and nuts.

The two elements should be connected in parallel at the kiln by attaching each terminal of the upper element to the corresponding terminal of the lower element, and from here the copper lead wires are connected to the 110-volt outlet. It is advisable to anchor the copper lead wires so that they cannot accidentally place a strain on the elements.

Next the roof. For extra strength and to prevent loss of heat through the cracks, the bricks forming the roof are put together with tongue-and-groove joints as shown in Fig. 76. The grooves are formed by making straight cuts with a back saw and then gouging out the portion in between with a chisel. The tongues are cut with the saw. When both tongue and groove are cut, the two bricks are rubbed together to make a perfect joint. Eight bricks are needed to make the roof. All joints, end as well as side, are tongue and groove.

The roof must be lifted off and on, and so baling wire is used to tie the bricks together. Metal guards, cut from tin cans, are placed at the corners to keep the wire from cutting into the bricks. This makes the roof a strong unit which can be easily handled. The bricks forming the wall can be wired together in similar fashion and so can each of the two layers of the base.

The completed kiln has a hexagonal chamber 6 inches on a side and 9 inches high, containing about 840 cubic inches. This shape is well suited to most sculptural forms, and the fact that the elements go around all sides makes for an even distribution of heat. The removable roof makes it easy to load.

A hole ½ inch in diameter is bored through one of the wall bricks to serve as a spy hole through which the cones can be watched during the firing. A plug for the spy hole is whittled out of one of the scraps cut from the bricks.

This kiln can be plugged into a 110-volt circuit fused for 25 amperes, but there should be no other electrical equipment on the line. It can reach a temperature of 2000° Fahrenheit in about 6 hours.

Two words of caution. Even though the floor is made of two layers of brick, there will be a lot of heat seeping through. The kiln should stand

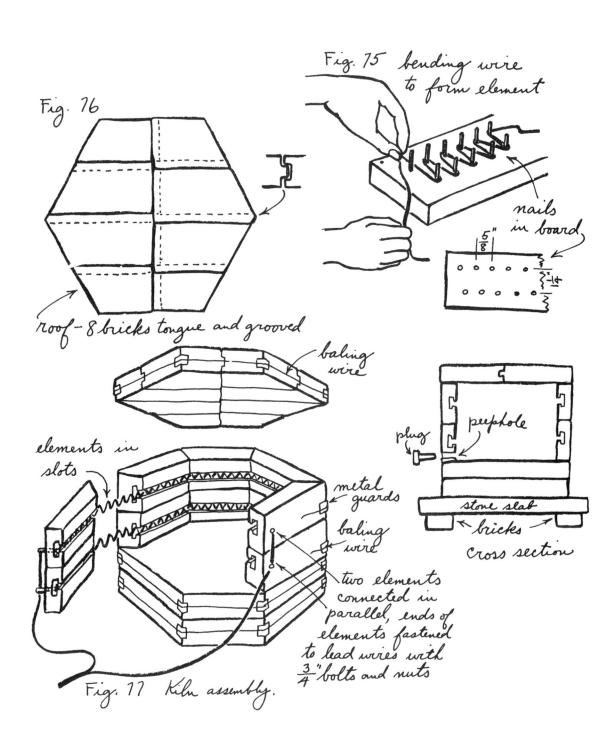

on some fireproof material such as a slab of slate and for additional safety the slab should be supported on bricks as shown in Fig. 77.

The second word of caution concerns the elements. These become extremely brittle after they have been heated, so see that they are securely fastened to the binding posts and that the binding posts are securely fastened to the bricks. Any movement here is liable to break the element.

Know your kiln

Kilns are individuals with different ways of behaving. Be thoroughly familiar with the action of the kiln you use, especially the way it distributes heat. The first time you fire it, place a number of cone pats in different parts. Put one on the floor toward the front, another on the floor at the rear. Place two more on the top shelf, one front and the other back, and put two more on a shelf near the middle, one at the center and another at the side. Mark each cone pat to indicate its position. After the firing you will be able to tell by examining the cones whether your kiln heats evenly and, if not, where the hot and the cool spots are.

In oil- and gas-fired kilns there is usually considerable temperature variation within the chamber. Updraft kilns are hottest on the floor at the back and coolest at the top front. With downdraft kilns the reverse is true; the hottest part is at the top. Keep these differences in mind when you stack. When firing pieces made of red clay and some made of buff, put the former in the coolest area. If the kiln contains glazed pieces, place them so that they will reach the temperature the glaze requires.

Updraft kilns with burners directly beneath the muffle become extremely hot at the bottom. In this case do not place anything on the floor but use kiln shelves supported on short props so that an inch or two of space is left between the bottom shelf and the kiln floor.

Some muffle type kilns that do not have tubes for conducting the flame up through the front portion are quite cool in the area directly in back of the door. The difference in temperature here is sometimes so great that it is advisable to build a wall of insulating brick inside of the door, leaving space so that it is still possible to use the peephole.

Electric kilns do not have as much variation in temperature within the chamber as gas- and oil-fired kilns, yet even here variations do exist. A lot depends upon the position of the elements; if these are placed in the door as well as in the sides and back, the distribution of heat will be more even. Since electric kilns do not have flues, no heat escapes up the chimney, and consequently the hottest part of the chamber is at the top. If an electric kiln is well insulated, the cones will continue to bend for a while after the kiln is turned off so that when you take them out they will be flatter than they were at the moment when you stopped the firing.

10 Decorative Ceramics

Some ceramic sculpture is made solely for decoration. Porcelain flowers, for example, serve no useful purpose but they can ornament boxes and other objects or they may be made into jewelry. In the next series of pictures the steps in making ceramic roses are demonstrated by the artist Monie DeMaggio, who with her sister operates a ceramic shop in Los Angeles, where she manufactures a line of decorative ceramic ware, sells ceramic supplies to home craftsmen, and fires their work.

Ceramic flowers

A thin layer of clay has been rolled with a rolling pin and placed on a newspaper. (A newspaper makes an excellent working surface.) The artist has used a tool which resembles a cookie-cutter to cut out circles of clay for petals. Leaf shapes are cut out with a pointed tool.

Tapering the edges of the petals. The artist uses her finger to make the edges of the clay circles thinner and smoother. In this operation the finger must touch both the clay and the newspaper on which it rests. Larger circles may be used for outer petals if a bigger rose is desired.

Petals are rolled into a cone shape, the point of the cone serving as the top of the bud. The first petal has been rolled. The artist grasps the wide end and holds it in her left hand while she prepares to place a second petal halfway around it.

Putting more petals in place. The edge of this petal is curled outward following the natural shape of a rose. If the petals start to crack, the finger tip is moistened on a damp sponge.

Each petal is placed so that it overlaps halfway around the previous one.

A completed rose. Petals have been added around the bud until the desired size was reached. Buds are made in the same way but are limited to 3 or 4 petals.

Making a leaf. Edges are thinned, notched, and lines are incised with a pointed tool. Leaves are twisted into shape and placed on a damp cloth until the artist is ready to use them.

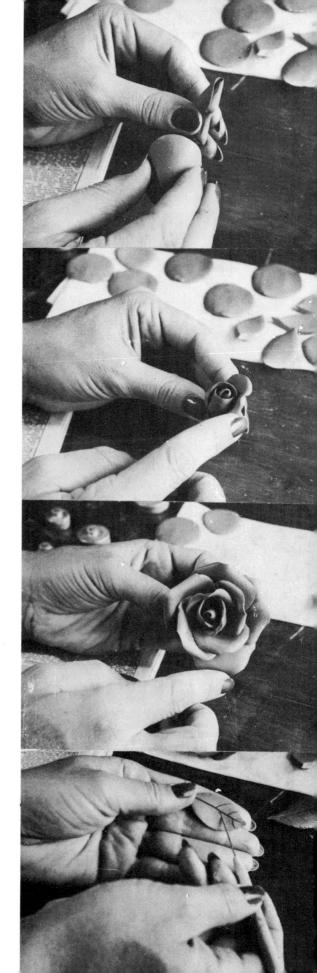

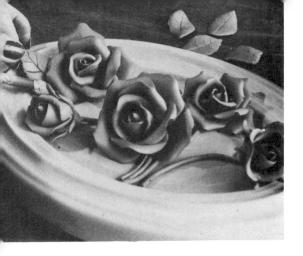

Combining a group of roses on a plaque. The plaque was made in a mold and it has not as yet been fired. Roses and leaves are attached with clay slip. Stems are made by rolling thin coils of clay. Thorns made of small pointed pieces of clay are attached to the stem with slip. Clay shrinks in drying so stems are attached to plaque at *one* end only, preferrably under a flower or a leaf. This prevents the stem from cracking and pulling away from the plaque.

Figurines

Ceramic figurines with their gay color can do a lot to brighten a room. The delicate porcelain shepherds and shepherdesses so popular in Europe a century ago added much to the charm of the interiors of their day. In fact it is difficult to imagine a living-room of that time without some of these porcelain ornaments.

Figurines of this type can be made today of other materials than porcelain. The white casting bodies that are available fire at much lower temperatures and make it possible to produce figurines at temperatures no higher than cone 06 or 05.

Figurines are usually made in molds. Here are the steps demonstrated by the sculptor, Mario Monteleone.

PHOTO SERIES 27

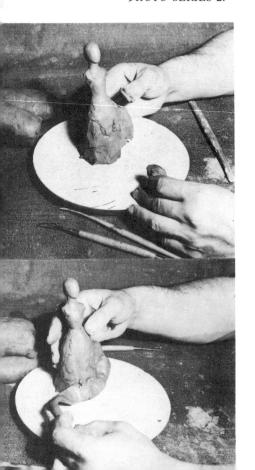

Starting to model a figure. An elongated lump of clay is pressed into the shape of a woman with a wide skirt. The sculptor works on a plaster bat.

Putting a ruffle on the skirt.

More ruffles have been added and the skirt is completed. The sculptor adds an arm.

The lady has a hat. The neckline of the dress has been modeled and the sculptor puts rufflles on the sleeves.

Modeling features, the sculptor has cut sockets for the eyes and now he models the lips.

Detail is added to the hair.

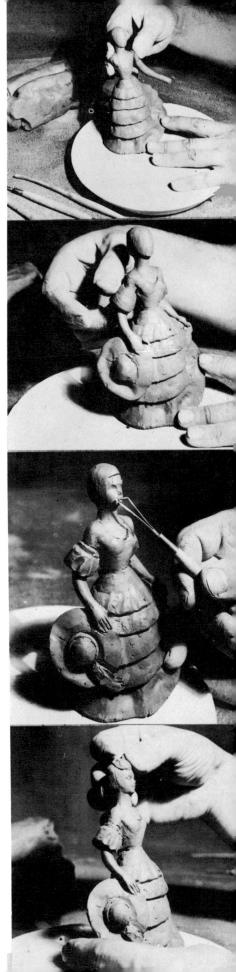

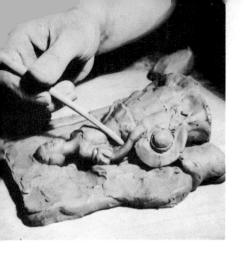

A mold for a figurine

When a model is not symmetrical and its widest portion is not in one plane, a template cannot be used. The model must be embedded in clay up to its widest portion. After this, a casting box will be set in place around the clay backing.

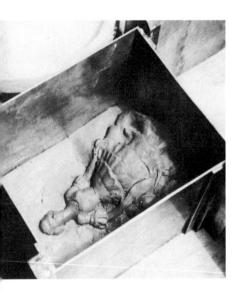

The casting box in place, ready to pour the first half of the mold. (Note that this is a special casting box made of metal, but a wooden one like that shown in Fig. 45 would work just as well.)

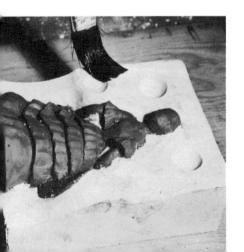

The first half of the mold has set and has been taken out of the casting box. The figure remains embedded in the plaster. The sculptor has cleaned up the edges of the mold and has cut notches. The first half of the mold is being sized.

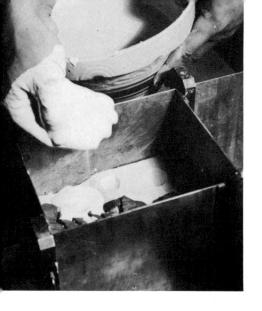

In the casting box again. Pouring plaster by hand for the second half.

The mold in use. The two halves were fastened together with rubber bands, and clay slip was poured into the molding. The finished casting removed from the mold.

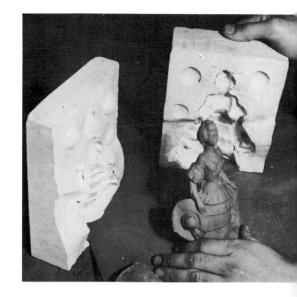

A figurine made in a mold must be rather simple in shape, yet the Staffordshire porcelains and the figures from Dresden and Meissen and other ceramic centers amaze us by their wealth of intricate detail. Shepherdesses wear ribbons in their hair, hold flowers in their hands, and sit under trees with delicate foliage. Some of them wear skirts trimmed with lace. Surely it is not possible to produce such complicated details in molds. How then is this work done?

The answer is that most of the delicate ornamentation is not formed in the mold at all but is added after the piece is cast. Some details are made in separate molds and attached. Ribbons and flowers are modeled by hand, and ceramic lace is made by the process of dipping cotton lace into clay slip and fastening it on.

Ceramic lace

Here are the steps in making ceramic lace demonstrated by the artist, Monie DeMaggio.

PHOTO SERIES 28

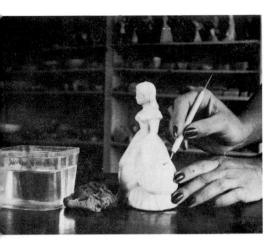

Cleaning the casting. The artist uses a cutting tool to remove the casting ridge. After this the figure is smoothed with a damp sponge.

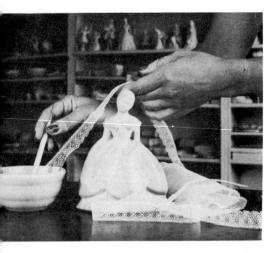

Preparing the lace. Cotton lace is soaked in a bowl of clay slip. This is the same slip that was used to cast the figure, but it was poured through an 80-mesh screen to remove some of the heavier sand. For this work the slip should have the consistency of heavy cream.

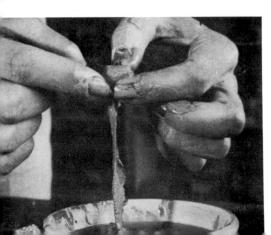

After the lace has been soaked for about 15 minutes, the strip is rolled. This will make it easier to handle, and at the same time excess slip is squeezed out of the lace. It is important not to allow the slip to fill any of the openings in the lace.

[214]

Putting the strip of lace on the figure. The portion where the lace is attached was moistened beforehand with thin slip. The lace is gathered to make ruffles and pressed into position with a pointed modeling tool. It must be pressed firmly against the figure so that it will not fall off.

A piece of cotton net has been soaked in slip. The cotton net is spread on the hand. Wherever the openings in the net have been filled, the excess slip must be patted out.

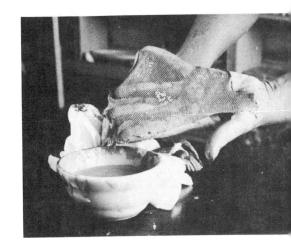

Attaching the net. This is fastened to the figure with slip, making $\frac{1}{4}$ " folds about the waist.

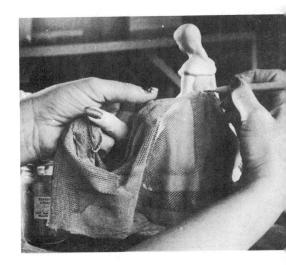

Draping the net. A pointed modeling tool is used.

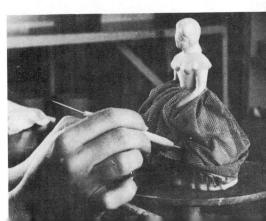

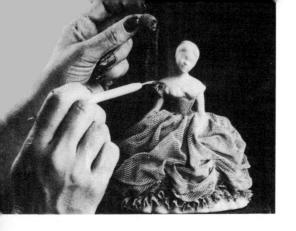

A bodice was added, now a sleeve is formed. Note that the roll of lace is held in one hand while the other hand attaches it.

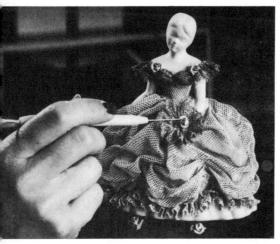

Lace has been added to trim the neckline, and the dress is completed. Lace and net must be coated with a thin solution of slip. Now the artist makes a bouquet.

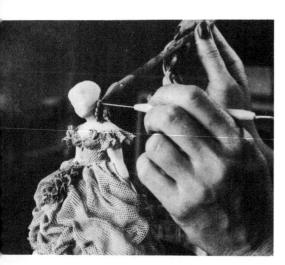

Adding hair. Tiny strips of clay are rolled to form curls and fastened in place.

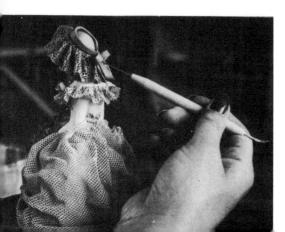

A bonnet is made of lace with a thin strip of clay for a crown and a bow at the back. The figurine is completed. Now it must be allowed to dry and then it will be ready for the kiln.

The finished figure.

The first firing of the figurine was at cone 05. After this it was dipped in transparent glaze, dry footed, and fired again at cone 06. After the second fire, features, ribbons and flowers were painted with china painting colors and a necklace was painted on with liquid bright gold, then the figurine was fired for the third time at cone 018.

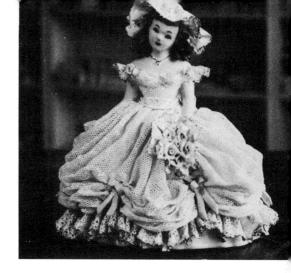

When this figure with the lace attached is put into the kiln, the cotton will burn out leaving the pattern of the lace reproduced in fired clay. This is extremely fragile; the slightest touch would make it crumble. After the figure has been glazed the lace will have more strength. It is a good plan, therefore, to spray a light coating of transparent glaze over the lace and net before it is put into the kiln for the first or bisque firing.

Decorating

The ceramic sculptor does not have as much occasion as the potter for decorating his work but there are times when he must use pigments to paint designs.

Underglaze painting

Underglaze colors are used either on unfired clay or on bisque. After the decoration is painted, the piece must be covered with transparent glaze and fired.

To use underglaze colors provide youself with a glass slab, a small spatula, some gum tragacanth or glycerine, and a fine brush. Place a small quantity of the color to be used on the glass and add an equal quantity of the transparent glaze which you are going to use over the decoration. This glaze is needed as a fluxing agent for the color. Some ceramists prefer to use other fluxing agents such as a clear frit or a special flux called #8 flux.

Mix the flux and the color, add a few drops of gum or glycerine and a few drops of water, and grind the mixture thoroughly with the spatula. Prepare a smooth pigment which can be handled easily with the brush. If it is too thick, add more gum and water until it is just the right consistency for painting.

When the decoration is to be painted on unfired clay, brush a thin coat of gum tragacanth over the surface of the clay first. This will make the clay

less absorbent and the painting will be easier. If the painting is done on bisqued clay, the preliminary coat of gum tragacanth is not necessary.

After the decoration is completed, the piece must be covered with a transparent glaze. It is difficult to apply glaze with a brush without spoiling the decoration in the process so apply the glaze by dipping or by spraying.

Some artists overcome the difficulty of putting glaze over the decoration by putting the piece into the kiln after it has been decorated but before the glaze is applied. The piece is then fired to a low temperature (about cone 010) which serves to harden the decoration on the piece so that glaze can be brushed over it without any chance of ruining the design.

In painting decorations on bisqued ware, ceramists often use oil as a vehicle. When this is done the ware must be put into the kiln for a preliminary firing to burn out the oil before a glaze is put over the decoration.

Polychrome

In the polychrome method of decoration, glazes of different colors are painted on areas of the work. This method was used in glazing the figure of the deer shown in Photo Series 8 on page 52.

Glazes #2, 3, and 4 can be used for polychrome work with colors added according to the table on page 150. Care should be taken to keep the color areas separated but even though there is some mingling of colors in the kiln this usually does not spoil the effectiveness of the glazing. Some ceramists who want to make sure that colors are kept separate, use the device of outlining each area with a thin line of highly refractory glaze. This glaze does not melt and run and so serves as a sort of fence to keep the pigments within bounds. When black underglaze is added to this refractory glaze, it serves to give an outline to each color area and thus sharpen the definition.

Glaze No. 45	Outline for color areas	cone $06 - 04$	
	White lead		12
	Whiting		16
	Feldspar		54
	China clay		10
	Flint		8
Add for black			
	Black underglass	color	10

Majolica

Majolica is a way of decorating ceramic objects by painting on top of a glaze before it is fired. To use this method cover the work with an opaque glaze containing tin or zircopax, then mix underglaze pigments with small portions of the glaze and paint designs on top of the glaze. During the firing the colors on top of the glaze melt into the glaze itself.

Majolica is good for decorating figurines. Use glaze #4, apply a smooth

coat of glaze to the entire piece, then put the underglaze colors you intend to use on a glass slab, add an equal quantity of the same glaze to each pigment, grind them with a spatula, add a few drops of gum tragacanth and you are ready to paint. It is necessary to work fast and no mistakes can be corrected. If you wish to try out your scheme of decoration you can paint it on the piece with India ink. This burns out completely during the firing and leaves no trace, so you can be as free as you wish in sketching the design. The surface of an unfired glaze is not easy to work on since it is just about as absorbent as a piece of blotting paper. If you find that you cannot control your brush strokes, brush a thin coating of gum tragacanth on top of the glaze before applying the decoration.

Even though you paint over the glaze you must use underglaze colors. This is because both glaze and colors are fired at the same time and so it is necessary to use pigments which can stand as high a temperature as the glaze itself.

Overglaze or china painting

Overglaze decorations are painted on ceramic pieces which have been glazed and fired. Overglaze pigments are used. These pigments must be ground on a glass slab with small quantities of special overglaze flux. Various oils are used as a vehicle for painting, among them lavender oil, fat oil of turpentine, and oil of balsam. When the decoration is completed, the piece is allowed to dry, then put into the kiln and fired to a temperature just high enough to allow the glaze to soften slightly so that the colors become locked in the glaze. Thus, although the glaze itself may have been fired to the temperature of cone 04 or higher, the overglaze decoration need be fired only as high as cone 018 to cone 012. Overglaze colors begin to fade out when they are raised to a higher temperature than this.

Dealers sell a wide variety of overglaze pigments which include just about all the colors you can imagine, as well as metallic platinum, metallic copper, and lustres. These can be purchased too in liquid form with flux and vehicle added, ready for use. The firing of these pigments must be carefully controlled since it is necessary to bring them to the exact temperature they require and no higher.

Gold

Gold is more widely used than any other metallic decoration on ceramic work. Several forms are available, liquid bright gold, brown powder gold, paste gold, and liquid burnish gold. For ceramic sculpture, liquid bright gold is the best to use. Painted on a glossy glaze this gives a brilliant shining surface; over a mat glaze it is less brilliant and more yellow.

Liquid gold contains resinous materials that act as vehicles so it requires no additional preparation but may be painted directly on the ware. A very thin application is needed and so, even though gold itself is costly, gold decoration on ceramic work is inexpensive. A touch of gold may add a lot to the beauty of a small figurine.

Gold must be fired to cone 018, preferably in a slow fire of 12 hours or longer.

Sgraffito in glaze

A type of sgraffito decoration can be made in glaze that has been applied to unfired ware. The method is similar to that described for engobe on page 142. A glaze that is not very fluid is put on a piece of raw ware, either with a brush or by spraying, then portions are cut away so that the clay beneath shows through, forming a design. When the piece is fired the design forms a contrast in both color and texture with the glazed portion.

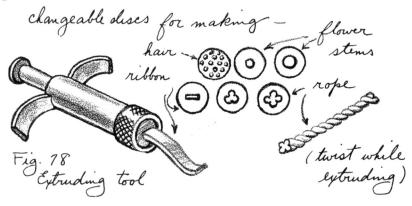

An extruding tool

The figurine shown in the last picture had an additional decoration added to her head-dress. This was made with an extruding tool like the one shown in Fig. 78. The tool consists of a cylinder and a plunger. When the cylinder is loaded with clay, pressure on the plunger forces the clay through a metal disc with perforations so that thin coils of clay are formed. Tools of this type are sold by ceramic dealers. They are provided with a number of discs with openings of different shapes. These discs make it possible to produce long coils of clay, ribbons, and other shapes. This is the way such a tool is used to make a fancy tail and mane for a horse.

The extruding tool produces clay hair. Note that the artist rests the work on a damp cloth.

PHOTO SERIES 29

A pointed tool is used to attach the hair to the figure. The horse was cast in a mold. The portion to which the hair is attached was moistened with slip.

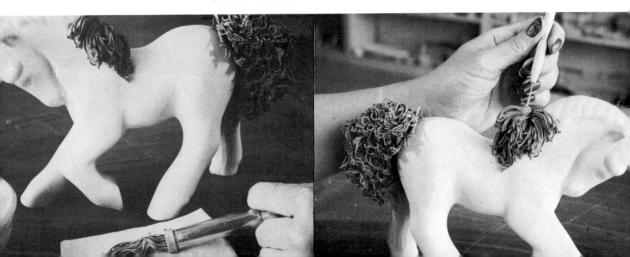

Decalcomanias

The English potters of the seventeenth century devised a method of decorating their china by using decalcomanias. Decorations were printed on specially prepared paper and then transferred to the ware. Copper plate engravings were used in this process and the printing was done in ceramic pigments so that when the ware was glazed and fired the decorations remained. Some beautiful work was produced this way.

A decoration will be applied on top of a fired white glaze. The ware must be clean. The artist uses her finger to apply a thin layer of decalcomania varnish. This must be allowed to dry until it becomes tacky. When the varnish is just right if you press your finger against it you can lift the plate slightly.

The decalcomania design is fastened to a sheet of transparent tissue paper with a piece of opaque paper on the back to protect it. The backing paper is peeled off.

PHOTO SERIES 30

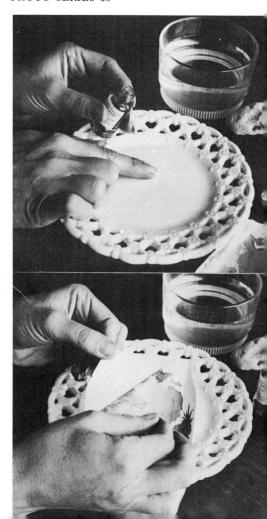

[221]

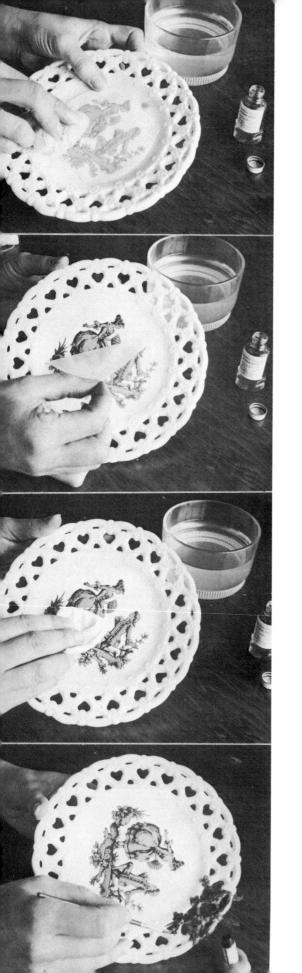

The design is put in place, color down, on the varnish and pressed with a damp sponge from the center out until the tissue paper becomes soaked and separates from the design.

Peeling off the layer of paper. This must be done with care so that the design is not marred in any way. Some artists prefer to hold the work under the tap and let the running water carry the paper off.

Pressing the design in place with a dry cloth to make sure that all water and air bubbles are removed. Don't rub. If an air bubble is trapped under the design, make a slight prick with a needle to release it and then press lightly with a cloth.

Painting the border with liquid bright gold. Note how the tiny bottle of gold is stuck in a wad of clay to keep it from tipping over.

Marbleizing

Here is another decorating technique. After the liquid gold has dried for an hour and a half, a coating of *marbleizing liquid* is brushed over it. This makes the gold break into thin lines and areas during the firing. The marbleizing liquid must cover thoroughly; if any area is missed the gold will be solid at that place and the effect will be spoiled. When the liquid is applied the cracks soon appear, so examine the work closely and touch up any spots free from cracks.

The finished plate.

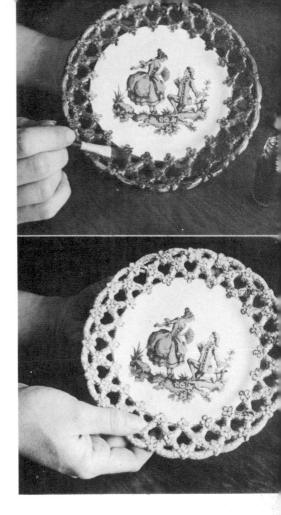

Ceramic crayons

It is possible to make colored pencils somewhat like crayons that can be used to decorate clay either in the raw or in the bisqued state. The method is to prepare a porcelain body, then add pigments and form the clay into crayon shape. After they have been fired to cone 04, such crayons will be firm enough to handle, yet soft enough so that the colors they contain will rub off on to the ware leaving marks very much like pencil marks.

To make such pencils, prepare a body as follows:

China clay	30
Ball clay	17
Feldspar	15
Flint	37
Bentonite	1

The above recipe weighed out in grams will be sufficient for about 10 pencils. Weigh the ingredients and mix them dry. When thoroughly mixed, weigh out 10 grams, enough to make one pencil. For color, add to each 10-gram batch the following quantities.

for	blue	_	2	grams cobalt carbonate
"	brown	_	5	grams manganese dioxide
"	green	_	2	grams chromium oxide
,,	red	_	50	grams maroon stain
,,	black	_	$\begin{cases} 2 \\ 1 \end{cases}$	grams manganese carbonate gram copper oxide gram cobalt

Mix the color and the porcelain body together dry. Then add enough water to make the material into a workable paste Form it into crayon shape, allow it to dry, then fire in your kiln to cone 04. After they have been hardened, these crayons are used in the same way as underglaze colors. If you wish to experiment further, try using any of the underglaze colors as pigments.

Defects in decoration

Decorations painted on ceramic ware sometime do not turn out as well as the potter had expected. One difficulty frequently encountered, especially with blues, is that the decoration shows as a rough area instead of as part of the smooth surface of the glaze. This is due to insufficient flux. Spray or brush a light coat of transparent glaze over the piece and fire it once more.

Another difficulty encountered with decorations is that the colors do not come out as they should. Brightness is lost, reds turn to brown, etc. This is frequently the result of over-firing. It is not possible to correct this defect, so try some test pieces at lower temperatures before using the decorative method again. If whites turn pink look out for chromium in the kiln.

Sometimes in majolica work decorations disappear because the colors run together and mingle. This happens when the glaze used is too fluid or when it is fired too high. Try again with a test piece firing to a temperature two or three cones lower.

Decorative ceramics

There are many kinds of ceramic sculpture. Among these, ornamental ware, like that described in this chapter, has its own place. Porcelain figurines of great beauty have been produced by craftsmen in this field, and some of their creations have become the treasured posessions of collectors in museums throughout the world. If you do this type of work, avoid going to excess. Aquire as much skill as you can. Handle your materials sincerely, and the objects you produce will be honest and satisfying works of art.

11 Ceramics for Use

CERAMIC SCULPTURE need not be made just to look at; it can combine beauty with utility. In this chapter we shall consider objects made of clay which, besides being ornamental, serve useful purposes.

Candlesticks

In Chapter 1 we made a candlestick by modeling the figure of an angel holding a basket. But candleholders need not have figures, they can be made of simple clay shapes. Some time ago at a party given by a sculptor friend of mine, there was a long buffet table lighted by a row of candles down the center. Each candle was stuck in a cube of clay — not fired, just plain plastic clay — and the effect was good.

Take a lump of clay and tap it with a flat block of wood into a cube about 2" on a side, then push a candle into the clay so that it is held upright. Twist the candle to make the hole a trifle larger (to take care of shrinkage), then remove it. You have a candlestick — a simple one, but practical.

Make a number of candleholders like this and fire and glaze them. You will find them convenient for various table arrangements. They can be grouped in different patterns and can be placed in dishes with flowers. Try other forms besides the cube — cylinders or half spheres or some abstract shapes made by simply squeezing a lump of clay in your hand.

Making a candleholder involves all of the principles of design. A good

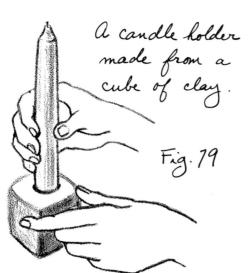

candlestick must be functional and suited to its purpose. Since its purpose is to hold a candle, it must have a receptacle of the right size, not too small so that the end of the candle has to be whittled to fit, nor so large that something must be wrapped around the end of the candle to keep it from wobbling. It must have a base big enough and heavy enough so that the weight of a candle will not tip it over. Candles sometimes drip; a well designed holder will provide for this and have some way of catching the wax that rolls down the

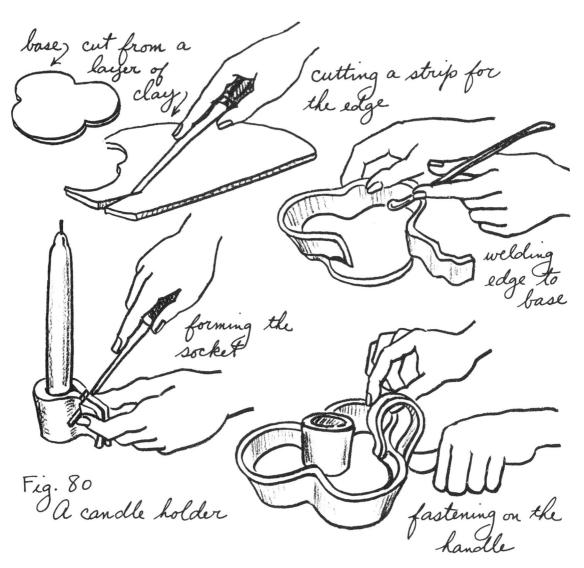

Candles are frequently moved about, so a holder should be easy to grasp in the hands. Finally, candleholders should be good to look at and in harmony with their surroundings.

A conventional type of candlestick with a socket standing in a saucer can be made by the slab method. Cut the shape of the bottom of the saucer out of a layer of clay that has been rolled to a thickness of ½", as shown in Fig. 80. Here we are using a trefoil shape but any other simple outline would serve as well. Fasten a strip of clay along the edge to make the saucer rim. To form the socket, wrap a strip of clay around a candle and fasten the ends, then attach it to the center of the saucer (enlarge it a bit to allow for shrinkage). The handle is made from another strip of clay. When bending strips this way it is necessary to coax the material so that it won't crack. Use clay that is plastic and quite soft. If it starts to crack moisten the outer edge. Be sure that all joints are welded firmly together.

Coil work

If you would like something more elaborate, here is a method of using a twisted rope of clay to make a holder for two candles.

Roll a long thin rope of soft clay and lift the ends so that the coil is folded in half.

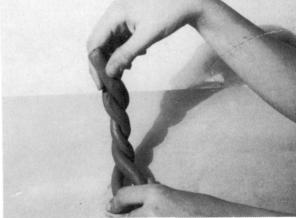

Twist.

Make a base out of a ball of clay flattened on one side. This base should be solid, for the extra weight is needed to give stability. Make sockets for the candles by pressing a piece of clay into a strip, and wrapping it around the end of a candle, squeezing the ends together and trimming off the excess. Cut a disc out of a layer of clay with a cookie cutter and fasten it to the base of the socket.

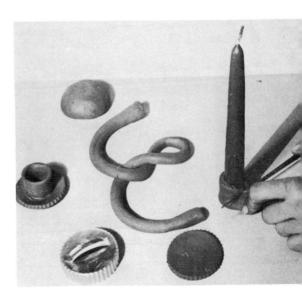

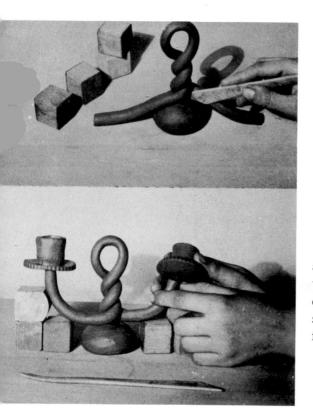

The sockets are completed. Fasten the twisted coil to the base as shown.

Bend up the ends of the coil and attach the sockets. The blocks of wood will support the coil until it is firm enough to stand by itself. The candlestick will then be ready to dry and be fired.

Clay strips

A simple holder for two candles can be made from a strip of clay placed on edge and formed into an S shape with the ends making complete loops as shown in Fig. 81. The strip should be about 10" long, 2" wide, and ½" thick. Try candles in the loops for size and press a wad of clay into the bottom of each to form a socket with no opening at the base. Variation in this design can be made by having the strip wider in the center and tapering at the ends, or roll a thin coil of clay and make a handle of it as shown.

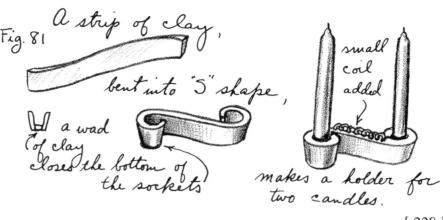

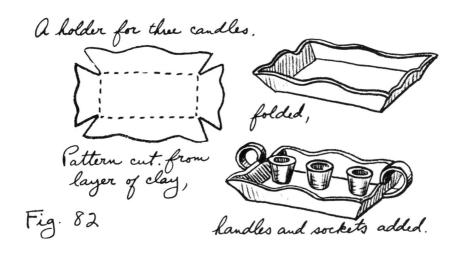

A holder for three candles like the one in Fig. 82 is made by rolling a layer of clay, cutting it to the shape of the pattern, and folding it together to form a long saucer. Three sockets are fastened in place as shown, and two handles are made from strips or coils of clay.

A wall candlestick

The steps in making a wall candleholder are shown in Fig. 83. Make a drawing of your idea, then cut the shape for the back out of a layer of clay $\frac{1}{2}$ " thick, then make a saucer and a socket as shown and attach them. Model a brace of clay and put it underneath the saucer for additional support.

The back should not be entirely flat; after it is cut out, model it slightly to give more of a three-dimensional quality. Don't forget to make a hole so that it can hang on a wall.

There are other ways of making candlesticks besides those we have shown. Coils and strips of clay can be folded into shapes to hold numbers of sockets. Fig. 84 offers a few suggestions.

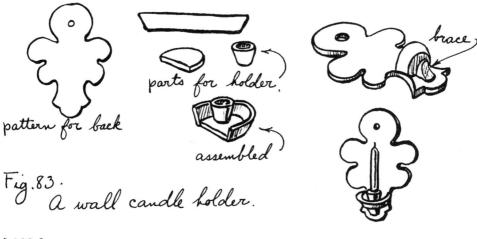

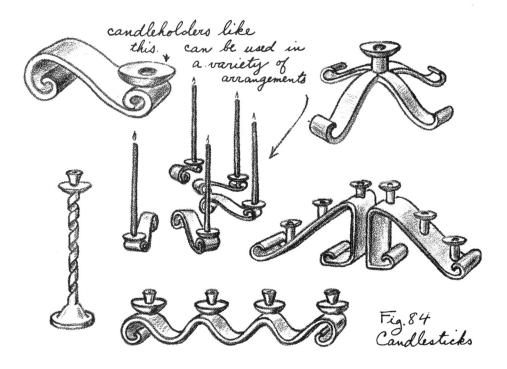

Lamps

Over two thousand years ago, potters were making lamps of clay — lamps that had wicks and burned oil. Today our lamps are lighted by electricity, but pottery is still a favorite material for their construction. The problem of making a lamp base is similar to that of the candleholder; after all, a lamp is really just a holder for an electric bulb.

Lamps in cylindrical form can be thrown on the potters' wheel, but if you don't own such a piece of equipment you can make a cylindrical lamp by slab building using a cardboard core as a temporary support. Let's watch the steps.

PHOTO SERIES 32

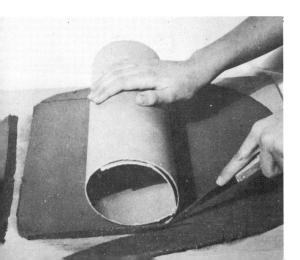

A layer of clay has been rolled ½" thick. The artist cuts a piece just the right size to wrap around the cardboard core. The ends are beveled so that they will join without making a thick place in the wall where they overlap.

[230]

Wrapping the clay around the cardboard.

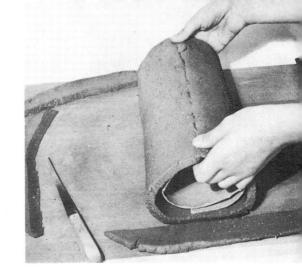

Welding the joint.

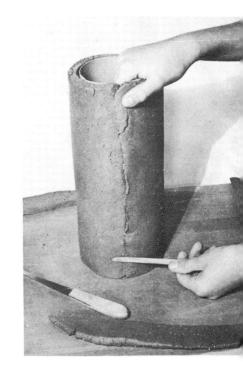

Making the top. A small cylinder of clay to form a neck is attached to a slab and welded fast. A pencil has made a hole through the neck and the slab.

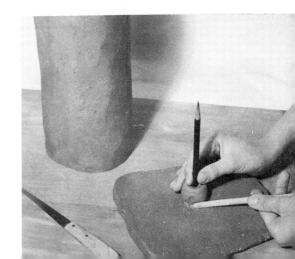

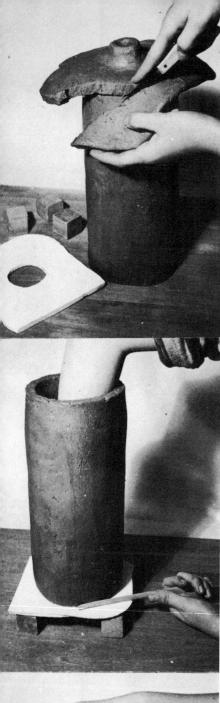

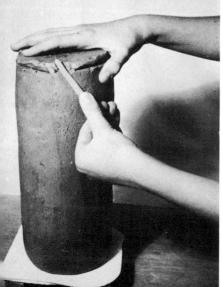

Putting the top on the cylinder and trimming off excess clay at the edge. When the top is welded to the side, the lamp will be turned upside down. The plaster slab with a hole cut in the center shown at the lower right will be placed on blocks of wood and the lamp will rest on the slab with the neck projecting through the hole.

The lamp upside down. The cardboard support has been removed. Welding the inside of the top.

Adding the base and welding it to the side. A depression should be made in the base so that the lamp will not wobble.

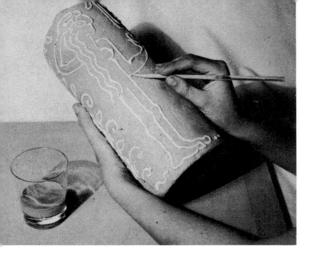

Decorating with a slip trailed design in white engobe (the lamp is made of red clay). The method of slip trailing is described in Chapter 7.

The design used shows Adam and Eve; this is Eve,

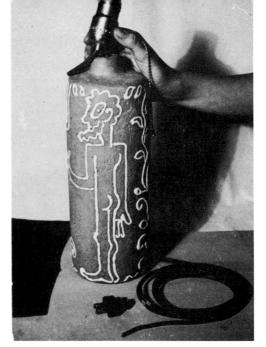

and here is Adam. The lamp has been fired and materials are assembled for wiring it.

Building a lamp with the whirler

Lamps that are vase shaped cannot be made of slabs, but they can be built by the coil method. An adjustable hand rest like the one shown in Fig. 17 on page 26 used with a whirler makes it possible to construct round forms that are perfectly true. The bar is raised or lowered to different heights and the right hand, holding a modeling tool, is braced on the bar while the whirler is turned with the left hand. In this way a form can be built by adding coils or slabs of clay, welding them in place and then truing up the shape by holding a tool against the clay as the whirler turns. Here are the steps illustrated.

PHOTO SERIES 33

Ready to start. A sketch of the lamp has been drawn on paper. The whirler is in place, and tools have been assembled. A ball of clay the size of an orange is flattened into a disc to serve as a base for the lamp.

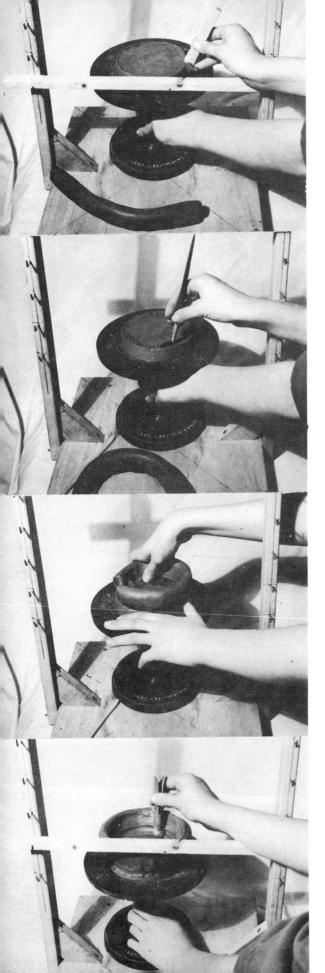

Shaping the base. The clay disc has been fastened to the whirler. The sculptor makes it round by holding a wooden block against the edge as the whirler is turned.

Starting to build the wall. The edge of the base has been roughened and is being moistened. A coil of clay has been rolled and is ready to put in place.

Welding the coil in place.

Truing up the inside surface. A clothes pin is a good tool for this purpose.

Truing up the outside with a wooden block.

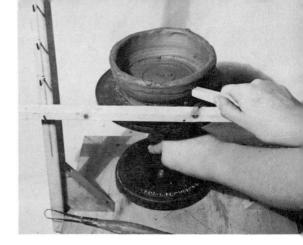

Adding another coil and welding it into position.

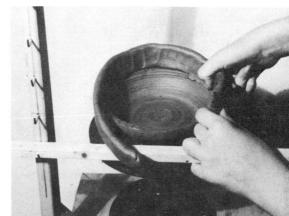

The wall grows higher. The handrest has been moved up a notch.

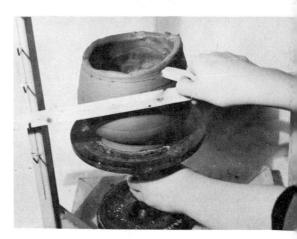

The wall grows still higher and the handrest has been raised three notches. A larger block of wood is used for the shaping.

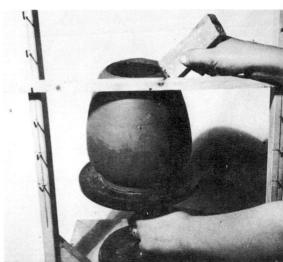

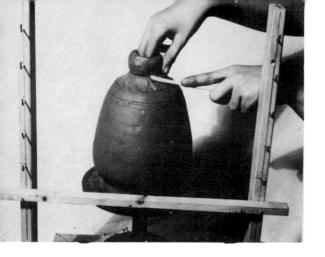

Putting the final coil in place.

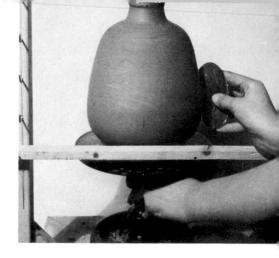

The coil building is completed. The surface is now being finished with a steel scraper.

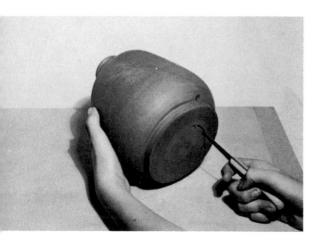

A hole is cut in the base so that the lighting fixture can be fastened from the inside. A small hole has been made just above the base for the wire.

The finished lamp, glazed with an ilmenite glaze No. 30, is shown on Color Plate 4.

Looks easy, doesn't it? Well it is. All of the steps in forming the lamp were completed in thirty minutes. Fig. 85 shows a number of other lamp forms that can be made in this manner.

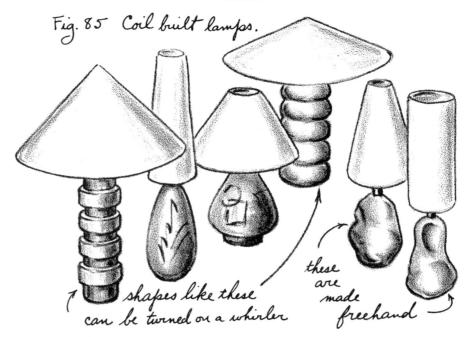

A rectangular lamp

Lamps of rectangular shape can be made by the slab method. This is how it is done.

PHOTO SERIES 34

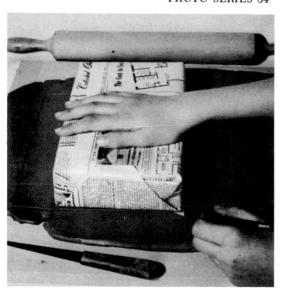

A layer of clay has been rolled $\frac{1}{2}$ " thick. A cardboard box will be used as a support while the lamp is formed. The box has been covered with newspaper (to make it easier to remove later on) and now it is being used to mark off a pattern on the clay.

Wrapping the clay around the box and sealing the joint. Care must be taken here to make sure that the ends are pressed firmly together.

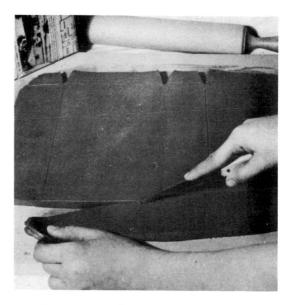

Cutting out the pattern to cover the top and sides of the box. (The bottom will be left open.) Note the beveled ends.

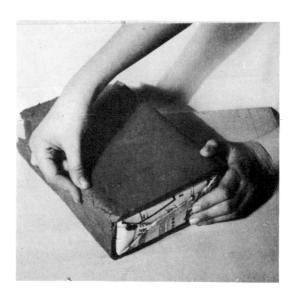

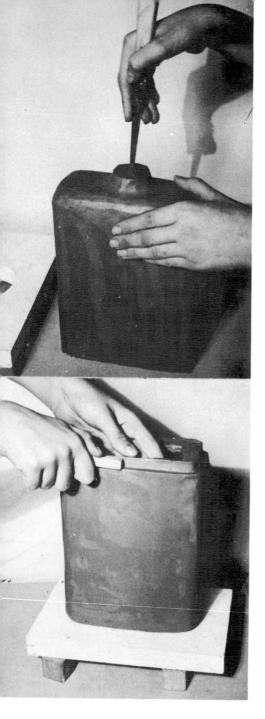

A cylinder of clay has been welded to the top to form a neck. Now a hole is cut for the light socket.

The lamp upside down resting on a plaster slab with a hole in the center for the neck. The box has been removed.

Adding a rim of clay to the base. This will improve the appearance of the lamp and at the same time will serve to prevent warping during the firing.

Applied decoration

A bit of sculptural decoration. An ornamental design is cut out of a thin layer of clay,

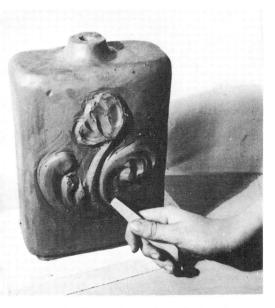

and applied to the side of the lamp. The back of the design was painted with slip beforehand. It is important to weld the design firmly in place. At the same time the ornament is worked on with modeling tools so that the cut-out look is destroyed.

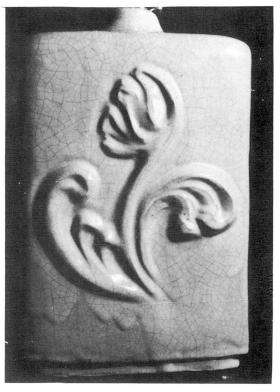

The finished lamp covered with a white crackle glaze, No. 28.

Making the base even

To make sure that a lamp will stand without wobbling, grind the base when it is leather hard or dry. Put a little water on a smooth board, hold the lamp with two hands, place it on the board and move it about with a circular motion for a few seconds as shown in Fig. 86. This will grind the bottom down to a perfectly level surface. Don't do too much of this because the grinding action is fast, and don't let the lamp stand motionless in the water at any time. If you do, it will glue itself firmly to the board and may break when you pull it away.

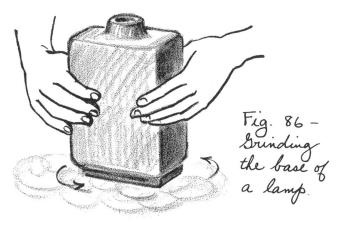

Wiring a lamp

The simplest type of lamp to wire is one planned so that the electric socket can merely be stuck in the end of the lamp as shown in Fig. 87 and fastened in place with Duco cement or plastic wood. To wire a lamp this way you will need a socket, a plug, and 8 feet of wire. The wire you buy may be rubber covered or covered with a rayon fabric. The rubber-covered wire wears better.

Pass the wire through the lamp so that one end comes out at the top and the other comes out through the hole in the base. Then attach the wire to the socket and to the plug.

The wire actually is two wires insulated from each other. To attach the wire to the plug, remove the insulation from the end exposing about 1" of bare copper wire. Each wire is not a single piece but a number of thin strands; be careful not to cut into these when you remove the insulation. The plug has two brass screws, or binding posts which must be loosened. Each wire from which you have removed the insulation must be twisted, then wrapped around one of the binding posts and the screw tightened firmly with a screwdriver. It is important to do this work so that the uninsulated wire is completely wrapped around the binding post; allow no portion of bare wire to touch any other part of the socket, otherwise you will have a short circuit.

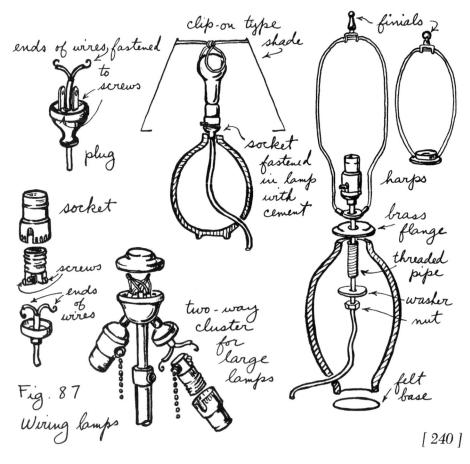

Color Plate 11 Ceramic fountain. Red clay glazed with transparent and majolica glazes.

Color Plate 12 Color samples. -

Top row

- 1-buff clay colored with artists oil colors
- 2-bronze patina
- 3-bronze patina with green pigment
- 4—buff clay treated with milk and iron oxide

Second row

- 1-buff clay with manganese and cobalt
- 2—buff clay covered with slip containing burnt sienna
- 3—buff clay with manganese cobalt and copper
- 4-buff clay with black underglaze color

Bottom row

- 1—red clay fired to maturing temperature
- 2-red clay underfired
- 3-red clay overfired
- 4-red clay waxed

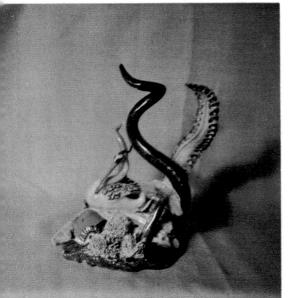

COLOR PLATE 13 Ceramic landscape decorated with china painting colors.

COLOR PLATE 14 Fish. Majolica.

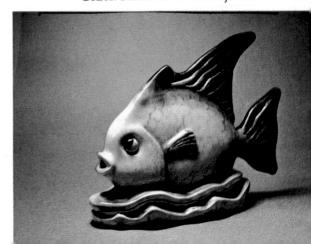

A socket has an inner portion and a casing in two parts that can be pulled apart as shown in Fig. 87. To attach the socket remove the insulation from the ends of the wire as before, pass the wire through the lower portion of the socket as shown and attach the two wires to the binding posts, then reassemble the socket.

All that remains now is to fasten the socket into the end of the lamp with cement or plastic wood and the job is done. This lamp has no fixture for holding up a shade so the shade must be of the clip-on-type that fastens over the bulb.

For a larger lamp which requires a heavier shade, it is necessary to have a metal frame called a *harp* at the top of which is a metal ornament that screws on, called a *finial*. This serves to hold the shade in place. Harps come in various sizes and in two styles. Type A shown in Fig. 87 is screwed onto the socket itself; type B is placed beneath the socket. To wire a lamp with a harp like type B, you will need a short section of threaded pipe, and some nuts and washers. You will also need a brass flange or vase top.

For lamps that are quite large and planned to hold two bulbs, a fixture called a two-way cluster is needed. All of these fixtures can be bought at hardware stores or at electrical supply houses. The methods of wiring them are shown in Fig. 87.

A felt base

A lamp should have a piece of felt glued to the bottom so that it can stand on polished surfaces without marring them. This is true of any piece of ceramic sculpture which is to be placed on finished woodwork. In the case of lamps, the felt bottom serves the additional purpose of hiding the opening that had to be left to make the wiring possible.

You can buy felt which has a coating of glue on one side. From this material cut out a shape, lay it in place and then press a hot iron against it. The heat softens the glue and makes the felt hold fast to the base of the lamp. If you cannot find felt of this type, any piece of felt will serve. Cut the shape and glue it to the base with Duco cement.

When you use Duco cement, do not make the mistake that I did the first time I tried it. I cut out a piece of felt, applied a good heavy coat of Duco cement to the lamp base, put the felt in place and then stood the lamp right side up on the dining room table (our best piece of furniture) to let the cement dry. But some of the solvent used in the cement soaked through the felt and when I tried to lift it up later, I found my lamp stuck fast. When I finally pried if off, I took the finish of the table along with it. So if you use Duco cement, make sure it is thoroughly dry before you stand the lamp on any finished surface.

Drilling a hole

When you make a lamp, don't forget to provide a hole for the wire to pass through at the base. This should be done, of course, before the lamp is fired because it is easy to pierce raw clay, but drilling through fired pottery is quite a task. If you should ever forget this detail and face the need of making an opening in a piece of pottery after it has been fired, you can make the hole with a small electric drill provided you keep the drill and the piece you are drilling moistened with turpentine. This will reduce vibration and make the drilling action possible.

Decorating a lamp

Ceramic lamps may be glazed with solid colors or they may have designs painted on them by any of the methods of underglaze or overglaze decoration described in Chapter 7. Decorations can be made with engobe as well. Clay slip in a contrasting color can be trailed on as shown on page 140; designs may be painted in slip with a brush, or sprayed against stencils as shown in Fig. 54 in Chapter 8.

Modern designers have made some effective lamps using the sgraffitto method of decoration. This is particularly good for large lamps that are not glazed. Here are the steps.

A lamp made of buff clay has a colored engobe brushed on over the entire surface before the lamp has been allowed to dry. The engobe is made of the same clay as the lamp with 20% of burnt umber added for color.

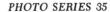

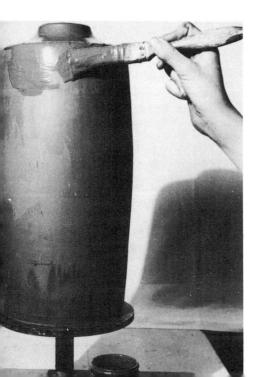

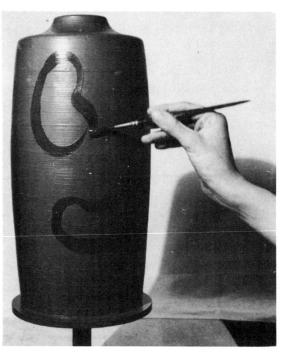

The lamp completely covered with engobe. Designs are painted on with engobe of a contrasting color made by adding 5% of black underglaze color to the original engobe.

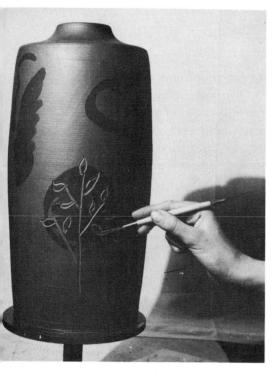

Sgraffitto. A wire loop tool is used to cut designs through the layers of engobe.

Modeling in relief

We saw in Photo Series 34 how decorations can becut from a layer of clay and applied to the side of a lamp. Another way of ornamenting lamps is to plan a decoration with the background cut out so that the design remains in relief. This is the method that was used in making the tile shown in Photo Series 15 in Chapter 6. Follow the same steps. Draw the design on paper and when the lamp is leather hard, transfer the design to it by putting the paper on the lamp and tracing the outline with a pencil. Then use a wire loop tool to cut out the background to a depth of ½" and complete the modeling of the design so that it doesn't look like a piece of jigsaw work. If you plan to decorate a lamp by this method make the walls a little thicker at the start so that you will have room for your carving.

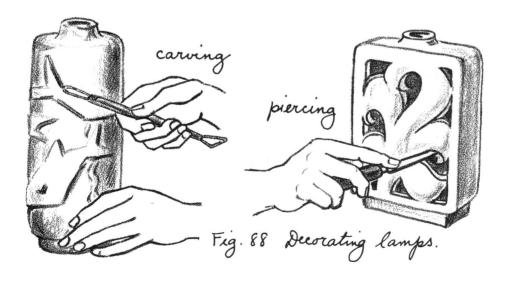

Pierced decoration

You can go a step further in carving your lamp and cut out the background completely, leaving only the design. On some lamps of rectangular shape, decorations made this way are quite successful. The design must be planned of course, so that the openings are not large enough or numerous enough to weaken the lamp itself. Remember, too, that the shapes you cut out are as important in the appearance of the finished product as the shapes that remain.

Spiral decorations

Lamps of cylindrical form are frequently decorated by bands of ornament that move around and up the lamp in spiral form. The placing of such decorations can be planned by wrapping a piece of string around the cylinder in the desired position. Spiraling a piece of rope around a lamp while the clay is still soft as shown in Fig. 89 will imprint a design that is pleasing.

Sprig molds

Raised decorations can be applied to lamps by using sprig molds. The method of making these was shown in Photo Series 17. Clay is pressed into a sprig mold to form an ornament, then it is carefully taken out, the back moistened with slip and fastened to the lamp. The final picture of Photo Series 23 shows a lamp decorated this way. One advantage of this method is that the ornament is modeled on a flat surface but the pressing from the mold can be wrapped around a curved surface. Another advantage is that it permits applying an ornament of one color clay to a clay of another

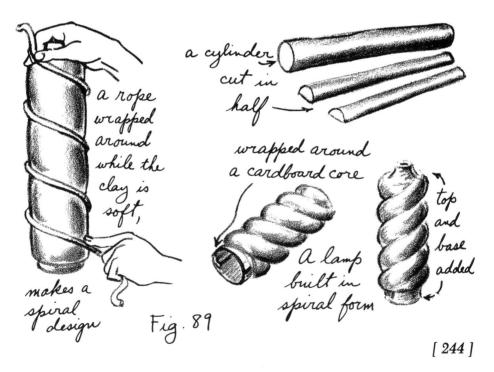

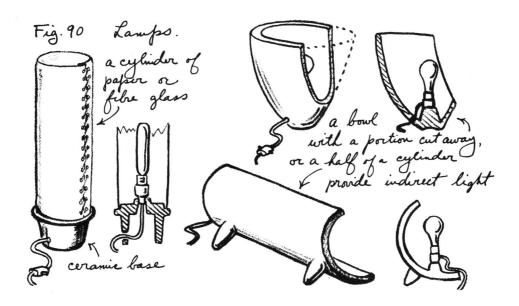

color. Interesting things can be produced this way when ornaments of white or pale buff clay are applied to lamps made of red clay and the finished work is covered with a transparent glaze containing a small percentage of some coloring oxide which tones down the contrast between the two colors. You may be interested in trying two clays of contrasting color this way, but it is important to use clays with the same degrees of shrinkage, otherwise the ornament will crack off either during the firing or before. One way of making sure that you have the same degree of shrinkage in the lamp and in the ornament is to use the same clay body for both but to introduce a coloring pigment into one.

Other lamp forms

In designing a lamp you need not be bound by convention or by style. You don't have to limit yourself to round forms or to rectangular ones. You can be truly original and create shapes completely unlike anything made before.

Lamps can be designed to provide indirect lighting as shown in Fig. 90 or planned like the shell form shown in Plate XI. Here the bulb is inside and the light comes to us by reflection from a series of glazed surfaces.

Flower holders

Besides conventional vases, all sorts of flower holders can be made of ceramics. These include containers for cut flowers as well as pots for growing plants. A glance in a florist's window will show how many shapes are made for the purpose of holding flowers. Certainly an effort is made to appeal to every type of taste. If you like fanciful and amusing flower holders, it is a simple matter to model figures like the donkey and cart or the girl with a basket in her arms shown in Fig. 91. The slab method can be

used to make wall holders for flowers, rectangular flower pots, and window boxes just the right length and width for a particular window-sill.

To keep cut flowers from toppling over when they are placed in a low vase or a dish, it is good to have something heavy in which the ends of the stems may be inserted. A way of making such a device is to take a lump of clay and pierce it in a number of places with a pencil. Another way is to cut a layer of clay into strips of varying widths. Let the strips be about three inches long and make some of them an inch wide, others two inches wide and some three inches. Roll the strips into cylinders and fasten them together in clusters as shown in Fig. 91. When such a cluster is fired it makes an effective holder for a bouquet.

When designing a flower holder, remember that flowers themselves are beautiful and it isn't fair to make them compete with gaudy colors in the container. The holders that best set off the beauty of the flowers they contain are of simple shape and neutral colors.

A tile-topped table

The home craftsman who is skilled in woodworking can combine ceramics with carpentry by making a tile-topped table. Any arrangement of decorative tiles with or without a border can be used. You can buy tiles and decorate them or you can make your own. Plan the design, then make the tiles by cutting them from a layer of clay. These may be of any size up to 6" square. The big problem will be to form and fire the tiles without having them warp. Use a generous proportion of grog in the clay and, for extra safety, add about 10% of flint. Roll a layer of clay using guide strips of wood to make sure that the layer is of even thickness. Work on a wooden drawing board with a piece of oilcloth on it, shiny side down. Use a cardboard template as a guide and cut the tiles with a potter's knife.

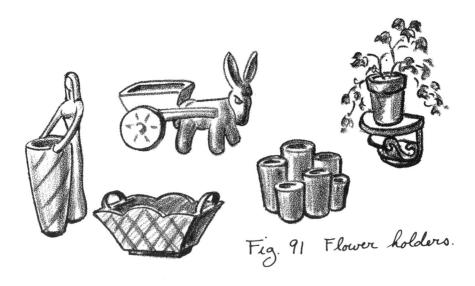

Now this is the place where special care is needed; once the clay has been rolled and cut it must not be lifted, for that would set up strains in the clay and make it certain to warp. To move the tile, place a slab of plaster over it so that the tile is sandwiched between the plaster and the wooden board, then reverse all three together so that the plaster slab is on bottom. You can now remove the wooden board and peel off the oilcloth. This leaves the tile resting on the plaster slab. Have another plaster slab in readiness and place this on top of the tile so that it can dry between the two pieces of plaster. Reverse the position of the slabs from time to time, making the top one become the bottom one and vice versa. This will make the tile dry evenly and will reduce the chances of warping. When the tile is thoroughly dry, fire it resting on a flat kiln shelf.

Since the tiles will shrink in the firing it is best to make the tiles before making the table — a better fit will result that way. Once the tiles have been fired to the bisque state, most of your troubles are over. It is now a simple matter to decorate them, using either an underglaze or an overglaze method as described in Chapter 8 and fire them again. Then build the table and set the tiles in place.

The sketch in Fig. 92 shows how a coffee table can be made with tiles set in the surface. The top of the table is made from a piece of plywood with a molding around the edge as shown. Use the least expensive type of construction plywood. To set the tiles you will need a type of elastic cement. I have used Miracle cement with good results. This is available at hardware stores. The cement is made with an asphalt base and it contains asbestos. It never hardens completely, and this is an advantage.

To set the tiles, spread a layer of cement with a spatula on the back of each tile, then set the tile in place and rock it back and forth until it is absolutely level. If you are using commercial tiles which are of uniform thickness with perfectly level backs, a thin layer of cement (about $\frac{1}{8}$ ") will suffice and you will require about one quart of cement for a 4' x 6' table. However, if you are using home-made tiles which are less regular and a bit uneven, use a thicker layer of cement; you will probably need two quarts for a table of the same size.

In placing the tiles, leave spaces of ½8" between them. These spaces must be filled with a hard setting cement so that the top of the table will be waterproof. Use regular tile-setter's white cement for this purpose. Wet the tiles thoroughly by pouring water into the joints, letting it stand for a few moments until it soaks into the tiles. Mix the cement with water to the consistency of thick cream, then pour it into the openings. Level off the surface of the joints with a spatula and remove any excess of cement from the surface of the tiles with a wet cloth before the cement has an opportunity to set. If any of the cement does set on the surface of the tiles it can be removed with steel wool later on. When the tile top is finished, let the cement harden for 24 hours.

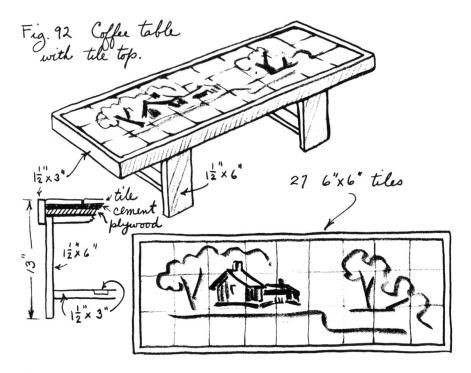

A tile tray

A simpler application of the process described for making a tile-topped table can be used to make a small serving tray suitable for hors d'oeuvres or sandwiches. Two 6" x 6" tiles are set in a wooden frame and a majolica decoration is painted on them. Plate XII shows a pair of trays made this way by Pat Lopez.

Ceramic stoves

Plate XIII shows a photograph of a little ceramic stove that I bought on a recent trip to Mexico. Stoves of this type are popular; they are portable, can be used either inside the house or outside on the ground, and when the family makes its weekly trip to a neighboring town on market day, the stove can be carried along to prepare the mid-day meal.

These stoves are made of clay by a combination of coil and slab building. They are unglazed but usually have a slip decoration. They work with a handful of charcoal. This is put into the top portion and lighted, then a ceramic cooking pot with a round bottom is placed in the bed of coals. The charcoal fire loafs along, so to speak, giving a mild heat for several hours. When more heat is needed, the cook fans the opening in the lower portion and makes the charcoal burn with a hotter flame. Cooks have told me that the combination of charcoal fire and ceramic cooking pot is responsible for the special flavor of many of the Mexican dishes. Such results cannot be obtained, they say, in any other way.

An electric stove

Charcoal stoves like those described above are probably more practical for use in Mexico than they are in our country. But if you want to make a ceramic stove that works with electricity, you can build one out of clay using the slab method. In addition to clay this project requires two 600-watt elements of the type used in electric toasters and a pair of terminals or lugs for attaching the electric cord. These can be purchased at a hardware store.

Essentially such a stove is a ceramic box with an open top. The elements are placed inside the box, fastened to the ends of the terminals. These project through the wall of the box. The elements must be raised above the bottom of the stove so that the floor does not become too hot. On the top over the elements there must be some type of metal grill or ceramic support to hold the cooking vessels. Here are the steps in making an electric ceramic stove.

PHOTO SERIES 36

Clay has been rolled into a layer 1/4" thick and a cardboard box has been prepared as a support. The box is covered with newspaper to make it easier to lift the clay off the box after the clay has been shaped.

A pattern is cut from the clay using the box as a guide.

Shaping the clay pattern over the box. Corners are squeezed together and excess clay is trimmed off. Feet are attached.

The clay has been turned right side up and the cardboard box that served as a support has been removed. Thin cylinders of clay are pressed into the joints between the stove and the feet so that the feet will be welded firmly in place.

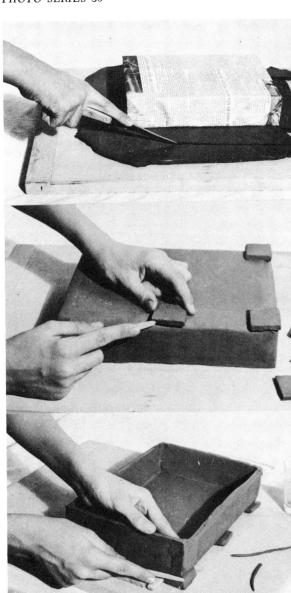

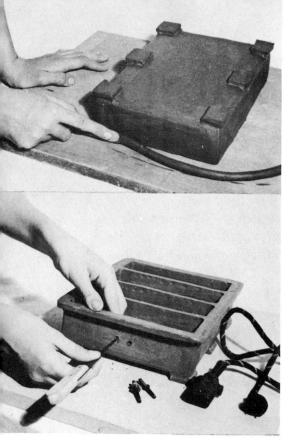

Welding a strip of clay around the edge to serve as a rim.

Three cross partitions have been fastened in place. Two holes are cut in the end for the electric terminals. These holes must be 3/4" apart. Use the plug at the end of the electric cord to get the spacing right, but remember to allow for shrinkage.

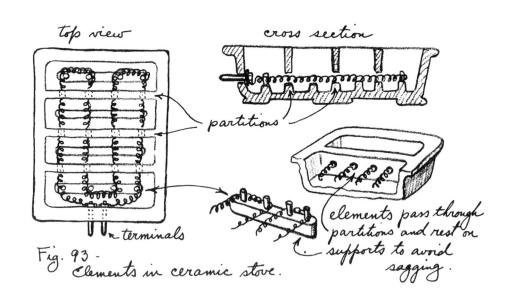

Two 600-watt elements will provide the heat in our stove. One element can be used by itself but this would get too hot. When we use two elements attaching them in series (that means hooking them up end to end), they will become only half as hot as one element used alone. This will provide better heat for our purpose.

In order to keep the elements from resting on the floor of the stove, each partition has four holes cut in it as shown in Fig. 93. The elements pass through these holes and are thus supported above the floor. In between the partitions, low walls of clay are constructed as shown. These keep the elements from sagging.

An electric plate warmer

Perhaps you have no need for a ceramic stove; all of your cooking is done in the kitchen. But a device to keep food warm at the table is always useful. This can be made quite simply by sandwiching three 600 wattelements between two layers of clay so that the elements are embedded in the slab.

A layer of clay has been rolled 3/4" thick, and a rectangular shape has been cut. A wire loop is used to make a groove for the elements. This is a red clay which will mature at cone 06. Grog has been added.

The groove has been completed and the three elements, joined end to end, are in place. The ends of the elements are connected to two metal terminals that are set in place in the clay with the prongs projecting. These will serve as the attachment for the socket of the electric cord.

PHOTO SERIES 37

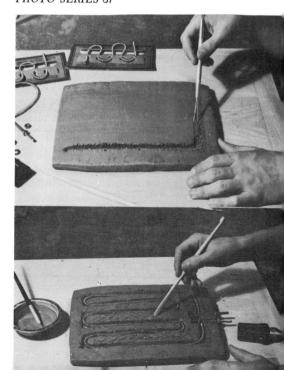

A second layer of clay has been placed on top of the first layer and the edges have been welded together. The electric elements are now enclosed in the center of a clay slab. Feet are added.

The plate warmer in use.

The next step is to fire the plate warmer. Since the clay used matures at 07, the piece can be carried to that temperature without serious damage to the metal elements or the metal terminals. The portions of the terminals that project will be oxidized and pitted, however, unless they are protected in some way. Cover them with a layer of kiln wash. After the firing this can be cracked off.

Useful objects

As you glance around your home, you will see many places where a piece of ceramic sculpture will prove useful. Book-ends are convenient and easy to make. So are containers for cigarettes. Clay is versatile, it lends itself so readily to the formation of any shape whatever, that it can be used for any number of attractive and useful articles. Ideas will suggest themselves to you for other ceramic objects besides the usual ones of lamps and flower holders. Have the courage to put your ideas to the test; you may evolve some highly original designs.

Craftsmanship

Articles made of clay by the methods described in this chapter will not have the perfect finish of things turned out in factories. They'll look handmade — and that is as it should be. The marks of your personality should show along with the marks of your fingers. If more perfection is required, make plaster molds of your clay models and cast the finished pieces.

Remember that clay is not sheet metal, something to be cut and folded and soldered together, and remember, too, that you are not a tinsmith. You are a sculptor. When you roll clay in layers and cut it into patterns to make things for your home, bear in mind that you are working with plastic material. It is your hand, not the pattern which creates the form.

12 Ceramic Sculpture For The Garden

CERAMIC SCULPTURE is well suited for use out of doors because it withstands the ravages of time and weather. It won't rust the way iron does, nor disintegrate like cement or plaster. It will even outlast many kinds of stone. Unglazed terra cotta, like brick, weathers beautifully. It does not lose its original color through the years but acquires a patina with age, and glazed pieces, provided the glaze fits properly, are always as bright as new.

It is too bad that we don't make greater use of ceramics in our architecture today. In Italy during the early days of the Renaissance, beautiful things were made with this material. Ceramic sculpture — plaques, coatsof-arms, as well as religious compositions — was used to decorate the outer walls of buildings. The della Robbia family and their contemporaries who made fine majolica altar pieces, produced ceramic sculpture for the outsides of churches as well, particularly semi-circular lunettes designed to fill the space between a rectangular doorway and the round arch above it. Where we find such a lunette the contrast between it and the surrounding stone is pronounced; while the stone is discolored, dull and grimy, the ceramic portion is as fresh as it was the day it came out of the kiln.

Unfortunately, with the passing of the della Robbia brothers, the use of ceramic sculpture out of doors declined. Perhaps they took some of their technical secrets with them and neglected to train a staff of apprentices to carry on their work. There are indications, however, that interest in ceramic sculpture as an ally of architecture may be reviving. Let us hope that this is so, for a judicious use of ceramic sculpture can add color and beauty to our cities.

As we think over the possibilities of ceramics out of doors, a number of ideas suggest themselves immediately — decorative garden figures, bird baths, feeding stations, flower pots, fountains, and many more. Except for the fact that such pieces are larger than interior ceramics, the problems of construction are the same and all of the methods of shaping clay described in earlier chapters may be used.

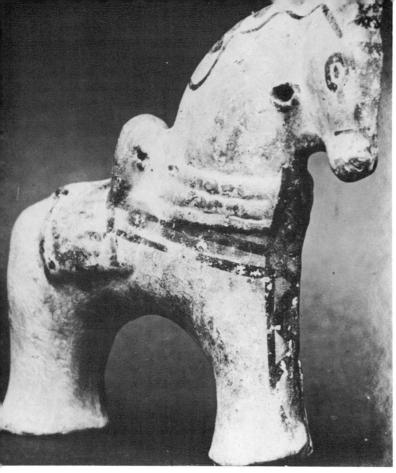

Pottery Horse from Antinoe, Egypt, ca. 550 A.D. Courtesy Brooklyn Museum.

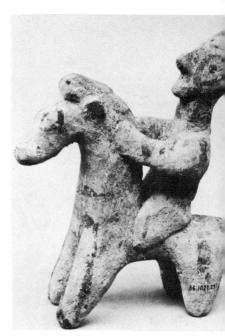

Archaic Horseman. Courtesy Metropolitan Museum of Art.

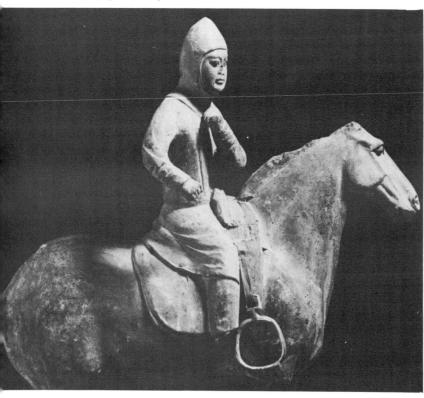

Horse and Rider. China. North Wei Dynasty. Courtesy Brooklyn Museum.

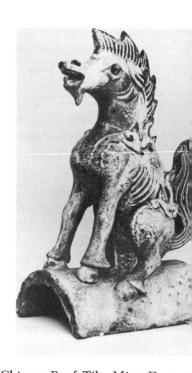

Chinese Roof Tile, Ming Dynasty Courtesy Metropolitan Museum of Art.

Firing in sections

Size, of course, is a problem; the pieces you make must be planned so that they will fit into your kiln. But this does not mean that you will never be able to make a composition larger than the chamber of your kiln — not at all. The della Robbia altar pieces were too large for the kilns they used, and so they had to be fired in sections. The original composition would be made in one piece, then it would be cut into smaller pieces, the lines of the cuts following the outlines of sculptural portions of the composition so that the joints would not be too obvious. After these smaller pieces were glazed and fired, it was a simple matter to reassemble the entire composition. Color Plate 10 shows an altar piece made this way.

If you plan a piece of work to be fired in sections, make the parts fit together perfectly so the piece, when assembled, will stand by itself. Do not rely upon glue or cement — you can use strips of burlap soaked in plaster placed on the inside to fasten sections together if you wish additional binders (see page 260) but your sculpture must be able to hold its shape without them.

"The Bride" by Berta Margoulies, is more than 2' tall yet it was fired in an electric kiln with a chamber only 14" high. It is made in two parts, the upper piece provided with a flange which fits into the lower portion very much as the lid fits on a teapot. In the series of pictures which follows, the sculptor shows how she created this figure using the coil building method.

PHOTO SERIES 38

A small sketch has been made in plasteline. There are no details in this sketch, but the design and the proportions of the final figure have been planned. Details will be added in the later stages of the modeling on the large figure.

Building a figure by the coil method

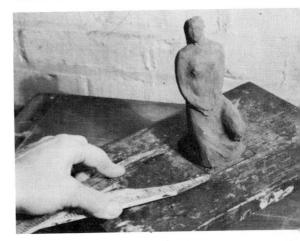

Proportional calipers

The sketch is a little over 8" tall, and it will have to be enlarged three times. To do this the artist uses a pair of home-made proportional calipers, fashioned from two yardsticks, set for an enlargement of three to one. (The method of making and setting calipers of this type is shown in Fig. 20 in Chap. 2). The artist measures the base of the sketch with the small end of the calipers,

[255]

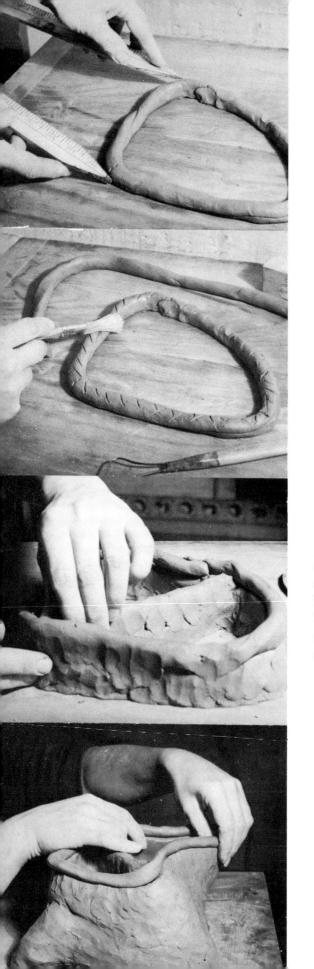

and lays out the base of the final figure with the larger end. One of the coils previously rolled forms the outline of the base. Note how the ends of this coil have been overlapped and welded together.

The first coil has been roughened with a modeling tool and now it is being moistened with a brush dipped in water. This operation must be repeated each time a coil is added.

The second and third coils have been placed. A bracing wall is being built across the inside of the piece for extra strength. The marks in the clay show how the coils have been welded together by the fingers. At this point the artist stopped, covered the work with damp cloths and left it overnight.

Next day. The clay has not been allowed to dry but it has become firm enough to permit the artist to build higher. Another coil is added as the wall continues to grow. The bracing wall will not be carried above this point.

Coil building is a slow process since not much more than 6" can be added to the height of a wall at one session. Here we see the work two days later. The artist is still adding coils and building higher; meanwhile much work and thinking have gone into the modeling of form.

Lying in front of the work is one of those highly individual tools all sculptors aquire. This one is a piece of a chair leg. The artist uses the square end to press clay into shape, while the round end is used for rolling over surfaces.

Using the proportional calipers again to check on height.

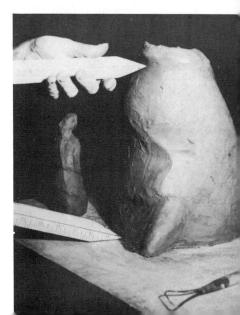

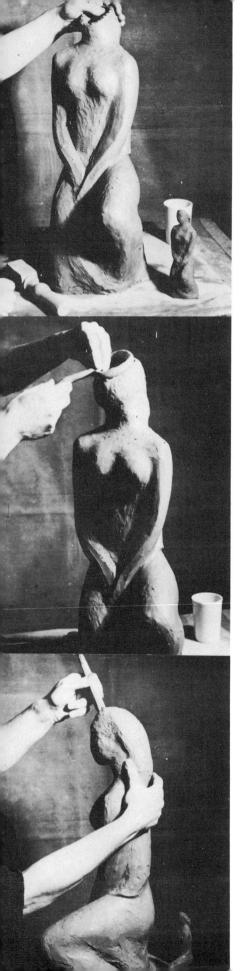

Two days later. Starting to finish the neck and the head. The artist has worked from the inside to bring out more definite form in the arms and the breasts.

Placing the next to the last coil. The mass of the hair in back serves to counteract the forward thrust of the head and balances the weight on the neck.

A small opening is left at the top of the head so that the artist can reach inside with a long tool and press the form outward wherever it is necessary. This hole will not be closed until the modeling has been entirely completed.

Cutting a woman in half

You don't have to be a magician to cut a woman in half. All you need is a knife with a long thin blade, and you do the trick this way.

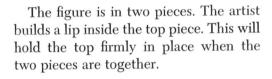

The two pieces have been put together and after some more modeling has been done, they will be allowed to dry together. To keep them from sticking, a strip of metal foil has been inserted in the joint.

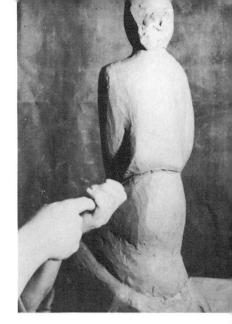

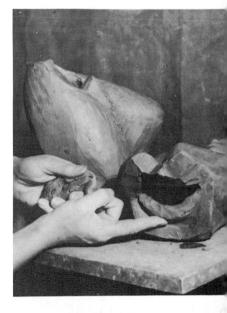

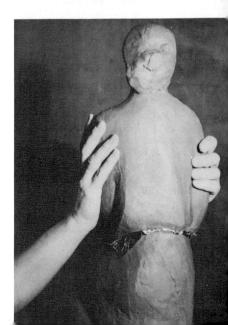

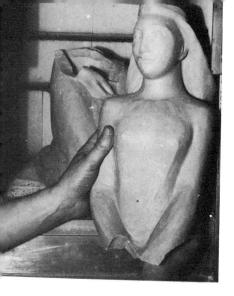

The two pieces being stacked in a small electric kiln. More detail has been added to the features. As a final thought, the artist has covered the hair with a bridal headdress.

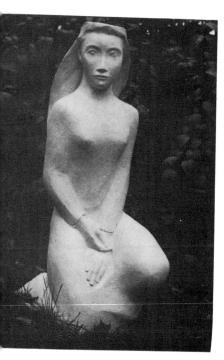

The completed figure in its garden setting.

Joining sections

The sculpture that we just watched in the making was left in two parts; the sections fit so well that no other joining is needed. If you have made a piece of sculpture in two or more parts and want to join them permanently, soak them in water, then fasten strips of burlap soaked in plaster of Paris on the inside. If the joint leaves a crack that needs to be concealed, scrape a small portion off the inside, crush it into a powder, mix it with sodium silicate and fill the crack with the mixture.

A ceramic flower box

A simpler project in ceramics for outdoor use, yet one that is highly practical, is a decorative flower box. Such a box can be built by the slab method, using a cardboard core for a support. When the box is completed, it may be ornamented with sculptured figures or designs carved directly in the side of the box.

Slab building has one serious disadvantage — unless extreme care is taken to seal the corner joints, they will come apart when the piece is fired. This is especially true of large pieces, so in making a large flower box it is safer to use a plaster mold. Make a model of the flower box in clay, then cast a mold over it. When the mold becomes dry a layer of clay pressed on the inside will form a flower box that has no seams at the corners and consequently is sturdier than a box built by the slab method.

If a carefully executed box is required or one with elaborate sculptural decoration and if more than one are to be made, it is well to add another step and make a waste mold from the clay model. A plaster model is then cast in the waste mold and the final press mold is made from the plaster model. Let's go through the steps of this process.

A wooden core

A model for a large flower box requires a great deal of clay. The job will be simpler if a wooden core is constructed first then covered with a layer of clay. Less clay will be required this way and the wooden core will help in making the model true and symmetrical. Here a box has been made and the sculptor has covered it with clay which he smooths with a steel scraper.

PHOTO SERIES 39

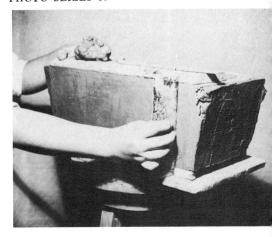

Modeling ornaments in relief. Signs of the zodiac will be used as decoration.

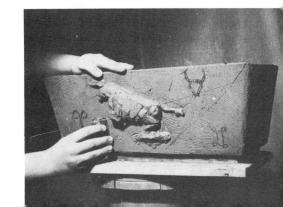

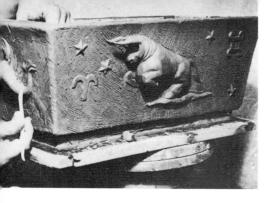

Continuing to model the decorations. At the end we see Scorpio and on the side, Taurus the bull.

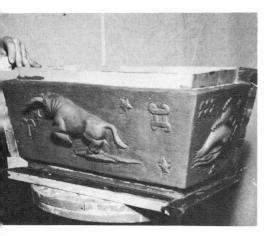

A waste mold

Setting shims in place to make the waste mold. This will be in two parts separating at opposite corners.

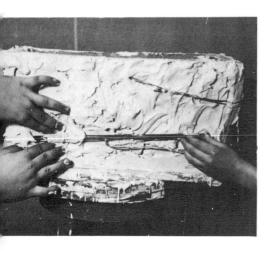

Making the waste mold. Placing metal strips in the plaster to provide reinforcing.

The plaster model

Starting to make the plaster model. The two halves of the waste mold have been sized and plaster is put into the portions which form the ornaments.

Completing the plaster model. The two halves of the mold have been tied together and placed on a table. The top of the table will serve as the bottom piece of the mold so it was sized first. Plaster is applied to the inside of the waste mold. Strips of burlap will be put in the plaster for reinforcement.

Chipping away the waste mold. On this end we see the zodiac sign of the fish, Pisces.

Starting to make the press mold. The ornaments on this box are complicated, with many undercuts, and so separate pieces of the mold must be made for the undercut portions. Here clay walls are set in place to cast three pieces along the underside of the bull. The bull's left horn which projects has been removed. This will be formed in a press mold and attached to the figure when the box is finished.

The clay walls in place. Sizing the plaster model.

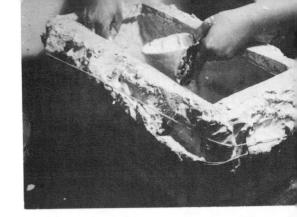

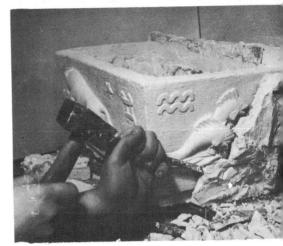

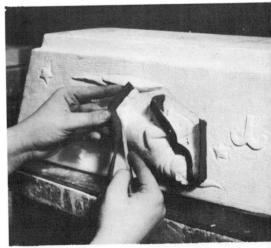

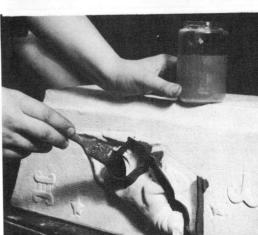

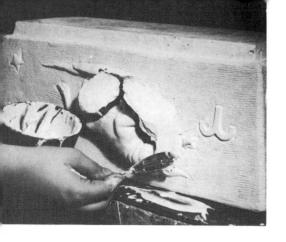

Applying plaster. Smoothing the surfaces of the small pieces with a spatula.

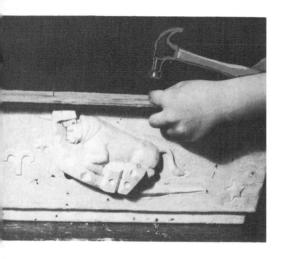

Ready to make the side piece of the press mold. The smaller portions that take care of the undercuts have been completed and notches have been cut so that they will be held in place in the side piece of the mold. A strip of wood is nailed to the wooden core along the top of the model. This will give the mold a smooth even top edge.

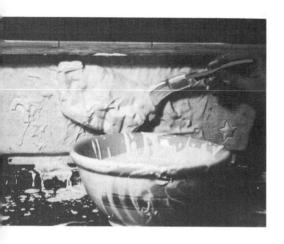

Applying the plaster to form the side piece of the press mold. The model and the small pieces were sized first.

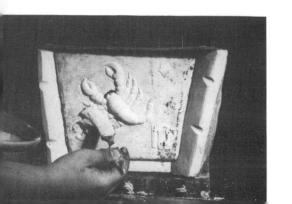

The two side pieces have been completed; notches have been cut and the sides are in place. The model and the ends of the side pieces have been sized and plaster is applied to form an end piece. The press mold completed. A piece was made for the bottom and an additional piece was cast along the top edge. This will serve the double purpose of holding the side pieces together and giving a smooth top surface to the box.

Pressing

Starting to press. The small portions that take care of the undercuts are in place and clay is pressed into the figures.

After this, a slab of clay is pressed onto the side.

When a layer of clay has been pressed on each side, the mold is assembled and the corners are joined. A strip of clay is pressed into the corner.

[265]

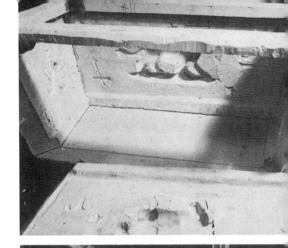

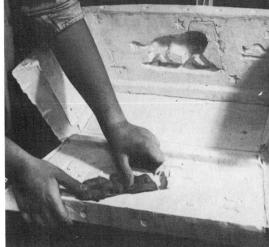

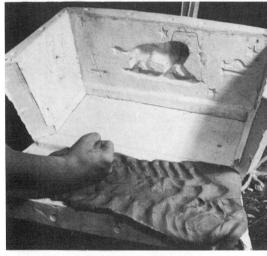

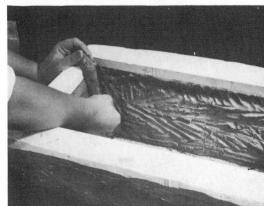

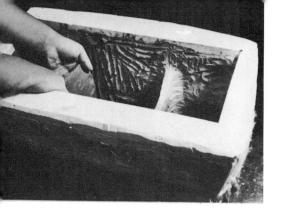

A box of this size is less likely to warp if cross partitions are built. These do not extend all the way to the bottom.

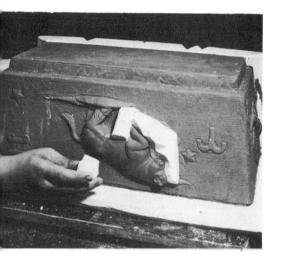

The pressing completed; the side pieces of the mold are removed. The small portions that form the undercuts do not come off with the side pieces but remain on the model and are then removed separately.

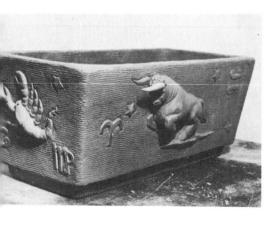

The finished box. The bull's horn was made in a two-piece press mold and attached.

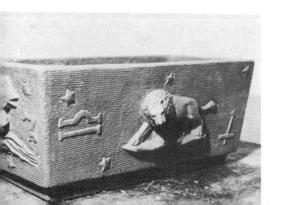

The other side, with Leo, the lion.

A fountain

A fountain is a delightful addition to a garden. It adds movement and sparkle. There are many ways to make a fountain; it can be large or small, it can be attached to a wall or stand at the end of a pool or in its center, it can be elaborate or simple. No matter how it is made, a fountain is a lot of fun to build.

In planning a fountain consider the problem of water; where it is to come from and where it is to go. A fountain at one end of a pool may serve as a way of filling the pool. In this case the stream of water may fall directly into the pool or into a basin from which it overflows. Such a fountain must have water piped to it and requires plumbing connections. A fountain on a wall must have two sets of pipes, one to carry the water in and another to take away the overflow.

We can eliminate the need for plumbing by planning a fountain with a pump which circulates the water from a basin through a figure from which it splashes back into the basin again. This is an economical way of doing it — no pipes are needed and no water is wasted, for the same water is used over and over again.

A fountain like this is made in two parts, a basin with a partition that encloses a housing for a small electric pump and a sculptural figure that

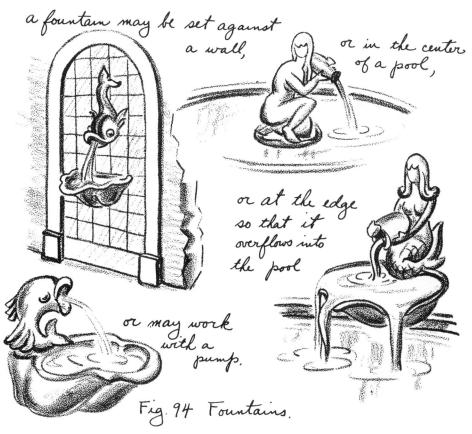

fits over the pump compartment. The best way to go about this is to make a solid clay model of the basin upside down, and then cast a plaster of Paris mold over it. When this mold has dried and been removed from the model, a layer of clay about 3/4" thick is pressed inside to form the basin of the fountain. At the back a partition of clay is set in place to form the pump compartment. A small hole drilled in this partition serves as the pump intake.

The figure must be made so that it rests on the back of the basin and on the partition serving as a roof over the pump compartment. It must be a separate piece for it will be necessary to lift the figure to insert the pump. The base of the figure should have a flange to fit into the top of the pump compartment in the same way that the top part of the figure on page 271 fits into the lower portion. The figure will be hollow. Copper tubing will lead from the intake to the pump and from the pump up through the figure.

This sounds complicated, but it really is not difficult. Here are the steps.

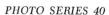

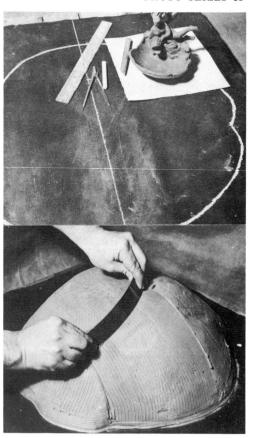

A sketch

Before embarking on a project of this size it is a good plan to make a small sketch in clay. The sketch will be enlarged four times. The outline of the top of the basin is drawn on a table top.

A mold for the basin

Starting to build the form of the basin. A toothed steel scraper is a good tool to use.

Making the plaster mold. Plaster has been poured over the clay model and strips of burlap, soaked in plaster, are added for reinforcing. The table was given a coat of size.

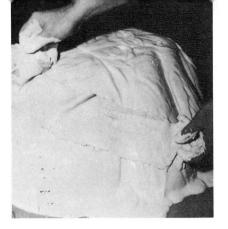

Pressing the basin

The plaster mold for the basin has been completed. Layers of clay are rolled and laid in place in the plaster form to make the basin. These layers should be 3/4" thick. Care must be taken where pieces overlap that no air space is left between the clay and the plaster mold and that the pieces are carefully joined together.

A wall of clay has been constructed at the rear portion of the basin. This wall will provide support for the figure and the portion in the back of this wall will serve as a housing for a small electric pump. A hole is cut for the pump intake.

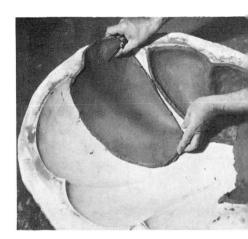

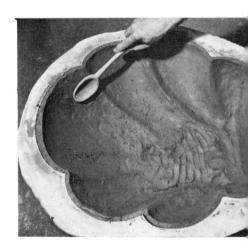

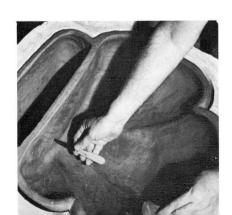

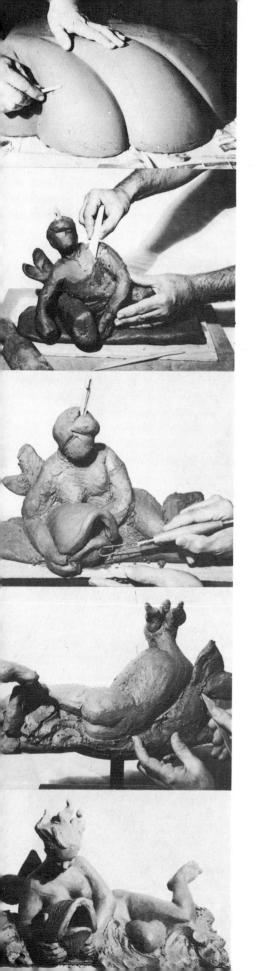

The basin removed from the mold. Smoothing the surface of the basin. Soft clay is pressed into any little cracks.

The figure

Starting to construct the figure. Using a wooden block to model planes. A stick of wood has been inserted in the head for temporary support.

Modeling the fish.

Modeling the back.

The figure completed.

Hollowing out. The figure is tipped back and rests on a cushion made of soft cloths. Openings are cut in the base; through these clay is scooped out so that the figure is a hollow shell.

Constructing a flange on the base of the figure which will fit into the pump housing. The pump housing was measured and the flange is made so that it will exactly fit into the opening.

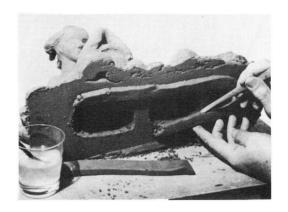

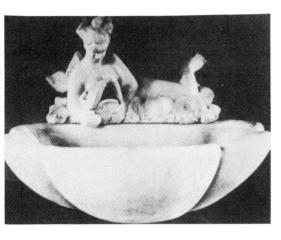

The flange is completed and the figure is in place on the basin.

The next step is to fire and glaze the figure, after which the pump is inserted in the housing and connected. Fig. 95 shows how this is done. The completed fountain, in operation, is shown in Color Plate 11.

A fountain planned like this one can be adapted to various designs. Once the basin is made and the pump has been connected, it is a simple matter to make another figure with a base that fits over the same opening and thus change the character of the fountain completely. A woman holding a fish whose mouth spouts water is not a new idea, it has been done many times. Some day when I get around to it, I'm going to make a more original fountain like the one in Fig. 96 with a mermaid wringing water out of her hair.

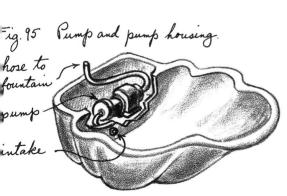

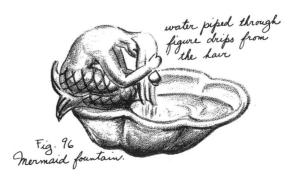

A bird bath

A ceramic bird bath can be made by the steps shown in Fig. 97. The column is built by the coil method following the steps shown in Photo Series 33 on page 233.

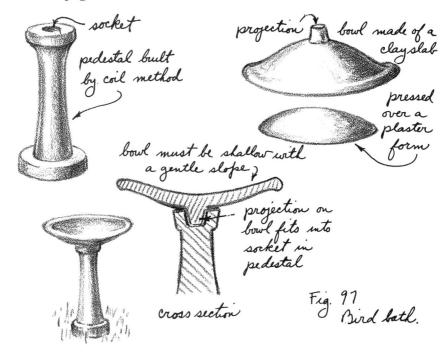

Cooperation with industry

If you plan to make large-scale ceramic sculpture for outdoor use, don't overlook the possibility of cooperation with some nearby brickyard or tile factory. Sculptors have often been able to have their work fired in the kilns of industrial ceramic plants and they have at times obtained their clay there also. The clay that is used to make building materials is good for sculpture as well.

Sewer pipe sculpture

Plate XIV shows an example of team work between a factory and a school. The sculpture classes of Scripps College are able to obtain from a tile factory large sections of clay sewer pipe that have been formed by extrusion and have not been fired. These massive cylinders of clay are fine for carving. As long as they are kept moist, the clay remains soft and easy to cut. When the carving is finished, the clay is allowed to dry, then returned to the tile factory for firing. Objects made this way are used as garden ornaments and flower boxes. The bottoms are open but this does not matter when they stand on the ground. If a flower container is intended for use on a terrace and requires a bottom, this can be made of clay and welded into the cylinder before it is fired, or a cement base can be cast in the piece after it has been fired.

The cylinder with pierced decoration shown on Plate XV will be used as a garden lantern with a light bulb placed inside.

Protection from the weather

Pieces of garden sculpture small enough to be carried easily may be brought inside during the winter. Those that stay outdoors all year in the northern part of our country must be able to stand extreme changes in weather. The climate in that region is not kind to sculpture. This was shown in 1882 when the obelisk, called Cleopatra's Needle, was brought from Egypt and placed in Central Park in New York City. This large piece of sculptured sandstone had stood in its native land for over 3000 years with little deterioration, yet three winters in its new home were too much for it. Moisture penetrated its porous surface, then froze, and sections of the obelisk began to fall off. It was evident that within a few years the sculptural decorations would be completely obliterated, so, in 1885, the obelisk was given a coating of hot paraffin. This sealed the pores, kept moisture from getting in, and preserved the piece.

Ceramic sculpture, if it is fired high enough so that the body is vitreous, will need no additional protection, but if the body is low fired it must be treated with something to make it non-porous. Linseed oil is good. Apply it as described on page 184. Melted paraffin is good, too. Brush this on the piece while it is warm. If it is not possible to heat the work, apply the paraffin on a hot day with the piece standing in strong sunlight.

Glazed pieces that stand outdoors must have glazes that fit without crazing, for tiny cracks will admit moisture and cause trouble.

Weep holes

If a piece of ceramic sculpture is to remain outdoors during the winter, look out for any portion that might hold water. Water collecting in a slight hollow will freeze and break the piece. Plan your design so that such hollows do not occur. Where it is not possible to eliminate them make weep holes. These are little holes made in the bottom of a depression so that water will run off and not collect.

All parts of a fountain must be emptied before freezing weather sets in, and the basin must be covered, unless a hole has been provided in the bottom for draining. A bird bath can remain outside all winter if the bowl is shallow and has a gentle slope as shown in Fig. 97. When water freezes in such a bowl, the ice rises above the surface and does not exert an outward pressure strong enough to cause harm.

Decorative figures made of fired clay add much to the beauty and charm of a garden. Like the rocks and the soil, ceramic sculpture is a product of the earth itself and so it is at home among trees and shrubs. Like the rocks too, ceramic sculpture is permanent; with proper firing and with the correct glaze it will last forever.

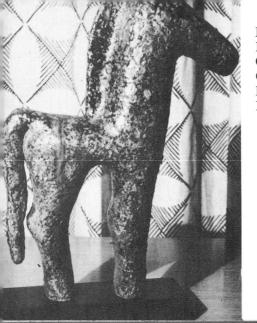

Polychrome Horse. Celeste. Courtesy Kagan and Dreyfuss.

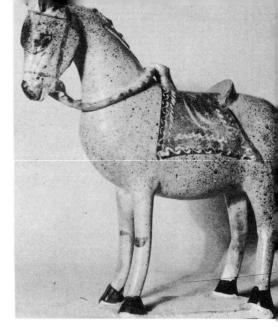

Pottery Bank. Mexico.

Horse and Rider. Student Work, Rhode Island School of Design.

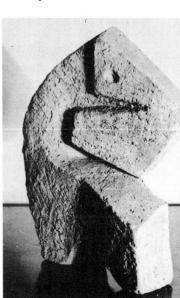

Terra-cotta Horse. Aaron Ben Schmul.

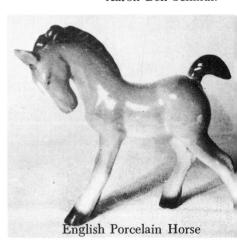

PLATE XVIII - MORE HORSES

13 Let's Have Fun

PERHAPS THE TITLE of this chapter needs a word of explanation. All sculpture is fun — or should be. Modeling in clay can never be forced; the sculptor's work is done with enjoyment and with love or not at all. When we use the word fun, we are thinking of things made of clay which serve to amuse. Wherever we find examples of ceramic art, whether modern or from ancient times, among the more serious pieces are some in a lighter vein in which the craftsman has used his material to express the spirit of play. Clay lends itself well to such use.

Ceramic figure jugs

When a potter achieves mastery over his clay and is able to make it obey his slightest command, he is soon tempted to squeeze some of the vases that he forms into shapes that suggest grotesque human or animal forms. We are familiar with the work of the eighteenth-century English potters who were so fond of making Toby jugs, those little figures of fat men wearing three-cornered hats. And we know too the amusing Rockingham ware, jugs and pitchers made by the early potters of America. These are collectors' items today. But the idea of pitchers in human or animal shape was thought of long before the eightenth century; relics unearthed on the sites of ancient civilizations show that craftsmen busy making pottery could not resist the temptation to distort some of their creations into amusing shapes.

The potters of France have produced numbers of novel ceramic bottles in human form. Some of them are well designed and quite appropriate for their purpose. For example, a bottle intended to hold Napoleon brandy is formed in the shape of the emperor himself, and a flask that holds liqueur of the Grand Chartreuse is shaped like a monk of that order. Recently I have seen a container made to hold maple syrup from Vermont shaped like a woodsman of that region.

To demonstrate the steps in making a ceramic bottle, let's make one shaped like a clown.

A layer of clay is wrapped around a bottle.

PHOTO SERIES 41

[275]

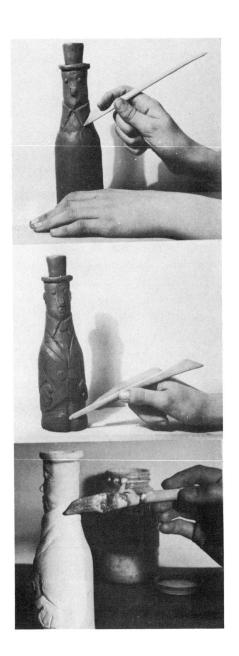

The bottle is completely covered. Features of a clown are modeled,

and details of costume are completed. A piece of clay is added to form the crown of the hat but this will not remain on the finished bottle. A cork will take its place. After this step, a two-piece drain mold will be made.

Glazing. A casting has been made and fired. Transparent glaze has been applied to the face and the hands; the rest of the figure is covered with opaque white glaze.

A bottle like this is intended to hold liquids and so it must be glazed on the inside as well as on the outside.

Before any glaze is put on the interior, the bisque piece should be dipped in water and then allowed to drain until all of the water disappears from the surface. This reduces the absorption of the bisque so that transparent glaze can be poured in and the piece rotated to form an even coating of glaze on the inside surface. When the entire inner surface is covered, the excess glaze is poured off.

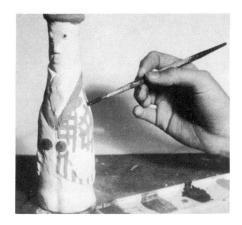

Decorating. This illustrates the majolica technique. Overglaze colors have been mixed with some of the glaze used on the figure and now they are being painted over the unfired glaze.

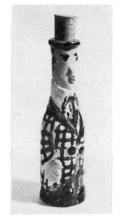

After its second firing, the finished bottle. A cork serves as a hat.

A ceramic whistle

Every tourist who has visited Mexico has seen little clay whistles for sale in the markets. These are simple objects, yet they are colorful and gay, usually in the shape of an animal or a bird, with an aperture to blow through and another where the sound comes out.

Fig. 98 shows a ceramic whistle in cross section. The tail serves as a mouthpiece, an opening in the base serves as a sound vent, and a hole in the chest allows variation in tone. If you keep the hole covered up with a finger as you blow, you will get one note; leaving it open will give a different one. To make such a whistle, model the form solid, then scoop it out from underneath with a wire loop tool. Bore a hole through the tail, make a hole in the chest, then seal the opening at the bottom and cut the sound vent. The sound vent must be made so that the stream of air coming from the mouthpiece is cut by the narrow edge of the vent. This sets up a vibration which makes the whistle.

After you have modeled the whistle, allow the clay to become leather hard, and then try it for sound. If this is not what you want it to be, change the shape of the sound vent. Make the narrow edge sharper by cutting it with a knife. Make sure that the whistle works before you put it into your kiln; if it doesn't blow before firing, it won't after. You will probably have to do some experimenting to get a whistle that works.

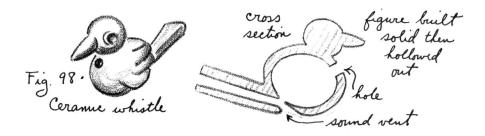

Ceramic jewelry

In ancient Egypt, ceramic jewelry was distributed to the guests at banquets in the same way that paper hats are given out at our New Year's Eve parties, yet even though they made them for fun, the Egyptians created some beautiful necklaces of ceramic beads. Great variety in design was achieved by making beads of different shapes and stringing them together in different ways.

Ceramic beads can be rolled as coils, then cut into sections and individually pierced or they may be shaped one by one. Extra ornamentation can be provided by sprig molds. A design can be cut in a plaster slab and beads of soft clay pressed against it so that each bead has the design in relief. The possibilities of variety are endless. Steps in making beads are shown in Fig. 99.

In forming beads be sure to make the holes large enough, and take care when glazing that the holes don't fill up. It is advisable to fire beads to bisque before glazing them. For the glaze firing they can be supported on pieces of steel wire resting on kiln props as shown in Fig. 69 on page 202.

Ceramic pins in the form of flowers, butterflies, etc., have enjoyed popularity for a long time. The steps in making a ceramic flower are shown in Chapter 10. Ceramic ornaments of this type can be used not only on pins but can be made into earrings as well. The fixtures (called findings) for making ornaments or pins out of them can be purchased in novelty supply houses and fastened to the finished ornaments with Duco cement. Before firing an ornament, have the pin-back or the earring base you plan to use on hand and press it against the ornament so that there will be a portion where the ornament and back fit together. This will give the Duco cement a better chance to hold. Ceramic jewelry can be decorated by any of the methods described in Chapter 8.

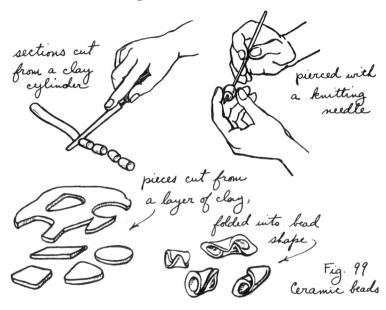

A ceramic fantasy

To see how the plastic quality of clay can give free rein to the imagination, let's watch the sculptor, David Micalizzi, create a ceramic fantasy in the form of a landscape.

PHOTO SERIES 42

He starts by rolling two strips of clay.

One strip is flattened to form a leaf. The other is fastened upright on a clay base to serve as a tree trunk.

The leaf is placed in position.

Another leaf and a mushroom have been added. Clay is pushed through the sieve to form grass.

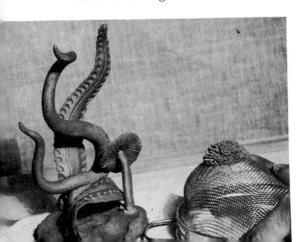

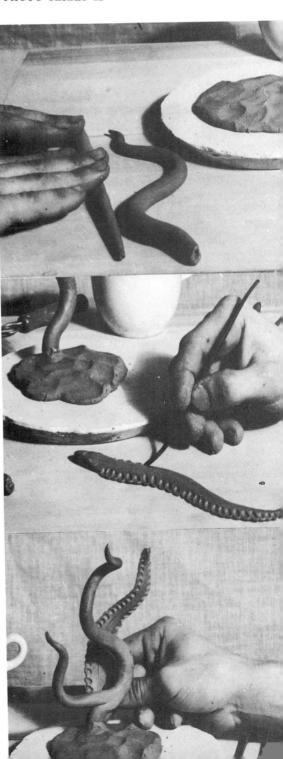

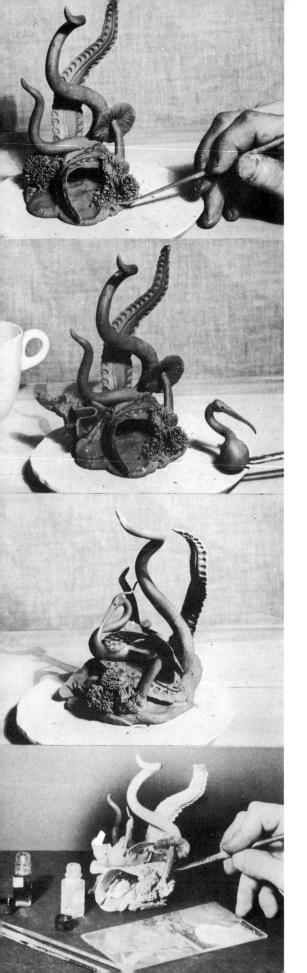

The grass in place.

Shaping a bird.

The composition completed. Can you find the sail that was added at the last minute?

Decorating. The piece has been fired, now it is painted with overglaze colors. These are ground on the glass.slab with overglaze flux. Fat oil and turpentine are used as painting media.

The finished group. Another view is shown on Color Plate 13.

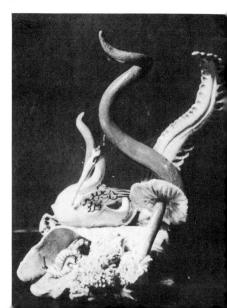

Ceramic chessmen

The ceramist who likes to play chess will derive a great deal of pleasure from ceramic chessmen. These may be modeled directly in clay and fired, or a master model of each piece can be formed and from this a two-piece press mold made. With a press mold, it is a simple matter to press the chessmen, but greater individuality is secured by modeling each piece separately and giving different features to the opposing teams.

Chessmen must be white and black. It is an easy matter to cover some with a white glaze and some with a black glaze or, if you prefer, one set of pieces may be made of white firing clay and the other from a clay that fires deep red. Then all may be covered with the same transparent glaze.

A well-designed ceramic chess set can be made out of rolled and cut shapes. A slight suggestion of realism will add humor and make the pieces different, but we must remember that chessmen should be simple and that over-realistic treatment should be avoided. Let's go through the steps.

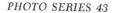

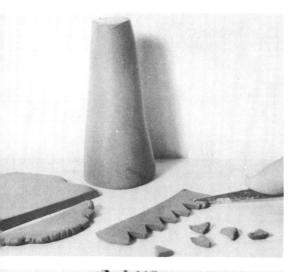

The king. A short cylinder of clay, slightly tapered at one end will serve as the body. A strip to form a crown is cut from a thin layer of clay.

The crown in place. Additional pieces are cut to form hair, beard and sleeves.

With hair, beard and sleeves attached, the king is completed. We begin work on the queen.

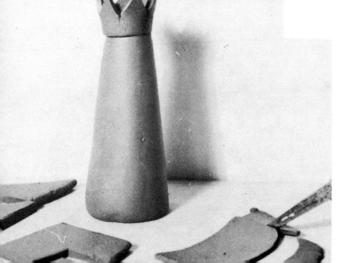

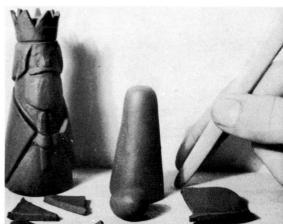

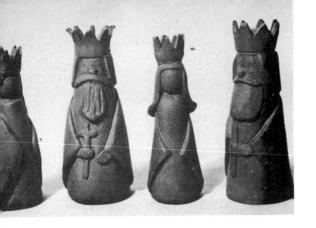

Their majesties completed. Differently shaped beards on the two kings and different hair styles on the queens add a touch of individuality.

Making a bishop. Pieces have been rolled to form body and head. A mitre is cut from another rolled piece. The long thin coil will be used to form the bishop's staff.

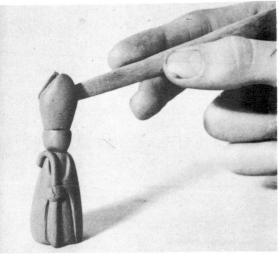

Putting the bishop together.

The knight is made from two simple shapes,

fastened together and modeled slightly,

to form a stylized horse.

The castle is made as a simple block,

with a few details added.

Pawns are made by cutting sections from a long coil and shaping them as shown. These sections form the bodies of the pawns. To each there is added a small disc to serve as a collar and a ball for a head.

To make sure that the pieces will not wobble when in use, the base of each should be made concave by pressing the rounded end of a modeling tool into the clay as shown.

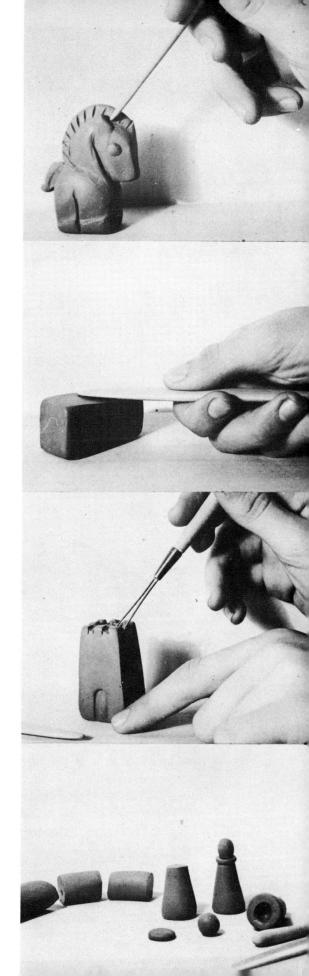

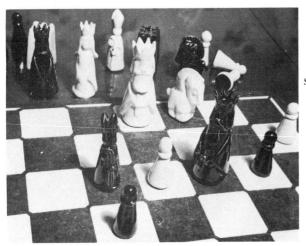

The chess set in use. Another view is shown on Color Plate 6.

After it has been fired and glazed, each chessman should have a piece of felt glued to the base with Duco cement in the same manner as that described for the bases of lamps on page 241.

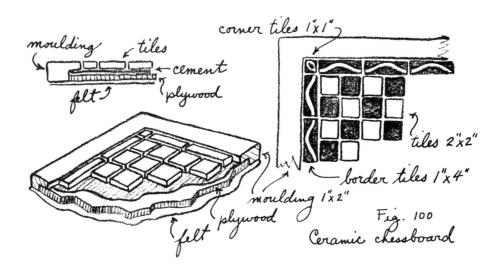

A chessboard

If you have made a chess set, you may be interested in making a chess-board as well. Make individual tiles for the squares, 2" x 2" x ½" thick, cut from layers of clay. If you use a white clay and a red clay you can take advantage of the natural clay color. When the tiles are fired, construct a wooden back and border as shown in Fig. 100. Fasten the tiles in place with an elastic cement using the method described for the tile-topped table in Chapter 10. After the board is finished, glue a piece of felt to the back.

Miniature gardens

The garden lover who does not own a country estate can still satisfy his love of growing things by planting a miniature garden in a bowl. The Chinese have shown us how much beauty can be created within the confines of a limited space. They have shown us, too, how little gardens can be improved by the addition of tiny ceramic sculpture, human and animal figures, houses, bridges, etc. A ceramic house like the one shown in Fig. 101 set in a dish and surrounded by plants will give the plants the appearance of large-sized shrubs or tall trees. I have had a lot of fun with a house planter like this, planting it with ordinary weeds which sometimes develop into beautiful arrangements as they grow. Note that the chimney is open and that there is an opening in what might be called the cellar of the house which permits the garden to be watered through the chimney.

Plate XV shows a group of ceramic figures made by a ceramist of southern France. These are less than half an inch high. Such tiny figures are gay additions to a miniature garden.

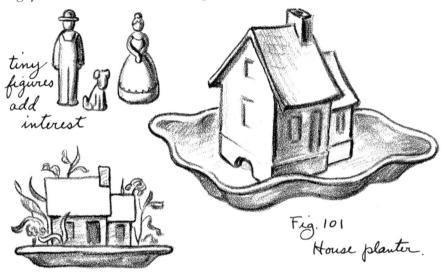

Ceramic sculpture thrown on the wheel

Forms can be created by throwing cylindrical and ball shapes on the potter's wheel, and then combining them to make fantastic animals or abstract shapes. Here are the steps in creating a piece of ceramic sculpture on the potter's wheel, a candlestick in the shape of a woman with arms outspread.

Shaping clay on the wheel, or *throwing*, involves four separate operations. Starting with a ball of thoroughly wedged clay about the size of a baseball, the potter throws it onto his wheelhead while the wheel is turning in a counter-clockwise direction. The wheel may be power operated or of the kick or treadle type, operated by foot. The potter can work directly on the wheelhead or he may use a plaster bat, so that finished work can be lifted off the wheel without being marred in shape.

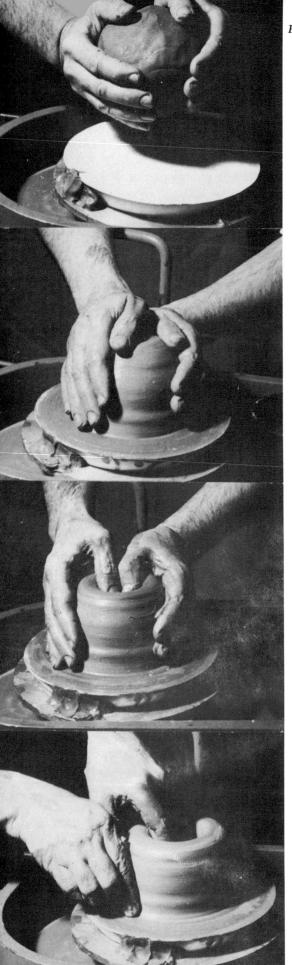

A plaster bat has been fastened to the wheelhead and a lump of clay is ready to be thrown on to it as the wheel turns.

When the clay is on the wheel, the potter begins the first operation, centering. The heel of the left hand is pressed firmly against the ball of clay while the right hand pulls the clay toward the center of the wheel. The object is to make the clay into a smooth and round shape with no bumps. A bowl of water is nearby because the hands must be kept wet during this process.

The second operation is *opening*. The two hands grasp the lump of clay while the thumbs are pressed downward in the center. This makes the clay take the shape of a shallow bowl with thick walls.

The third operation is pulling up. The potter puts his right hand on the outside of the clay and his left index finger on the inside. By bringing his two hands together and drawing them up he makes the clay take the form of a cylinder. Practice is required to perform this feat successfully. Again the potter keeps his hands thoroughly wet. To raise the cylinder to the proper height it is necessary to repeat the pulling-up operation three or four times (not more than four because the clay becomes too weak and will collapse). Starting with a lump of clay the size of a baseball, the skillful potter should be able to make a cylinder 4" in diameter, 10" high, with walls 3%" thick.

Continuing to raise a cylinder. The clay is pressed between the two index fingers. The thumb of the left hand is braced against the right hand so that the distance between the two index fingers can be kept the same. This produces a wall of even thickness.

The fourth step is *shaping*. A narrow portion is created in the cylinder by pressing against the clay with both hands. This will be our lady's waist.

The waist is made still narrower.

The top of the shape is closed to form a head. This makes the figure complete except for arms.

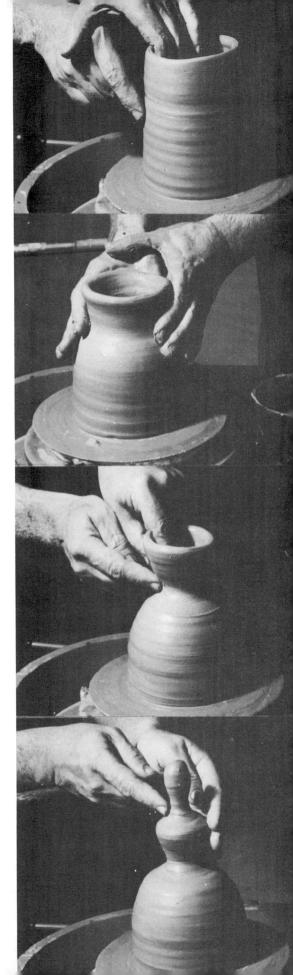

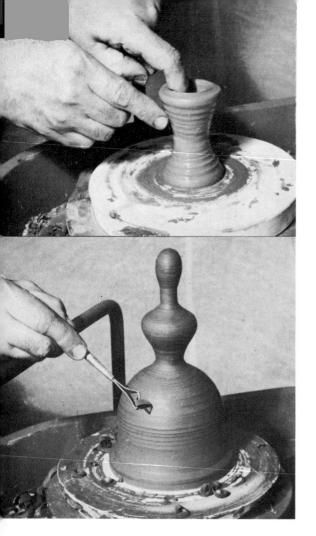

A small cylinder of clay is thrown and made narrower in the middle. This will be cut in half to make two arms with flowing sleeves.

Turning. The figure has been left in a damp closet for 24 hours. Now it is leather hard and ready for turning. The bat is fastened on the wheel once more and a wire loop tool is held against the figure as it turns. This cuts off thin shavings of clay and makes it possible to get the shape just right.

Attaching the arms. The cylinder which was thrown separately was allowed to become leather hard and was then cut in half. Each half is attached with clay slip.

The candle sockets and the hands must be modeled separately. The end of a knife handle is pressed into a ball of clay to make a candle socket.

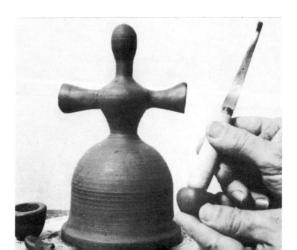

Attaching the candle socket and a hand. The hand is made from a flattened strip of clay fastened to the bottom of the socket.

Adding hair. The two hands and the sockets are in place supported by temporary clay props. Clay props are better for this purpose than wooden ones because as it dries the clay will shrink and so the clay props shrink along with the figure. If wooden props were used the arms would crack off as the figure dried.

The hair is made from thin coils of clay moistened and fastened in place.

A collar for my lady's dress. This is made from a strip of clay cut into scallops, moistened and pressed into place with a wooden modeling tool.

A ruffle for her skirt. This is made from another thin coil of clay. Here we see the back view of the figure. Note how coils of clay have given her a stylized hair-do.

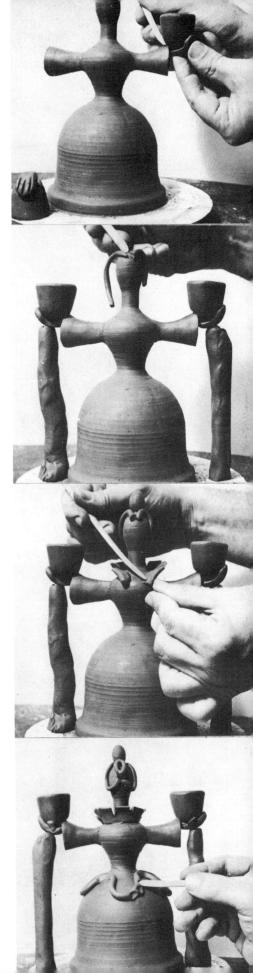

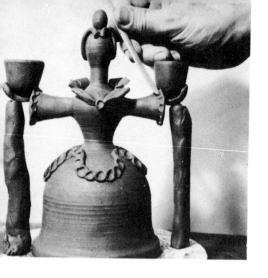

Ruffles on the sleeve. Thin coils of clay are wrapped around the end of the sleeves and put into place. Notice how here and on the ruffles of the skirt the marks made by the wooden modeling tool produces a ruffled effect. The figure is now complete.

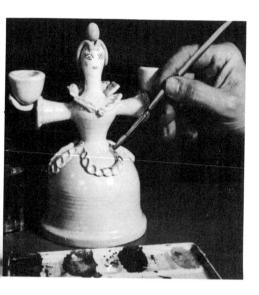

Decorating. The figure has been given a coat of opaque white glaze and fired. Now features are painted with underglaze colors on top of the fired glaze.

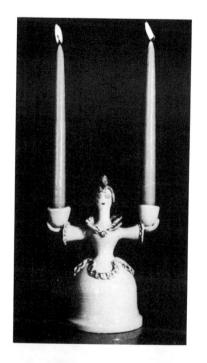

After its second firing, the candlestick in use.

Plate XVI illustrates some thrown ceramic sculpture. Experiment with cylinders and ball shapes thrown on the wheel. Cut them and combine them to form some original shapes.

If you do not own a potter's wheel, it is still possible to create sculpture of this type using the whirler and the adjustable hand rest illustrated in Fig. 17 on page 26. In Chapter 11 we saw how this device can be used to make lamps of cylindrical or globular shape. It can be used as well to make cylinders and globes to form ceramic sculpture.

A word of caution

In ceramics the line that separates the gay and amusing from the merely banal is a thin one, and it is easy to slip across. Guard against that by thinking of the material you work with. The clay in your hands is a wonderful material. It took thousands of centuries to produce it. It has inherent beauty and dignity. Don't degrade it by making objects in bad taste.

We get into trouble when we start talking about taste. What is taste? The dictionary calls it the power to recognize and to appreciate what is noble and beautiful in nature and in art, but if we ask "What is beautiful?" we receive different answers from different people. We don't all enjoy the same things; tastes differ, yet they may all be good.

If we cannot agree on what is good taste, perhaps we can agree on its opposite. What then is bad taste? Anything that repels us, that is out of harmony with its surroundings, that takes away pleasure instead of giving it is in bad taste. Something that masquerades as what it is not, an imitation, a copy of something created by someone else — all these are in bad taste. Ceramic forms made as cheap novelties, reproduced in great quantities that lower the value of the ceramic sculptor's work, are in bad taste.

Don't make anything that will shame you later on. To make doubly sure, as your taste changes (and it will certainly change as you continue to work with clay and grow in insight and understanding of the material) have the courage to look back with a critical eye at the things you have made. Weed out those pieces that seem less inspired and less satisfying than they did at the time you made them. If they do not measure up to your standards, get out the hammer and consign them to the oblivion they deserve.

Throughout all periods, from ancient to modern times, clay has been a favorite material for playthings for both children and grownups. Use it freely to create objects of whimsy and fantasy, but at the same time treat it with respect.

Madonna and Saints, Lyle Perkins.

Fisherman. Eugene Friley.

Guitar Players. Student work, School of Industrial Art, New York City.

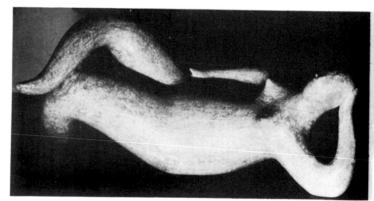

Reclining Figure. Ann Gatewood Van Kleeck. Courtesy Kagan and Dreyfuss.

Form. Student Work, University of Kansas. Glazed with Volcanic Ash Glaze.

PLATE XIX - MORE WAYS THAN ONE

14 More Ways Than One

The Chinese have a saying about sculpture. They say it should be made so that it can roll down a long steep hill and suffer no injury. In other words it must be compact, with no delicate projecting parts. Well, that is one point of view; adherence to it will produce solid, simple forms. But it is not the only point of view by any means. There are other ways of shaping clay to produce work quite different from the sculpture of the Chinese, yet equally satisfying.

At the beginning of Chapter 1 we said there is no one way to make sculpture, and in the pages that followed we emphasized that fact again and again. Each of the sculptors we have watched works in his own individual fashion; if we had the opportunity to visit more studios we should discover as many methods of working with clay as there are sculptors.

Not only are there individual ways of working, there are also individual ways of seeing. The same object makes different impressions on different artists and their ways of recording their impressions in clay vary. Let's glance at some of the sculptured representations that have been made of one of man's oldest and best friends, the horse. Plate XVII shows a terracotta horse from Egypt made over 1000 years ago and also an ancient ceramic horse and rider from China. The Chinese, master ceramists of olden times, modeled figures of horses in clay that are breathtaking in their beauty. They made horses and riders to decorate their homes; they even put them on their rooftops, attached to tiles. And when a wealthy man died, terracotta horses were placed in his tomb, along with replicas of his house and his servants, so that he could ride in comfort when he reached the other world.

As man's artistic progress continued down the years, wherever the horse existed, artists perpetuated him in sculpture. Sometimes they made him as realistic as the English porcelain horse shown on Plate XVIII. Sometimes they made simpler portraits like the Mexican earthenware horses. A group of more sophisticated ceramic horse from a modern decorator's shop is also illustrated on Plate XVIII. In these, the artists have used the horse merely as an idea to start out with and from that beginning, have gone to the creation of forms verging on the abstract.

Representation

Besides having different methods of working and different ways of seeing, sculptors have different objectives — different aims in making sculpture. With some, the purpose is to represent things as they are. With others, the aims are something else, yet representation is probably the beginning for most of those who work in three-dimensional art forms.

It is natural to start with representation. Watch a child making mudpies. Ask him what he is doing and his answer will be that he is making something — a man, or a dog, or a house. And in similar fashion when we start to model in clay we think first of reproducing some familiar shape. When people see sculpture for the first time, it must represent something to them. The passer-by stops and looks and feels an emotional response because the sculpture depicts something that he recognizes — a figure, an animal, or an interesting group. Subject matter is important.

Distortion

But even when the sculptor's aim is representation, he does not seek it completely. For absolute realism we must go to the taxidermist — he'll give us a stuffed animal with real fur and teeth. When the sculptor presents his work he does not say, "This is a cat." He says, "This is my idea of a cat and my work is a way of expressing my idea to you." And so he does not copy a cat but creates a form, and this involves distorting or changing natural shapes. His idea, expressed in clay, will look like what it is — a piece of clay sculpture and not a real cat.

Even if it were possible to achieve absolute realism in sculpture, the result would be unrewarding. A plaster cast made from an apple is not as satisfying as a model of the apple shaped directly in clay. All art involves distortion or change in some degree; it is part of the language of art. Where there is no change at all there is no art, for the maker has copied, not created.

Stylization

Stylization is a special kind of distortion in which natural forms are changed for the purpose of achieving a more direct and simple statement along with design. We see this frequently in architecture where a figure is adapted to fit a space within a building and we see it too on smaller works where natural forms are subordinated to decoration. Stylized work is not realistic but despite simplification and exaggeration, it shows clearly its natural source. The horse shown in Photo Series 1 is not at all realistic, yet there is no question about what it is. Anyone looking at it would recognize it as a horse. And in similar fashion, the rooster on Plate VII would be recognized, despite its stylized distortion.

Abstraction

Now we come to another kind of work in which distortion is carried

still further. The artist starts with a natural form but changes it until its resemblance to nature is lost. This type of work presents a challenge to the sculptor. He must stop the passer-by and hold his attention through the artistry of his forms. The appeal of subject matter is discarded except when it lingers on as a bit of mystery in the title of the piece.

Your interest may be in fields other than this. You may prefer the more representative type of sculpture, but even so you will find making an abstraction to be a worthwhile experience. Make a figure or a small group — a man playing a guitar or a boy with his dog — but get away from realistic presentation. Let your aim be not to make a portrait but to create an interesting arrangement of masses. Start by modeling a figure. Then select the important lines and strengthen them. Eliminate details and anything that interrupts larger movements. Emphasize planes. As you work, the clay will help you. Forms will develop. Preserve what is good, discard what is not satisfying, then fire and glaze the result.

Look at the photos of the guitar players on Plate XIX. These show how two sculptors handled the same theme, one realistically and the other abstractly.

Non-objective sculpture

As you acquire greater experience in sculpture through your own work and through seeing the work of others, you will become more and more interested in form, with less concern for what the form is supposed to represent. And that is right. Sculpture should appeal through the arrangement and the balance of volumes, through the play of light on planes and surfaces, through contrasts of textures. All of these can be present in sculpture which is quite realistic. They can be present also in sculpture which is completely non-objective, which makes no attempt to suggest anything that already exists.

Some of the proponents of modern sculpture say that starting with the idea of an actual figure or object in mind is like using a crutch, and they will have none of it. They work with form alone. Sculpture of this type does not appeal equally to all people, but everyone who works in clay can profit by some exercises in non-objective arrangements. Start with the basic shapes — the cube, the sphere, the cylinder and the cone. Alter their shapes, make them intersect, combine them in arrangements that are arresting and original.

Sculpture that moves

Our concepts of ceramic sculpture have undergone a change in recent years. Not so long ago a friend of mine submitted a piece of work to a sculpture show and the jury turned it down. It wasn't sculpture, they said. My friend had made an amusing figure of a monkey to be hung in a tree. It had no base and no fixed position, and sculpture, in the jury's opinion, had to have a base and had to be static. Movement was out of place.

Our ideas are changed today. While some pieces of sculpture suggest quiet and repose, others are dynamic and suggest movement. Some modern

St. Peter, France. Courtesy Musée des Arts et Traditions Populaires, Paris.

St. Francis. Student work, School of Industrial Art, New York City.
This figure, 21" high, was fired in a kiln with a chamber 14" high. It is made in two parts.

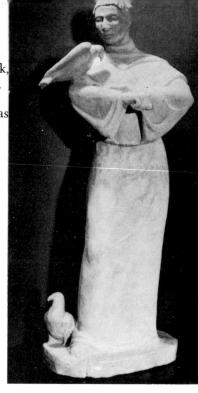

Figure, to be lighted from within.
Lynn Wolfe.

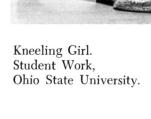

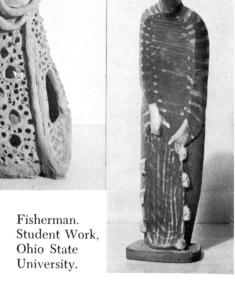

Prehistoric Terra-cotta Figures from the Shores of Lake Chapalla, Mexico. sculptors have gone a step further and, instead of suggesting movement, have created sculptural compositions which actually move. These are *mobiles* — arrangements of rods, chains, wires, discs, shapes cut from metal and wood — which hang from the ceiling and swing in the breeze, making ever changing patterns in space, throwing ever changing shadows, fascinating the beholder in much the same way as the flickering lights and shadows of a fireplace.

Movable sculpture can be made in ceramics too. The monkey tree shown in Photo Series 10 is not a mobile in the true sense of the term, yet it can move.

Materials in combination

The monkey tree uses wood as well as clay. Many ceramic sculptors use combinations of materials effectively. Plate XIX shows a fisherman made of terra cotta and wire. If you would like to try this kind of work, here is a suggestion. Make a ceramic horse with brass shim metal used for mane and tail.

A functional approach

It is not easy at the beginning to tackle the problem of creating pure form. We find it so much simpler to start with the idea of making something. Here is a compromise — we'll shape a piece of clay, not to represent an object, but to serve a purpose. Make a small free-form dish to be used as an ash tray.

PHOTO SERIES 45

Start with a lump of clay and press it between your fingers for a few minutes, then form it into a rough bowl. Don't make it circular but press it into a shape easy to hold, one that fits well into the hollow of the hand.

To add interest, look for lines of movement and emphasize them by moving the fingers over the clay in the directions suggested by the lines. A block of wood helps in the modeling.

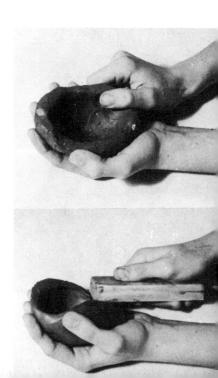

Now put the work aside for a few hours so that it can become a trifle firmer. Don't let the clay become dry. If you leave it overnight, cover it with a cloth that is slightly damp so that when you resume work it will be leather hard.

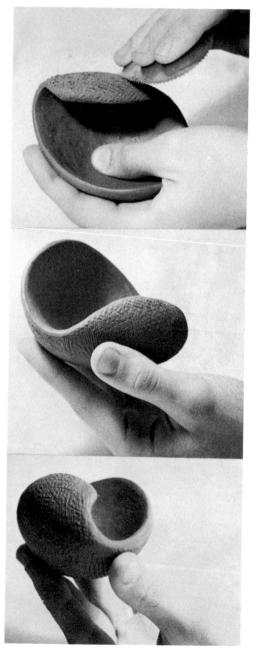

When the clay is firm but not dry, you can work on it with cutting tools. Use a toothed steel scraper to refine the shape. Streamline the object; pull surfaces together eliminating extraneous projections and hollows. Where walls are too heavy make them thinner.

Study the form

from all sides. Feel the way it balances in the hand and see how it rests on the table. When the form is right, remove the marks of the teeth by using the straight side of the scraper. Let the clay become bone dry, then work on it some more with fine sandpaper and finish the surface with a damp sponge.

The finished piece. Here we have solved a problem in form by modeling a shape to suit a purpose. But the clay helped us. The final form was arrived at not only through our fingers and our tools but also through the natural fluid movement of the clay itself.

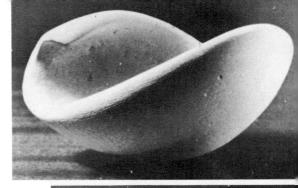

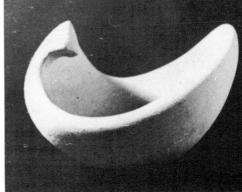

Another view.

Space

Ceramic sculpture is not flat. Except for tiles and plaques in low relief which may really be considered forms of drawing, ceramic sculpture is round; it is made to be looked at from all sides. Sculpture exists in space. The artist who paints on canvas composes elements within an area that is enclosed by a frame. He must think of the shapes around the things he paints as well as the shapes of the objects themselves. When you draw a black silhouette on a piece of paper you create not one shape but two. The part of the paper that remains white has shape just as surely as the part colored black. Cut out the black portion and a void is created with form and character of its own.

The sculptor's work is not set in a frame, yet when he models a shape in clay he alters the form of the space around it. Sculpture makes a hole in space just as the cut-out silhouette makes a hole in the paper. Think of this as you work.

Light

Sculpture exists in light. In fact everything that we see exists in light, but flat surfaces are viewed in one light alone while three-dimensional objects are viewed in many. The visual aspect of sculpture depends upon the kind of light that falls upon it and upon the direction and the source of light. Ceramic sculpture can be lighted from above or below, front or back, even from within. Light is an important element for the sculptor. Work with light and let light work for you.

[299]

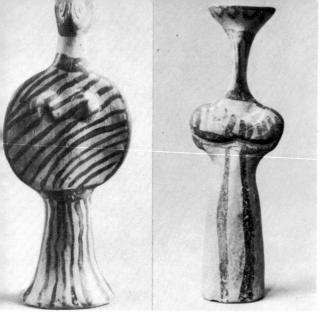

Archaic Greek Figures. Courtesy Metropolitan Museum of Art.

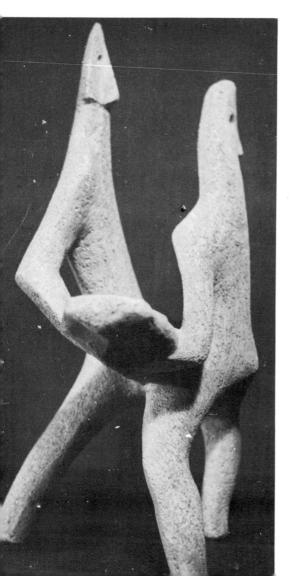

Prehistoric Funerary Figur Courtesy Brooklyn Museu

Prehistoric Funerary Figure, Egypt. Courtesy Brooklyn Museum.

Burial at Sea. Lyle Perkins.

Design

What is good design in ceramic sculpture, how can we recognize it and how can we work for it? The answer to this question is not easy to give but here are some principles.

Well-designed sculpture has rhythm, flowing lines, and movement.

It has good proportions, a satisfactory arrangement, and a balance of masses.

It has harmony; it is at home in its surroundings.

It has sincerity; it shows that the artist has given his best, that he believes in what he has done.

It is planned for a purpose and is suited to that purpose.

It has economy of line and form. Nothing is present that is not needed; shapes are not cluttered, lines are not complex.

It has originality.

It has honesty, honesty in the selection of shapes and honesty in the use of materials.

Skill

Acquire as much skill as you can but don't lose anything in the process. With some students of sculpture, as technical skill increases something seems to leave the work. A quality of simplicity and directness that was present in the earlier work disappears when the novice masters his medium, especially if his joy at learning that he can model things in clay so that they actually look like real objects leads him to become preoccupied with representation and the reproduction of unimportant details.

This artistic development in the individual has a parallel in the development of civilizations where the strong work of the primitive artists is replaced by the more skillful but often less satisfying work of the artists who came later. If we compare the Greek sculpture of the archaic period from the tenth to the eighth century B.C. with that of the period of decadence in the third century B.C., we see that the latter has technical perfection while the former has vitality and strength.

This does not mean that technical skill is to be neglected, not by any means. As a sculptor, you must learn how to handle your tools and your materials — but don't let them master you.

Be yourself

The way that you work with clay will depend upon your taste and your experience. Don't develop mannerisms in the hope that they will become an individual style. Work for craftsmanship. Your style will come by itself.

Study the work of the artists shown in these pages. Study the work of as many other artists as you can. Look at contemporary sculpture as well as the sculpture of the old masters, but don't copy any of it. Learn the language of ceramic sculpture and when you can speak that language take the clay in your hands and use it to say what you yourself have to say.

The last time I visited a museum I saw a little ceramic figure of a laughing man, made by a Chinese sculptor long, long ago. I don't know the sculptor's name but let's call him Chu Ying. One day when the sun was shining brightly and Chu Ying felt happy and gay, he took a piece of clay in his hands and modeled this little figure and in doing so he breathed into it some of his feeling that life was good.

Chu Ying has been dust for over 2000 years, but because he worked in clay and fired the piece he made, the feeling of happiness he had that day long ago has become immortal. Over the centuries Chu Ying speaks to us in a language we can understand, the language of a fellow craftsman, for he is one who has shared with us the joy of working in clay.

Index

Hydrostone, 82

Absorption, 126 common, 120, 124 Figurines, 210 Fillers, 122 Abstraction, 294 Dalton, 5 drying, 8 Edgar Lake, 119 Filter press, 131 Firing cycle, 197 Acetic acid, 10 Agate ware, 136 Firing in sections, 255 Firing range, 124, 127 Flint, 89, 123, 148 Aging, 127 fire, 119 flour, 7 Alumina, 118, 121, 158 Anatomy, animal, 61 Anatomy, human, 35, 77 Animals, 48 Gorden, 5 Jordan, 5 Flower box, 261 Monmouth, 5 Flower holders, 245 Flowers, ceramic, 208 Antimony, 169 non-hardening, 17 oven-hardening, 16 Armatures, 13, 46, 59, 71 Flux, 120, 148 preparing, 132 residual, 118 Aventurine glaze, 167 Form, 17 Fountains, 267 Free form, 297 Frit, 121, 153 sedimentary, 119 Ball mill, 172 Balsam, oil of, 219 self-hardening, 16 Banding wheel, 26, 233 Barium, 159 Frogs, 29 stoneware, 16 testing, 126 Cleopatra's Needle, 273 Cobalt, 137, 170 Fuels, 191 Fuller's earth, 191 Bats, plaster, 93, 286 Beads, 278 Function, 297 Coil building, 11, 227, 233, 255 Colemanite, 155, 164 Color, 133, 171 Bentonite, 120 Gale, Eleanor, 49, 103 Benzine, 144 Garden sculpture, 253 Bird bath, 272 Blending, 135 Gardens, miniature, 285 Color in clay, 133, 137 Gate, 100 Color in glazes, 148, 169 Composition, 17 Blistering, 182 Blow out, 125 Glass cullet, 122, 155 Glass fibre, 191 Blowers, 145 Bluing, 106 Cones, pyrometric, 189 Cone temperatures, XV Cooling, 199 Copper, 137, 170 Core, 12, 50, 71, 261 Cornwall stone, 166 Cracking, 9 Glass-forming engobe, 144 Glass tubing, 140 Blunging, 131 Glaze, 146 Board, modeling, 27 alkaline, 152 Board, wedging, 25 Bottle, 276 Borax, 152, 164 borosilicate, 155 Bristol, 157 Cracking, 9 Crackle, 160 Crawling, 181 celadon, 166 crackle, 160 defects, 180 Boron, 152 Borosilicate glaze, 155 Crayons, ceramic, 223 Crazing, 160, 180 Crimson base, 167 Bowl, drying, 94 feldspathic, 166 Brass, shim, 105 Bricks, 191 fritted, 153 gun metal, 163 Bronze, 186 Crystallization, 87, 159 lead, 148 Bubbling, 164 Burlap, 6, 15, 107, 110, 113, leadless, 152, 155 lustre, 169 mat, 158 Damp closet, 14, 15, 27 De-airing, 131 260° Decalcomania, 221 Butterflies, 59 Decomposition, 118 majolica, 151 Decorating, 114, 208, 217, 238, 242, 277 metallic, 162 Calcining, 148
Calcium, 150
Calipers, 28, 255
Candlesticks, 3, 101, 225, 286 mixing, 172 Decoration, defects in, 224 opaque, 151 porcelain, 166 prepared, 146 recipes, 148 Deflocculation, 123 Dehydration, 197 Carving, 111 Casing, 110 Design, 301 red, 166 salt, 165 Dextrine, 150 Casting, 128 Casting box, 95, 213 Cavallito, Albino, 59, 77 DiMaggio, Monie, 208 Dipping, 176 sang-de-boeuf, 166 Distortion, 294 speckled, 161 Celadon glaze, 166 Cement, Duco, 116, 240, 241 Ceramispar, 120 Dolomite, 157 stoneware, 166 Draft, 84, 100 volcanic ash, 156 Dresden, 213 Drilling, 241 Glazing, 147, 176 Globar, 192 Ceremul, A, 144 Chess board, 284 Glossiness, 182 Gold, 104, 219 Dry footing, 201 Chessmen, 281 Drying, 8, 17, 87 China painting, 219 Chromium, 137, 168, 169 Clay, Alberhill, 5 ball, 119 Dryness in glaze, 182 Gouges, 112 Grinding, 199, 239 Grog, 10, 87, 137 Electrolytes, 123 Elements, electric, 192, 251 Eliscu, Frank, 33, 43, 52 Eliscu, Frank, 33, 43, 52 Engobe, 50, 138 Engobe defects, 146 Enlarging, 49, 255 Epsom salts, 155 Gum arabic, 150 Barnard, 5, 144 blackbird, 5, 144 bodies, 5, 6, 128, 131 Gum cellulose, CMC, 150 Gum tragacanth, 150 Gypsum, 81 body recipes, 128 Hand rest, 26, 233 High fire, 198 buying, 5 Equestrian sculpture, 59 calcined, 148 Extruding, 220 Campbell's, 5 casting, 7 china, 119, 147 Hollowing, 11, 74, 271 Horses, 293 Fantasy, ceramic, 279 Fat oil of turpentine, 219 Houdon, 43 Feldspar, 118, 121, 147 Felt, 46, 241 cleaning, 125 color, 127, 133, 137 Hydrocal, 82

Slip painting, 141 Slip trailing, 139, 233 Soapstone, 184 Soda, 118, 121, 152 Soda ash, 123, 152 Ilmenite, 162 Overglaze painting, 219 Incising, 243 Inlaying, 50, 136 Oxidation, 135, 200 Paint, 16, 185 Insulation, 191 Paint, cement base, 185 Iron, 121, 137, 167, 170 Iron chromate, 137, 170 Painting engobe, 141 Paraffin, 143 Sodium alginate, 150 Sodium silicate, 123 Jewelry, 278 Joining, 9 Jugs, 275 Patina, 186 Sodium tannate, 123 Peeling, 146 Pencils, ceramic, 175 Spatter, 161 Space, 299 Spirals, 244 Piercing, 244 Kanthal, 192 Kaolin, 119, 147 Pigments, 137 Pinholes, 182 Sprias, 244
Spraying, 15, 27, 35, 177
Sprigs, 92, 112, 244
Stacking, 200
Stains, 137, 171
Stencils, 139
Start 201 Kiln wash, 202 Pink oxide, 167 Plasteline, 17, 24 Plaster of Paris, 25, 81 Kilns, 189 construction, 203 downdraft, 195 blue coat, 106 electric, 191 gas, 194 muffle, 194 Stilts, 201 carving, 111 drying, 87 Stoneware, 129 Stoves, 248, 250 mixing, 84 models, 108, 263 oil, 195 Stylization, 294 periodic, 196 Table, 246 Talc, 89, 122, 130, 184 period of plasticity, 100, 110 pottery, 82 supports, 201 tunnel, 196 pouring, 86, 107 reinforcing, 103, 106 setting, 87, 114, 115 Plastic bags, 6, 7, 14 Plasticity, 124, 127 Template, 99, 112 updraft, 194 Terra cotta, 71, 123, 130 Terra sigillata, 145 Lace, 214 Testing, 126, 175 Texture, 21, 87, 183 Thermal shock, 122 Lamps, 230 wiring, 240 Lavender, oil of, 219 Plate warmer, 251 Lead, 149 Lead chromate, 170 Polychrome, 45, 218 Porcelain, 121, 128 Thread separation, 108 Throwing, 286 Tiles, 83, 87, 141, 247 Porosity, 10, 127 Portraiture, 71 Potash, 118, 121, 152 Leather-hard ware, 8, 15 Light, 29, 299 Lime, 121 Tin, 171 Tin enamel glaze, 151 Titanium, 159, 171 Linseed oil, 184 Potassium, 152 Lopez, Pat, 128, 248 Lustre, 168 Potter's wheel, 285 Tools, 20 Pressing, 87, 104, 265, 269 Pugmill, 131 plaster, 115 Translucent bodies, 122 Magnesite, 157 Pumicite, 156 Translucent glaze, 152 Magnesium, 157 Magnetite, 137 Pump, 267 Tray, 248 Turning, 288 Turning box, 112 Pyrometers, 191 Majolica, 151, 218, 277 Manganese, 137, 170 Marbleizing, 223 Margoulies, Berta, 255 Realism, 32 Turntable, 26 Reclaiming clay, 17, 125 Reduction, 135, 200 Turpentine, 242 Turtles, 64 Marking fluid, 175 Maroon base, 167 Refractories, 191 Twine, 13 Reinforcing, 103, 106 Relief, 84, 111, 243 Maturing point, 123, 198 Meissen, 213 Micalizzi, David, 22, 279 Umber, 144, 171 Representation, 294 Undercuts, 98 Retaining walls, 90, 95, 96 Underglaze colors, 172, 290 Milk, 184 Reticulation, 165 Underglaze painting, 217 Mirror, 31, 75 Mobile sculpture, 295 Rubbing, 185 Running in glazes, 182 Vanadium, 171 Vaseline, 117 Modeling board, 27 Running plaster, 112 Vermiculite, 184, 191 Vinegar, 10, 95 Modeling in plaster, 110 Rutile, 159, 170 Modeling stand, 27 Volcanic ash, 156 Saggers, 195 Molds, 81 Salt glaze, 165 Salts, soluble, 171 Volclay, 120 drain, 89 figurine, 212 press, 71, 82, 96, 103, 263 sprig, 92, 112, 244 squeeze, 71 Warping, 9 Sand, 13, 123, 125 Water, 181 Water, chemically combined, 8 Sang-de-boeuf, 1 Screens, 10, 125 166 Water of plasticity, 8th Sculpture body, 128 Water smoking, 197 two-piece, 96 waste, 105, 108, 262 Setting, 87 Wax, 184 Settling, 155 Wax resist, 143 Wedging, 7 Molasses, 150 Sewer pipe, 272 Sgraffito, 142, 220, 242 Shellac, 16, 95, 99 Wedging, 7 Wedging board, 25 Monteleone, Mario, 210 Mounting, 74 Wedgwood, Josiah, 137 Shelling, 146 Nepheline syenite, 121 Weep holes, 273 Whirler, 26, 233 Whistles, 277 Shims, 105 Net, 215 Shivering, 180 Nichrome, 192 Shrinkage, 8, 126 Sienna, 137, 144 Sieves, 10, 125 Silica, 118, 121, 123 Size, 94, 99 Nickel, 170 White bodies, 130 Non-objective sculpture, 295 Whiting, 150 Wire, chicken, 110 Notches, 97 Wire, piano, 25 Ochre, 144, 170 Oil of balsam, 219 Oil of lavender, 219 Wiring lamps, 240 Sketching, 32 Steb building, 12, 55, 230, 237 Slabs plaster, 93 Slaking, 17, 85 Slip, 7, 17, 91, 123 Yellow base, 172 Oilcloth, 14 **Z**inc, 171 Organic matter, 10, 184, 198 Zirconium, 152, 171 Overglaze colors, 172

Zircopax, 171